PRAISE FOR

I LIKE TO WATCH

FINALIST FOR THE PEN/DIAMONSTEIN-SPIELVOGEL AWARD FOR THE ART OF THE ESSAY

"You'll be delighted. . . . Nussbaum's essay about men, art, and the #MeToo movement is alone worth the price of the book."

—*The Washington Post*

"Lucky us. *I Like to Watch: Arguing My Way Through the TV Revolution* is a collection of thirty-two brilliant, generous essays. . . . They are marbled with her thinking about prestige and power and gender and taste, but they are also funny. . . . She insists implicitly and explicitly that TV should be mind-expanding, complex, generous, and, above all, have things to say about who we are and what we want."

—NPR

"What Nussbaum does is thrillingly different; she treats television as art in its own right—not the kind of rarefied, fragile museum piece that requires you to handle it with a hushed reverence and kid gloves, but a robust, roiling form that can take whatever you throw its way. . . . This is confident, dauntless criticism—smart and spiky, brilliantly sure of itself and the medium it depicts."

—*The New York Times*

"Some critics, even great ones, you read to agree or disagree with them, but Emily Nussbaum writing about television is something else again. As you read her, you can feel her enlarging your mind: not just what you think about the show at hand or television itself, but pop culture and our place inside of it. Her fantastically smart work has always been a pleasure to read a week at a time; this book proves she's equally great to binge, and 'Confessions of a Human Shield,' a new essay on how to think about art in the time of #MeToo, is essential twenty-first-century reading."

—ELIZABETH MCCRACKEN, author of *Bowlaway*

"Reading Emily Nussbaum makes us smarter not just about what we watch, but about how we live, what we love. and who we are. *I Like to Watch* is a joy."

—REBECCA TRAISTER, author of *Good and Mad*

"Television might disappoint you; Emily Nussbaum never has and never will. Taken together, the pieces in *I Like to Watch* form a searching, brilliant history of American attraction, repulsion, and fascination in the era of peak TV. The book assembles a picture, alive with rigor and pleasure, that only Nussbaum could paint of a medium that has risen and transformed into a high-culture institution that's also an ever-shifting experiment about scorn and anxiety and desire. We're lucky to have this record of it, as well as this casual reminder that criticism, at its very best, is an irreplaceable thrill."

—JIA TOLENTINO, author of *Trick Mirror*

"Emily Nussbaum is the perfect critic—smart, engaging, funny, generous, and insightful. All of these talents are on display in this marvelous anthology of her essays on television. They illuminate the shows shaping our culture, and the power of this flourishing art form."

—DAVID GRANN, author of *Killers of the Flower Moon*

I LIKE
TO
WATCH

———————————

I LIKE
TO
WATCH

ARGUING MY WAY THROUGH THE TV REVOLUTION

Emily Nussbaum

RANDOM HOUSE

NEW YORK

Published in the United States by Random House, an imprint and
division of Penguin Random House LLC, New York.

RANDOM HOUSE and the HOUSE colophon are registered trademarks
of Penguin Random House LLC.

Originally published in hardcover in the United States by Random House,
an imprint and division of Penguin Random House LLC, in 2019.

Most of the essays in this work were originally published, in slightly
different form, in *New York* and *The New Yorker*.

Grateful acknowledgment is made to Alfred A. Knopf, an imprint of the Knopf
Doubleday Publishing Group, a division of Penguin Random House LLC, for their
permission to reprint an excerpt from "The Elder Sister" from *The Dead and the
Living* by Sharon Olds, copyright © 1975, 1978, 1979, 1980, 1981, 1982, 1983 by
Sharon Olds. Used by permission of Alfred A. Knopf, an imprint of the Knopf
Doubleday Publishing Group, a division of Penguin Random House LLC.

LIBRARY OF CONGRESS CATALOGING-IN-PUBLICATION DATA
Names: Nussbaum, Emily, author.
Title: I like to watch: arguing my way through the TV revolution /
Emily Nussbaum.
Description: New York: Random House, [2019]
Identifiers: LCCN 2018055067 | ISBN 9780525508984 (paperback) |
ISBN 9780525508977 (ebook)
Subjects: LCSH: Television series—United States—History and criticism. |
Nussbaum, Emily
Classification: LCC PN1992.8.S4 N87 2019 | DDC 791.45/750973—dc23 LC
record available at https://lccn.loc.gov/2018055067

Printed in the United States of America on acid-free paper

randomhousebooks.com

Book design by Caroline Cunningham

Dedicated to my husband, Clive Thompson,

and my sons, Gabriel and Zev, the world's biggest fans of

Jane the Virgin and *Parks and Recreation*

CONTENTS

AUTHOR'S NOTE xi

THE BIG PICTURE: How *Buffy the Vampire Slayer* Turned
Me Into a TV Critic 3

THE LONG CON: *The Sopranos* 25

THE GREAT DIVIDE: Norman Lear, Archie Bunker,
and the Rise of the Bad Fan 36

DIFFICULT WOMEN: How *Sex and the City* Lost Its
Good Name 48

COOL STORY, BRO: The Shallow Deep Talk of
True Detective 56

LAST GIRL IN LARCHMONT: The Legacy of Joan Rivers 62

GIRLS GIRLS GIRLS
 Hannah Barbaric: *Girls* and *Enlightened* 74
 Big Gulp: *Vanderpump Rules* 81

Shark Week: *House of Cards* and *Scandal* 87

The Little Tramp: *Inside Amy Schumer* 91

Hello, Gorgeous: *The Marvelous Mrs. Maisel* 97

Candy Girl: *Unbreakable Kimmy Schmidt* 102

CONFESSIONS OF THE HUMAN SHIELD 107

HOW JOKES WON THE ELECTION: How Do You Fight
an Enemy Who's Just Kidding? 158

BREAKING THE BOX

Love, Actually: *Jane the Virgin* 171

Return of the Repressed: *The Comeback* 176

Shedding Her Skin: *The Good Wife* 181

Castles in the Air: *Adventure Time* 187

Depression Modern: *The Leftovers* 192

Swing States: *The Middle* 197

Smoke and Mirrors: *High Maintenance* 202

WHAT TINA FEY WOULD DO FOR A SOYJOY: The Trouble
with Product Integration 207

IN LIVING COLOR: With *Black-ish*, Kenya Barris Rethinks
the Family Sitcom 223

IN PRAISE OF SEX AND VIOLENCE

To Serve Man: *Hannibal* 249

Trauma Queen: *Law & Order: Special Victims Unit* 255

Graphic, Novel: *Marvel's Jessica Jones* 260

L.A. Confidential: *Behind the Candelabra* 265

What About Bob? *The Jinx* 270

The Americans Is Too Bleak and That's Why It's Great 275

RIOT GIRL: Jenji Kohan's Hot Provocations 279

A DISAPPOINTED FAN IS STILL A FAN: *Lost* 305

MR. BIG: How Ryan Murphy Became the Most Powerful
 Man on TV 313

ACKNOWLEDGMENTS 349

INDEX 351

AUTHOR'S NOTE

This is a book celebrating television, but it's not a Top 10 list—or a Top 20 list, or any other kind of rating system. In other words, it's not a book about my favorite shows. (If it were, it would surely include an essay on *Slings and Arrows*.) I like some of these shows, I love others, and a few are not my cup of tea. These reviews are simply the ones that I thought held up the best as criticism—and also, the ones that most effectively made my argument about TV.

I LIKE
TO
WATCH

THE BIG PICTURE

How *Buffy the Vampire Slayer* Turned Me Into a TV Critic

W hat happens when your side wins the fight, the drunken cultural brawl that you've been caught up in for nearly two decades? And then the rules change, midway through? That's the crisis that I'm currently facing, when it comes to the beauty and power—and lately, even the definition—of television as an art form.

When I first began watching television, there didn't seem to be much to argue about. Like many children of the seventies, I grew up sitting cross-legged in front of a big console in the living room, singing along to *The Electric Company* while my mom made Kraft Macaroni & Cheese. I dug *Taxi*, I loved *M*A*S*H*. In my teens, I memorized *Monty Python* sketches with my friend Maria. But I also regarded TV the way that Americans had been taught to, since the 1950s. Television was junk. It wasn't worthy of deep thought, the way that books or movies might be. It was something that you enjoyed, then forgot about. It wasn't until my thirties that I had what amounted to a soul-shaking conversion, on the night that I watched Sunnydale High School principal Bob Flutie die, torn to bits by hyenas.

At the time, in the spring of 1997, I was a literature doctoral student at NYU, foggily planning on becoming a professor, maybe a Victorianist, but anyway, somebody who read for a living. Every morning, I woke up, flopped onto the sofa, and opened up yet another 900-pager. Across the room was an old-fashioned console TV, a dinosaur even for the era, with a broken remote control, so in order to watch my first episode of *Buffy the Vampire Slayer*, I had to physically walk across the room, then click the circular dial over to Channel 11, The WB, a brand-new "netlet," and then walk all the way back to the sofa.

Walking across the room to change the channel was still a normal thing to do, in 1997. It had been nearly sixty years since the first television (spookily nicknamed the Phantom Televeiver) launched at the 1939 World's Fair, and yet the medium was—with a few advances, like the addition of color and the still-tentative expansion of cable—not that different from what it had been in the 1950s, when families gathered to watch Milton Berle. Shows aired once a week. They were broken up by ads. When the ads were on, you peed. When they ended, someone in the other room would yell, "You're missing it!" and you'd run back in. If you loved a particular show, you had to consult the elaborate grids in the print newspaper or in *TV Guide* to know when to watch: "*ALF* (CC)—Comedy. ALF is upstaged by a loveable dog that followed Brian home, so he gives the pooch away to a crotchety woman (Anne Ramsey)."

The main thing, though, was that television went away. It was a disposable product, like a Dixie Cup. Although scripted television hadn't aired live for many decades, it still *felt* live. You could watch rental movies on your VCR (and for a few years, they were everywhere) but most people I was friendly with didn't regularly pre-program theirs to record much TV, because doing so was such a pain: spinning three plastic dials, for the day, the hour, and the minute. Each videotape held only a few hours of programming; rewinding and fast-forwarding were clumsy processes (and pausing might break the tape). There were no DVDs yet, let alone

DVRs. Even if you were an early Internet adopter, which I was, dialing in was a grindingly slow, unreliable process—and when you *did* connect, with the hostile shriek of static that we optimistically called a "handshake," no videos showed up, just a wall of blinking neon fonts. Nothing, ever, arrived "on demand."

This glitchy, ephemeral quality, and the ads that broke up the episodes, were a major part of TV's crappy reputation. This part may be hard to remember, even if you lived through it. But just before the turn of the century—nearly universally, by default, and with an intensity that's tough to summon up now—television was viewed as a shameful activity, as "chewing gum for the eyes," to quote drama critic John Mason Brown. This was true not only of snobs who boasted that they "didn't even own a TV"; it was true of people who *liked* TV. It was true of the people who made it, too. TV was entertainment, not art. It was furniture (literally—it sat in your living room) that helped you kill time (it was how to numb lonely hours while eating a "TV dinner," shorthand for a pathetic existence). TV might be a gold mine, economically speaking, but that only made it more corrupt. If you were an artist, writing TV was selling out; if you were an intellectual, watching it was a sordid pleasure, like chain-smoking. People still referred to television, with no irony, as "the boob tube" and "the idiot box." (Some people still do.)

This is not to say there were no good shows. Critics praised (and, often, overpraised) the grit of *Hill Street Blues*, the nihilistic wit of *Seinfeld*, yadda yadda yadda. In the mid-'90s, there were several major breakthroughs in the medium, among them the teen drama *My So-Called Life* and the sci-fi series *The X-Files*. But among serious people, even the best television wasn't considered worthy of real analysis. This was particularly true among my grad-school peers, the thinky guys whom I had privately nicknamed "the sweater-vests"—the men who were also, not coincidentally, the ones whose opinions tended to dominate mainstream media conversation. For them, books were sacrosanct. Movies were respected. Television was a sketchy additive that corporations had

tipped into the cultural tap water, a sort of spiritual backbone-weakener.

The scripture for this set of thinkers was an essay by the writer George W. S. Trow, "Within the Context of No-Context," which people recommended to me so frequently that it started to feel like a prank. A masterwork of contempt, "Within the Context" was a trippy string of koans that was initially published in 1980 in *The New Yorker*. It came out in book form in 1981, then got rereleased in paperback in 1997, the same year that *Buffy the Vampire Slayer* debuted. As Trow saw it, television was a purely sinister force. It was a mass medium whose mass-ness was its danger, because it conflated ratings with quality, "big" with "good." The vaster television got, the more it ate away at the decent values of mid-century America—back when viewers were people, not demographics; adults, not children; capable of intimacy and proportion. "Television does not vary," he wrote. "The trivial is raised up to power. The powerful is lowered toward the trivial." Also: "What is loved is a hit. What is a hit is loved." It was an elitist screed, nostalgic for an America that had never really existed, but it had a penetrating, pungent force.

On *Charlie Rose* in 1996, novelists David Foster Wallace, Mark Leyner, and Jonathan Franzen struck an only slightly less apocalyptic note, spending nearly half of what was advertised as a panel on "The Future of American Fiction" denouncing television as "a commercial art that's a lot of fun that requires very little of the recipient." Their worries about television's "kinetic bursts" were a precursor to the pseudoscientific rhetoric ("dopamine squirts") that would later greet the Internet, once that stepped in as a cultural bogeyman. But then, they were part of a long tradition. In 1958, newscaster Edward R. Murrow had warned about the propagandistic dangers of the medium in his brilliant "box of lights and wires" speech. In the 1970s, popular jeremiads like Jerry Mander's *Four Arguments for the Elimination of Television* and Marie Winn's *The Plug-In Drug* diagnosed TV as an addiction. In the 1980s, the

slogan "Kill Your Television" was a hip bumper sticker. At the turn of the century, watching TV was still widely seen, in the much-quoted (although possibly apocryphal) words of nineties comic Bill Hicks, as a spiritually harmful act, like "taking black spray paint to your third eye."

There were occasional exceptions to this mood, among them Chip McGrath's 1995 cover story in *The New York Times Magazine*, "The Triumph of the Prime-Time Novel," in which he praised *ER* and *Homicide: Life on the Street* for their "classic American realism, the realism of Dreiser and Hopper." But as his title indicated, McGrath's argument was just the flip side of the one made by the Charlie Rose panel. TV might, in fact, be worth watching—but only when it stopped being TV.

This was the value system that I was soaking in, Palmolive-style, on the night that I watched my first episode of *Buffy the Vampire Slayer*. Even more than most television of that era, the show sounded like a throwaway. It had that silly title. It was based on a campy movie, created by a little-known writer/director named Joss Whedon. It starred a soap opera actress, Sarah Michelle Gellar, and an actor from a Taster's Choice ad, Tony Head. And if you tried to describe the plot, it screamed "guilty pleasure": It was a horror comedy about a superpowered cheerleader leading a double life. By day, Buffy Summers flirted with boys and flunked her classes. By night, she was "The Chosen One," stabbing vampires in the heart with pointy wooden stakes. The credits opened with a wolf howling, wild riffs of hard-rock guitar, and shots of Buffy herself doing kung fu. It looked like a good way to kill time before getting back to analyzing themes of the public woman in George Eliot's *Daniel Deronda*.

Instead, I fell into a trance of joy. Now to be clear, the episode I was watching is not only not one of the standout episodes of Buffy, it is also not an episode that most—or really, any—Buffy viewers

consider to be much good. Instead, it's a first-season story that fans tend to remember as "Wait, that one with the hyenas?" In "The Pack," a clique of high-school bullies gets possessed by the wild beasts that Buffy describes with disgust as "the schmoes of the animal kingdom." The villain is a resentful zookeeper, straight out of *Scooby-Doo* (long story short, he wanted to be possessed by a hyena himself, but misfired his spell). And yet "The Pack," for all its schlocky affect, was the one that hooked me, hard. In one scene, in which the bullies strutted in slo-mo through the high school courtyard, I got chills. In another, in which Buffy's friend Willow wept, my eyes welled up. The show had a peculiar tonal blend, at once bleak and goofy, formulaic and anarchic. It had a fascination with sexual violence—including the threat of "nice guys," like Buffy's hyena-possessed friend Xander—but it folded those dark themes together with screwball banter and fun pop-culture references ("I cannot believe that you, of all people, are trying to Scully me").

Then, just before the second ad break, the plot took a grotesque turn: The bullies gobbled up a live pig, Herbert, the Sunnydale High School mascot. A few scenes later, the hyena-possessed kids surrounded, taunted, and then literally *ate* the school principal, Bob Flutie, a character who had been, up until he was eaten, a significant part of the ensemble. "Crunchy!" snickered the pretty ringleader. Flutie's death was a fabulously macabre twist—one of many such twists in a series that had no interest at all in Dreiser-like realism—but it wasn't exactly a joke. Once Flutie got eaten, he stayed dead.

Cannibalizing a high school principal probably sounds like small potatoes in the era of *Game of Thrones*. But in 1997, the moment felt bracing, particularly on a fluffy teen comedy on an off-brand netlet. Still, what really got me was the show's peculiar originality, the ways in which it felt stealthily experimental beneath its conventional surfaces, which were low-budget and, aesthetically, nothing special. As he would often explain in interviews,

Whedon had taken the bimbo victim of every exploitation film—the eye candy, tottering to her death down a dark alley—and let her spin around and become the avenger. Thrillingly, *Buffy* treated this one girl's story not as something trivial, but as a grand, oceanic metaphor. It made her story mythic, not cartoonish. Like plenty of teenagers, Buffy believed that what was happening to her was the end of the world. But she was right; her demons were real. The fact that the show was silly, too, that it was sexy and playful, that it riffed off TV formula and had cheesy cliff-hangers and close-ups and sitcom "buttons," didn't make the show dumb. It made it smart.

During the commercial break, I called a friend, the one who had recommended the series, and, because cellphones barely existed, I had to use a landline, coiling the spiral cord around my arm. I said to him in fascination, "Did you see that guy get eaten before the ad break? This show is *wild*."

I'd never finish my doctorate. Instead, *Buffy* spiked my way of thinking entirely, sending me stumbling along a new path. My *Buffy* fanhood was not unlike any first love. It was life-swamping, more than a bit out of proportion to the object of my affection, and something that I wanted to discuss with everyone, whether they liked it or not. I'd been an enthusiast before, but not a fan in the stalker-crazy-obsessive sense. I had other work to do, teaching and editing and, eventually, working as a magazine journalist, but for several years, the only thing I actually *wanted* to do was analyze *Buffy the Vampire Slayer*. In practice, this meant that I was online a lot. When "Earshot," an episode about a school shooting, was pulled from the airwaves because it was too soon after the Columbine massacre, I found a stranger up in Canada who sent me a bootleg videotape. One time, someone set me up on a blind date because the guy liked *Buffy the Vampire Slayer*, too. It didn't last, but the setup struck us both as entirely reasonable.

Still, there matters might have remained—as a hobby, not a life plan—were it not for the near-simultaneous emergence of another

television show, HBO's mob drama *The Sopranos,* in 1999. *The Sopranos* was my other favorite. Like many viewers, I got hooked after watching the first-season episode "College," the one in which Tony strangled a snitch with a length of wire, midway through a tour of New England colleges with his daughter, Meadow. And yet loving *The Sopranos* was a very different experience, at the turn of the century, from loving *Buffy the Vampire Slayer. The Sopranos* was a show for adults, something to brag about, not apologize for. It was the series that defined the twenty-first-century model of "prestige television," a category that doubled as a social-class distinction and an intellectual one. After the first season finale, Stephen Holden, in *The New York Times,* called the show "the greatest work of American popular culture of the last quarter century." Not the best television show, or the best cable drama; after one season, *The Sopranos* had already escaped the orbit of its lowly medium entirely. It was real art, which meant that it was worthy of real criticism.

This response made some sense, given that *The Sopranos* was produced and distributed by HBO, a velvet-rope pay cable network whose new slogan was "It's not TV. It's HBO." HBO, with its fat budget and its breakthrough reliance on subscriptions rather than ad minutes, could take risks that the networks could not. And, in fact, *The Sopranos did* have qualities that were unlike most television that came before it. It had no ad breaks. It had no cliff-hangers. Because it didn't have to play to nervous censors, it overflowed with cursing, violence, and the bouncy boobs at the Bada Bing. It also looked fantastic. Visually, the series was what people tended to call "gritty"—not realistic, precisely, but *authentic,* with a sense of place (specifically, a sense of New Jersey) that distinguished it from most other TV series. Filmed on location, with a budget that helped it look almost good enough to play on the big screen, *The Sopranos* emphasized imagery over action, characters over plot, letting threads dangle and themes build. It felt like a book; it looked like a movie. Its hero was someone viewers took seriously, a tow-

ering symbolic figure: Tony Soprano, the first of the great middle-aged white male antiheroes who would dominate TV for nearly a decade. These characters were, very often, created by men who were cut from a somewhat similar cloth, insofar as they were working out their own issues with authority—including the authority of television itself, that collaborative, formulaic, culturally derided medium that they worked inside.

I watched *The Sopranos* every Sunday on my newly installed cable box, and then, as an early adopter, on my first-generation TiVo, hitting "pause" to admire all those perfectly composed shots of Tony's massive kitchen island, rewinding to get the dialogue. In this book, you'll find an essay about what made *The Sopranos* so great—which was, in part, how thoroughly David Chase's masterwork punished its own audience for loving it too passionately.

But the split in critical response bugged me. Even when *Buffy* won praise, as it began to take big swings—a musical episode, a silent episode, the Christ-like death of the main character at the end of the fifth season—the series was still slotted, culturally, as optional viewing. It was a girl show. It was a teen show. It was geeky, jokey, romantic, juvenile, and formulaic. It was disposable—a Dixie Cup. *The Sopranos* was the canonical stuff, the keeper: It was masculine, literary, weighty, bleakly challenging, a rule-breaker. It was more like an original vinyl copy of *Blood on the Tracks*. (And this impression seemed true to people even when it wasn't true at all. *The Sopranos* was frequently hilarious, while *Buffy the Vampire Slayer* could make you sob.)

The genre that *The Sopranos* had critiqued and cannibalized—the mob drama—was considered a serious one, tied directly to the Best-Film-Ever, Francis Ford Coppola's *The Godfather*. The genres that *Buffy* mashed together (teen soaps, vampire horror, situation comedy, superhero comics) were not. *Buffy* was disco; *The Sopranos* was rock. When you were watching *The Sopranos*, you were symbolically watching side by side with a middle-aged man, even if you were a teen girl. When you watched *Buffy*, your invisible

companion was a fifteen-year-old girl, even if you were a middle-aged man. From my perspective, both of these shows were equally radical interventions into their medium: One of them was a mind-blowing mob drama about postwar capitalism and boomer masculinity, the other a blazing feminist genre experiment about mortality and sex. But only one of these shows transcended television. The other one *was* television.

Superficially, this split masqueraded as lowbrow versus highbrow. But the more that I argued—and I found myself fighting about these subjects again and again, eventually arguing my way into my dream job—the more the divide felt profound. Crucially, it felt tied to the problem of TV's deep, historically grounded, seemingly intractable case of status anxiety, its sense of itself as a throwaway, a bad habit. When I proselytized for *Buffy*, or debated my fellow graduate students about *Sex and the City*, the fight felt like a way to hash out other questions—questions of values, which were embedded (and, often, hidden) in questions of aesthetics. Centrally, these were arguments about whose stories carried weight, about what kind of creativity counted as ambitious, and about who (which characters, which creators, and also, which audience members) deserved attention. What kind of person got to be a genius? Whose story counted as universal? Which type of art had staying power?

None of these arguments were new, of course. Fights about art had always doubled as fights about what the world takes seriously—which is another way to say, they were fights about politics. They were fights about power. I wasn't a fan of heavy-handed, pedantic TV, which had its own tradition in the medium (part of television's legacy as a public resource, the aqueduct that everyone's kids drank from). But even shows that weren't polemical, that didn't feature "very special episodes," had a different sort of politics, the type that soaked through everywhere, disguised in the look and feel and structure. As a mass medium, TV was our public square. It was where the rules got enforced. It was also

where we hashed out the news as it happened, where we looked for our reflections. Critical contempt for television was like refusing to look into the mirror.

In the two decades that followed *Buffy* and *The Sopranos*, this status anxiety has continued to shape the critical consensus around television, often invisibly so. Long after that show's divisive blackout finale, *The Sopranos* was considered the default for television ambition; other shows might be good, but never great. There had to be a No. 1 show, always: often a grim drama, but sometimes a nihilistic comedy. That show might be nowhere as good as *The Sopranos*. It might be glum or sadistic or pretentious. But, the consensus held—even once television had begun to warp and alter—that a show like *The Sopranos* would always be the real stuff, the adult stuff, which meant the hard stuff, in several senses. If it was punishing to watch, it was better. Viewers who craved other visions of creativity, other styles of filmmaking, or a different brand of funny or beautiful, felt that pressure, too; we felt it from without (in media messages that certain art was less important) but also from within. It was hard not to internalize these rules, even when you resisted them, even when they excluded your story.

By the time I began to write about television in earnest—for a column called "Reruns" in *The New York Times*, then at *New York* magazine and *The New Yorker*—television was in a state of radical reinvention. A sparkling multiverse of cable networks had begun branding themselves around one show or another, just as The WB had done with *Buffy the Vampire Slayer* and HBO with *The Sopranos*. DVDs and then DVRs turned TV into a collectible, a text that could be analyzed, and also easily shared. In 2005, YouTube launched, followed in 2007 by Hulu; in 2013, Netflix began to stream original content, entire seasons at a time. As the technology changed, and along with it the economics and distribution of television, the artistry altered as well.

The old rules of what the audience could tolerate began to break down: Shows got slower (*Mad Men*), faster (*Scandal*), denser

(*The Wire*), and more dreamlike (*The Leftovers*). The wall between comedy and drama fell so far into disrepair that *Orange Is the New Black* got nominated in both categories at the Emmys, on alternate years. Auteurist creators remade the sitcom in their own images; marquee-name directors arrived from Hollywood, and so did movie stars, for whom TV had previously been a career-wrecker. Reality TV emerged, becoming the television of television, as my colleague Kelefa Sanneh has written —the source of a cavalcade of brand-new moral panics. There were new genres, new structures, new production models, and eventually, at last, in a burst of oxygen, an influx of fresh, more diverse voices (female, black, brown, young, queer)—shockwaves of innovation to a medium that was notorious for repeating itself.

Some days, it seemed like my favorite medium had changed so much that it was barely recognizable. Even as I edited the introduction to this book, the arguments that I'd been making, so grouchily, with that ancient 1997 chip on my shoulder, seemed at times to be slipping into the conventional wisdom—or maybe it was that the terms had changed, as the brash antihero fell out of favor once one was elected president. The only thing that everyone seemed to agree on, these days, was that there was simply too much television, and no way to keep up. Luckily, I liked to watch.

This book is an account of a two-decade-long argument about television, in the form of the reviews and profiles I've written— and because it's a collection, it traces my thinking as I've changed and as the medium has changed. Criticism is a lot of different things: It's a conversation and it's a form of theater. It's a way of thinking out loud, while letting everyone overhear you, which means risking getting things wrong and, on occasion, being obnoxious. But what unites these essays and profiles is my struggle— and, over time, my growing frustration—with that hidden ladder of status, the unspoken, invisible biases that hobbled TV even as it

became culturally dominant. Often, these biases involve class, gender, race, and sexuality, disguised as biases about aesthetics. (Green/gray drama, serious; neon-pink musical, guilty pleasure. Single-cam sitcom, upscale; multi-cam, working class.) Sometimes those biases have been mine, too—and several essays show me wrestling with them, sometimes more successfully than others. (Like anyone constructing an anthology, I tried not to include the terrible ones, but you make the call.) There are a few pans in the mix, but not many. This collection is not in any way a list of my favorite shows: It's mostly the pieces that reflected best on my main argument about television, the case that began to cook when I watched "The Pack." Criticism isn't memoir, but it's certainly personal, so you can consider these essays to be a portrait of me struggling to change my mind.

When I first started writing about television, it was an excuse, as a new journalist, to write about what interested me. Being a critic was never my goal, however—and in fact, it was a path that I'd deliberately stepped away from. Not long after graduate school, I'd taken some freelance gigs reviewing poetry for *The New York Times Book Review*. But as exciting as it felt to get published in the *Times*, I started turning those assignments down, because they made me miserable. The problem was structural. Poetry was an "elevated" art form. But while everybody respected it, no one read it. One person wrote each book—and even if that book was a hit, the writer made very little money. Under these conditions, the stakes were at once ridiculously high and very low, making even a mixed review feel cruel. If you can't pan art, you can't be a critic.

The minute I started writing about television, however, something clicked. Television, it seemed to me, was the opposite of poetry. While poetry was respected and rarely read, television was, as Franzen had observed on *Charlie Rose*, what nobody respected and everyone watched. It made money; it was created collaboratively; the people who created it made good money, too. But the default response to TV was condescension—a pat on the back when it did

anything even faintly impressive, because it seemed more like a product than an art form. Historically, a lot of TV coverage hadn't really been arts criticism at all: It was written by industry reporters, whose beat blurred the distinction between a hit and a quality series; or by intellectuals like Trow, who used the medium as a backboard for potshots at American culture; or by academics, who analyzed it as sociology. Writing mixed or negative television reviews struck me as a brand of cruelty that I could get behind: Even the harshest pan was a way of praising TV itself, by insisting that it could and should be great, by treating it as art.

And what *was* television, anyway? What made television *television*, distinct from other art forms? It became an obsession for me to try to understand its unique qualities, to help forge a critical rhetoric unique to the medium, one less bogged down by invidious comparisons to Dickens and Scorsese. I had no scholarly background in TV or in cinema studies: At *The New Yorker*, especially, I tried to sneakily assign myself essays—on advertising, say, or the history of the cliff-hanger—that would give me an excuse to self-educate. Knowing that history helped me shed the lazy presumption, which I held in my early years, that TV always moved forward and eternally got better. I learned more about the early days of television, during the first so-called "Golden Age," back when TV was a live medium based in New York, a platform for sketch comedy, opera, and Paddy Chayefsky teleplays; and then about the aggressive shift to television as a mass commercialized industry, the big cheap box that families watched together (and that babysat the kids). I revisited the Norman Lear–era breakthroughs of the 1970s, when creators smashed through standards and practices to reflect the world around them, and the Reaganite retreat into escapism; the one-step-forward-two-steps-back struggle for sexual and racial inclusivity; and the glide, during the 1990s and into the early aughts, toward greater seriality and complex narratives, a move that happened parallel to the emergence of fans gathering online, eager to mob-solve any puzzle.

Somewhere along the way, I read the full context for that 1961 quote from then-FCC chairman Newton Minow, the one in which he called television "a vast wasteland." It was more of a lament than an insult: Minow hated that TV pandered so hard, that it was such coarse, exploitative, repetitive crap, under the thumb of its sponsors. He wanted a more wholesome, patriotic slate of shows— and that's not what he got, in the long run. But decades later, it was TV's "vastness," the same enormity that had so disturbed George W. S. Trow, that released its capacity for originality: Once there was less pressure on every show to please every viewer (and also sell every product), creators took risks.

And I began to think of my job, with a grandiosity that was motivational but frankly a little nuts, as a mission. Television deserved a critical stance less hobbled by shame—a language that treated television as its own viable force, not the weak sibling to superior mediums. I wasn't especially young, but I was part of a cohort of writers—many of whom had come of age online—who shared these values. Some of my peers were part of a TV-loving generation of print critics; others wrote more "unofficial" types of criticism, which proliferated in digital spaces. Some wrote recaps— summaries of individual episodes—or fan fiction. Others participated (as I had, anonymously, back in those *Buffy*-fever years) in thousand-post-long debates with strangers about the minutiae of a single scene of *Felicity*. Others—okay, also me—watched *Big Brother* live on a webcam, then held debates about its sociopolitical impact and weird aesthetics on reality-TV discussion boards.

My inspiration was less Pauline Kael and Roland Barthes than the fizzy, bratty community on the discussion boards of the website *Television Without Pity*, which, from 1998 to 2007 (before it was bought up by Bravo and turned into a zombie version of itself), hosted threads about nearly every series. You could describe *TWoP* as a fan site, except that it was full of haters, too. It had started out as a website called *Dawson's Wrap*, which was devoted to mocking the pretentious teen soap opera *Dawson's Creek*. That site's cre-

ators, Sarah D. Bunting and Tara Ariano, had in turn been inspired by Daniel Drennan's hilariously digressive "wrap-ups" of *Beverly Hills 90210,* early recaps that were posted, initially, on the online community ECHO (for East Coast Hangout.) I'd joined ECHO in the late 1990s, too. Both environments were aggressively geeky, which is to say, obsessive, rudely funny, and unconcerned with sounding normal. For newspaper critics, a one-time negative review of *Dawson's Creek* might suffice. Online, commenters felt obliged to drop by every single day in order to debate why the show *wasn't getting any better.* (It was a point of pride that I got kicked off *TWoP* for too vehemently defending another Joss Whedon show, the Fox space Western *Firefly,* against a particularly contemptuous recapper. Like any troll, I changed my name and got a new account.)

Over the years, a basic definition of the medium began to emerge in my thinking, a map of what made television television. On the most obvious level, it was an episodic art form. For most of its history, television had been served up in evenly sliced segments, generally one per week. A half-hour show was, conventionally speaking, a comedy; an hour-long show, most of the time, a drama. For decades, a set of genres had grown, like coral, around the gulfs that the advertisers demanded: the sitcom, the police procedural, the soap opera. (Along with the game show, the news hour, the talk show.) In TV's earliest years, these genres were inspired by radio and theater—not so much movies or books. They were also, by design, formulaic. Because TV got repeated, then run out of order in reruns, any viewer who changed the channel needed to know what to expect. The only true "serialized" storytelling showed up in daytime soaps, which were regarded as the most lowbrow, and, not coincidentally, the most feminine genre, designed to sell soap to housewives.

But when, as the years passed, TV began to warp—as comedies got sadder and dramas funnier; as primetime stories absorbed the serialized daytime model, allowing characters to change and sto-

ries to take bigger leaps; as dramas began to wrestle with worldly subject matter—TV didn't abandon those tight, seemingly repressive genres. Instead, it worked off their restraints. It both resisted them and exploited them. In the 1970s and the 1980s, *Mary Hartman, Mary Hartman* and *Soap* at once mimicked and mocked the cliff-hanger-heavy style of soap operas, expanding the way that stories could be told. In the early aughts, *The Wire* critiqued the police procedural; it also *was* a police procedural. The British version of *The Office* emerged as a caustic satire of reality television, a form of resistance to a cheaply made new genre that threatened the primacy of scripted television, but it also repurposed the visual tools of reality (the confessional, the peek through the blinds, the quick flashback) as a fresh way to be funny.

On *Charlie Rose*, David Foster Wallace had marveled at how many TV shows made fun of TV, something he argued reflected viewer contempt. In his manifesto "E Unibus Pluram: Television and U.S. Fiction," the novelist warned that the boob tube was infecting literary novels with this empty self-loathing, passing on a strain of nihilistic irony like some aesthetic tapeworm. He wasn't wrong about a certain shift in the zeitgeist (although he did, oddly, assume that all viewers shared his own response to TV—that they were in danger of hipster detachment, not heartfelt fanhood, my own pitfall). But the fact that television continually responded to television meant something different to me: It was the medium talking to itself as it grew, developing the spiky, affectionate self-consciousness native to any newly energized art form—a sign of growth but, also, a formal quality that was way more interesting to write about than whether TV could ascend and become more like a movie or a book.

The second big thing about television was that it was built by more than one person. More than one writer, yes, but also, multiple directors, many producers, a bunch of editors, and so on. Again, this was for pragmatic reasons. Networks demanded twenty-two new episodes a year; even on cable, a season was eight

or ten hours long. No one creator could oversee so much material, the way you could, theoretically, singlehandedly make a movie or a book. What's more, no one, ever, had been truly free to create their own television show, without interference—instead, "notes" (that were really demands) rained down from above, from executives and advertisers (who, in TV's early years, were the same people). Working under these factorylike conditions, TV makers had, early on, adopted something like a blue-collar blend of pride and shame in their own labor. Like contractors, they built to someone else's specs, often anonymously. Making television meant making something you'd never own.

This aggressive collaboration, like television's reliance on formula, was a big part of why people had so much trouble seeing TV as ambitious art: It was harder to assign genius to a group. As the medium changed and more "auteurist" shows got greenlighted, and as "showrunner" became a term of art, turning television writers into celebrities with their own fan bases, shows that could be traced to one clear creator often got more credit from critics—a bias that tended, among other things, to favor drama over comedy. To quote *BoJack Horseman*: "Diane, the whole point of television is it's a collaborative medium where one person gets all the credit."

TV was also, historically, a writer's medium, where words counted more than images. Even once that was no longer true, in the post-HBO era, TV directors were still mostly hired hands, popped in weekly, bossed around by the head writer, the inverse of the Hollywood hierarchy. The writers' room was where artists learned to compromise, to pour their voices into someone else's vision. For TV-makers, the existential question had always been whether it was possible to wrestle something truly original—challenging and strange, idiosyncratic rather than formulaic—from a system so synonymous with groupthink. It was probably no coincidence that television had produced so many workplace shows, often about a brilliant boss struggling to harness a team of

eccentrics. They were fun-house reflections of the writers' room itself, TV's primal scene.

Finally, more than nearly any other artistic medium, television took place over time—it took time to make, it took time to watch, it happened *over* time. A director films a movie, then later, people watch it; a novelist writes, then readers read. But television takes weeks, seasons, years, even decades. A fan had to keep inviting her favorite show back in. The result was a messily intense feedback loop between viewers and creators, a sadomasochistic intimacy that both sides craved and resented. Later seasons of television were altered by how audiences had responded to the show early on, an issue that was heightened by the presence of vocal fans gathering on the Internet: Showrunners could play to audience demands or angrily push back at them, but they couldn't ignore them. Television was an art form that was somehow permanent and ephemeral at once, a record of its own improvisational creation.

And, of course, the person who writes a TV pilot isn't the same person who writes a finale a decade later, if only because writers themselves are changed by time, too. Television ends, often unpredictably. Sometimes it gets canceled; sometimes it gets to play out those final days in a foggy, sentimental economic hospice, tolerated until it expires. Either way, the finale carries a weight no other episode does. I wanted to write about that, too.

This became my working definition of television, the model that I cherished, and, also, the tool that I wielded when arguing in favor of shows that I saw as misunderstood or condescended to, as *Buffy the Vampire Slayer* had been. Television was episodic, collaborative, writer-driven, and formulaic; it was gorgeous not despite but because of its own wonky elasticity, the way it altered with time, in conversation with its own history. It had to be appreciated for its variety, from moody dramedies to stylized network melodrama, without being squashed into a top ten list, reduced to a status-addled hierarchy. Yet there's a level at which I can't entirely

explain my adoration for television, my sense of it as not subject matter but a cause. There was something alive about the medium to me, organic in a way that other art is not. You enter *into* it; you get changed with it; it changes with you. I like movies, but I'm not a cinephile; you'll never catch me ululating about camera technique, for better or worse. I love books, but I have little desire to review them. Television was what did it for me. For two decades, as the medium moved steadily from the cultural margins to its hot center, it was where I wanted to live.

In a way, compiling this book of essays has been a process of grieving a certain model of television, even as it transforms into something new. After all, in the two decades since "The Pack" first aired on The WB, every one of television's defining qualities—the same ones I was so eager to illuminate for unbelievers—has shifted. When a streaming network releases an entire season at once, ad-free, it *does* feel more like a novel. (Just as many novels themselves were originally printed chapter by chapter.) When Sundance airs a nearly silent Jane Campion crime drama, like *Top of the Lake*, full of gorgeous New Zealand vistas, it is much more like a movie. When a small cable channel produces a short-run show, directed by one person, for a niche audience, with two years between seasons, solo creativity is no longer an illusion. What classic TV genre is a show like *The Leftovers* riffing off? None, maybe. Meanwhile, time itself has bent: Among other things, we've gained access to archives of older shows, putting the context of no context back into context. There's probably a whole essay to be written about the seismic impact of the "Pause" button alone, the simple invention that helped turn television from a flow into a text, to be frozen and meditated upon.

Some days, the one thing that feels stable is the episode, that flexible slice, the wave inside the ocean, the part that has to double as the whole.

None of these changes has made me love television less; they've made me love it more. I'm drowning in it, of course. We all are. Every year, the waves roll in faster. John Landgraf, the CEO of the cable network FX, once warned about a phenomenon he labeled "Peak TV," a fit of overproduction that, he predicted, had to end soon. I felt a sneaky flash of relief: Now, no television critic could claim to be comprehensive. I could drop the shows that bored me.

That was in 2015. Just three years later, with Netflix dropping several new series daily, Landgraf's peak seems like a tiny hill off in the distance. My children rarely watch TV, except with me; they watch YouTubers play Minecraft instead. Some days, when the neck-snapping changes in my favorite medium feel particularly hard to grasp, I pull down an old copy of *Playboy* magazine from 1976. In it, there's an interview with Norman Lear, back when he was overseeing half a dozen sitcoms, a kingpin of a showrunner, when that job was still called "executive producer." Lear wasn't universally adored back then, as he is now. 1976 was a fraught year, for all his success: He hadn't been able to place the cutting-edge *Mary Hartman, Mary Hartman* with a network, so that show was running on independent stations, at odd hours. His latest sitcom, *The Dumplings*, would be a flop. Meanwhile, he was suing both the networks and the FCC, institutions that had conspired, to Lear's frustration, on a brand-new "family hour," a time-slot policy that the writer regarded as "a gutless give-in" to priggish activists. "It's hard to talk through a muzzle," he groused, calling the current prime-time lineup "bland opposite bland opposite bland."

Yet Lear also models, in the midst of these complaints, something inspiring: a blend of pugnacity and optimism, along with an insistence that television is great even when it fails to achieve that greatness. Back when no one believed they were in a Golden Age, Lear shrugged off the way that his native medium had always been "a convenient whipping boy" for American malaise. It was the *networks* who thought small, he argued, and who were condescend-

ing to their viewers: "I've never seen anything I thought was too good for the American people or so far above them that they'd never reach for it if they had the chance." To Lear, TV was still all potential, particularly an untapped potential for variety—it just needed to "replace imitation with originality as the formula for success." He envisions cross-medium experiments: "How do they know there wouldn't be as large an audience for a John Cheever or a Ray Bradbury drama as there is for a Norman Lear or a Mary Tyler Moore show?" He defends his own sitcoms against critics, arguing that they aren't coarse or loud, but honest, showing real, loving fights in real families. With an almost startling prescience, he agitates for industry changes that were many decades away: creators taking breaks between seasons, or switching styles; limited-run shows and fewer commercials. He's confident that television will land in the right hands, someday: led by creators, not admen.

In 2019, at ninety-six, Lear is still out there producing TV, merging an old-fashioned sitcom with a newfangled distribution model: His reboot of *One Day at a Time*, now set among Cuban-American immigrants, is currently streaming on Netflix. He seems immune to status anxiety. "As far back as I can remember, I have divided people into wets and drys," he told *Playboy* back in the 1970s. "If you're wet, you're warm, tender, passionate, Mediterranean. . . . If you're dry, you're brittle, flaky, tight-assed, and who needs you?" That's rude, but that's Lear. It also happens to be a decent definition of fanhood, the kind of passion that expresses itself in a rolling debate, as if television itself were worth fighting for. That's my model of criticism, too. It's about celebrating what never stops changing.

THE LONG CON

The Sopranos

New York magazine, June 14, 2007

The day after *The Sopranos* aired its divisive finale, my boss at
New York magazine, Adam Moss, asked me to write something
ambitious—but also, to write it fast. This was the result, my first
substantive TV analysis, after years of reviews, recaps, and col-
umns. It was also my first serious attempt at writing about what
became a personal obsession, the role of the audience as a col-
laborator in TV. The first line is a little over-personal.

David Chase, you sadist. We trusted you, and then you turned
on us—and maybe we deserved it.

Since *The Sopranos'* premiere in 1999, critics have preached that
it was like nothing else on television: It was novelistic (Dicken-
sian!), cinematic (Fellini-esque!), iconic (Is there any other show
where most viewers still watch the opening credits?), a metaphor
for Bush's America. The implication has always been that, at last,
TV was playing way out of its league.

But HBO's slogan aside, *The Sopranos* was TV—and great be-
cause of that fact, not despite it. Chase was the first TV creator to
truly take advantage, in every sense, of the odd bond a series has

with its audience: an intimate dynamic that builds over time, like any therapeutic relationship. Unlike a novel, a TV drama is not invented in some solitary genius's cork-lined chamber. It is a collaboration, with viewer response providing a crucial feedback loop—a fitting dynamic for a mob story, a genre predicated on a certain level of bloodlust in those who consume it. For eight years, the characters themselves obsessively watched (and quoted and analyzed and emulated) *GoodFellas* and *The Godfather,* and we obsessively watched (and quoted and analyzed and emulated) *The Sopranos,* and all along, Chase was out there watching us watching them. As the show became more popular, the characters more beloved, the fans more openly excited by the violence, one got the distinct sense that Chase did not always like what he saw.

But he was willing to give us what we didn't want. There are many breeds of TV auteurs: the great mythologizers, *Buffy*'s Joss Whedon and *Lost*'s J. J. Abrams and *The X-Files*' Chris Carter; the quirky dialogists, like *Gilmore Girls*' Amy Sherman-Palladino and *Ally McBeal*'s David E. Kelley; deadpan formula craftsmen like Dick Wolf and sadomasochistic visionaries like Tom Fontana and California dreamers like Alan Ball. There are the utopian solipsists (okay, just Aaron Sorkin). But they all share an essential love for their characters—a natural side effect, one might imagine, of building one story for many years. Their protagonists suffer, but they rarely corrode.

In this sense, Chase was a true iconoclast, a prophet of disgust. He seemed determined to test TV's most distinctive quality, the way it requires us to say yes each week. To be a fan, we needed to welcome Tony Soprano again and again into our homes, like a vampire or a therapy patient. Chase gave that choice a terrible weight.

Now that it's over, no longer a work in progress, we are finally free to criticize it for real or praise it as a whole, and despite some missteps (A gambling problem, really? And what was that Furio-Carmela thing back in Season 4?), I do think the show will reward

rewatching. It was, in fact, truly revolutionary, but not because it was adult or novelistic. *The Sopranos* was the first series that dared us to slam the door, to reject it. And when we never did, it slammed the door on us: a silent black screen, a fitting conclusion to a show that was itself a bit of a long con, that seduced us as an audience, then dismantled its own charms before our eyes.

When we first met Tony Soprano, he was a mess, but we loved him, we couldn't help it. Underneath that bulk (and James Gandolfini was significantly smaller at the start, almost light on his feet), he was a hurting bad boy. Smart despite the malapropisms, Tony struck many viewers as simply an extreme variation on the midlife baby boomer: He was struggling with aging relatives, mouthy teenage kids, and that old work-life balance. His deepest desire was to be a better parent than his own (an ambition that was aiming low). He was terrified of death. And his greatest enemy was the most brilliant strategist of them all, his mother, Livia, a villain who crushed her enemies with the illusion of powerlessness.

Those early episodes are jauntier and broader than what came later, with a stylized quality strongly reminiscent of *GoodFellas*—Chase's master influence, he's said. The first moment of violence is practically a dance sequence, a loopy action shot in which Tony's cover story to Dr. Melfi ("Then we had coffee") is contrasted with a slapstick beating in daylight, scored to a doo-wop song. (On the DVD commentary, Chase says it's the one musical choice he regrets: "I think it's hackneyed, silly, and I'm sorry.") Carmela is a broader character, too, and knows more about Tony's business—she hides money in false Campbell's soup cans, and even brandishes a gun.

But if the show was playful, it took one thing seriously: Tony's therapy sessions with Melfi. He'd gone to her for help with panic attacks, but their meetings quickly became something stranger and deeper, an experiment in self-knowledge. The show's central question was simple and bold: Can this man change? It's no wonder *Slate* assembled a panel of shrinks to weigh in. Back then, *The*

Sopranos could be viewed without irony as a drama of human potential, however dark-humored and extreme.

Not that Tony himself welcomed the challenge. "Nowadays, everybody's got to go to shrinks and counselors and go on Sally Jessy Raphael and talk about their problems," he raves during his first session. "Whatever happened to Gary Cooper, the strong, silent type? That was an American. He wasn't in touch with his feelings. He just did what he had to do. What they didn't know is that once they got Gary Cooper in touch with his feelings, that they wouldn't be able to shut him up! And then it's dysfunction this and dysfunction that and dysfunction *va fangul!*"

And yet, like Portnoy, he began. His rants were denial, the necessary pushback before committing to such painful work. Early episodes are containers for baseline psychoanalytic insights. In the first, Tony discovers that "talking [helps]. Hope comes in many forms." In the second, he learns that if he doesn't admit to his rage at his mother, he will displace it onto others. Next, he struggles with whether he is a golem—an empty self, a monster for hire. And by "Pax Soprana," he confesses his love to Melfi and she tells him about transference. "This psychiatry shit, apparently what you're feeling is not what you're feeling," he explains to Carmela. "And what you're not feeling is your real agenda."

The question of Tony's sociopathy was also there up front, but the people raising it were weasels and weaklings. "You know you can't treat sociopaths! He's scum, and you shouldn't help him with his bed-wetting," complains Melfi's strutting yuppie ex over a family dinner. Later in the episode, he was clearer: "Call him a patient. Man's a criminal, Jennifer. And after a while, finally, you're going to get beyond psychotherapy, with its cheesy moral relativism, finally you're going to get to good and evil. And he's evil."

But then, Melfi's ex-husband was the enemy. He was a smug insider, a condescending voyeur—one of a host of such characters, like Tony's next-door neighbors (and Melfi's friends) the Cusamanos, who exploited him for show-and-tell at their golf

club. (Tony's ex Charmaine Bucco was the sole exception: She judged him, but did it from the inside—making her the show's only moral character. It was nice to see her briefly reappear in the penultimate episode, her eyes still narrowed eight years later.) It was no wonder Melfi had begun to identify with Tony. Among the yuppies and therapists who surrounded her, she felt like a misunderstood outlaw, the only one who dared to see the abused child within the monster.

And it was no wonder that we, as an audience, identified with Melfi. She was—hard to remember, but it's true—a perfectly decent therapist. She handled Tony's transference gently; she gave him tools to cope with his mother and uncle (tools he used to consolidate power, but still). She even saved a life, that of Meadow's child-molesting soccer coach. Instead of ordering the murder, Tony stumbles stoned into the family rec room, stunned with the effort of not killing, moaning to his wife, "Carmela, Carmela, I didn't hurt nobody."

Back then, this scene struck me as the show's iconic moment—it was a bravura sequence in which the decision not to commit violence was as vivid as any bloody hit. In a drama built on gore, it was thrilling. Though Tony continued to collect envelopes, order hits, screw goomars, it seemed like evidence that he could be a different man.

And then something in Chase's vision went black.

Over the course of the show, Tony's sessions with Melfi have taken on many metaphors. They are like sessions with a hooker: She takes his money and plays a seductive role. (In one sequence, he dreams her office is a bordello.) They are like sessions with a priest: She hears confessions and guides him toward meaning. They are like sessions with the FBI: By talking to her, he's betraying his family, putting his livelihood at risk, and violating omertà.

But most unsettlingly, they became a metaphor for our relationship, as viewers, with the show. Like Melfi, we began openhearted, proud of our empathy, and thrilled to have a character so

rich to explore. Then came the countertransference, the audience crushes, the endless articles on James Gandolfini, sex symbol. And slowly, as years passed, one could feel an insistent chill, even as Melfi herself receded into the background and message boards flooded with fans aping mobspeak. The violence was growing more intense episode by episode: the assassination of Big Pussy, then Adriana, that brutal scene where Ralphie killed a pregnant stripper (a brilliantly sick sequence that caused a wave of viewer protest), the curbing of Coco. Dread, not excitement, began to feel like the show's signature emotion.

And Tony himself was changing, or rather, more alarmingly, he had stopped changing. In the first season, we saw Tony the struggling father, binging on whipped cream with A. J.; he beamed proudly as Meadow sang in her school chorus, squeezing Carmela's shoulder. Even his darkest crimes—say, that witness-protection rat he strangled bare-handed in Maine—could be justified. The guy was an informer, after all; he was still on the con, manipulating junkies. It was revenge, and, hey, the rat was trying to kill Tony when Tony got him.

But the show's agenda was shifting. Among the earliest hints was the Season 2 finale, which concluded with a montage of Meadow's graduation party. Pussy is dead, and the family is gathered, glowing with prosperity and peace; yet their revelry is intercut with shots of the mob's victims from the past two seasons, from immigrants being sold fake phone cards to a junkie nodding off in the Hasidic owner's hotel from back in Episode 3. It felt like a message from Chase to us: Don't forget, these are the real victims.

As for Tony, it had become harder to make excuses. When he was depressed, we could hear Livia speaking through him: "Poor you," he'd snap. He stalked Carmela; he nearly seduced, then coldly ordered a hit on Adriana. He corrupted and abandoned his closest companions, from Bobby to Hesh, while soaking in self-pity and a kind of poisonous nostalgia. At times, David Chase's

frustration seemed to beat behind the scenes: You like strippers, think misogyny is funny? How about watching a goomar beaten to death? That fun, too? He even created a parody of what some *Sopranos* fans seemed to want the show to be: *Cleaver*, that *Saw II* of mob flicks.

But the moment that really wrenched the show off its axis was a brief, almost throwaway scene in the third season, in an episode titled "Second Opinion." I remember the first time I watched it, the way it seemed to invert everything that came before. Carmela goes to a psychiatrist we've never met before, a Dr. Krakower. She is eager to make the session a referendum on personal growth: She wants to "define my boundaries more clearly." From her perspective, the issue is that she's unhappily married. She's toying with divorce.

But Krakower cuts her off. With riveting bluntness, he addresses Carmela not as a seeker but as a sinner. She is not Tony's wife, he informs her; she's his accomplice. She needs to leave now, reject Tony's "blood money," and save her children ("or what's left of them"). And he adds a remark that might serve as a punch line for the series: "One thing you can never say, that you haven't been told."

Of course, it doesn't work. How could it? Carmela does leave Tony, but she goes back, and when she does, she becomes something far worse than she was before: a woman who has consciously decided to become unconscious. To me, Krakower is Chase, and we are Carmela. He told us who Tony is, and each episode, he became crueler in delivering that message. This shift narrowed Chase's artistic palette, cutting out the warmer shades of the early episodes. But it also lent the show an acid originality, a sadistic narrative engagement with the audience and our own corruption.

Meanwhile, what began as a valentine to talk therapy transformed, by increments, into a condemnation. Each season, Tony knew himself better. He gained more sophisticated tools to cope with life. But he became a better mobster, not a better man. Every

crime left him receding into his most charmless self: menacing, piggish, a wall of flesh topped by a smirk.

And yet, he continued to make breakthroughs. The first, of course, was that famous revelation about the ducks. In an early session, Tony tells Melfi about a dream in which his penis falls off and a bird flies off with it. What kind of bird? Melfi pries. The exchange feels like psychobabble at its goofiest, and then suddenly, it works: Tony breaks down—a moment of shocking poignancy. "It was just a trip having those wild creatures come into my pool and have their little babies," Tony says, his voice cracking. "I'm afraid I'm gonna lose my family, like I lost the ducks. That's what I'm full of dread about. That's always with me."

It's a full-fledged, A-1 psychotherapeutic breakthrough, and in Gandolfini's performance, intensely affecting. But with each season, such insights became more suspect. There was the shock of acknowledging that his mother was trying to kill him—another life saved by Melfi. (For Tony Soprano's brand of depression, death threats have always been the equivalent of electroshock.) There were the insights he gained in love affairs—the melodrama with the suicidal car dealer, the bonding with the one-legged Pole. There was his coma dream of a life as a peaceful man and the New Age mellowness that followed, when he fixated on the Ojibwa koan on the hospital wall: "Sometimes I go about in pity for myself, and all the while a great wind carries me across the sky."

But by the time Tony was howling in the desert like Jim Morrison, high on peyote and screaming, "I get it! I get it!" we'd had our own revelation. Tony's life was just a series of empty epiphanies. Sure, he was capable of guilt and anger and sentimentality—of deep emotion and loyalty. But no catharsis resulted in any true action. Instead, he was becoming his real self: the empty golem.

And this was true for all the characters. Each was eager for greater self-esteem, more spiritual mojo, but in their hands, self-knowledge had zero correlation with ethical action. Carmela gazed at cathedrals in Paris, dizzy with spiritual longing, but her

capacity for questioning had dwindled to a nub, a carapace of false piety and clichés. ("It's better to have loved and lost!") Tony's sister Janice used yogic wisdom as a cosmic switchblade. And in the show's most remarkable case, Christopher became a sincere AA member while continuing to shoot people in the head—his sobriety impinging barely at all on his livelihood, other than his losing the ability to bond with Paulie Walnuts over sambuca.

Each drama of self-discovery met its shadow version late in the series. Tony's epic depression was miniaturized in his son—who was at once more pathetic and more swiftly manipulative—then cured by a shiny car and a decent script. (In one bitter little sequence in the show's finale, A. J.'s therapist is a leggy Melfi doppelgänger; meeting her, Tony goes off on a rant about Livia, now long dead. Carmela's deadpan gaze is priceless: Her husband is stuck in a time warp, his once-affecting rants now toxic parodies.)

Even Melfi's first encounter with Tony's soft side seems, in retrospect, a red flag, mere manipulative sentimentality about babies and animals—a hallmark (at least according to *The Criminal Personality*, the study that pushed Melfi into her ex-husband's camp) of a sociopath who can't be saved.

A friend of mine watched the *Sopranos* finale having never seen any of the rest of the series. He was understandably thrown, not so much by the final blackout but by the characters. Who were these people who had fascinated so many devoted viewers? What he couldn't see, of course, was that each had become a shrunken version of his or her former self: Tony grimly arranging hits, Carmela ogling real estate, a Meadow who had drifted so far from the savvy girl of Season 1 that she could tell her father, with apparent earnestness, that his oppression by the FBI had motivated her to enter law school.

By the final episodes, we seemed to be heading toward the conventional ending for a mob story: a bloodbath. But perhaps it was appropriate that the most brutal rubout was Melfi's hit on Tony. After enduring endless needling from her smug therapist, Elliot—

like her ex-husband, a truth-telling bad guy, hard to listen to but essentially correct—Melfi confronts her own complicity. As she lies alone in bed, the words of that Yochelson and Samenow study flash up at her—and, more alarmingly, at us, centered and bold on our screens: "For the criminal, therapy is just another criminal operation."

Some viewers thought the scene that followed came out of the blue, but I bought it 100 percent: not just the breakup with Tony but Melfi's incompetence at ending it, the rupture of her emotions through a once-professional wall. Melfi feels exposed as a dupe; her pathetic countertransference has endured for years ("Toodle-oo!" she told Tony flirtatiously in Season 2, running into him after terminating therapy the first time), and she is humiliated and furious, no brave renegade but the woman who built a more functional evil person. "But we're making progress!" Tony protests. And he adds a resonant punch line: "As a doctor, I think that what you're doing is immoral."

It's understandable many viewers wish they could go back in time, back to the first season, which ended on a comparably heartwarming note, when the show seemed like it might be just a metaphor about the value of family. A thunderstorm was drenching New Jersey, the electricity was out; Tony and Carmela picked up the kids in their car, and they were wheeling around town, looking for a place to land. They wound up at Artie Bucco's new restaurant, where Artie, after a moment of hesitation, invited them in. By candlelight, they shared some pasta made on the gas stove in the back.

Tony was surrounded by members of both of his families. At one table, Silvio and Paulie hashed out the revelation that Tony was in therapy, preparing for the new regime now that Junior was in prison. Chris and Adriana canoodled at the bar. And Tony raised his glass: "I'd like to propose a toast, to my family. Someday soon, you're gonna have families of your own. And if you're lucky, you'll remember the little moments, like this. That were good. Cheers!"

This was the scene that Chase repurposed for the finale. With the family gathered once again for a meal, A. J. harks back to what used to be, saying "You once told us to try to focus on the things that are good." But this final scene has none of the earlier's warmth, no sense of shelter. Instead, we see a family of bad guys—dim, dwindled, corrupted, contentedly sharing a plate of onion rings. And then the door slams shut.

Looking back, we, too, can think about the good times: that first truly brilliant episode, "College"; the wrenching sight of Big Pussy sobbing in the bathroom of Tony's mansion; Season 4's marital dissolution in "Whitecaps"; the tragic tale of Adriana; the perverse tale of Vito; and in this season's opener, that quiet scene of Tony's brooding at Janice's lake house, while all the while a great wind carries him. We can take pleasure in our favorite series and how much we've enjoyed it, how much we loved Tony; what a fabulous character, wasn't he? And remember how cool that scene was, the one where Pop-Pop's head got popped beneath an SUV?

But we can never say that nobody ever told us.

THE GREAT DIVIDE

Norman Lear, Archie Bunker, and the Rise of the Bad Fan

The New Yorker, April 7, 2014

Although this essay is about Archie Bunker, Bad Fan Theory is something that evolved out of my recaps of *Breaking Bad*, when I was struggling to reconcile the show I thought I was watching—an artistically wrenching drama about the nature of evil—with the show a lot of my fellow online fans seemed to be watching—a fun thriller about a badass in a black hat. The show, I began to believe, was made to be read both ways.

Over the years, I've heard the theory applied to many other shows, and also the 2016 presidential election.

"The program you are about to see is *All in the Family*. It seeks to throw a humorous spotlight on our frailties, prejudices and concerns. By making them a source of laughter, we hope to show—in a mature fashion—just how absurd they are."

This nervous disclaimer, which was likely as powerful as a "Do not remove under penalty of law" tag on a mattress, ran over the opening credits of Norman Lear's new CBS sitcom. It was 1971, deep into the Vietnam War and an era of political art and outrage,

but television was dominated by escapist fare like *Bewitched* and *Bonanza*. *All in the Family* was designed to explode the medium's taboos, using an incendiary device named Archie Bunker. A Republican loading-dock worker living in Queens, Bunker railed from his easy chair against "coons" and "hebes," "spics" and "fags." He yelled at his wife and he screamed at his son-in-law, and even when he was quiet he was fuming about "the good old days." He was also, as played by the remarkable Carroll O'Connor, very funny, a spray of malapropisms and sly illogic.

CBS arranged for extra operators to take complaints from offended viewers, but few came in—and by Season 2, *All in the Family* was TV's biggest hit. It held the No. 1 spot for five years. At the show's peak, 60 percent of the viewing public were watching the series, more than fifty million viewers nationwide, every Saturday night. Lear became the original pugnacious showrunner, long before that term existed. He produced spin-off after spin-off ("cookies from my cookie cutter," he described them to *Playboy* in 1976), including *Maude* and *The Jeffersons*, which had their own mouthy curmudgeons. At the Emmys, Johnny Carson joked that Lear had optioned his own acceptance speech. A proud liberal, Lear had clear ideological aims: He wanted his shows to be funny, and he certainly wanted them to be hits, but he also wanted to purge prejudice by exposing it. By giving bigotry a human face, Lear believed, his show could help liberate American TV viewers. He hoped that audiences would embrace Archie but reject his beliefs.

Yet, as Saul Austerlitz explains in his smart new book, *Sitcom: A History in 24 Episodes from* I Love Lucy *to* Community, Lear's most successful character managed to defy his creator, with a Frankenstein-like audacity. "A funny thing happened on the way to TV immortality: Audiences liked Archie," Austerlitz writes. "Not in an ironic way, not in a so-racist-he's-funny way; Archie was TV royalty because fans saw him as one of their own."

This sort of audience divide, not between those who love a

show and those who hate it but between those who love it in very different ways, has become a familiar schism in the past fifteen years during the rise of—oh, God, that phrase again—Golden Age television. This is particularly true of the much-lauded stream of cable "dark dramas," whose protagonists shimmer between the repulsive and the magnetic. As anyone who has ever read the comments on a recap can tell you, there has always been a less ambivalent way of regarding an antihero: as a hero. Some of the most passionate fans of *The Sopranos* fast-forwarded through Carmela and Dr. Melfi to freeze-frame Tony strangling a snitch with wire. (David Chase satirized their bloodlust with a plot about *Cleaver*, a mob horror movie with all of the whackings, none of the Freud.) More recently, a subset of viewers cheered for Walter White on *Breaking Bad*, growling threats at anyone who nagged him to stop selling meth. In a blog post about that brilliant series, I labeled these viewers "bad fans," and the responses I got made me feel as if I'd poured a bucket of oil onto a flame war from the parapets of my snobby critical castle. Truthfully, my haters had a point: Who wants to hear that they're watching something *wrong*?

But television's original bad-fan crisis did not, as it happens, concern a criminal bad boy, or even take place on a drama. It involved Norman Lear's right-wing icon, Archie Bunker, the loud-mouthed buffoon who became one of TV's most resonant and beloved television characters. Archie was the first masculine power-house to simultaneously charm and alienate viewers, and, much like the men who came after him, he longed for an era when "guys like us, we had it made." O'Connor's noisy, tender, and sometimes frightening performance made the character unforgettable, but from the beginning he was a source of huge anxiety, triggering as many think pieces as Lena Dunham. Archie represented the danger and the potential of television itself, its ability to influence viewers rather than merely help them kill time. Ironically, for a character so desperate to return to the past, he ended up steering the medium toward the future.

All in the Family began as a British show called *Till Death Us Do Part,* a hit comedy about Alf Garnett, a Cockney xenophobe who had a sharp-tongued wife, a hip daughter, and a socialist son-in-law. The show, which first aired in 1965, was a ratings hit, spawning catchphrases ("You silly moo") and mass British identification with Garnett—a response that troubled the show's creator, Johnny Speight, even as he made the case for its pungent zingers. "To make him truthful, he's got to say those things, and they are nasty things," Speight argued.

By 1967, Norman Lear, a Second World War veteran who never finished college, had spent years cutting a path through show biz. As recounted in *Archie & Edith, Mike & Gloria,* by Donna McCrohan, he began by collecting gossip tips, ghostwrote syndicated columns, and then jumped into comedy, having scammed his way into the office of the comedy bigwig Danny Thomas by pretending to be a reporter. After a successful stretch working on 1950s showcases, including *The Martha Raye Show,* he teamed up with the producer Bud Yorkin. The two became industry machers, packaging TV specials and making movies, such as *Divorce American Style.* When Lear read about *Till Death* in *Variety,* he felt a stab of identification. His father, Herman Lear, a Jewish salesman from Connecticut, was a "rascal," in Norman's words, who went to prison when Norman was nine, convicted of shady dealings; like Alf Garnett, he was at once loving and bigoted. Lear bought the rights to Speight's show, without ever having seen it, and hammered out a treatment. He gave Archie one of his own father's favorite insults for him—"you meathead, dead from the neck up"—and Archie, like Herman Lear, called his wife a "dingbat" and demanded that she "stifle." It's the origin story of nearly every breakthrough sitcom, as recounted in Austerlitz's book: memoir mined for a resonant, replicable pattern—in this case, the clash between the Greatest Generation and the emerging Baby Boomers, embodied by Archie Bunker and Michael "Meathead" Stivic, his son-in-law.

ABC was interested, but the network was concerned about the show's raw language. For the next two years, the executives and Lear went through an elaborate production process, taping two pilots—the first in September 1968, titled *Justice for All* (Archie's last name was originally Justice), the second in February of the following year, called *Those Were the Days*. Lear wanted to cast Mickey Rooney as the lead, but the actor thought it was too risky. (Rooney did offer to make a different show: "Listen to this— Vietnam vet. Short. Blind. Private eye. Large dog!") So Lear offered the part to O'Connor, an Irish-American actor whose rare mixture of "bombast and sweetness" he described to reporters as being ideal for the role. Lear cast Jean Stapleton as Edith, who transformed the British show's battle-ax—she resembled the tart-tongued Alice of *The Honeymooners*—into a figure of genuine pathos, a quavery-voiced housewife whose tenderness cut through the show's anger, and who gradually became its voice of reason.

In those two clunky early pilots, Archie's son-in-law is Irish, not Polish. In one version, he sports a hilarious puka-shell necklace; in the other, he's a clean-cut jock. The chemistry is all wrong, a testament to how much of comedy is casting: When Archie and these lesser Meatheads spar over the insult "the laziest white man I ever seen" (another Herman Lear original), there's none of the electrical fury that the show gained once the hulking, manic Rob Reiner took the role. ABC killed the project, and Lear went back to making movies. The experiment seemed to be dead until 1970, when the CBS president, Robert Wood, stepped in. Wood, who had just taken the job, was seeking a hip property that could replace the shows that skewed to older audiences—sitcoms like *Green Acres* and tentpoles like *Lassie*—which he planned to cancel in what would become known as "the rural purge." He pulled Lear's project from the scrap pile, and a third pilot was thrown together, with the script essentially unchanged, at Lear's insistence (although the network balked at his request to film it in black-and-white). O'Connor was so sure it would be another dud that he bargained

aggressively for a clause guaranteeing his family plane fare back to Europe, where they were living at the time.

There were a few more last-minute skirmishes, since Lear was determined to set a precedent for network noncooperation: In an industry that liked to sand down the pointy, he wanted to provoke viewers. He refused to eliminate what the censor called "explicit sex" (innuendo that would seem prudish these days), and he threatened to quit rather than run the milder second episode, about Richard Nixon, as the show's debut. CBS caved. In the pilot that ran, it's Archie and Edith's wedding anniversary. They return from church early, catching Michael and a miniskirted Gloria on their way to the bedroom. There's a loud belch—Lear's shows pioneered TV toilet humor—and Archie and Michael fight about atheism and Black Power. "I didn't have no million people out there marching and protesting to get me my job," Archie sneers. "No, his uncle got it for him," Edith replies. Some jokes stick, others fizzle, but it's Archie's volcanic charisma that lingers—at moments, it's easy to imagine him hitting Edith, though the sitcom rhythms reassure us he won't.

Right away, critics were split. *Variety* raved that *All in the Family* was "the best TV comedy since the original *The Honeymooners*." Its sister publication, *Daily Variety*, called it "nothing less than an insult to any unbigoted televiewer." In *Life*, John Leonard wrote a virulent pan, in which he sounded a theme that became a chorus on op-ed pages: that a show like this demanded a moral response. "Why review a wretched program?" he wrote. "Well, why vacuum the living room or fix the septic tank? Every once in a while the reviewer must assume the role of a bottle of Johnson's No-Roach with the spray applicator: Let's clean up this culture." The *Times* flooded the zone with pieces, from "Can Bigotry Be Laughed Away? It's Worth a Try" to "The Message Sounds Like 'Hate Thy Neighbor.'" One side felt that the show satirized bigotry; the other argued that it *was* bigotry, and that all those vaudevillian yuks and awws were merely camouflage for Archie's ugly words.

As the show's ratings rose, it began to saturate American culture, high and low. In 1971, the *Saturday Review* reported that teachers were requesting study guides to use the show to teach their students lessons about bigotry. The literary theorist Paul de Man quoted Archie and Edith's dialogue to dramatize a point, appropriately enough, about the slipperiness of meaning: the idea that the intent of words was endlessly interpretable. A paperback called *The Wit & Wisdom of Archie Bunker* became a bestseller ("Move Over Chairman Mao—Here Comes Archie Bunker!"), with quips like "I never said a man that wears glasses is a queer. A man that wears glasses is a four-eyes. A man that's a fag is a queer!" In 1973, a poll found that Archie Bunker's was the most recognized face in America, and for a while, there was a craze for bumper stickers reading "Archie Bunker for President." At the 1972 Democratic Convention in Miami, the character got a vote for vice president.

The weightiest criticism came in another *Times* essay, by Laura Z. Hobson, the elderly author of *Gentleman's Agreement*, the source for Elia Kazan's earnest Oscar-winning 1947 film about anti-Semitism. In September 1971, she published a five-thousand-word critique called "As I Listened to Archie Say 'Hebe' . . ." Hobson argued that Lear had attempted to "deodorize" bigotry, to make it safe and cute: Among other things, Archie used words like "coon" and "yid," but he didn't say "nigger" or "kike." Rather than puncturing hatred, she argued, Lear had made Archie into a flattering mirror for bigots. "I don't think you can be a black-baiter and lovable, nor an anti-Semite and lovable," she wrote. "And I don't think the millions who watch this show should be conned into thinking that you can be."

Lear responded with his own *Times* essay, "As I Read How Laura Saw Archie," arguing that of course bigots could be lovable, as anyone with a family knew. If Archie Bunker didn't use harsher language, it was because those words were "from another decade." Besides, Michael and Gloria, the bleeding-heart liberals, al-

ways got the last word. Despite Lear's playful response, later episodes of *All in the Family* contain many echoes of this debate. The show's tone gradually softened, and the more caustic slang dropped out; Archie even stopped telling Edith to "stifle." (As with *M*A*S*H*, its creators were influenced by the rise of feminism.) In Season 8, there's a trenchant sequence in which Archie, drunk and trapped in a storage room with Michael, talks about his childhood. Yes, his father said "nigger" while he was growing up, Archie says—everybody did—and when Michael tells him what his father said was wrong, Archie delivers a touching, confused defense of the man who raised him, who held his hand, but who also beat him and shoved him in a closet. It was all out of love, Archie insists. "How could any man that loves you tell you anything that's wrong?" he murmurs, just before he passes out. The scene should have been grotesquely manipulative and mawkish, but, strengthened by O'Connor's affecting performance, it makes Lear's point more strongly than any op-ed, even decades later: Bigotry is resilient, because rejecting it often means rejecting your own family.

Civil-rights advocates, including the National Urban League and the Anti-Defamation League, tended to share Hobson's distrust of the series. (In contrast, the ACLU awarded Lear the Freedom of the Press Award in 1973.) Bill Cosby, who was a major TV star after *I Spy*, downright despised Archie Bunker. Even a decade later, on *The Phil Donahue Show*, Cosby was still expressing frustration that Bunker had never apologized for anything, making him "a hero to too many Americans for his shortsightedness, his tunnel vision." He added, "And I'm really a believer that the show never taught or tried to teach anybody anything."

To critics, the show wasn't the real problem: Its audience was. In 1974, the social psychologists Neil Vidmar and Milton Rokeach offered some evidence for this argument in a study published in the *Journal of Communication* using two samples, one of teenagers, the other of adults. Subjects, whether bigoted or not, found the show funny, but most bigoted viewers didn't perceive the program

as satirical. They identified with Archie's perspective, saw him as winning arguments, and, "perhaps most disturbing, saw nothing wrong with Archie's use of racial and ethnic slurs." Lear's series seemed to be even more appealing to those who shared Archie's frustrations with the culture around him, a "silent majority" who got off on hearing taboo thoughts said aloud.

This clearly wasn't true of every bigot—at least not Richard Nixon, who eagerly recapped the series for H. R. Haldeman and John Ehrlichman. In the Watergate tapes, Nixon describes in detail an episode in which a gay friend of Michael's comes to visit, leading Archie to discover that his own football-player buddy is gay. The series "made a fool out of a good man," Nixon grumbles. He theorizes that Michael probably "goes both ways" and worries that the show will corrupt children, just as Socrates did in ancient Greece. Ehrlichman interjects, in Socrates's defense, that at least "he never had the influence that television had."

"A vast wasteland"! It's impossible to discuss TV, even today, without stumbling upon the medium's most famous slander, its own version of "meathead." Much of the context has been lost, though. That description comes from the first official speech given by Newton Minow, shortly after President Kennedy appointed him chairman of the FCC in 1961. Minow wasn't arguing that what aired on television was merely artistically, aesthetically bad; he was arguing that it was amoral. He quoted, with approval, the words of the industry's own Television Code and urged the networks to live up to them: "Program materials should enlarge the horizons of the viewer, provide him with wholesome entertainment, afford helpful stimulation, and remind him of the responsibilities which the citizen has toward his society."

From a modern perspective, the passage can feel prissy and laughable, the residue of an era when television was considered a public utility: It was in everyone's best interest to keep it pure, and

then add fluoride. No critic could support that approach, least of all those who see TV as an art form and want to free it from anxious comparisons to novels and movies—to celebrate TV as TV. During a recent visit to a university, I bridled when an ethicist praised me for taking a moral stance. (I'd called a network show "odious torture porn.") I told her that I wanted originality, even if it was ugly, and that I'd rather watch a show that unsettled me than something that was merely "good."

That's true, or true enough. And yet, like Archie himself, I have to admit to my own fascination with the good old days—in particular, that spiky, surreal moment when people found television so dangerous that they slapped warning stickers on it. Lear and his critics disagreed about how his show affected people, but they agreed that it should affect people. Every day marked a fresh skirmish: Should there be a "family hour"? Were Starsky and Hutch making viewers violent? Back when television was a mass phenomenon, controlled by three networks, watched live by the whole family, it was no wonder that observers wrung their hands over whether it might turn its viewers into monsters. (These days, we reserve those concerns for the Internet.)

Five years after *All in the Family*, Lear launched an even more radical show, *Mary Hartman, Mary Hartman*, a prophetic, neglected TV classic stuffed with anti-TV themes. A satire of soap operas, and one of the first truly serial evening shows, it was so loopy and avant-garde that its producers syndicated it independently, airing it on affiliates mostly late at night. Lear explicitly designed *Mary Hartman* to appeal to two audiences: those who enjoyed it as melodrama and those who took it as social satire. In the finale of the first season, its eponymous housewife heroine (played by Louise Lasser) has a nervous breakdown on David Susskind's talk show as moralists hammer her with questions. "Were your orgasms better before Johnny Carson?" the ideologues shout. "Erase! Erase!" Mary Hartman begs, panicked that she has said something wrong. It was a cry of terror that seemed to symbolize the mood of that

era: The world was in chaos, and viewers like Mary were tragically vulnerable to the media's influence. Yet Lasser's character's odd, raw humanity—together with the show's disorienting, deliberately ugly editing rhythms—was also a form of resistance. (The next season, she was institutionalized and happily became a member of the hospital's Nielsen family.)

Decades later, television has a different relationship with its audience. We collect and record it; we recap it with strangers; it pours through hundreds of narrow channels. Perhaps it's not so odd that, around the time the digital revolution began, another Archie-like figure rose up, as if from TV's unconscious: the rancorous middle-aged white male antihero, nostalgic for a past when he was powerful—and often conceived by a middle-aged white male showrunner, the demographic with the greatest economic ability to shake things up. As with *All in the Family*, the best of these dramas shoved TV forward with a rough charisma, blasting through piety and formula, frightening us and turning us on— and, often, dividing the audience in two. Then this genre, too, became a pious formula.

In *Sitcom*, Austerlitz argues that, as important as *All in the Family* was, the show is surprisingly hard to rewatch: Among other problems, its racial politics are dated, reducing racism to mere personal prejudice. There's some truth to that, and yet, these days, Lear's legacy is everywhere, often in stealthy packages. Lear set the stage for agitating comedies like *Girls*, lacerating satires like *It's Always Sunny in Philadelphia*, and boundary-crossers less to my taste, like Seth MacFarlane's *Family Guy*. Ryan Murphy, the creator of *Glee* and *American Horror Story*, is a professed admirer of Lear, and his shows feature diva-bigots who are female variants of Archie Bunker. Lear is a hero to Judd Apatow, too. Every time a show crosses the line of good taste, from humane pulp like *Orange Is the New Black* to bleak nightmares like *Hannibal*, it enlarges Lear's territory. Some of these shows place people who look nothing like

Archie at the center, helped by production models that don't require reaching every viewer.

There is no way—and maybe no reason—to unite TV's divided audience. If television creators began by trying desperately not to offend, they clearly learned that the opposite approach can work just as well: A show that speaks to multiple audiences can get ratings by offering many ways to be a fan. As for the "vast wasteland" debate, at times it feels as if the balance has shifted so far toward a reflexive cynicism (about torture as entertainment, for example) that it's difficult even to talk about the subject—at least without getting called a Margaret Dumont. Perhaps there's another way to look at it, which is to imagine an ethical quality that is embedded in originality. The best series rattle us and wake us up; the worst are numbing agents. Sometimes, a divided audience is a result of mixed messages, an incoherent text; sometimes, it's a sign of a bold experiment that we are still learning how to watch. But there's a lot to be said for a show that is potent without being perfect, or maybe simply perfect for its moment, part of a conversation instead of the permanent record: storytelling that alters the audience by demanding that viewers do more than just watch.

DIFFICULT WOMEN

How *Sex and the City* Lost Its Good Name

The New Yorker, July 29, 2013

By far the most popular thing I've ever written, this is basically a Trojan horse essay, containing all my main arguments about television, especially about which kind gets valued and which kind gets dismissed. Still, I spent the weekend before this sucker went to print sweating with anxiety, certain that it was a disaster. What I didn't understand was that I'd cracked the puzzle of how to write about a divisive show: Wait a decade.

When people talk about the rise of great TV, they inevitably credit one show, *The Sopranos*. Even before James Gandolfini's death, the HBO drama's mystique was secure: Novelistic and cinematic, David Chase's auteurist masterpiece had cracked open the gangster genre like a rib cage, releasing television's latent ambition and launching the Golden Age.

The Sopranos deserves the hype. Yet there's something screwy about the way the show and its cable-drama blood brothers have come to dominate the conversation, elbowing other forms of greatness out of the frame. It's a bias that bubbles up early in Brett

Martin's otherwise excellent new book, *Difficult Men: Behind the Scenes of a Creative Revolution: From* The Sopranos *and* The Wire *to* Mad Men *and* Breaking Bad, a deeply reported and dishy account of just how your prestige-cable sausage is made. I tore through the book, yet when I reached Martin's chronicle of the rise of HBO, I felt a jolt. "It might as well have been a tourism campaign for a post–Rudolph Giuliani, de-ethnicized Gotham awash in money," Martin writes of one of my favorite shows. "Its characters were types as familiar as those in *The Golden Girls:* the Slut, the Prude, the Career Woman, the Heroine. But they talked more explicitly, certainly about their bodies, but also about their desires and discontents outside the bedroom, than women on TV ever had before."

Martin gives *Sex and the City* credit for jump-starting HBO, but the condescension is palpable, and the grudging praise is reserved for only one aspect of the series—the rawness of its subject matter. Martin hardly invented this attitude; he is simply reiterating what has become the reflexive consensus on the show, right down to the hackneyed *Golden Girls* gag. Even as *The Sopranos* has ascended to TV's Mount Olympus, the reputation of *Sex and the City* has shrunk and faded, like some tragic dry-clean-only dress tossed into a decadelong hot cycle. By the show's fifteen-year anniversary, this year, we fans had trained ourselves to downgrade the show to a "guilty pleasure," to mock its puns, to get into self-flagellating conversations about those blinkered and blinged-out movies. Whenever a new chick-centric series debuts, there are invidious comparisons: Don't worry, it's no *Sex and the City,* they say. As if that were a good thing.

But *Sex and the City,* too, was once one of HBO's flagship shows. It was the peer of *The Sopranos,* albeit in a different tone and in a different milieu, deconstructing a different genre. Mob shows, cop shows, cowboy shows—those are formulas with gravitas. *Sex and the City,* in contrast, was pigeonholed as a sitcom. In fact, it was a bold riff on the romantic comedy: The show wrestled with the

limits of that pink-tinted genre for almost its entire run. In the end, it gave in. Yet until that last-minute stumble it was sharp, icono-clastic television. High-feminine instead of fetishistically mascu-line, glittery rather than gritty, and daring in its conception of character, *Sex and the City* was a brilliant and, in certain ways, radi-cal show. It also originated the unacknowledged first female anti-hero on television: ladies and gentlemen, Carrie Bradshaw.

Please, people, I can hear your objections from here. But first think back. Before *Sex and the City*, the vast majority of iconic "sin-gle girl" characters on television, from That Girl to Mary Tyler Moore and Molly Dodd, had been you-go-girl types—which is to say, easy-to-love role models. (Ally McBeal was a notable and prob-lematic exception; so was Murphy Brown, in her way.) They were pioneers who offered many single women the representation they craved, and they were also, crucially, adorable to men: vulnerable and plucky and warm. However varied the layers they displayed over time, they flattered a specific pathology: the cultural require-ment that women greet other women with the refrain "Oh, me, too! Me, too!"

In contrast, Carrie and her friends—Miranda, Samantha, and Charlotte—were odder birds by far, jagged, aggressive, and some-times frightening figures, like a makeup mirror lit up in neon. They were simultaneously real and abstract, emotionally complex and philosophically stylized. Women identified with them—"I'm a Carrie!"—but then became furious when they showed flaws. And, with the exception of Charlotte (Kristin Davis), men didn't find them likable: There were endless cruel jokes about Samantha (Kim Cattrall), Miranda (Cynthia Nixon), and Carrie as sluts, man-haters, or gold diggers. To me, as a single woman, the show felt like a definite sign of progress, since the elemental representation of single life at the time was the comic strip *Cathy* (ack! choco-

late!). Better that one's life should be viewed as glamorously threatening than as sad and lonely.

Carrie Bradshaw herself began as a mirror for another woman: She was the avatar of *New York Observer* columnist Candace Bushnell, a steely "sexual anthropologist" on the prowl for blind items. When the initial showrunner, Darren Star, and his mostly female writing staff adapted Bushnell's columns, they transformed that icy Carrie, pouring her into the warm body of Sarah Jessica Parker. Out popped a chatterbox with a schnoz, whose advanced fashion sense was not intended to lure men into matrimony. For a half dozen episodes, Carrie was a happy, curious explorer, out companionably smoking with modelizers. If she'd stayed that way, the show might have been another *Mary Tyler Moore*: a playful, empowering comedy about one woman's adventures in the big city.

Instead, Carrie fell under the thrall of Mr. Big, the sexy, emotionally withholding forty-three-year-old financier played by Chris Noth. From then on, pleasurable as *Sex and the City* remained, it also felt designed to push back at its audience's wish for identification, triggering as much anxiety as relief. It switched the romantic comedy's primal scene from "Me, too!" to "Am I like her?" A man practically woven out of red flags, Big wasn't there to rescue Carrie; instead, his "great love" was a slow poisoning. She spun out, becoming anxious, obsessive, and, despite her charm, wildly self-centered—in her own words, "the frightening woman whose fear ate her sanity." Their relationship was viewed with concern by Carrie's three friends, who were not, as Martin suggests, mere "types" but portrayals of a narrow slice of wealthy white thirtysomething Manhattanites: the WASPy gallerina, the liberal-feminist lawyer, the decadent power publicist.

Although the show's first season is its slightest, it swiftly establishes a bold mixture of moods—fizzy and sour, blunt and arch—and shifts between satirical and sincere modes of storytelling. (It's not even especially dated; though the show has gained a reputa-

tion for over-the-top absurdity, I can tell you that these nightclubs and fashion shows do exist—maybe even more so now that Manhattan has become a gated island for the wealthy.) There is already a melancholic undertow, full of foreshadowing. "What if he never calls and three weeks from now I pick up *The New York Times* and I read that he's married some perfect little woman who never passes gas under his five-hundred-dollar sheets?" Carrie frets in Episode 11. In a moment of clarity, she tells Miranda that, when she's around Big, "I'm not like me. I'm, like, Together Carrie. I wear little outfits: Sexy Carrie and Casual Carrie. Sometimes I catch myself actually posing. It's just—it's exhausting."

That was the conundrum Carrie faced for the entire series: True love turned her into a fake. The Season 1 neurotic Carrie didn't stick, though. She and Big fixed things, then they broke up again, harder. He moved to Paris. She met Aidan (John Corbett), the marrying type. In Season 3, the writers upped the ante, having Carrie do something overtly antiheroic: She cheated on a decent man with a bad one (Big, of course), now married to that "perfect little woman," Natasha. They didn't paper over the repercussions: Natasha's humiliation, and the way Carrie's betrayal hardened Aidan, even once he took her back. During six seasons, Carrie changed, as anyone might from thirty-two to thirty-eight, and not always in positive ways. She got more honest and more responsible; she became a saner girlfriend. But she also became scarred, prissier, strikingly gun-shy—and, finally, she panicked at the question of what it would mean to be an older single woman.

Her friends went through changes, too, often upon being confronted with their worst flaws—Charlotte's superficiality, Miranda's caustic tongue, Samantha's refusal to be vulnerable. In a departure from nearly all earlier half-hour comedies, the writers fully embraced the richness of serial storytelling. In a movie we go from glare to kiss in two hours. *Sex and the City* was liberated from closure, turning "once upon a time" into a wry mantra, treating its characters' struggles with a rare mixture of bluntness and compas-

sion. It was one of the first television comedies to let its characters change in serious ways, several years before other half-hour comedies, like *The Office*, went and stole all the credit.

So why is the show so often portrayed as a set of empty, static cartoons, an embarrassment to womankind? It's a classic misunderstanding, I think, stemming from an unexamined hierarchy: the assumption that anything stylized (or formulaic, or pleasurable, or funny, or feminine, or explicit about sex rather than about violence, or made collaboratively) must be inferior. Certainly, the show's formula was strict: usually four plots—two deep, two shallow—linked by Carrie's voice-over. The B plots generally involved one of the non-Carrie women getting laid; these slapstick sequences were crucial to the show's rude rhythms, interjecting energy and rupturing anything sentimental. (It's one reason those bowdlerized reruns on E! are such a crime: With the literal and figurative fucks edited out, the show is a rom-com.)

Most unusually, the characters themselves were symbolic. As I've written elsewhere—and argued, often drunkenly, at cocktail parties—the four friends operated as near-allegorical figures, pegged to contemporary debates about women's lives, mapped along three overlapping continuums. The first was emotional: Carrie and Charlotte were romantics; Miranda and Samantha were cynics. The second was ideological: Miranda and Carrie were second-wave feminists, who believed in egalitarianism; Charlotte and Samantha were third-wave feminists, focused on exploiting the power of femininity from opposing angles, the Rules Girl and the Power Slut. The third concerned sex itself. At first, Miranda and Charlotte were prudes, while Samantha and Carrie were libertines. Unsettlingly, as the show progressed, Carrie began to glide toward caution, away from freedom, growing more fearful, not less.

Every conversation the friends had, at brunch or out shopping,

amounted to a *Crossfire*-like debate. When Carrie sleeps with a dreamy French architect and he leaves a thousand dollars by her bed, she consults her friends. "Money is power. Sex is power," Samantha argues. "Therefore, getting money for sex is simply an exchange of power." "Don't listen to the dime-store Camille Paglia," Miranda shoots back. The most famous such conversation took place four episodes in, after Charlotte's boyfriend asked her to have anal sex. The friends pile into a cab for a raucous debate about whether her choice is about power-exchange (Miranda) or about finding a fun new hole (Samantha). "I'm not a hole!" Charlotte protests, and they hit a pothole, then lurch forward. "What was that?" Charlotte asks. "A preview," Miranda and Samantha say in unison, and burst out laughing.

The show's basic value system aligns with Carrie: romantic, second-wave, libertine. But *Sex and the City*'s real strength was its willingness not to stack the deck; it let every side make a case, so that complexity carried the day. When Carrie and Aidan break up, they are both right. When Miranda and Carrie argue about her move to Paris, they are both right. The show's style could be brittle, but its substance was flexible, in a way that made the series feel peculiarly broad-ranging, covering so much ground, so fleetly, that it became easy to take it for granted.

Endings count in television, maybe too much. *The Sopranos* concluded with a black screen; it rejected easy satisfaction and pissed off its most devoted fans. (David Chase fled to the South of France.) Three years earlier, in 2004, *Sex and the City* had other pressures to contend with: While a mob film ends in murder, we all know where a romantic comedy ends. I'll defend until my dying day the sixth-season plot in which Carrie seeks respite with a celebrity like her, the Russian artist Aleksandr (Mikhail Baryshnikov), a chilly genius she doesn't love but who offers her a dreamlike fairy tale, the highly specific one she has always longed for: Paris, safety,

money, pleasure. It felt ugly, and sad, in a realistic way. In one of
the season's, and the show's, best episodes, she saw other older
women "settling" (Candice Bergen) or falling out of windows (the
hilarious Kristen Johnston, who delivered one of *Sex and the City*'s
best monologues: "When did everybody stop smoking? When did
everybody pair off? . . . I'm so bored I could die"). The show al-
ways had a realpolitik directness about such social pressures; as
another HBO series put it later on, winter was coming.

And then, in the final round, *Sex and the City* pulled its punches
and let Big rescue Carrie. It honored the wishes of its heroine, and
at least half of the audience, and it gave us a very memorable
dress, too. But it also showed a failure of nerve, an inability of the
writers to imagine, or trust themselves to portray, any other kind
of ending—happy or not. And I can't help but wonder: What
would the show look like without that finale? What if it were the
story of a woman who lost herself in her thirties, who was changed
by a poisonous, powerful love affair, and who emerged, finally, sur-
rounded by her friends? Who would Carrie be then? It's an inter-
esting question, one that shouldn't erase the show's powerful
legacy. We'll just have to wait for another show to answer it.

COOL STORY, BRO

The Shallow Deep Talk of
True Detective

The New Yorker, March 3, 2014

No piece has gotten me more aggressive hate mail. One hand-written letter, which addressed me as "Princess," claimed that I didn't understand "shiksa crazy pussy." (I do understand shiksa crazy pussy.) To be fair, this essay is written with a certain obnoxious flair, because I was trying to puncture what felt like a gaseous balloon of overpraise, three-quarters of the way through the first season. It worked.

Judged purely on style, HBO's *True Detective* is a great television drama. Every week, it offers up an assortment of shiver-inducing cable TV intoxicants, from an action sequence so liquid that it rivals a Scorsese flick to pungent scenes of rural degradation, filmed on location in Louisiana, a setting that has become a bit of an HBO specialty. (*Treme* and *True Blood* are also set there.)

Like many critics, I was initially charmed by the show's anthology structure (eight episodes and out; next season a fresh story) and its witty chronology, which chops and dices a serial-killer investigation using two time lines. In the 1990s time line, two detec-

tives, Marty Hart and Rust Cohle (Woody Harrelson and Matthew McConaughey), hunt down a fetishistic murderer, the sort of artsy bastard who tattoos his female victims, then accessorizes them with antlers and scatters cultish tchotchkes at the crime scene. In the contemporary time line, these ex-partners are questioned by two other cops, who suspect that the murders have begun again. If you share my weakness for shows that shuffle time or have tense interrogations—like the late, great *Homicide: Life on the Street* or the better seasons of *Damages*—you may enjoy seeing these methods combined. The modern interviews become a voice-over, which is in turn layered over flashbacks, and the contrast between words and images reveals that our narrators have been cherry-picking details and, at crucial junctures, they've been flat-out lying. So far, so complex.

On the other hand, you might take a close look at the show's opening credits, which suggest a simpler tale: one that's about heroic male outlines and close-ups of female asses, crouched over spiked high heels. And the deeper we get into the season, the more I'm starting to suspect that those asses tell the real story.

This aspect of *True Detective* (which is written by Nic Pizzolatto and directed by Cary Joji Fukunaga) will be gratingly familiar to anyone who has ever watched a new cable drama get acclaimed as "a dark masterpiece": the slack-jawed teen prostitutes; the strippers gyrating in the background of police work; the flashes of nudity from the designated put-upon wifey character; and much more nudity from the occasional cameo hussy, like Marty's mistress, whose rack bounces merrily through Episode 2. Don't get me wrong: I love a nice bouncy rack. And if a show has something smart to say about sex, bring it on. But, after years of watching *Boardwalk Empire*, *Ray Donovan*, *House of Lies*, and so on, I've gotten prickly and tired of trying to be, in the novelist Gillian Flynn's useful phrase, the Cool Girl: a good sport when something smells like macho nonsense. And, look, *True Detective* reeks of the stuff. The series, for all its good looks and its movie-star charisma, isn't

just using dorm-room deep talk as a come-on: It has fallen for its own sales pitch.

To state the obvious: While the male detectives of *True Detective* are avenging women and children, and bro-bonding over "crazy pussy," every live woman they meet is paper-thin. The female characters are wives and sluts and daughters—none with any interior life. Instead of an ensemble, *True Detective* has just two characters, the family-man adulterer Marty, who seems like a real and flawed person (an interesting asshole, in Harrelson's excellent performance), and Rust, who is a macho fantasy straight out of Carlos Castaneda. A sinewy weirdo with a tragic past, Rust delivers arias of philosophy, a mash-up of Nietzsche, Lovecraft, and the nihilist horror writer Thomas Ligotti. At first, this buddy pairing comes across as a funky dialectic: When Rust rants, Marty rolls his eyes. But, six episodes in, I've come to suspect that the show is dead serious about this dude.

Rust is a heretic with a heart of gold. He's *our* fetish object—the cop who keeps digging when everyone ignores the truth, the action hero who rescues children in the midst of violent chaos, the outsider with painful secrets and harsh truths and nice arms. McConaughey gives an exciting performance (in *Grantland*, Andy Greenwald aptly called him "a rubber band wrapped tight around a razor blade"), but his rap is premium baloney. And everyone around these cops, male or female, is a dark-drama cliché, from the coked-up dealers and the sinister preachers to that curvy corpse in her antlers. *True Detective* has some tangy dialogue ("You are the Michael Jordan of being a son of a bitch") and Fukunaga's direction whips up an ominous atmosphere, rippling with psychedelia, but these strengths finally dissipate, because the show is so solipsistically focused on the phony duet.

Meanwhile, Marty's wife, Maggie—played by Michelle Monaghan, she is the only prominent female character on the show—is an utter nothing-burger, all fuming prettiness with zero insides. Stand her next to the other, far more richly portrayed betrayed

wives of television—like Mellie, on *Scandal*; or Alicia, on *The Good Wife*; or Cersei, on *Game of Thrones*; or even Claire, on *House of Cards*—and Maggie disappears. Last week, Maggie finally got her own episode, in which she is interrogated by the cops. She lies to them, with noir composure, as the visuals reveal a predictable twist: Maggie has had revenge sex with Rust. That sex is filmed as gasp-worthy, though it lasts thirty seconds. We see Monaghan's butt, plus the thrusting cheeks of McConaughey. But the betrayal carries no weight, since the love triangle is missing a side.

An earlier sex scene is even more absurd and features still another slice of strange: a lusty, anal-sex-offering, sext-happy ex-hooker. She seduces Marty with her own philosophical sweet nothings ("There is nothing wrong with the way he made us"), and, since she's a gorgeous unknown, we get to see her ride Harrelson like a bronco, as ceramic angels and devil dolls look on from the dresser.

I'm certain that, if you're a fan of the series, this analysis irritates you. It's no fun to be a killjoy when people are yelling "Best show ever"; this is the kind of debate that tends to turn both sides into scolds, each accusing the other of being prudes or suckers. A few months ago, a similar debate erupted about Martin Scorsese's *The Wolf of Wall Street*, a film that inspired its advocates to rage that those who didn't "get it" just needed to get laid. There were more nuanced arguments out there, though: In the *Times*, A. O. Scott argued that, while the film did a fine job sending up the corruption of the grifter Jordan Belfort, there was little distinction, visually, between Belfort's misogyny and the film's own display. Cool Girl that I am, I didn't entirely agree: Like *True Detective, Wolf* unfolds in flashback, through voice-over, but its outrageous images ripple to reflect Belfort's own mania. With the exception of a few shots—like one of a stewardess, whose assault the movie treats as a joke in a way that made me twitch—the nudity, nasty as it is, makes sense.

On *True Detective*, however, we're not watching the distorted

testimony of an addict, punctured by flashes of accidental self-revelation. The scenes we see are supposed to be what really happened. And when a mystery show is about interchangeable female corpses, and the living women are eye candy, it's a drag. Whatever the length of the show's much-admired tracking shot (six minutes, uncut!), it feels less hardboiled than softheaded. Which might be okay if *True Detective* were dumb fun, but, good God, it's not; the show has got so much gravitas it could run for president.

It's possible that my crankiness derives from having watched so many recent, better crime series, telling similar stories in far more original ways, getting much less attention in the media. Most notable were Jane Campion's soaring *Top of the Lake* on Sundance, and Allan Cubitt's nightmare-inducing BBC series *The Fall*. In *Top of the Lake*, Campion jolts the viewer with what qualifies as a legitimately taboo use of nudity, transgressive because it's genuinely rare for television. She films the saggy bodies of middle-aged women, the members of a female self-help encampment, without either judgment or celebration. Then she combines this subplot—in which she satirizes the cult of feminist victimhood—with a small-town mystery about sex crimes against teenage girls, who are filmed with comparative discretion. Like *True Detective*, Campion's miniseries is a moody, pastoral rape-and-murder drama. But it's all about torquing viewer expectations, not providing titillation—it's about how communities agree to treat crimes against women as if they were bad dreams. Both shows feature mystery plots about pedophilic conspiracies among powerful men. The difference is that, while *Top of the Lake* is about survivors, *True Detective* is about witnesses. In *Top of the Lake*, the girls' experiences matter. In *True Detective*, the crimes are just symbols of the universe's awesome Lovecraftian horror.

In contrast, *The Fall* (which is available on Netflix) has even more conventional nudity than *True Detective*. It, too, tells a story

about a team of detectives who are hunting for a rapist-murderer obsessed with symbolism. *The Fall* features pervy stalker shots, along with sick-making imagery of female corpses in bondage, photographed as keepsakes. Some critics have called the show misogynistic, or torture porn: By turning viewers on, it's taking a rapist's-eye view. And that's true. But in the case of *The Fall*, the technique is deliberate. The show reveals the murderer right away and then forces us to empathize, seeing the world through his eyes. Then, episode by episode, it tears that identification apart.

Just like Rust Cohle in *True Detective*, *The Fall*'s rapist speaks in an elaborate pseudo-intellectual lingo, full of Nietzsche quotes. But an icy female cop, played by Gillian Anderson, sees right through him—and, in the finale, she shreds his pretensions with one smart speech: "You think you're some kind of artist, but you're not. . . . You try to dignify what you do. But it's just misogyny. Age-old male violence against women." Anderson's character aside, *The Fall* overflows with richly conceived female characters, who include not merely the killer's victims but their families, the murderer's wife, his daughter, and his mistress. As beautiful as *The Fall* looks, it's much harder to watch than *True Detective*, because there is a soul inside each body we ogle. When women suffer, their pain isn't purely decorative.

True Detective isn't over, of course; like any mystery, it can't be fully judged before the finale—it might yet complete that mystical time loop Rust keeps ranting about. There are hints of the supernatural, with endless references to the "Yellow King" and the "Lost City of Carcosa": Maybe the show will reveal that it was Cthulhu all along, in the library, with the candlestick. But for now I'm an unbeliever. Bring me some unpretentious pulp, like Cinemax's *Banshee*, or an intelligent thriller, like FX's *The Americans*, which is beginning its second season later this month and has fresh things to say about the existential slipperiness of human identity. If you're going to gaze into the abyss, find one that's worth the look.

LAST GIRL IN LARCHMONT

The Legacy of Joan Rivers

The New Yorker, February 23 & March 2, 2015

My original pitch to my editor was for an essay drawing links between Joan Rivers—who had died months earlier—and the *Real Housewives* reality series. That idea went straight out the window, since Rivers is a fascinating enough figure for twelve essays. Due credit to my husband, who during one late-night brainstorm, made the brilliant point to me that Helen Gurley Brown was Machiavelli to Joan Rivers's Hobbes.

Six months before Joan Rivers died, last year, she went on *The Howard Stern Show:* Two old friends, serial offenders, knocking down targets. They talked about Mayor Bill de Blasio. ("Rich against the poor!" she sneered.) Stern asked her opinion of Woody Allen, with whom Rivers had come up in the club scene, in the early sixties. "I think he's brilliant. What Woody does in his private life is his private life. You want to be a pedophile, be a pedophile. I like . . . what's her name? Ping-Pong. The wife. She wears yellow too much. Too matchy-matchy."

Then, abruptly, Rivers changed the subject, to a topic more divisive than class warfare or Woody Allen: Lena Dunham's body. "Let me ask you something!" she said. "Lena Dunham. Who I think is, again, terrific. How can she wear dresses above the knee?" Stern said that what he loved about Dunham was that "she doesn't give a shit." "Oh, she has to," Rivers insisted. "Every woman gives a shit." When Stern and his co-host described funny scenes from *Girls* of Dunham in a bikini, Rivers nearly sputtered: "But that's wrong! You're sending a message out to people saying, 'It's okay, stay fat, get diabetes, everybody die, lose your fingers.'" In a passionate rasp, she made her case. Dunham was a hypocrite for doing *Vogue*, she said, because it showed that she cared about being pretty. Stern was another hypocrite, for his "tits and ass" jokes, for his hot second wife—would he have married Dunham? Stern said that he thought Rivers would "rejoice" in the younger woman's freedom. "But don't make yourself, physically—don't let them laugh at you physically," Rivers pleaded, sounding adrift. "Don't say it's okay that other girls can look like this. Try to look better!"

The discussion felt poignant: Joan Rivers's reflexive emphasis on marriage and weight, her hard-bitten advice for surviving in a man's world, seemed almost naive in the context of Dunham's fourth-wave-feminist exhibitionism. (Why would Dunham want to marry Stern?) The *Girls* creator was violating the rules that Rivers built her life on—was hemmed in by, protested, and enforced, often all at the same time. From the 1960s on, Rivers had been the purveyor of a harsh realpolitik, one based on her experience: Looks mattered. If you got cut off from access to men and money—and from men as the route to money—you were dead in the water. Women were one another's competition, always. For half a century, this dark comedy of scarce resources had been her forte: many hands grasping, but only one golden ring. Rivers herself had fought hard for the token slot allotted to a female comic, yet she seemed thrown by a world in which that might no longer

be necessary. Like Moses and the Promised Land, she couldn't cross over.

A devotee of rude candor, Joan Rivers had always blown a raspberry at the concept of "too soon." After her husband, Edgar, committed suicide, she said she'd scattered his ashes at Neiman Marcus, so she could visit five times a week. Days after the Twin Towers fell, she called her friend Jonathan Van Meter and invited him to "Windows on the Ground." According to the loving profile he wrote of her in *New York*, she had a pillow that read "Don't Expect Praise Without Envy Until You Are Dead." And for decades Rivers proclaimed (sometimes bitterly, but also proudly) that when she died she'd be sanctified, like her hero, Lenny Bruce. That prophecy has come true; since her death in September, at eighty-one, she's been celebrated as a trailblazer, a pioneer for female comics. The 2010 documentary *Joan Rivers: A Piece of Work* cast a glow over Rivers's later years, emphasizing her fantastic work ethic and how, after a series of devastating losses—when Johnny Carson blackballed her, her talk show was canceled, and Edgar died—she'd stubbornly refused to fold, taking any gig she could get, high or low. (In one of the best scenes, Rivers riffles through her zingers, thousands of which are stored in silver file drawers with labels such as "Pets" and "Politically Incorrect," "New York" and "No Self Worth.")

That admiring portrait was true, but it obscured a more complicated reality: In *A Piece of Work*, there are plenty of Holocaust jokes, and some hilarious elder-sex bits, but not a single fat joke, although for many decades jokes about female bodies were Rivers's specialty. There is no "Fashion Police," and no red-carpet routine, no mention of the night Rivers said, when the twenty-two-year-old Kate Winslet was up for an Academy Award, that the actress's fat arms had sunk the *Titanic*. Was that a joke or an insult? A message to Winslet or to other girls watching? (Try to look better!) This was the harder-to-handle part of Rivers's legacy, her powerful alloy of girl talk and woman hate, her instinct for how

misogyny can double as female bonding. In many ways, Joan Rivers was the first Real Housewife: She was brazen, unapologetically. materialistic, a glamorous warrior in an all-female battleground— a gladiator. To honor her, as both a role model and a cautionary tale, you can't airbrush that out.

When I first noticed Joan Rivers, she looked like the enemy. This was in the early eighties, at the height of her fame. She was Johnny Carson's permanent guest host at the time—warm to his cold; abrasive yet charismatic; with a brash engagement with the audience. (Her trademark line: "Can we talk?") I was a teenage comedy nerd, into *SCTV* and Tom Lehrer, obsessed with Woody Allen and David Letterman. I was eager for female role models, of whom there were only a handful, other than Gilda Radner and the mysterious Elaine May, no longer on the scene. Yet Rivers terrified me. Glamorous in her Oscar de la Renta dresses and her pouf of blond hair, she was the body cop who circled the flaws on every other powerful woman—she announced who was fat, who had no chin, who was hot but, because she was hot, was a slut or dim. She made it clear that if you rose to fame, the world would use your body to cut you down. The fact that she was funny made her more scary, not less: "What's Liz Taylor's blood type? Ragú!" I laughed, then hated myself for laughing.

But, if Rivers was chilling to me, I was a prig about her. Among other things, I didn't understand much about the forces that shaped her—or that, during her own ascent, she hadn't been an insult comic at all but part of a new wave of sixties experimental stand-ups. Born in 1933, Joan Molinsky was the child of a doctor and his status-obsessed wife, who bought a fancy house in Larchmont as a "picture frame" for their two daughters. (The kitchen was painted pink to be more flattering when they brought boys home.) In the early fifties, when Rivers was a chubby freshman at Connecticut College, that mating ground for WASPs (she later transferred to

artsy Barnard), a blind date picked her up at her dorm. When she came downstairs, her date turned to his friend and said, in disgust, "Why didn't you tell me?" Such rejections seared into Rivers a life-long identity as a "meeskite"—an ugly girl—even after she slimmed down, bobbed her nose, and became, in society's terms, attractive. Later, in 1973, she turned the anecdote into a TV movie, *The Girl Most Likely To . . .* , in which a former fat girl murders the men who rejected her.

In her gritty first memoir, *Enter Talking*, published in 1986, she describes her path as a Pilgrim's Progress of heartbreak and ambition. She dumped her first love, a poet, for an early marriage—to the "right" kind of guy—that failed. She lived at home through her twenties, commuting into Manhattan in a beat-up Buick, dreaming of being a serious actress, "J. Sondra Meredith." Instead, she took sleazy gigs as a strip club emcee, Pepper January: Comedy with Spice. She bombed, twice, on *The Jack Paar Tonight Show*. She stole other comics' routines; agents shunned her. Once, after a promising gig, her parents encouraged her to perform at their Westchester country club. She flopped so aggressively that the Molinskys sneaked out through the kitchen. Her father called her a "tramp"; Rivers ran away. For months, she was homeless; with the help of her Brooklyn boyfriend, she shacked up at midtown hotels, ducking the bill, fixing her face at Grand Central. Eventually, exhausted, she slunk back to her teenage bedroom.

Then, when she was nearly thirty, Rivers's act finally began to click, creatively. During a stint at Second City in Chicago in 1961, she introduced a character named Rita, a desperate, needy, aging single girl. Back in Greenwich Village, in dingy clubs like The Duplex, she experimented with this autobiographical material, raw stories of bad dates and shame about her body. She dished about birth control, her affair with a married man, and her gay friend, Mr. Phyllis. Her closing line was "My name is Joan Rivers and I put out." When she saw a Lenny Bruce performance, she was electrified, struck by a routine in which he called the audience "niggers"

and "kikes"; outrageousness, she thought, might be "healthy and cleansing." One night, when Rivers bombed, Bruce sent her a note: "You're right, they're wrong." She tucked it into her bra as a talisman, until she made her debut with Carson in 1965, her big break at last.

In those early years, her act was self-loathing, in the tradition of older female comics—she'd blow up her cheeks and hold out her arms, mocking herself as fat—but it also had an edge of empowerment. "The whole society is not for single girls, you know that?" she shouted in 1967 on *The Ed Sullivan Show.* "A girl can't *call.* Girl, you have to wait for the phone to ring, right? And when you finally go on the date, the girl has to be well-dressed, the face has to look nice, the hair has to be in shape. The girl has to be the one that's bright and pretty, intellig— A good sport. 'Howard Johnson's again! Hooray, hooray.'" She waggled her arms in fake enthusiasm, as if repulsed by her phoniness. "I'm from a little town called Larchmont, where if you're not married, and you're a girl, and you're over twenty-one, you're better off dead. It's that simple, you know? And I was"—her voice became a growl—"The. Last. Girl. In. Larchmont. Do you know how that feels? . . . Twenty-one. Twenty-two. Twenty-four."

In the *Times* in October 1965, Charles L. Mee praised Rivers as one of the New Comedians who had broken away from Borscht Belt shtick. "The style is conversational, suited to television 'talk' programs," Mee wrote. "It may take the form of Bill Cosby's colloquial stories or Woody Allen's self-analysis or Mort Sahl's intellectual nervosities. But it is not Jack Benny. Benny may be a tightwad on stage and a philanthropist off. Not so with the new comedians. They write their own jokes and are expected to live them offstage as well as on." Funky authenticity was her generation's fetish. But Rivers's act also worked because of her look. "Female comics are usually horrors who de-sex themselves for a laugh," Eugene Boe wrote in *Cue* in 1963. "But Miss R. remains visibly—and unalterably—a girl throughout her stream-of-

consciousness script." In 1970, the *Times* published a trend piece about stylish "comediennes"—titled "The Funny Thing Is That They Are Still Feminine"—in which Rivers claimed that she dressed simply for strategic reasons: "That way you're less of a threat to women." Onstage and on TV, she had a girl-next-door cuteness, a daffiness and a vulnerability, that lent a sting to her observations: If this nice Barnard coed, in her black dress and pearls, saw herself as a hideous loser, clearly the game was rigged.

As the rare female New Comedian, Rivers's persona also hit a nerve, playing as it did off a contemporary slur, the Jewish American Princess. In 1959, Norman Mailer had published a notorious short story, "The Time of Her Time," in which a bullfighter gives a Jewish college girl her first orgasm by means of sodomy and the phrase "dirty little Jew"; the same year, Philip Roth published *Goodbye, Columbus*, with its iconic Princess, Brenda Patimkin. In 1971, Julie Baumgold wrote a cover story for *New York*, at once disdainful and sympathetic, called "The Persistence of the Jewish American Princess," portraying the type as a spoiled girl who wouldn't cook or clean. Obsessively groomed, the JAP has been crippled by her mother, who refuses to let her daughter call herself ugly. She's "the soul of daytime drama," waiting for a rich man to save her: "Clops and blows come from Above, but still she expects. It isn't mere hope; it is her due."

Rivers took that sexist bogeywoman and made it her own, raging at society from inside the stereotype: She was the Princess who did nothing but call herself ugly. She vomited that news out, mockingly, yearningly, with a shrug or with a finger pointed at the audience. "Arf, arf," she'd bark, joking that a rapist had asked if they could just be friends. A woman I know used to sneak into the TV room, after her parents fell asleep, for the illicit thrill of seeing another woman call herself flat-chested. If Rivers's act wasn't explicitly feminist, it was radical in its own way: She was like a person trapped in a prison, shouting escape routes from her cell.

From the sixties to the eighties, Johnny Carson was, for aspiring comics, the model of a scarce resource; to get to the big time, you had to make it with Johnny. But Carson, notoriously, didn't like female comics. In Yael Kohen's *We Killed: The Rise of Women in American Comedy*, from 2012, the show's talent coordinator Patricia Bradford recalls the atmosphere: "They hired women over their dead bodies. They just didn't want them there." Even popular female comedians—Totie Fields in the sixties, Elayne Boosler in the eighties—couldn't get traction. "I don't ever want to see that waitress on my show again," Carson told his booker about Boosler, when she was considered a top stand-up, the peer of Jerry Seinfeld.

Yet, back in 1965, Joan Rivers had slipped through the eye of that needle; she was funny enough, feminine enough, new enough, traditional enough, just right. It was a trick she never forgot—after years of struggle, she'd become, in her eyes, Carson's daughter. The gig was a mercy booking: the "death slot," the last ten minutes. In her black dress and pearls, Rivers was introduced not as a stand-up but as that rarity, a "girl writer." She did "Last Girl in Larchmont"; she told a story about her wig being run over on the West Side Highway. When the segment ended, Johnny wiped tears from his eyes and said, on camera, "God, you're funny. You're going to be a star."

Within days, it was true: She got press, she got gigs, she got famous. Months later, she married Edgar, a British producer to whom she'd been introduced by Carson, just days after they met. For sentiment's sake, she wore that same outfit on the night of her final appearance with Carson on *The Tonight Show*, in 1986, to plug *Enter Talking*, which was dedicated "To Johnny Carson, who made it all happen." But, behind the scenes, she was insecure: Among other developments, she had seen an NBC document that listed ten men as potential Carson replacements. Two weeks after her appearance, Carson learned that Rivers had signed to do a competing show on Fox. She called to explain; he hung up. He never

spoke to her again. Two of Carson's successors at *The Tonight Show*, Jay Leno and Conan O'Brien, honored the ban, and she didn't appear on the show again until Jimmy Fallon broke the spell, six months before her death.

Still, for more than twenty years, Carson and Rivers had bantered, with him serving her the straight lines—"But don't you think men really like intelligence?"—and her lobbing back the punch line: "No man has put his hand up a woman's dress looking for a library card." It was a heavenly match; their ideas about men and women were congruent, like Lego bricks. At first, she worked her single-girl material: "Looks matter!" Then she tried a streak of softer, Erma Bombeck–like material, exploring subjects like housework and breastfeeding. (One of her early books was a pregnancy guide.) In both iterations, she rarely criticized other women, other than the fun slut "Heidi Abromowitz" and abstract rivals, like the airline stewardesses who, in one of Rivers's routines, cater only to men.

Then, in 1976, Rivers had a new breakthrough: She saw Elizabeth Taylor on the cover of *People*. As she wrote in *Still Talking*, the 1991 sequel to *Enter Talking*, she realized that "nobody had dared say about this icon, 'She's a blimp,' dared admit that you could stamp Goodyear on her and use her at the Rose Bowl." When Rivers tried Liz-is-fat gags, the audience exploded. If she cut them, they'd shout requests. "We women were furious when the most beautiful of all women let herself go," Rivers wrote. "If she became a slob, there was no hope for any of us."

These crude gags—about Liz, Christie Brinkley, Madonna—became her hottest material, on Carson and in front of Vegas crowds, as Rivers plugged into tabloid culture. Liz Taylor puts mayonnaise on aspirin! When she pierces her ears, gravy comes out. In *Enter Talking*, which she wrote well into her Hollywood era, Rivers never mentions her Liz Taylor jokes. But in *Still Talking*, five years later, she makes a case for these gags as a cathartic form of women's humor. "I never look at the men in the audience,

never deal with them," she wrote, describing appearances in Las Vegas. It's wives who get it: stay-at-home moms who wish they'd married rich; middle-aged women who love Rivers's bitter blurt about how Jane Fonda had the perfect body and her husband left anyway. Rivers is explicit about her aim, which is not just to entertain but to educate: She wants fat girls to know that "they need to pull it together," to resist their mothers' dangerous lies about inner beauty. "If Blanche DuBois took stock and said, 'This is where it's at, and I'm going to get rid of these schmatte clothes and get me a nice pants suit, and look smart here, with a pocketbook and a hat'—she would have been all right."

There's a sympathetic way to view these routines: Rivers wanted women to be savvy, not naive, about what the opposite sex was really like. She was a fiery pragmatist—another tagline was "Grow up!" During the seventies and eighties, she shared this message with the popular magazine editor Helen Gurley Brown, another skinny meeskite (although she called herself a "mouseburger"), the cheerful Machiavelli to Rivers's angry Hobbes, who, in *Cosmopolitan* and her books, offered practical tips on how to thrive in a sexist world, albeit as a mistress rather than as a wife. For both women, there was little use in trying to change, or even reason with, men; you just needed to find a way to get their attention, then harness their power as your own.

At the end of her Vegas act, Rivers would offer to reward a woman in the audience with a ficus tree—she'd drag it across the stage, struggling, as the orchestra watched but refused to help. She describes the moment in *Still Talking*: "I say, 'Fucking liberation. We did it to ourselves.' Women love that line. I am raging out like King Lear—Queen Lear—screaming into the wind, screaming for all us women."

"Michelle Obama is a tranny." "What's Adele's song, 'Rolling in the Deep'? She should add 'fried chicken.'" All her life, Rivers de-

fended even the most rancid zingers as a way of puncturing Hollywood puff, saying what we really thought—"punching up." Stars could take it, Rivers argued. ("You don't think so?" she said to *Playboy* in 1986. "Jackie Onassis, with her eyes on either side of her head like E.T., is not fair game? With her $38,000,000?") It's boring to be offended, more boring than a bad joke. But, watching *Fashion Police*, Rivers's celebrity panel with its "twat" gags, I'd get queasy, the way I've felt at a bad bachelorette party: Is this how we bond?

Still, other times I get it. Among women, the pugilistic brutality can be delicious, the fun of using these goddesses (or Bachelorettes, or Housewives) as shorthand: conduits for taboo emotions like envy, disgust, fear, the anxiety of falling short. By most accounts, by the time Rivers died she was less embattled than she had been after Edgar's death, when she struggled with bulimia and depression. She was close to her daughter and grandson, to the comics she'd mentored, to the gay men who dug her diva vibe, to the many who "got" and loved her. When I saw Rivers's famous face, I'd wonder if part of the appeal of plastic surgery wasn't the surgery itself. When it's over, you're new, whether you're beautiful or not; you've made the battle visible, instead of pretending there was no battle. In her 2009 book, *Men Are Stupid . . . and They Like Big Boobs*, she put it straight: "It's the way things are, accept it, or go live under a rock." Or, as the women in my family told me, in Yiddish, "You've got to suffer for beauty."

As a teenager, Rivers looked much like the teenage Dunham: She was pudgy, with a beaming grin and friendly eyes. But the caption she wrote for the picture of her in *Enter Talking* reads, "The thirteen-year-old fat pig, wishing she could teach her arms and hips to inhale and hold their breath."

That makes me sad. But, then, she wasn't wrong about the world that girl was walking into. Look at the male comics who were her peers at The Duplex: Bill Cosby, Woody Allen, and Mort Sahl, who became a devout anti-feminist. Look at Johnny Carson,

or at Jerry Lewis, who is still repelled by female comics. In *Still Talking*, there's a passage in which Rivers expresses her disgust "that the public buys the hypocrisy of the men revered as national institutions." And yet her humor was rarely directed at men: These were jokes by women, for women, at women. There's no reality series making fun of the men who wrecked Wall Street, but there is one, a hilarious one, adored by female viewers, devoted to their catfighting, parasitic, bedazzled wives.

There's a poem by Sharon Olds called "The Elder Sister." In it, the narrator talks about how much she used to hate her sister, "sitting and pissing on me." But then she learned to see that the harsh marks on her older sister's face (her wrinkles, the frown lines) were "the dents on my shield, the blows that did not reach me." Her sister had protected her simply by being there, facing the abuse, first—not with love "but as a / hostage protects the one who makes her / escape as I made my escape, with my sister's / body held in front of me."

Maybe that's true of Rivers: Her flamboyant self-hatred made possible this generation's flamboyant self-love, set the groundwork for the crazy profusion of female comics on TV these days, on cable and network, cheerleading one another, collaborating and producing and working in teams, as if women weren't enemies at all. (Everywhere but in late-night TV: Decades after Carson, there are still ten men on that list.) Rivers came first—and if her view darkened, if she became an evangelist for the ideas that had hurt her the most, she also refused to give in, to disappear. "I would not want to live if I could not perform," she once said. "It's in my will. I am not to be revived unless I can do an hour of stand-up." That's inspiration, too. We can celebrate it without looking away.

GIRLS GIRLS GIRLS

HANNAH BARBARIC

Girls and *Enlightened*

The New Yorker, February 11 & 18, 2013

When I got my job at *The New Yorker,* I was midway through reporting a cover profile of Lena Dunham for *New York* magazine. As a result, I didn't write an actual review of her HBO series, *Girls,* until the second season—at which point, I had to lobby for the opportunity. The show felt so oversaturated by media coverage, my editor suggested I skip it. It's shocking how much has changed since then, for Dunham and for the world around her. But I still love *Girls* and I stand by this piece, which explores how much the show and its harsh critical reception were intertwined. Rereading it, I can see a prickly defensiveness to the essay that reflects the moment as much as any of the ideas expressed.

My biggest regret is not having devoted an entirely separate column to *Enlightened,* which was also one of the best shows on HBO that year, but which didn't get *enough* press.

The HBO series *Girls* has been a trending topic all year, but in one sense it's nothing new. Created, written, and directed by twenty-six-year-old Lena Dunham, who plays the wannabe memoirist Hannah Horvath, *Girls* is merely the latest in a set of culture-rattling narratives about young women, each of which has inspired enough bile to overwhelm any liver. Among the most famous is Mary McCarthy's novel *The Group*, from 1963, with its scene of a humiliated girl sitting in Washington Square Park with her contraceptive "pessary." Women clung to that book like a life raft, but *The Group* was sniffed at by Norman Podhoretz as "a trivial lady writer's novel," while Norman Mailer called its author "a duncey broad" who was "in danger of ending up absurd, an old-maid collector of Manx cats." (Lady writers, beware of men named Norman.)

This dialectic recurs again and again. There was Rona Jaffe's dishy potboiler *The Best of Everything*, from 1958; Wendy Wasserstein's plays of the seventies and eighties (a sweeter vintage); and Mary Gaitskill's collection of kinky short stories, *Bad Behavior*, from 1988. (Not to mention the work of Sylvia Plath and every song by Fiona Apple and Liz Phair.) These are stories about smart, strange girls diving into experience, often through bad sex with their worst critics. They're almost always set in New York. While other female-centered hits, with more likable heroines, are ignored or patronized, these racy fables agitate audiences, in part because they violate the dictate that women, both fictional and real, not make anyone uncomfortable.

Like *Girls*, these are also stories about privilege, by and about white upper-middle-class women who went to fancy schools. Wasserstein's awesomely strange early play *Uncommon Women and Others* features the Hannah Horvath of Mount Holyoke: fat, sharp-eyed, horny Holly Kaplan, making late-night phone calls to a man she's barely met. *The Group* was about Vassar graduates in lousy marriages to leftist blowhards. *The Best of Everything* starred Caroline, a Radcliffe graduate, who falls for an older drunk who

might as well be *Girls'* sardonic barista, Ray (the great Alex Kar-povsky). Because such stories exposed the private lives of male in-tellectuals, they got critiqued as icky, sticky memoir—score-settling, not art. (In contrast, young men seeking revenge on their exes are generally called "comedians" or "novelists" or "Philip Roth.") There's clearly an appetite for this prurient ritual, in which privi-leged girls, in their rise to power, get humiliated, first in fiction, then in criticism—like a Roman Colosseum for gender anxieties.

Girls has been attacked, and lauded, and exploited as SEO link bait, and served up as the lead for style-trend pieces, to the point of exhaustion. The authors of these analyses have often fretted over privilege: The show is too white, Hannah's a spoiled brat, or a bad role model for millennials, or too fat to qualify to have sex on cable television. But when there's a tiny aperture for women's stories— and a presumption that men won't watch them—when almost no women are Hollywood directors, when few women write TV shows, of course it's the privileged ones who get traction. These artists have what Dunham has referred to as Hannah's Unsinkable Molly Brown force. (Molly Brown, after all, was a mouthy rich woman who survived the *Titanic*.) To me, the whiteness of *Girls* is realistic, within the circumscribed social worlds that it explores, although the show is both slyer and clearer about class than about race. But, as Ta-Nehisi Coates wrote recently in *The Atlantic,* "the problem isn't the Lena Dunham show about a narrow world. The problem is that there aren't more narrow worlds on screen. Broader is not synonymous with better."

The specificity of *Girls* also links it to earlier eras. In particular, it echoes a time when the legendary wildness of male New York intellectuals and artists was made possible by middle-class girl-friends who paid the rent and absorbed hipness from the kitchen. As Joyce Johnson, Jack Kerouac's onetime girlfriend, observed in her scathing memoir *Minor Characters,* an account of kohl-eyed Barnard coeds fleeing to Greenwich Village, "Even a very young

woman can achieve old-ladyhood, become the mainstay of some-one else's self-destructive genius."

In a different time, Hannah and her friends are the bohemians, fresh out of Oberlin. Hannah, her uptight friend Marnie, her dec-adent friend Jessa, Jessa's cousin Shoshanna, and an assortment of male friends and lovers live in shifting roommate arrangements, on the fringes of New York's creative industries. With admirable bluntness, *Girls* exposes the financial safety nets that most stories about New York—and many New Yorkers—prefer to leave invisi-ble. Last year, at Jessa's surprise wedding to a finance guy, a scene that might have been the climax of an ordinary meet-cute roman-tic comedy, Shoshanna blurted out, "Everyone's a stupid whore." The show began with Hannah stealing a maid's tip, and characters are forever ducking out on the rent or ogling someone's brown-stone. In an early episode, Hannah was humiliated when her hookup Adam masturbated in front of her; in a fury, she turned her complaints into a demented dominatrix routine, which ended with a demand for cab money, plus extra for pizza and gum. Then she took a hundred-dollar bill—likely the one that Adam's grand-mother sends him each month. It felt like a metaphor for her own confused professional ambitions: Earlier, she'd sabotaged an office job she didn't want anyway; now she'd turned her sex life into art and got paid.

This season, it's Marnie who walks straight into the spider's web. Fired from her art-gallery gig, she finds a "pretty girl" job where she caters to rich men. She meets a scornful art star she's got a crush on, and he locks her into one of his installations and bombards her with violent videos. She staggers out like Patty Hearst, gasping, "You're so fucking talented." But he's a pompous jackrabbit in bed—he makes her stare at a doll the entire time—and after their awful sex she bursts out laughing, with a surprising, loose, lovely spontaneity. Grim as their date is, the experience also seems cathartic, even liberating—it's a bad time that's a good story.

Maybe not now; maybe in twenty years. For now, she smiles in the bathroom, and texts Hannah, telling her where she is.

As Elaine Blair wrote last year in *The New York Review of Books*, in pretty much the only essay on the show worth reading, "For all of its emphasis on sexual and romantic experience, *Girls* never suggests that a smoothly pleasant sex life is something worthy of serious aspiration. The ultimate prize to be wrung from all of these baffling sexual predicaments is a deeper understanding of oneself." For some, this is bleak viewing. But for others, the harshest of these stories can be thrilling, because they make private pain public (and embarrassing stories funny), and also because they work as a sly how-to, on ways to thicken one's skin. In its first season, *Girls* captured how sex can be theater—not just faking orgasms but faking coolness, kinkiness, independence. There's power in gulling men, which is Jessa's stock-in-trade. (One of the best plots this season involves Jessa's husband's eyes being opened: "You're my worst nightmare," he announces, almost in awe, as their marriage collapses in a Williamsburg loft.)

Still, the most significant thing about *Girls* may be that it's not a book, a play, a song, or a poem. And not a movie, either; since women rarely control production, there are few movies of this type, and even fewer that have mass impact. *Girls* is television. It's in the tradition of sitcoms in which comics play humbled versions of themselves: Lucy, Roseanne, Raymond, Seinfeld. But it's also TV in a more modern mode: spiky, raw, and auteurist. During the past fifteen years, the medium has been transformed by bad boys like Walter White and sad sacks like Louis C.K. *Girls* is the crest of a second, female-centered wave of change, on both cable and network, of shows that are not for everyone, that make viewers uncomfortable. It helps that the show's creator has her own roguish, troublemaking quality, a Molly Brown air that lets Dunham wade into controversy without (at least, so far) drowning.

Like every "concern troll"—the Internet term for one who ices her sneer with dignified worry—I may be making *Girls* sound like

a dissertation. It's a comedy: a slight one, an odd one, an emotional one. The show isn't perfect—it's got cartoonish bits—but then most interesting art isn't. And, unlike previous versions of this story, which arrived complete, *Girls,* like Hannah, also isn't done: Because it's television, it's being built in front of us, absorbing and defying critiques along the way. It lingers and rankles and upsets. It shows the audience something new, then dares it to look away. Small wonder some viewers itch to give the show a sound spanking.

Girls airs on Sundays, the same night as another HBO series with an off-putting female protagonist, one that's received too little attention instead of too much. Now in its second season, *Enlightened* is an anxious, jubilant comedy created by Mike White, starring Laura Dern as Amy Jellicoe, a corporate employee sent to rehab in Hawaii after she has a nervous breakdown. When she returns to L.A., she's banished to the company's basement to work among the data-processing drones, one of whom is the nerdy Tyler, played by White himself. If Hannah mirrors Louis C.K., Amy is a sister to Larry David. She wants to be peaceful, brave, and decent, but her needy personality makes everyone she meets want to claw off his or her own face—and this season, when Amy becomes a corporate whistle-blower, her egotism and her idealism are indistinguishable.

This might be unbearable, if it weren't for *Enlightened*'s highly original and humane comic engine: It's a satire of feminine New Age do-gooderism that shares the values of all it satirizes. Like *Parks and Recreation,* *Enlightened* bridges the comedy divide between warmth and smarts; it makes me cry more than any comedy I've seen. If *Girls* teaches you to thicken your skin, *Enlightened* advocates emotional openness, even when it hurts.

The third episode of the season, which aired two weeks ago, focused on Amy's ex-husband, Levi, who goes to the same Hawai-

ian rehab center, at her urging. Instead of her narration, we hear his. Like many smart addicts, he takes in his surroundings with blighted insight: "They say to live in the moment. But what if the moment is endless? It's headaches and phlegm and farts and whiners whining about every fucking thing that ever happened to 'em." He bonds with the bad kids in the rehab, sliding first toward ecstatic freedom, then disillusionment, then emptiness. In the end, he's saved only by thoughts of Amy and her refusal to see him as a lost cause. "You saw something in me that didn't exist," he says. "Or maybe it did. Maybe you're my higher power."

In the next episode, we're back to Amy, who's flirting with an investigative journalist who describes Internet activism as a way for nobodies to become important. This idea hits Amy like a jolt of electricity, and what follows is a provocative, visually artful meditation, directed by White, on the temptations of the digital world. (Other directors this season include Nicole Holofcener and Todd Haynes.) Amy attends a glamorous party of the global digerati; a montage draws subtle links among hacked emails, a CEO watching YouTube footage, and laptop-tapping strangers at a café. In her intoxication, Amy has begun to imagine the Internet in spiritual terms: "I can hear its angels humming." Like her brand-new Twitter feed, *Enlightened* can seem unnerving and out of control. But you should follow.

BIG GULP

Vanderpump Rules

The New Yorker, May 23, 2016

One of the SUR ensemble tweeted a winky-face emoji to me after this piece came out.

Beyoncé's sumptuous adultery opera *Lemonade* came out the week I began watching the Bravo reality series *Vanderpump Rules,* and it turned out to be an oddly appropriate soundtrack for the show. "What's worse? Looking jealous or crazy?" Beyoncé croons in the video, swinging a baseball bat labeled "Hot Sauce." "I really don't want to cry off all this makeup I just put on," a waitress named Scheana says on *Vanderpump Rules,* struggling to compose herself for a photo shoot. "Something's telling me I may or may not have a fake friend," Ariana, another waitress, seethes, glaring over at Scheana.

I'd downloaded *Vanderpump Rules* onto my phone so I could watch the show's four seasons more efficiently: on the F train, in line at the supermarket, and while drifting off to sleep, an approach that felt less like binge-watching than like inserting an IV of sangria. A humble spin-off of the sprawling *Real Housewives* multiverse, *Vanderpump Rules* revolves around the employees of SUR (an acronym for Sexy Unique Restaurant), a West Hollywood

venue owned by Lisa Vanderpump, a longtime cast member of *The Real Housewives of Beverly Hills,* which ended its sixth season last week. I'd fallen so far behind on that show, I'd never catch up. Rather than approach the intimidating portal of the original franchise, with its decadelong cross-series feuds, jail sentences, lifestyle brands, divorces, and handbag lines, I would sneak in through the servants' entrance.

When the *Real Housewives* franchise debuted in 2006, set in Orange County, I was a deep devotee of the reality genre. I was a *Big Brother* Web-watcher and a *Real World* completist, and caught up on shows from *The Amazing Race* to *Wife Swap.* Yet *The Real Housewives* left me cold. It rankled me in a way that earlier shows—even schlock series like *Joe Millionaire*—had not. The few episodes I saw felt like misogynist vaudeville, with cast members monetizing the world's ugliest ideas about women, in a type of auto-drag, humiliating rather than quasi-celebratory. Over the years, I'd developed a private theory about the franchise's appeal: When the New York version became an enormous hit, around 2008, it seemed to me to be a cultural conspiracy to distract the world from the almost universally male villains of the financial crash. Rather than satirize rich white men in suits, the show put the bull's-eyes on their trophy wives, painting them as vain parasites, symbols of greed— consumerist gargoyles who might absorb the fury that was more logically directed at Wall Street itself.

That seemed plausible, and maybe it was a little bit true. But, then again, I'd never really watched the *Housewives.* For one thing, the women weren't married to any hedge-fund quants. It's always easier to condescend to a reality show before you start watching it—and watching it, and watching it. This is true of almost all reality soaps: The pleasure is less in the show than in the bubbly, cathartic, alternately cruel and tender talk that surrounds it, with its Wikipedian rabbit holes and weirdly therapeutic reunions and aftershows, the fizzy in-jokes of a largely queer and female audience. Watching *Vanderpump* felt less like watching TV than like

becoming a sports fan. One minute, the show was a grim slog, a repetitive ritual that threatened to drag on forever, like baseball. The next minute, it was aggressively fun—the kind of thing that makes your heart leap whenever a fight breaks out, like hockey! To enjoy it, you just have to ignore the potential brain damage for the players once the game ends, like football.

The premise of *Vanderpump Rules* is simple enough: A group of hot people work at a restaurant that is run by a wealthy woman with a taste for neon pink and small dogs. Early on, the employees are mostly dull couples, but invariably they cheat, break up, and re-form into new friendships and romantic pairings, absorbing once-excluded newcomers and icing out former BFFs. Lisa Vanderpump comes off as the Aaron Burr of *The Real Housewives*, elegant and inscrutable; as Lin-Manuel Miranda might put it, she sexts less, smiles more. The members of her waitstaff, in contrast, are weepy and easily enraged, and despite the show's contrivances, the milieu is not unrealistic. Maybe they wouldn't crash quite so many engagement parties, but the characters—part-time models with vague plans to be ultra-famous—aren't that different from other L.A. waiters. It's a reality show about the types of people who are most likely to agree to appear on a reality show.

One of my favorite current series is Rachel Bloom's musical comedy, *Crazy Ex-Girlfriend*, on The CW, which does a wonderfully empathetic job exploring what it feels like to be a female magnet for chaos—self-destructive and longing for love. And yet I've never entirely understood one of the main relationships on the show, the toxic romance between the surfer-bro Josh and his fiancée, the hot yoga instructor Valencia, who nags and bullies him nonstop. *Vanderpump Rules* helped me get it, because that show is pretty much a Neapolitan dessert made up entirely of Joshes and Valencias. The same conflict recurs over and over, the sympathies shifting, in a drama you might call "the betrayed princess": A sexy, bossy girl

dates a man who barely has a job. Then things blow up when—take your pick—he cheats in Las Vegas, reveals a pill addiction, or steals sunglasses in Hawaii. These betrayals are both real and imaginary: It's hard for a viewer to be disturbed when it's unclear which emotions are genuine and which have been scripted, an ambiguity that protects you from destabilizing empathy.

And yet there's something legitimately poignant about the show's *Lemonade*-flavored blend of grandiosity and fragility. There may not be any potential Beyoncés at SUR, but there are many girls who think of themselves, not unreasonably, as vulnerable public brands. When you believe you're the show's romantic lead, it's extra-hideous to realize that you're the dupe in a low-rent sex comedy, breaking into some guy's iPhone to find shady Uber receipts. Or, as Beyoncé sings on "Hold Up," "I'm not too perfect to ever feel this worthless."

At times, the SUR universe can seem as creepily misogynist (and as thrillingly stylized) as the ballet world in *Black Swan*—put on those painful shoes and, lady, someone's going to bleed. Slutty girls call other girls "skanks." Skanky girls call other girls "pathetic." All of them pretend to be chill babes who don't mind their boyfriends taking a guys-only trip to Vegas—but, eventually, most of them end up nagging for a ring. As it went on, *Vanderpump Rules* began to remind me of an old saying: that, after straight couples break up, all ex-girlfriends are "crazy," while all ex-boyfriends are either "confused" or "assholes." Meanwhile, the men engage in a conspiracy of "bro-code," which is broken so often that it's more of a bro guideline. Perversely, the worst thing you can accuse someone of is being "judgmental."

The cast members themselves are somehow both memorable and interchangeable. There's Stassi, who is basically a grown-up version of the nasty little girl in the *Free to Be . . . You and Me* fable "Ladies First," the one who gets eaten by tigers. Stassi's ex-boyfriend, Jax, is pretty much a sociopath: He's an admitted thief

who cheats and lies. ("He's had three noses in one year," Lisa Van-
derpump observes. "He doesn't understand the word 'commit-
ment.'") There's a selection of sulky brunettes, including Katie,
"the Shakespeare of rage-texting." Black waitresses tend to get
sidelined, treated as sexless confidantes or silent extras. (There's a
lot of weird racial stuff in the mix, as the nearly all-white cast gos-
sips about who qualifies as a "ghetto bitch" or a "ratchet whore-
bag.") There's also a nudist trickster named Lala, and Ariana, a
hipster comic who startled me when she complained—during yet
another fight over whether a boyfriend should go to Vegas—that
she hated "heteronormative fucking bullshit." The nice men are
hard to tell apart, since half of them seem to be named Tom.

It's easy to make fun of these characters—the show is designed
to encourage it—but, to judge from the aftershow, they're often in
on the joke. And it's not as if anyone who has been through a bad
breakup hasn't been there, pathetic/judgmental/skank-wise. But
there are hints of darker themes, especially when it comes to sex.
A couple gets engaged, then never, ever gets laid. After a breakup,
each partner denounces the other for carnal acts committed on a
cursed IKEA-ish sofa—or, alarmingly often, while they're so drunk
that they have a debate about whether anything even happened.
Ugly details like this surface, then get abandoned, or treated as a
joke, because the show is contractually obligated to party on. The
true climax of Season 4 was a tiny moment when a minor charac-
ter, a waitress who'd just hooked up with a busboy/DJ, yelled for
her jealous ex to remove his microphone. It was the rare indication
that anyone knew they were on TV, a titillating exposure that felt
sexier than pixelated D-cups could ever be.

Many years ago, I wrote a profile of a new bar in Los Angeles
that was run by Mike "Boogie" Malin, one of the villains of an
early season of *Big Brother*. Back then, he was still licking his
wounds, confused by his ruinous experience on the show; a few
years later, he won one of the All-Star competitions and was back

on top. But he was just one of many former reality stars floating around Hollywood, disrupting the ecosystem of fame. They were thirsty, to use the modern term; they wanted it too much.

The truth is, the most nuanced perspective on reality may be found not in the shows themselves but in parodies of them, like the champagne-bubbly satire *The Hotwives of Orlando* on Hulu, and the behind-the-scenes drama *Unreal* on Lifetime, which returns for its second season in June. These shows capture the genre from the inside, exploring the vulnerability of those who keep trying to beat a system that, like a casino, rarely lets any player win for long. I still sometimes have the urge to critique the reality machine; it's certainly asking for it. But it's also true that reality is where the action is. It's an easily mocked mass artistic medium that's corrupted by half-hidden deals, but it also provides a magnetizing mirror for the culture, dirty and mesmerizing. It's television's television.

SHARK WEEK

House of Cards and Scandal

The New Yorker, February 25, 2013

This is the second piece I wrote about *Scandal*. The first column was about the first seven episodes; it argued that a not-great network drama with an African American heroine was still a meaningful breakthrough, maybe a bigger one than a great show. But by the second season, the series transformed, or maybe I changed—maybe it was both of us—and I turned into a full-on *Scandal* superfan, live-tweeting on TGIT (Thank God It's Thursday), and arguing about Fitz versus Jake. I ended up writing about the show more than once.

Ironically, life began imitating Shonda Rhimes around the time Trump ran for president. Eventually, *Scandal* had to rework a plot in which the Russians hacked the election. Too on the nose.

House of Cards is an original release from Netflix, a DVD-distribution and streaming company that has decided, after several years of selling tickets to the circus, to jump into the ring. Adapted from a British political thriller and produced by David Fincher, the series stars Kevin Spacey as a mercenary Democratic House Majority Whip and Robin Wright as his wife. This presti-

résumé has turned *House of Cards* into big news—not least ause Netflix has cleverly released all thirteen episodes at once. a model of TV production, it's an exciting experiment, with the potential to liberate showrunners from the agony of weekly ratings. It suggests fresh possibilities for the medium, feeding an audience that has already been trained to binge on quality TV in DVD form.

As a television show, however, *House of Cards* is not so revolutionary. This isn't to say it's bad, or not worth watching, or unmemorable. (Certain lines, such as "Twitter twat, WTF?," might become catchphrases—for all its elegant contours, the show is marbled with camp.) Over a recent weekend, *House of Cards* acted something like a scotch bender, with definite highs and lows. I found the first two episodes handsome but sleazy, like a CEO in a hotel bar. Yet by Episode 5, I was hypnotized by the show's ensemble of two-faced sociopaths. Episode 8 was a thoughtful side trip into sympathy for Spacey's devilish main character, but by then I was exhausted, and only my compulsive streak kept me going until the finale—at which point I was critically destabilized and looking forward to Season 2.

Sensually, visually, *House of Cards* is a pleasure. Its acrid view of political ambition is nothing new (that perspective is all over TV these days, on shows like HBO's *Veep* and Starz's *Boss*), but the series has some sharp twists, with an emphasis on corporate graft and media grandstanding. There's also one truly poignant plot about a working-class congressman hooked on drugs. Yet, in the days after I watched the show, its bewitching spell grew fainter— and if *House of Cards* had been delivered weekly, I might have given up earlier. Much of the problem is Spacey himself, as Francis "Frank" Underwood, a wheeler-dealer who is denied the job of secretary of state and then conspires, with his steely wife, to go even higher. Spacey's basilisk gaze seems ideal for the role, but he's miscast by being *too* well cast—there's no tension in seeing a shark play a shark. It's a lot easier to buy his opposite number, the

investigative blogger Zoe Barnes (the awesomely hoydenish Kate Mara), who strikes up an affair with Underwood in return for access. Her hair slicked down like a seal, her eyes dead, and her T-shirt sexily V-necked, Barnes is like some millennial demon from the digital unconscious, catnip for condescending older men. You could criticize the show's portrayal of female reporters as venal sluts in black eyeliner, but it's hard to object too much, since Mara's performance, which has a freaky, repressive verve, is the liveliest thing in the show. Robin Wright is regal as Claire, Underwood's charity-running wife, and Sakina Jaffrey makes a quiet impact as the president's chief of staff, a restrained professional who, in this lurid context, feels downright exotic.

Fincher's Washington is full of eerie imagery, such as a homeless man folding a twenty-dollar bill into an origami swan, and it's magnificently lit (although I don't understand why a sought-after journalist like Zoe lives in a flophouse full of spiders). But eventually the show's theatrical panache, along with Spacey's Shakespearean asides to the camera, starts to feel as gimmicky as a fashion-magazine shoot, with melancholic shots of Claire jogging in a graveyard. The show may be made of elegant material, but it's not built to last—it's a meditation on amorality that tells us mostly what we already know.

And, honestly, the more I watched, the more my mind kept wandering over to Shonda Rhimes's *Scandal*, on ABC—a series that's soapy rather than noirish but much more fun, and that, in its lunatic way, may have more to say about Washington ambition. *Scandal*, which is inspired by a real-life political "fixer," started slowly as a legal procedural blended with a Rielle Hunter–flavored presidential affair. It took a season to shed its early conception of Kerry Washington's PR bigwig Olivia Pope as a "white hat." But once it did—whoa, Nelly. Popping with colorful villains, vote-rigging conspiracies, waterboarding, assassinations, montages set to R & B songs, and the best gay couple on television (the president's chief of staff, Cyrus, and his husband, James, an investiga-

tive reporter), the series has become a giddy, paranoid fever dream, like 24 crossed with *The West Wing*, lit up in neon pink. Last week's episode was such a #GameChanger—that's the hashtag the show's creator used to advertise the episode—that Twitter exploded with exclamation points.

Because *Scandal* is so playful, and is unafraid to be ridiculous, it has access to emotional colors that rarely show up in Fincher's universe, the aesthetics of which insist we take it seriously. Like Underwood, Jeff Perry's Cyrus is a Machiavelli who cozies up to the president, but he's got rage, wit, and a capacity for passion, not just oleaginous asides. During last week's episode, he and his husband faced off, naked, in a fight about Cyrus's crimes. (They'd stripped to demonstrate that they weren't wearing wires.) The scene was absurd, but also genuinely intimate, with all the daring that *House of Cards* lacks.

Rhimes's show is made under the opposite circumstances from Fincher's: nearly twice as many episodes, ratings pressure, constant threat of cancellation, a ravenous tweeting audience. These forces wreck other network dramas, and Rhimes's previous shows have at times flown off the rails, but *Scandal* has only gotten stronger. It's become more opera than soap opera, as the critic Ryan McGee observed online. Like much genre fiction, *Scandal* uses its freedom to indulge in crazy what-ifs: What if everyone but the president knew that the election was fixed? What if the president tried to divorce his pregnant wife? What if—well, I don't want to spoil everything, but you might consider jumping in at the beginning of Season 2. It's a different kind of binge-watch.

THE LITTLE TRAMP

Inside Amy Schumer

The New Yorker, May 11, 2015

I had been waiting for a column in which I could find an excuse to talk about my beloved copy of the 1970s feminist humor anthology *Titters*.

"I really need to stop making so many white girls," God, played by Paul Giamatti, groans on Comedy Central's *Inside Amy Schumer*. In this sketch, the blond ditz "Amy Schumer"—a self-lacerating version of the comedian who plays her—finds out that she's got herpes from a hookup. Her irritated Creator notes that this is the first time she's prayed to him in years. Schumer explains that she's a role model now, so young girls shouldn't see her buying Valtrex. God says that he'll have to destroy a village in Uzbekistan to cure her; she's cool with that. However, she refuses his demand that she stop drinking. "Can I just blow you?" she whines. "I'm gay," he replies, disgusted.

Raunchy, rough, a destabilizing mixture of daffy and caustic, Schumer's series debuted under the radar in 2013. A blend of stand-up routines, mostly about sex; person-on-the-street interviews, also about sex; and satirical sketches about sex, the series

had an unusually high hit rate for a new comedy show. But this spring is clearly Schumer's breakout moment. She's on the cover of *Entertainment Weekly* in a parody of the poster for *American Beauty*, blond curls splayed, lying on a bed of minibar liquor bottles rather than rose petals. In July, her romantic comedy *Trainwreck*, directed by Judd Apatow (who has unexpectedly blossomed into female comedy's fairy godfather), will debut. The show's new season, its third, has a higher profile, too: It's more star-studded and also more overtly political. The show has always had feminist streaks; now it's letting those roots grow out. The first episode, which aired two weeks ago, yielded two viral hits: one a perfect *Friday Night Lights* parody, in which Josh Charles plays a football coach who outrages his town with a "no raping" rule, the other a sketch about Hollywood double standards called "Last Fuckable Day," starring Tina Fey, Julia Louis-Dreyfus, and Patricia Arquette.

The two skits were timely and also very funny. ("Football Town Nights," in particular, was a sharp interrogation of football culture, featuring earnest jocks so confused about the coach's new rule that they pepper him with questions like "But what if my mom's a DA and won't prosecute?") That said, there's a risk to Schumer's rise: When you're put on a pedestal, the whole world gets to upskirt you. Now comes the hype, the lash, and the backlash, and the backlash to the backlash, the hero worship, and the red-hot fury—no pressure, Amy Schumer! It's happened again and again to the new wave of female TV creators, the Tinas and Mindys and Lenas, whose fans want role models as well as artists— a demand that many female comics embrace but that's more rarely required of men. And yet it's hard to deny the effectiveness of the speech Schumer gave at a Ms. Foundation event last year, in which she described, in raw detail, a cruddy college sexual encounter. It woke her up to how far she'd sunk—and the way that the world's focus on "fuckability" can throw her right back into self-hatred. "I say if I'm beautiful. I say if I'm strong," she told the audience, de-

livering a sort of mission statement for her show, in which she dredges the wreckage of that younger self.

There's nothing new about comedy with a feminist bent: One of my most prized possessions is a humor collection called *Titters*, whose cover features a busty woman in a tight T-shirt. Published in 1976, and edited by the few female writers of *Saturday Night Live*, it was the "first collection of humor by women," with contributors ranging from Phyllis Diller to a pre-Huffington Arianna Stassinopoulos. Like many classic humor anthologies, it's largely dated and dumb, aside from some bits that are hilariously mean. (If you think feminist infighting is new, check out the parody of Nora Ephron's "small breasts" essay, which turns that body part into "sharp elbows.") But it's a useful relic of a time when feminists were libeled as humorless, a smear that persists. The truth is, the polemicists of the seventies, from Bella Abzug to Flo Kennedy to Valerie Solanas, with her *SCUM Manifesto*, were often outrageously funny, using gonzo cracks to express anger. Anti-feminists have always disguised their insults as jokes. ("Can't you take a joke?") But a joke can be the slickest response; it's an expression of savoir faire in the face of hatred.

Comedy with a message can also easily turn didactic—or, worse, it can turn smug. Luckily, Schumer's show feels built to withstand this pressure, even as it expands its reach, touching on subjects like reproductive rights and equal pay. (Credit is due to the show's writers, including Jessi Klein, Tig Notaro, and Schumer's sister, Kim Caramele.) This is mainly because of the grotty, chaotic persona that Schumer has developed, allowing her to poke just as hard at young single women, in their blinkered vanity, as she does at the toxic messages that surround them. In Schumer's stand-up, she's one of them: "sluttier than the average bear," a binge drinker who knows that blacking out isn't cute anymore. Her target is the ugli-

ness of urban heterosexual hookups: Plan B, money shots, and other hassles of the age. In this iteration, she's smart but self-destructive, the sadder-but-wiser girl, who knows how easily desperation can masquerade as freedom.

In contrast to that knowing girl, the one whom Schumer satirizes in her sketches is brutally clueless. She's the subject of every op-ed on "girls today"—a needy narcissist, all bravado and entitlement. This Amy is the "dumb slut" and the "whiny white girl." She's the bad bridesmaid, the chick who gives out blow jobs like handshakes, who is so obsessed with taking the perfect selfie that she hires a team of stylists. She's the Whoo! Girl, out at Coyote Ugly with her posse, fake-twerking, then weeping at 3 A.M. In some of these sketches, that alternate Amy is a self-obsessed monster, but in others, she's vulnerable. In one great early routine, she gets a booty-call text and keeps writing and deleting replies, from "I am so lonely all the ti—" and "I would love another shot at giving you a blo—" to "Tell me what all my remotes do." (When the guy sends a dick pic, she replies, "I love pugs!!! Is it a rescue?") When she's a secret agent, her code name is Butterface. When she agrees to appear in a children's animated film, her character turns out to be a meerkat with exposed labia, who defecates onscreen. Her only line in the script is a growled catchphrase: "Wooorms."

This sort of self-mockery could turn into masochism, but so far, that hasn't happened, in part because the sharpness of the jokes is itself a form of self-assertion. In the first season, Amy recommends "porn from a woman's POV," then shows footage with angles staring up a guy's nostril; in another sketch, she announces that, as a feminist, she's hosting a gang bang (sponsored by Sea Spray), "to prove that women aren't objects." A murderously funny ad for plastic surgery asks, "Don't you owe it to yourself to look like you fell into a tank of chemicals while fighting Batman?" Such sketches satirize a degrading culture, but they also take aim at women's gameness to prove that they are, to quote one recent sketch, "cool with it." Some of the best scenes involve a circle of

female friends competing to put themselves down, such as one in which the women are so competitively self-deprecating that when one accepts a compliment all the others commit suicide.

This subject matter isn't Schumer's alone, of course. It would be easy to put her in a category with female comedians who talk dirty: the lacerating Sarah Silverman; that defiantly dead-souled essentialist Whitney Cummings; Lena Dunham, our era's greatest op-ed magnet; the satirical narcissist Mindy Kaling; the funky Laverne & Shirley of *Broad City*, Abbi Jacobson and Ilana Glazer; the flamboyant boozehound Chelsea Handler. They follow in a tradition that extends back to Mae West and Moms Mabley, and outward to comic artists like Aline Kominsky-Crumb and Julie Doucet, creators inspired by female abjection. Such comparisons can be a trap: They suggest that female artists exist only in the context of one another and must be compared, so that some may be deemed insufficiently radical. But there's something to be said for an "All boats rise" moment. The haters (an actual set of people—I've met them) dismiss Schumer's act as "guy humor," talking dirty to please men. But graphic sex talk is what gets Schumer to uncomfortable places, including rare candor about the underside of a porn-soaked world. There are moments when Schumer's comedy verges on Dworkinesque, nailing some girls' willingness to eat shit, just to be liked.

Even better, just as she hits the mainstream, Schumer is increasing the number of her targets. The most ambitious material in this season's first three episodes is a half-hour, black-and-white parody of the movie *12 Angry Men*. It begins as a reboot of an earlier sketch on the show, in which an all-male focus group debates whether Amy is hot enough for TV, but this one is much more ambitious. A remarkable cast, which includes Jeff Goldblum, Vincent Kartheiser, Kumail Nanjiani, and a fuming Giamatti, begins by rating Amy's looks, but as the conversation expands the men start to fight about the roots of sexual attraction, the rise of female comedy, and just whose tastes count as normal. This somehow leads to

dueling dildos, which replace the knives from the movie. By the end, the sketch feels like it's an investigation of the fury of men online, the ones who fill every comment thread about Schumer— or any other female comic—with scathing judgments. It's a comedic method as old as grade school: She's rubber, they're glue.

HELLO, GORGEOUS

The Marvelous Mrs. Maisel

The New Yorker, December 24, 2018

A pan as harsh as the one for *True Detective,* but for whatever reason, I got mostly love notes in response. Many were from people who agreed with me about *Maisel,* but others were from fans of the show who still thought I made some reasonable points. This matches up with my general experience: Pan an antihero drama, you'll get threats; pan a relationship series, you'll make friends for life.

It took two minutes of Season 2 before someone said the words: "Gosh, you're amazing." The speaker was one of Miriam (Midge) Maisel's colleagues at the B. Altman switchboard, but, really, it might have been anyone: a genius painter at the Cedar Inn, who says, "It's like Vermeer painted you! Or you swallowed a light bulb"; a Johnny Mathis–esque crooner at a telethon; Lenny Bruce; Jane Jacobs; Midge's estranged husband, Joel, who is still stuck on her; her boyfriend, a choosy doctor who prefers Midge to the vapid gold diggers in the Catskills; her devoted agent, Susie; or even some Parisian drag queens, who dub her Miss America. Is there anyone who *doesn't* love Midge?

Me, as it happens. Last year, *The Marvelous Mrs. Maisel* was a boffo hit for Amazon and for its top-hatted creator, Amy Sherman-Palladino. The series swept the Emmys. It sent shivers of delight up the spines of vintage shoppers everywhere. Lusciously art-directed, from Midge's classic six to her kitten heels, the production landed at an ideal moment, tapping into a desperation—particularly among women—for something sweet and inspiring. No more *Handmaid's Tale*, no more pussy-grabbing. *Mrs. Maisel* offered a bright-pink escape hatch from 2017.

I craved such an escape myself—but I was also mystified by the show's reception, because the first season struck me as both treacly and exhausting. This was true despite its having a premise so far up my alley it was practically chopping onions in my kitchen: A Jewish girl does stand-up comedy in the late 1950s in New York, when Joan Rivers first rose to fame. And, in fact, the show's heroine, played by Rachel Brosnahan, is—exactly like Rivers was—a college-educated rich girl in her twenties, who is forced to move back home after her marriage blows up. When Midge enters show biz, her shtick—just like Rivers's was—is to dress for a date, in a black dress and pearls, then free-associate truths about women's lives. As with Rivers, the radical "sick" comic Lenny Bruce is Midge's inspiration—and, in the show, Bruce (Luke Kirby) becomes her mentor. (In real life, after Rivers once bombed, Bruce left her a note: "You're right, they're wrong." She kept it in her bra, for luck.)

But *The Marvelous Mrs. Maisel* makes two major adjustments. First, it gives Midge kids, a baby and a toddler. It also makes her a winner. Whereas Rivers was an alienated oddball, a loner fueled by rejection, gagging onstage at her own "ugliness," Midge is popular and pretty. She's skilled (and brags of her skill) at everything from sex to brisket. When Joel, a wannabe comic, cheats with his secretary, Midge gets drunk and jumps onstage, and, right away, she kills. She keeps on killing—at cocktail parties and dive bars, even at a Washington Square rally, where she awes Jane Jacobs

with a speech about how women "accessorize" the world, as a multiethnic crowd cheers. "Oh, that's good, write that down," Jacobs tells her assistant.

Midge builds her "tight ten" routine faster than any comic ever, according to Susie (Alex Borstein), who gets teary at her client's raw talent. (The butch Susie is so focused on Midge's prospects that she never gets a crush on her, or on anyone. Neither does Lenny Bruce. For a show about a woman who works blue, it's oddly prudish.) By the finale of the first season, Midge has a dangerous enemy—Sophie Lennon (Jane Lynch), an older star who tells fat jokes, in a fat suit—but, as ever, Midge keeps killing, swatting down sexists. As the crowd roars, her louse of an ex wanders the street, moaning at her talent: "She's *good*. She's *good*." The show is downright Sorkinian in its emphasis on Midge's superiority—and more than a bit Streisandian, too, except that Midge starts *and* ends as a swan.

Many people found this fantasy invigorating. For me, it felt grating, and not just in terms of verisimilitude—the verbal anachronisms ("totally"), the sitcom clams ("Good talk!"), the cloying Disneyfication of Midge's Jewish family—but in its central psychology. In *The Marvelous Mrs. Maisel*, sexism exists. But it never gets *inside* Midge. Her marvelousness comes from the fact that she's immune, a self-adoring alpha whose routines feel like feminist TED talks, with some "fucks" thrown in. Brosnahan delivers them with moxie, but they're rarely funny. They're also the opposite of Rivers's act, which relied on the tension between looking pretty and *calling* herself a dog—provoking taboo laughs from the revelation that even this nice girl felt like a loser, desperate, unfuckable.

In *Mrs. Maisel*, Rivers's more unsettling qualities—her vengefulness, her perception of women as competitors, her eating disorder—all get displaced onto Midge's foe, fat-joke Sophie, who lives in an opulent French-themed apartment, like the one Rivers lived in, collects furs, and, like the real Joan, wanted to be a serious

actress. It's as if Rivers has been split into good Joan and bad Joan, because it's too hard to make such a caustic trailblazer seem cute, to acknowledge how much her success derived from being shaped by misogyny, not from transcending it.

Believe me, when a TV hit unites women, it's no fun to be Morales in *A Chorus Line*, feeling nothing. As with Sherman-Palladino's earlier shows, the sometimes charming, often irritating *Gilmore Girls* and the more effectively bittersweet *Bunheads*, this is a show that is fantastical by design. Why nitpick? Why growl at Midge's icebox parenting, which the show sees as adorable? Why kvetch about Midge's greedy father-in-law, a portrait so coarse that it verges on anti-Semitism? Why mutter that, if the series hadn't magically pushed Rivers's nightclub origins back into the fifties, it might have had to show her 1961 peers at the Gaslight Café, including Woody Allen and Bill Cosby, figures who are far tougher to sanitize?

So I tried to open my heart to Season 2. People grow, people change—even critics, even shows. But the season begins with a tooth-rottingly twee trip to Paris, followed by a cloying trip to the Catskills, a setting far better served by *Dirty Dancing*. It veers from one inconsistent family plot to another, with a baffling focus on Joel, who screws around but finds no one who lives up to his ex. (Despite its feminist theme, *Mrs. Maisel* has more one-line bimbos than *Entourage*.) There's loads of ethnic shtick, from chain-smoking Frenchies to an Italian family singing "Funiculì, Funiculà." Things perk up whenever the focus shifts to the salty, bruised Susie, a scrapper from the Rockaways—but even her plots are marred by dese-and-dose mobsters.

The show's writers do, to be fair, give their heroine more pushback this season. When she slams male comics (rightly, because they're pigs), she loses gigs. When she gives a filthy toast at a Catholic wedding, the bride won't forgive her. (I cheered for the bride.)

When her dad catches her using him as material, he gives her the silent treatment. Her act rarely matches her charmed life—why would Midge, so wooed and worshipped, rave about how women are experts on rejection?—but Brosnahan jolts each bit with charisma. Yet, by the finale, nothing adds up. When the season lands on a note of darkness, tied to Lenny Bruce's routine "All Alone," it feels unearned. Why should Midge choose art over love? Her patient, supportive boyfriend *and* her ex think she's a comic genius. Her childcare is free (and often invisible). No force keeps her from having both, other than her own unacknowledged solipsism.

There are better escape hatches. There's also high-feminine mythmaking (as well as fashion inspo and more authentic Jewishness) available on less pretentious TV shows, among them *Broad City, Crazy Ex-Girlfriend, Claws, Younger, GLOW, Call the Midwife*, and *Jane the Virgin*. But what I'd really recommend is digging up an old copy of *This Is My Life*, the first movie Nora Ephron directed, based on a novel by Meg Wolitzer. Julie Kavner stars as Dottie Ingels, a divorced Jewish comedian from New York, whose quest for fame leads her to ditch her kids. The movie manages to celebrate that choice without stacking the deck. It's realistic about a sexist industry. It treats Dottie's children as real people, who are as interesting as she is. It even manages to be funny. There's more than one way to have it all.

CANDY GIRL

Unbreakable Kimmy Schmidt

The New Yorker, March 30, 2015

The first season of Tina Fey's follow-up to *30 Rock* looked trivial but concealed odd depths.

In the credit sequence for *Unbreakable Kimmy Schmidt*, a trailer-park resident gets interviewed on local TV, only to have his words auto-tuned into a catchy jingle, a variation on a viral meme. Flooded with emotion, the man is struggling to describe a bizarre police rescue, in which four women have emerged from a bunker where they'd been held captive, for years, by the "weird old white dude" next door. "Unbreakable!" the man shouts, waving his arms. "They *alive*, dammit. But *females. Are strong as hell*."

At once crude and affecting (and impossible to get out of your head), the clip operates as shorthand for the show itself, the first post–*30 Rock* series to be produced by Tina Fey and Robert Carlock. Like its opening credits, *Kimmy Schmidt* is a peculiar, propulsive mash-up of tabloid obsessions, a sitcom about one of the "Indiana mole women," Kimmy Schmidt, who was kidnapped by the Reverend Richard Wayne Gary Wayne in eighth grade. She then endured— the show strongly implies—pretty much what you'd imagine. When Kimmy escapes, however, she doesn't look wrecked: Instead, her

expression is pure sunshine, a toothy grin of astonishment and delight. In her intractable optimism, she shares something with another Indiana native, Leslie Knope, from *Parks and Recreation*, except that this is a Leslie Knope who has been to hell.

In the first episode, Kimmy and her fellow captives appear on the *Today* show, where they're offered an "ambush makeover" and gift bags, then sent off with a cry of "Thank you, victims!" As the van heads out, Kimmy makes a run for it. Rather than go back to her hometown, she decides, she'll reinvent herself in Manhattan: She'll get a job, an apartment, and a life in which no one sees her as damaged goods. She finds a batty landlady, played by Carol Kane, and an outrageous roommate, Titus Andromedon (played by Tituss Burgess, who was D'Fwan on *30 Rock*'s *Real Housewives* parody, *Queen of Jordan*); she also finds a boss, Jacqueline Voorhees (Jane Krakowski), an Upper East Side trophy wife, whom Kimmy initially mistakes for another captive—because, after a face peel, Jacqueline isn't allowed to step outside her gated town house. "Is that your reverend?" Kimmy asks, seeing a portrait of Jacqueline's husband. "Did he peel your face? Do you need help?" She does need help, actually: Kimmy becomes her assistant.

Fey and Carlock sold the show to NBC under the title *Tooken*, but the network eventually passed—at which point Netflix stepped in, committing to two seasons. In the context of cable comedy, *Kimmy Schmidt* is a very odd bird. Plenty of ambitious series do dark material, but they match their insides to their outsides: They're dramedies, like *Getting On*, or indie-inflected auteurist shows, like *Louie* and *Girls;* sometimes they're caustic satires, in the tradition of the original British version of *The Office*. *Kimmy Schmidt*, on the other hand, is network bright. It's all neon pink and Peeps yellow, energized by the Muppet-like intensity of Ellie Kemper's performance as Kimmy, and packed, like *30 Rock*, with surreal zingers. At times, it resembles a Nickelodeon tween show— which is just how its heroine might imagine her own life. Yet, without any contradiction, it's also a sitcom about a rape survivor.

The show doesn't address sexual violence head-on; it's possible to watch without dwelling on the details. But Kimmy's ugly history comes through, in inference and in sly, unsettling jokes about trauma, jagged bits that puncture what is a colorful fish-out-of-water comedy. The backstory that emerges combines elements from a number of familiar tabloid stories: those of Katie Beers (abducted from her abusive family, kept in an underground bunker), Elizabeth Smart (snatched from her bedroom by a self-styled messiah), Jaycee Dugard (abducted from her front yard), and the three women who were rescued two years ago in Cleveland, after having been beaten and raped for years by Ariel Castro. At times, the story feels inspired by Michelle Knight, one of Castro's victims, who wrote a memoir called *Finding Me*. Like Kimmy, Knight had no family to go back to; her upbringing was a horror. But, to judge from newspaper profiles, she has not merely survived the abuse—she's resilient and downright giggly, a fan of karaoke and dancing, angels and affirmations. It's a powerfully girlish model of human toughness.

Kimmy's vision of the good life has exactly that vibe: She wants to enjoy what she's missed out on. Roaming around New York, she binges on candy, like a crazed toddler. She buys sparkly sneakers. Peppy and curious to the point of naivete, she acts as if she'd learned about life from sitcoms—she gets into a love triangle, she goes back to school, she's eager for every party. But there's also something tense and over-chipper about Kimmy's zest, an artificial quality that even the cartoonish characters around her can sense is "off." Yes, there was "weird sex stuff" in the bunker, she blurts out to her roommate. She has an unexplained Velcro phobia. At night, she wakes up from a fugue state and finds herself rinsing off a knife in the shower or attacking her roommate. ("This isn't the Chinatown bus!" Titus tells her. "You can't just choke people who are sleeping.") When Kimmy decides to take things to "the next level" with her new boyfriend, she mashes his face with the heel of

her palm and tries to overpower him. She marvels, "All the stuff I thought I knew was way wrong."

This is rare material for a sitcom. But it's not unusual for modern television, which has been experiencing an uptick in stories about sexual violence—a subject once reserved for Lifetime and *Law & Order*. Here's a partial list of dramas in which at least one central character has been raped: *Game of Thrones*, *House of Cards*, *Mad Men*, *American Horror Story*, *Outlander*, *The Americans*, *The Fall*, *The Fosters*, *Scandal*, *Top of the Lake*, *How to Get Away with Murder*, and *Switched at Birth*. You could call this a copycat phenomenon, but I'd argue that better roles for actresses made it happen: When women's lives are taken seriously, sexual violence is going to be part of the drama.

For some critics, these recurrent rape stories seem cheap and exploitative—a way to show violent sex in the guise of social commentary or, in other cases, to insert a sad backstory to justify a woman's harshness. There are definitely examples of this: A scene in *Game of Thrones* last season in which an evil brother overpowered his evil sister (who was also his evil lover—this is *Game of Thrones* we're talking about) was so incoherently conceived that it couldn't separate kink from assault. But what's striking is that most such plots, in genres from camp melodrama to domestic fiction, are skillfully handled. Well-drawn characters like Mellie Grant on *Scandal*, Elizabeth Jennings on *The Americans*, and Callie Jacob on *The Fosters* may be rape survivors, but that's not where their stories stop. They're more than their worst day.

In Kimmy's sparkliest dreams, that's how she hopes the world will see her, too. Like many newbie sitcoms, *Kimmy Schmidt* stumbles, at times, to find its tone—and, with thirteen episodes launched at once, it doesn't have the freedom to rejigger itself. A few characters flop, such as Kimmy's Gomer Pyle–ish stepdad. While jokes about race were a strength of *30 Rock*, in *Kimmy Schmidt* they have

a lower hit rate. Titus, an effervescently gay, black failed actor from Mississippi, pulls off every daring gag. (He also gets the best subplots, including a truly silly music video called "Pinot Noir," by which he means "black penis.") But Kimmy's Vietnamese boyfriend, Dong, is bland, and one of her fellow hostages, a Latina maid, is a cipher. As Arthur Chu wrote in a sharp essay for *Slate*, the problem isn't that the show's hackier ethnic jokes are rude, it's that they're not rude enough—they don't explode stereotypes with real daring and specificity.

When it comes to jokes about trauma, however, the show takes more risks. Kimmy buries her PTSD attacks in a SoulCycle–like class, only to find that she has submitted to another cult. She dates a Second World War veteran, since he's the perfect shrink: He's too senile to remember what she tells him. In one of the show's funniest episodes, Kimmy and Jacqueline bond over their desire to hide any sign of sadness—an "outside in" philosophy. When Kimmy is disturbed by seeing her first selfie, Jacqueline takes her to her plastic surgeon, played by a deranged Martin Short, his face perverted into gargoyle features. Dr. Grant (pronounced Franff) is fascinated by Kimmy's appearance: "Absolutely no sun damage, but you've clearly experienced a tremendous amount of stress. Are you a coal miner? Submarine captain? Because you have very distinct scream lines. Where did those come from, I wonder."

In the pilot, Titus tells Kimmy to go home to Indiana; he's trying to protect her. "Protect me from what?" she snorts. "The worst thing that ever happened to me happened in my own front yard." The line echoes an incident from Fey's life: At five, in her family's yard, she was slashed by a mentally ill stranger, leaving her with a scar—a distinctive but not defining feature. It's not the type of experience you'd think would inspire comedy, but that's the key to *Kimmy Schmidt*'s ambition: By making horrible things funny, it suggests that surviving could be more than just living on. It could be a kind of freedom, too.

CONFESSIONS
OF THE
HUMAN SHIELD

I'd originally planned to write a few straightforward essays
about television for this anthology: one on collaboration, one on
"bad fan theory," one on morality and TV—I hadn't decided yet.
Instead, the Harvey Weinstein story broke, the #MeToo move-
ment started, and this is what I wrote instead.

Well into my twenties, Woody Allen was my North Star. The
first movie I ever saw was *Bananas*, back when I was just
five years old, snuggled up in my pajamas at a drive-in with my
parents. In junior high school, I read Allen's three books of comic
essays, *Without Feathers*, *Side Effects*, and *Getting Even*, giggling at
my favorites, especially "The Whore of Mensa," a satire about
lonely johns who hire intellectual prostitutes to discuss Ezra
Pound. I wore out my vinyl records of Allen's stand-up perfor-
mances from the mid-sixties. I could recite his routine "The
Moose" by heart, imitating his inflections. ("He and the Berko-
witzes lock antlers in the living room.")

Allen's sensibility became the base coat for nearly everything
about my identity as a teenage girl: my notion of what was funny
and what was sophisticated, my idea of what intellectual and ro-

mantic adult life might consist of—my larger vision of what it meant to be a writer in New York, to have a broken heart, to have taste, to have a nervous breakdown, to have a cocktail party. Although my boss at *The New Yorker* once told me that Allen's movie *Manhattan* had become unwatchable, I've watched it at least twenty times. Decades earlier, I had gotten tickets with a friend to see the director play clarinet at Café Carlyle, which was a thrill even though I hate jazz. The point was to see my hero in person.

Around sixteen, I had a dream that I still remember, decades later. In it, I went to visit Woody Allen and Mia Farrow in the Hamptons. At the time, the two of them were a famous celebrity couple, and I had been charmed by newspaper accounts of them waving towels at one another from separate apartments across Central Park (a story that makes much less sense now that I've been to Central Park). In the dream, I'd baked Allen chocolate chip cookies, but I packed them inside one of those fancy round gift tins, the kind for expensive store-bought desserts, the sort of gift you'd bring to impress a rich friend. I was worried that because of the way the cookies were wrapped, he wouldn't understand that mine were homemade.

You could come up with a Freudian interpretation for that dream—that would certainly be on-brand for Woody Allen—but to me, it's a pure fan dream. It's about wanting the artist you care for to know that your admiration for them is authentic, genuine, and from the heart.

When Dylan Farrow's heart-stabbing open letter was printed in *The New York Times* in 2014, it was aimed specifically at people like me. "What's your favorite Woody Allen movie?" it began. "Before you answer, you should know: When I was seven years old, Woody Allen took me by the hand and led me into a dim, closet-like attic on the second floor of our house." By then, I was ready to read it. Allen hadn't been my hero for many years—a slow decline, over decades, as his movies got worse and his reputation degraded, on parallel tracks. In a detective-like way, with an anxious, unhappy,

obsessive focus that was the exact mirror image of fanhood, I'd gulped down every book ever written about Allen, including biographies both authorized and unauthorized, as well as Maureen Orth's coverage of the child molestation allegations in *Vanity Fair*, plus all those essays by Allen's friends that were meant to defend his reputation (and central to that process, attack Mia Farrow's) but mostly made Allen look worse, like a manipulator who was surrounded by sycophants. I was no longer agnostic about the question of whether Woody Allen was innocent of molesting his young daughter, or even whether he was "not guilty," those two linked but separate existential states. I believed her account.

Three years before Dylan's essay came out, I'd also seen a play by Allen, one of three one-acts, by Allen, Ethan Coen, and Elaine May, that were combined into a bill called *Relatively Speaking*. (I was writing a profile of Marlo Thomas at the time, and she was appearing in the May play.) Allen's contribution, *Honeymoon Motel*, was a hokey sex farce about a middle-aged man marrying a bimbo, to the disapproval of his family. Wedged inside the script, there was a sick joke, like a rotted mouse in the floorboards. The joke is part of a scene, late in the play, in which an elderly woman named Fay announces, in a competitive tone, that her childhood was the most deprived of the entire ensemble: After all, she says, her uncle Shlomo had molested her as a child. Instead of sympathizing, the other characters unite to mock Fay, rolling their eyes at the fact she's telling this story once again, that she's blaming an ancient trauma for a life of troubles.

In the middle of the argument, Fay insists, querulously, on the detail that she was molested with *three* fingers, rather than five. This was, I recognized with a shock, slumped in my fancy comped Broadway seat, a joke about the specific crime that Allen had been accused of by his daughter, which, to be graphic, was digital molestation; according to the account that Dylan gave to investigators, he had touched her genitals. (In a later TV interview, she clarified that he had used one finger to touch her labia and vulva.)

The play itself was corny, crude, and full of dated references; it was unclear when Woody Allen had even written that joke, whether it was decades ago or more recently. But it felt like a watermark of ancient scorn, contempt that had been alchemized into something more culturally acceptable, a punch line.

Even if you chose to put Dylan's story to the side, however, Woody Allen's reputation had warped. My opinion had changed, too, because I was no longer a teenage girl. The older I got, the more obvious it seemed that Allen's relationship with his then-girlfriend's daughter, Soon-Yi Previn, had predatory origins. The fact that the two of them had stayed married, that they'd raised kids, didn't erase that fact. What made things worse was the way that Allen responded to any questions, even decades later, about this painful history: He seemed to regard the entire subject as unsophisticated, very non-French, old news; in interviews, he waved away any mention of the repercussions to the people around him, including the idea that he'd harmed Soon-Yi's siblings by forcing them to choose between their mother and their sister. If he had regrets, he never expressed them. My favorite artist struck me as many things, but mainly, he struck me as a malignant narcissist.

Even so, my favorite Woody Allen film was *The Purple Rose of Cairo.*

What should we do with the art of terrible men?

In the wake of the Harvey Weinstein exposé, in the age of #MeToo, even asking that question has felt, on many days, like a betrayal of justice. When that portal finally opened in October 2017, eight months into Donald Trump's presidency, and the rancid stories began to pour out, it felt like they would never stop: first one man, then another, then another. It was like lava from a volcano, vomited up, all the misogyny and abuse that people had ignored, everywhere, in every industry, but especially in Hollywood.

Miraculously, when victims named names, harassers began to lose their jobs—an outcome that had seemed inconceivable a year before. All through that autumn, while I struggled to write this essay—an essay in which I'd hoped to wrestle with my own history with the work of terrible men—another hideous story emerged nearly every day: Dustin Hoffman, Kevin Spacey, James Toback. Directors, comics, playwrights, choreographers, hip-hop producers, and classical-music conductors, the men were toppling, one by one (or were shoved, or once in a while, threw themselves) from their pedestals. The women who spoke out were heroic figures, willing to go public to expose abusive acts, often at enormous risk to themselves. So were the journalists who helped to expose the rotten systems around them. It was enough to torque my oldest ideas, raising repressed emotions from the ocean's floor. It made it hard to think. It made it hard to feel. It made the job of criticizing art seem like an indulgence—the monocle-peering that intellectuals resort to when we should be talking about justice.

Whenever someone new went down, there was a lament, but also, often, a shrug of acknowledgment: Their work had to go with them. There were plenty of strong pragmatic arguments for this position—for the call to erase, to "cancel" or "delete," the work of bad men, in the stark rhetoric of Twitter. Some of these arguments were economic ones, that we should starve abuse by starving the system that produced it. Giving Bill Cosby money means supporting Bill Cosby. But giving someone attention is also a type of currency. Devoting magazine columns to Cosby, or publishing books about his work, watching his work and then analyzing it, accomplishes the same thing—it's a way of burnishing his legend, making it marketable by making it central.

To purge a broken system, this argument went, you needed to make more radical choices; you had to train your eyes to look for what was missing, not what was there. There was a giddy, liberatory energy to the moment, an unbuckled urge to not merely edit,

but rewrite, start from scratch. It was better to focus not on the art of bad men, but on the *other* art, the art that never got made, and also, the art made in the margins. It was better to seek out the attempts that went unnoticed, because criminals controlled the machine. In fall 2017, as these arguments began to dominate the conversation, they swayed me and they shamed me. Some days, I made them myself.

As an arts critic, however, I knew that every time I shifted, in public, in that direction, a buried part of me kept on privately, stubbornly, rudely snapping back. I craved something else, and it was what all journalists crave, and detectives and maybe shrinks, shoplifters and also plenty of artists: endless access, radical entitlement, the greedy ability to dig up to my elbows into any dirt pile, to chew on the rotten apple instead of spitting it out. I didn't want to erase the art made by these men: I wanted to scribble all over it in rage, confusion, in pleasure, too—to make it mine instead of theirs. This was true even, and sometimes especially, when the art was saturated with the man's behavior, as Woody Allen's clearly was. In certain ways, this impulse felt (and still feels) like simple honesty: It would be nuts for me to behave as if I'd never seen *Bananas, Manhattan, The Purple Rose of Cairo, Broadway Danny Rose,* or *Annie Hall,* never to refer to those movies, not to place the world in their context, or myself in their context. (It was easier to do this with Allen's later films, which I'd largely given up on.) If I weren't an arts critic, maybe it would feel different. But a critic can't be clean; you can't scrub history off your skin.

To tolerate these contradictions, which is to say, these desires, I'd decades ago adopted a rigorous, faintly sociopathic, reasoning of my own, a sort of "good for the goose" critical philosophy. Decent people sometimes create bad art. Amoral people can and have created transcendent works. A cruel and selfish person—a criminal, even—might make something that was generous, life-giving, and humane. Or alternatively, they might create something that was grotesque in a way that you couldn't tear your eyes away from

it, full of contradictions that were *themselves* magnetic. History was full of such perversity. If artists could separate themselves, well then, so could I. Erasing art didn't appeal to me, anyway. That felt basic to my nature. But, of course, as with any other strong belief, it looked more contingent when I began to look back. In fact, when I thought about it, it was clear that I'd spent my early twenties reaching the conclusion that the worst thing that a person could be was a censor. Where had I gotten that idea? Unsurprisingly, from politics that I'd found censorious.

I'd gone to college in the mid-eighties, 1984–88, at the small liberal arts school Oberlin. (Kindly play 'Til Tuesday's "Voices Carry" over this paragraph.) This was at the height of the Reagan era, during a vertiginous clash of sensibilities. Nancy Reagan's "Just Say No" campaign was happening side by side with coked-up Trumpian decadence. ACT UP was roaring in the streets; punk and hip-hop were seething at the margins; and yet the majority of mainstream pop culture, including most television, was dominated by a slick, complacent celebration of wealth, all *Lifestyles of the Rich and Famous* and "Material Girl," *Dynasty* and *Vanity Fair*. It was a smothering and sharp-edged period, all at once. And the message in every glossy magazine was that feminism was *no longer necessary:* Women were now lawyers in sneakers, problem solved. Activism was the kind of thing that your mom had probably needed, way back in the 1970s.

There *was* one type of feminism that was in full flower, however: the anti-pornography movement, which was represented by an organization called Women Against Pornography, founded in the late 1970s. For a brief flash in the 1980s, which happened to coincide with my early adulthood, this ideological vanguard seemed to *be* establishment feminism—although this is often hard to describe to younger women, since it doesn't fit easily into the "wave" story that gets taught as feminist history. The two leaders of the anti-pornography cause were the legal scholar Catharine MacKinnon and the radical feminist activist Andrea Dworkin, who

hovered above the landscape like twin moons. MacKinnon was the icy one, a Yale-educated legal powerhouse who had spearheaded the legal concept of sexual harassment. The Midwestern daughter of a right-wing judge, she went on TV in high-necked pastels and pearls, along with the bun of a Victorian reformer. Dworkin was the fiery one, a polemicist from New Jersey, whose obese body, sloppy overalls, and frizzy Jewish ringlets felt like a middle finger to 1980s media; her body itself was a great fuck-you to the patriarchy and she seemed appealingly funny and angry instead of cerebral. I couldn't stop staring at pictures of Dworkin. She was a scare figure with huge emotional power, a fetish object for cultural disgust.

The two of them argued, in contrasting tones, against patriarchal oppression. Violence against women, including sexual violence, was everywhere, they pointed out—normalized, trivialized, and ignored by the law. It was the air we breathed in, invisible. I was onboard for that part of the argument; at a Take Back the Night rally, I remember my naive confidence that the new concept of "date rape" was about to remake the justice system, permanently. But in 1984, during my freshman year, Dworkin and MacKinnon formed common cause with the religious right, led by figures like Jerry Falwell and anti-feminist activist Phyllis Schlafly. Or at least, their rhetoric began to overlap: The same legislation Dworkin and MacKinnon had written, which defined pornography as a civil rights offense against women, became the basis for laws introduced to the Indianapolis City Council by an anti-ERA activist. They were signed into law by a Republican mayor. The fact that they got overturned didn't matter. For young feminists, this development was an ideological shock not unlike the Hitler-Stalin pact had been for my Jewish immigrant grandparents; it was grotesque and disqualifying.

Crucially, this all took place long before the Internet, when print was all that existed. Sexual material, in any medium, was a relative rarity, not easily accessible outside big cities. And, histori-

cally, a lot of ban-worthy sexual expression involved queer sex, which was considered pornographic by cultural default and in many states was illegal. In one notorious case in the 1980s and early 1990s, Canadian Customs blocked books about gay and lesbian sex that were shipped from the U.S., citing "obscenity." All of this overlapped, in my head, with the near-simultaneous attempts by Tipper Gore to ban rap lyrics, NEA vetoes of grants for performance artists like Karen Finley, and censorship of dissident art in the Soviet Union. I didn't trust any attempt to clamp down on speech, whether it came from the right or the left. In interviews, anti-porn feminists continually insisted that the law could distinguish between "erotica" and "pornography," but I didn't buy it. Many of my favorite writers—from Mary Gaitskill to Dennis Cooper—hovered on the boundary between art and smut.

Still, what bugged me most was the notion that some types of speech weren't speech at all. They weren't words or images, they were *violence*. In the ordinances Women Against Pornography supported, pornography was defined as "the sexually explicit subordination of women." The credo of the era was feminist activist Robin Morgan's coinage "pornography is the theory; rape is the practice." This was true whether or not the participants consented. The notion of consent was wobbly, anyway, under patriarchy, because free choice was illusory for anyone in the feminized role (which, in 1980s anti-porn analysis, frequently included gay men). That wasn't a crazy idea: Marital rape, for example, was not fully criminalized until 1993. But during my college years and early adulthood, as the parameters of the conversation about pornography kept expanding, I began to feel intensely alienated by this analysis, and, also, accused by it. Blame seemed to extend not merely to rapists, but to anyone linked to the sexist culture: publishers of sexually graphic material, women who stripped or turned tricks, those who were turned on by porn, or who had kinky sex, or who had rape fantasies, or even who sympathized with women who did these things. *All* of it was complicity.

Among true believers, these weren't just disagreements, but a clash between the enlightened and those poisoned by "false consciousness," the self-hatred dressed up as desire—a feminist extension of Marxist theories about the origins of consumer behavior. (The basic theory of false consciousness was that desire was a form of brainwashing: "You don't even know what you want.") It's this period that Margaret Atwood reflected in the 1985 book *The Handmaid's Tale*, when Offred remembers attending a protest with her feminist mother, where they burn sadomasochistic pornography, showing women hanging from chains. "Don't let her see it, said my mother. Here, she said to me, toss it in, quick. I threw the magazine into the flames. It riffled open in the wind of its burning; big flakes of paper came loose, sailed into the air, still on fire, parts of women's bodies, turning to black ash, in the air, before my eyes."

The Sex Wars had all sorts of weird interpersonal effects in my immediate circle. A friend who worked at Good Vibrations, the feminist sex store in San Francisco, had anti-porn activists scream at her for being a traitor. In the early 1990s, another friend confessed that I was the first "pro-porn" feminist she'd ever met; she was surprised she could be close with someone with such rancid beliefs. In 1989, I had a screaming argument in a co-op kitchen about whether it was okay for me to read *Glamour* magazine, a debate that descended into a detailed discussion of which sex acts qualified as erotica: Blow job? Blow job, clothes off? What if one person was dressed as a boss and the other as a secretary? A male friend's girlfriend found a porn magazine in his closet, then yelled at him for betraying her by masturbating to the pictures. Out of curiosity, I attended an anti-porn workshop at Brown University, which was run by Dworkin's partner John Stoltenberg, author of the 1989 book *Refusing to Be a Man*. It was a disaster that involved a man volunteering to pose with his legs spread in order to experience the humiliation of pornography—and ended in a screaming

match between a lesbian-feminist and a male "ally." Honestly, the whole decade felt like that workshop.

Even heterosexual sex itself sometimes seemed to be suspect. At one point during a college internship at a publishing company in New York in 1987, I picked up a galley of Dworkin's book *Intercourse,* which was lying around my boss's office. I read it during lunch, feeling that I should open my mind to Dworkin's ideas, which included an extended description of penetrative sex as a form of colonization: "The thrusting is persistent invasion. She is opened up, split down the center." I didn't get far. Instead, I became so enraged that I threw the galley into a garbage can, effectively banning something because it seemed to want to ban me.

Why were these ideas so alienating? Part of it was my strong distrust of safety as an ideal. Unlike Andrea Dworkin, who had been beaten by her ex-husband and sexually violated by a prison doctor, I had lived a comparatively safe life, with only a handful of exceptions, none very traumatic. Safety and freedom seemed to me to be in opposition; if you got one, you lost the other. Historically speaking, the rhetoric of keeping women "safe"—especially white women, who were more prized in a racist culture, treated as "pure"—was a way to control them, not protect them. And I was a young woman who wanted to get the world's fingerprints on me, just like men got to do. When feminist activists boycotted Bret Easton Ellis's *American Psycho* in 1991, I read the book, curious; when there were attempts to shut down the movies *Basic Instinct* and *The Silence of the Lambs,* I wanted to see them, to judge for myself. (I was a morally conflicted goody-goody, it's true: I once snuck into a theater to see *Basic Instinct,* since it seemed wrong for me to judge without seeing it—but also, maybe, wrong to pay for a homophobic movie.)

I read the feminist porn magazine *On Our Backs,* as well as polemicists like Susie Bright and queer journalists like Donna Minkowitz, Pat Califia, and Joan Nestle. I pored over *Pleasure and*

Danger, an anthology that included essays by prostitutes. I was hardly a major sex radical in my personal life, but I nonetheless *thought* of myself as a member of the "pro-sex" resistance, even if no one in that resistance knew I existed.

My side won, in the end. Three decades later, young feminists regard porn as an unremarkable part of human sexuality, particularly now that we all have cameras on our phones. Being a porn actress is viewed as a potentially empowering career choice—and the women formerly known as hookers and strippers are now sex workers, victims not of false consciousness but of slut-shaming. There's a dizzy topsy-turviness for many feminists my age, now that nearly every ideological perspective has flipped, left to right and vice versa. In the 1980s, I would have called myself a free-speech absolutist: The correct way to oppose bad speech, as I saw it, was with good speech, strong arguments that cracked weak ones. But I felt this in part because my *own* speech felt very much at risk of being shut down. And the stakes felt lower, before the Internet, because nobody involved in these debates was literally a Nazi, however much we lobbed that word as an insult. I was wary of campus speech codes, too, when they began to emerge during my undergraduate years. My economic politics were left wing, but my cultural politics were borderline libertarian, and that position did not seem, in those years, to be right wing. In fact, it seemed classically liberal, anti-authoritarian, this gut instinct to resist all forms of governmental—and even institutional—power, as long as I wasn't harming others. As far as I was concerned, I should be free to decide what I read, what I said, what kind of sex I had, what drugs I took, whether I had an abortion, and so on.

If my feminism was anti-censorship, this was true not merely intellectually but emotionally. I hated the idea of being a prig, a censor, a label that had stuck to feminists since Prohibition and earlier. In a 1979 *New York Times* article about Women Against Pornography–run tours of then-seedy Times Square, a young feminist named Barbara Mehrhof described her fear of being seen

as "anti-sex" for attending an anti-porn event: "As women, we're susceptible to that. We're the puritans, the prigs, and the prudes." To be seen as humorless was a horror to me, not just in my twenties but into middle age—to a fault, it feels now. (Who was I so desperate to have see me as funny?) Still, those years left me with a lasting repulsion for any attempt to shut down something because it was offensive. I would make up my own mind. I didn't need to be protected. If my favorite artists could compartmentalize, so could I.

And I had my favorites. Roman Polanski had raped a thirteen-year-old girl, Samantha Geimer, in 1977 during a photo shoot at Jack Nicholson's house. He fed her champagne and quaaludes; then, in the hot tub, he coerced her, first into vaginal sex, then into anal sex. I believed that Polanski had been let off easy in the courts. Whenever the case came up, I retweeted a damning Calvin Trillin poem, which satirized the support that was given to Polanski by glib elites such as myself. The second verse reads:

> *This man is brilliant, that's for sure—*
> *Authentically, a film auteur.*
> *He gets awards that are his due.*
> *He knows important people, too—*
> *Important people just like us.*
> *And we know how to make a fuss.*
> *Celebrities would just be fools*
> *To play by little people's rules.*
> *So Roman's banner we unfurl.*
> *He only raped one little girl.*

And yet my favorite Roman Polanski movie was *Rosemary's Baby*. That, I wouldn't give up.

It was a masterpiece, a fraught category. He was a genius, same. The film seemed, somehow, to be both tainted and deepened by his biography. During my senior year in high school, I had

a monthlong internship at William Morrow publishing. As part of my job, I'd been asked to mark up the manuscript of Roman Polanski's memoir, *Roman*. It was 1984. I was seventeen years old, a judgmental virgin who was fascinated by stories about sex crimes, a sort of prurient prude. In the book, Polanski wrote about his paralyzing grief after the murder of his wife, Sharon Tate, who was stabbed to death by Charles Manson's followers. Numb and reeling, the director flew away from Los Angeles, hiding out in Gstaad at the chalet of a friend, a Swiss industrialist whose hobbies Polanski describes as "flying, skiing, and girls." The chalet was located near Swiss boarding schools, and to distract himself, Polanski pursued those students, who were my age, sixteen to nineteen. He describes them as "fresh-faced, nubile young girls of all nationalities," teenagers who were refreshingly uninterested in his films or in gossip about the murder. He found them "more beautiful, in a natural, coltish way, than they ever would be again." He describes their late-night visits with him, when they snuck out of their dorms, as "forbidden fruit"—from his perspective, he was *their* sneaky, exciting rebellion, not the other way around. Maybe that was true; I have no way to know. I've never spoken to those girls, who would be my age now.

Rereading the passage, I can't remember at all how I interpreted his words when I was seventeen: Did I see them, as I do at fifty-one, as not merely sexist but also absurdly clichéd, callow, ridiculous, or maybe simply grotesque, coming from such a worldly man, in the context of such a wrenching tragedy? Or did I take them, when I was seventeen, at face value—as a compliment, with their implication that girls my age were a sort of delicacy, our inexperience a soothing opiate for men in trouble? Polanski's book is a strange document. There are deeply moving passages about his childhood in Nazi-occupied Poland; his account of Tate's murder is heartbreaking. But, eventually, the book shrivels into propaganda for Polanski's self-image as a worldly martyr, a genius

hounded by prudes. He paints Geimer and her family in a crude, cruel light: To him, she's merely some American bore, unlike those "nubile young girls of all nationalities." He makes the rape itself seem like her fault, almost an accident, by occluding the details and never mentioning anal sex. Geimer is just some trap he stumbled into.

Geimer's own memoir, *The Girl*, was published in 2013. It's a far better book and certainly miles more generous to her rapist than he ever was to her. It also presents a surprising philosophy that lets Polanski fans off the hook: She argues that both she and Polanski were brutalized by the legal system, and, in particular, by a corrupt judge, Justice Laurence Rittenband, who violated the deal he'd brokered with both the prosecution and the defense. She believes that Polanski's paid his price. She describes the crime in graphic detail—making it quite clear that it was rape, not consensual sex—but she also says that she's forgiven him. In 2018, in the wake of #MeToo, Geimer was explicit about her reaction to anyone who used her name to ban Polanski's art, calling it "puritanism and censorship dressed as empowerment." She isn't interested in seeing his career destroyed: "How would that help me?"

Does Geimer's book make it safer for fans to watch *Rosemary's Baby* than the films of Woody Allen? Is that what "listen to women" means, or does it mean something much different, far less granular? The tougher question was *Rosemary's Baby* itself, one of the world's sharper portraits of rape culture. The story of a sweet young wife who gets tricked into bearing the devil's spawn, it's a rudely funny allegory about the biological prison of reproduction, the psychological trap disguised as nature. In it, Mia Farrow gives one of her best performances as a perfect portrait of gaslit femininity, her hair clipped like a novice nun, whispering into a phone booth for help that will never come. *Rosemary's Baby* is a thriller about dependency, about false consciousness, about being a carrier for patriarchy—and about helplessly granting it your love, be-

cause it's easier to submit to that power than to fight, if you know that you can't win. (The movie also makes a strong case against marrying an actor or renting above your price point.)

When you look at Rosemary's Baby sideways, it becomes a darkly funny cautionary tale that could have been written by Andrea Dworkin, a description that I intend as a compliment. The movie also contains one of the most unsettling rape scenes ever filmed, specifically because it draws no distinction between the humor and the horror, the camera gazing at Mia Farrow's huge eyes, drugged and dilated and ringed in kohl, as they stare straight into the devil's mask. The movie was a feminist masterpiece created by a sex criminal.

It is impossible for a casual viewer to say if those themes were an incidental or a purposeful expression by a director who knew something about deals with the devil. But as time passed, and norms about sexual assault shifted, I clung to Rosemary's Baby. I owned the Criterion disc. I had lent it to pregnant friends, because there was something reassuring about seeing a movie that ratified your deepest paranoia: You weren't crazy to feel crazy. The movie was a lens that let us see more clearly what it meant to be a woman in a sexist world, the world that could produce a man like Polanski. Should we smash that lens?

And yet, insisting that I could and should hold on to the art of terrible men also required me to be perpetually forgetful, to detach myself in a way that felt strangely unhealthy. In 1990, I'd read a volume of essays by the poet Pearl Cleage called Mad at Miles: A Blackwoman's Guide to Truth. I was twenty-four at the time, working as a secretary for an industrial real estate company in Atlanta. In my off hours, I did volunteer work at a rape crisis hotline and, with my boyfriend, had co-founded a gay-rights organization for heterosexual allies called Straight but Not Narrow. Cleage's book, which was intended as a clapback to Shahrazad Ali's much-

publicized *The Blackman's Guide to Understanding the Blackwoman*, was featured at Charis Books, the feminist bookstore that had become my regular hangout. One night, I went to a reading where Cleage performed the title piece. It was an essay about Miles Davis, whose album *Kind of Blue* had helped Cleage through her divorce. A male friend had given her the album; Cleage turned it into a musical agent of seduction and healing, the soundtrack for her single-woman's bohemian apartment. Just as Woody Allen movies had been for me, Miles Davis was the symbol for Cleage of female sophistication.

Later on, however, Cleage learned more about her hero. Miles Davis was a violent abuser who had beaten his wife, the actress Cicely Tyson. Davis hadn't merely committed those crimes, either: He'd bragged about them, treating them as a sign of masculine prowess. In his autobiography, he wrote about a night when Tyson called 911 after Davis had "slapped the shit" out of her for having brought over a friend whom he didn't like. Tyson ran, terrified, and hid in the couple's basement; but when the cops arrived, Davis spent time, upstairs, bonding with them, joking around. Once they drove away, Davis went downstairs. "Before I knew it, I had slapped her again. So she never did pull that kind of shit on me again," he wrote.

In *Mad at Miles*, Cleage thinks out loud about her own response to learning these facts. "I tried to just forget about it. But that didn't work." In the essay, she keeps returning to a rhetorical refrain that slowly becomes deliberately, darkly comic (there were waves of nervous, excited laughter during the reading), as she repeats this underlined and italicized phrase: "He is guilty of self-confessed violent crimes against women such that we should break his albums, burn his tapes and scratch up his CDs until he acknowledges and apologizes and rethinks his position on The Woman Question." She raises this varyingly as a question, as a provocation, a joke, and a demand. Each time she says it, she follows the phrase with a brief, parenthetical, amused reexamination

of how those words sound when spoken out loud, which alters as she moves through the essay: "It gets easier to say the more you say it. It's starting to sound almost legitimate, isn't it?"

The essay flips the moral lens a few times. In its final phase, Cleage does a fascinating pivot: She decided to try out the premise from a new angle, by changing the demographics. What if the victims in question had been black men, not black women? What if Miles Davis were instead . . . Kenny G? "I can't help wondering what our reaction would be if, say, Kenny [Gee]—a resourceful, crossover white male who is selling well enough in our community these days to tie with Anita Baker and Luther Vandross as the seduction music of choice for black urban professionals between the ages of twenty and forty-five . . . What if Kenny [Gee] was revealed to be kicking black men's asses all over the country in between concert appearances and recording sessions? What if Kenny [Gee] wrote a book saying that sometimes he had to slap black men around a little just to make them cool out and leave him the fuck alone so he could get some peace and quiet?"

Would Kenny G, she asks, "be the music we would play when our black male friends came to call?" The final paragraph is an oracular list of questions, which plays out Cleage's conclusions with musical force. "How can they hit us and still be our heroes? . . . Our leaders? Our husbands? Our lovers? Our geniuses? Our friends?" She concludes with two sentences. The first is "And the answer is . . . they can't." The second is, *"Can they?"*

Back when I heard Cleage's essay, nearly three decades ago, clapping with the audience on our rickety chairs in Charis Books, I remember finding it convincing, but I clearly also tucked it away, designating it as a manifesto that I agreed with but would, somehow, never apply in real life. That's what often happens with any challenging idea: You absorb it, you nod, you clap, and then you alter it once it's inside you. Over the years, when I thought of Cleage's essay, which I tended to do whenever the subject of separating the artist from the art came up, I had erased my memory of

the line, "They can't." I preferred, "Can they?" This was even truer once I became an arts critic. I liked to let questions override answers. When you could linger inside the question, it let you keep looking at the art itself, and I had to find a way to keep doing that.

The question of what to do also changed for me, as it does for many people, depending on who the artist was. I was most confident in arguing that we should not reject the art of bad men when it came to artists I did not love, a situation that made the ethical choice abstract. Bill Cosby, for instance, had never been my guy. Even at his height in the 1980s, I hadn't memorized Cosby's shaggy-dog comedy routines or read his books about family life. During the years when *The Cosby Show* was a blockbuster, I watched largely out of cultural obligation, because I recognized—in a stiff suburban white-guilt way that afflicted me even as a child—that the show was "opening doors." In contrast, I genuinely adored the show's spin-off, *A Different World*, which was set at a Morehouse-ish historically black university, a joyfully varied universe of black perspectives, a romantic series that dramatized intra-community tensions that were new to me. I loved the original *Roseanne*, too, back when it felt like Cosby's sitcom mirror. But Cosby made me itch, in particular the character he played, OB/GYN Dr. Heathcliff Huxtable, with his cutesy condescension, that hangdog horny-little-boy style he directed at his elegant wife, Clair. I particularly hated the way he behaved with his son, Theo, mocking him for his vulnerabilities. But none of this mattered too deeply, because Bill Cosby wasn't somebody that I dreamed about giving cookies to.

Around the turn of the century, as I began reading the coverage in *The Philadelphia Inquirer*, I recognized that Cosby's admirable "Dr. Bill Cosby" character was, like Dr. Heathcliff Huxtable, what the equally fictional serial killer Hannibal Lecter used to describe as his "human suit." Cosby's celebrity persona was public relations for his private self: It was that thing that made him look normal and safe to the world; it got him access to his victims. When a pre-

release copy of Mark Whitaker's Cosby biography landed on my desk, I flipped through the index. There was nothing about the dozens of allegations of Cosby drugging women. I threw the galley in the garbage, just like *Intercourse*. It wasn't a real biography if it left those stories out. But the Cosby revelations didn't make me question my own judgment; they only reinforced it.

When the debate began about how best to respond to Cosby's art, I argued—and would still argue—that it made no sense to ban, or to erase (to delete, to cancel), *The Cosby Show*. (Or his early hit show *I Spy*, for that matter, or the popular kids' cartoon *Fat Albert and the Cosby Kids*.) As far as I was concerned, *The Cosby Show* should still be available for anyone to view, and not only because it was a collaborative project, created by more people than just Cosby. It was a crucial show if you wanted to understand the history of sitcoms, television, race, masculinity, and, especially, the vast influence of Cosby himself: how his cracked brand of affable, bullying fatherhood had become so seductive and so influential. Modern television made much less sense without *The Cosby Show*. It was the key follow-up to the family shows of the 1950s, like *Father Knows Best* and *The Adventures of Ozzie and Harriet*, diversifying TV's patriarchal franchise. It was a crucial precursor to the black family sitcoms that followed in its wake, among them Kenya Barris's *black-ish*, a show that replicated and complicated its vision of the childlike dad. *The Cosby Show* was the crossover catalyst for the wave of black nineties sitcoms that launched networks like Fox. It was the model for respectability politics against which a hip, incendiary series like *Atlanta* stood, thirty years later. It was an ancient argument in sitcom form with Norman Lear, whose work Cosby had loathed because he thought Lear made racism look cute. Erase *The Cosby Show* and you can't see television as clearly.

Also, *The Cosby Show* was a different show when you actually watched it. It was a representational trailblazer—but also an all-black family sitcom on which no one talked about race. There's no episode in which Dr. Huxtable gives Theo "The Talk," about stay-

ing safe in a white world. There are no debates about internecine tensions within the African American community, as there were nearly every week on *A Different World*. Visually and musically, *The Cosby Show* teemed with signifiers of African American identity (kente cloth, anti-apartheid posters, jazz, and R & B). But its obsession was not race but gender. Over and over, Dr. Huxtable lectures younger men that they should respect women, never condescend to them, treat them as more than servants. Dr. Huxtable's marriage with Clair is offered up as an ethical model to Theo, to Rudy's chauvinist friend Bud, to Sondra's insecure fiancé, Elvin. (These episodes grew shadows when Cosby's crimes came out: In one episode, after Clair reams Elvin for sexism, she leaves to get him coffee. "When she brings the coffee back, if I were you, I wouldn't drink it," says Cosby.) Dr. Huxtable's central role is as a performative male feminist, his respect for women the gong that the show beats again and again. That's Cosby's deepest contradiction, the tension that still feels worth wrestling with, not despite but because of its disturbing qualities. It's the contradiction that shaped the generation that watched it.

So I had no trouble advocating for watching *Cosby* while reviling Bill Cosby. Certain artists, certain art forms, I could see from a distance. It was easier to detach myself when it came to music or painting or sculpture; it was much easier with mediums (jazz and abstract expressionism, say) that felt less narrative, more mathematical. It was harder with someone who made you laugh, because laughter is intimate, a loss of control. It was easier when I hated both the art and the artist. It was harder when the work felt like it was about me, my world. It was easier, too, to have a soothing sense of dispassion when it felt like it was not my place to judge. It was easier, for example, to detach myself from debates over misogyny in hip-hop music. I don't know much about opera, either; I observed from a cool distance when the Guerilla Girls criticized sexism in the art world; I love country music but I didn't feel obliged to weigh in on its uglier aspects. When I absorbed Cle-

age's critique of Miles Davis, that was in part because it felt like it was her critique to make, not mine. Plenty of artists could never betray me. I didn't like the movies of James Toback, I found Brett Ratner revolting, I hadn't had any run-ins with Harvey Weinstein, and I didn't like Matt Lauer's interviews. That wasn't my form of collusion.

Still, in the aftermath of the Weinstein exposé, I began considering, obsessively and anxiously, my own taste. Why did I like so many works of art that were fueled by contempt or fear of women? Because God knows it was true. Woody wasn't the only one who mesmerized me this way; I often found art that was fueled by angry, queasy, or flat-out misogynist visions to be car-crash compelling. Pablo Picasso, Alfred Hitchcock, Philip Roth, Eddie Murphy: I grokked the low-level buzz of hate that was present in certain forms of male creativity, finding those works attractive despite those toxins; or maybe because of them; or both. Why? Why was this contradiction more acceptable, or more intriguing, to me, when that wasn't nearly as true of aggressively anti-Semitic or racist art? (Which was Cleage's question, too: What if Miles Davis had been transformed into Kenny G, if he'd been a white man abusing black men?)

Also: What did it mean that I'd succeeded in a media world that pushed so many women into the margins? Perhaps it meant that I was special: I'd squeezed through narrow cracks! I'd beaten the odds. Or perhaps it meant that I was a sellout, a woman who was capable of pleasing, or sedating, or otherwise not challenging the sexism of the men in power. Maybe I was much more of a creature of Woody Allen than I'd even begun to consider. Maybe I was still wrapping cookies for him in my teenage dreams, hoping that he'd recognize that they were homemade.

Maybe, as a young woman, I'd opened my heart so wide to sexist art because that was among the most celebrated art—or maybe, as a heterosexual woman, it was because I felt like it would help me learn things about men. Maybe it did. The #MeToo moment

had raised up uncomfortable feelings from the past: the ugly awareness, for instance, that the praise of young women wasn't quite as meaningful to me, because I took it for granted, while the praise of older men felt harder to get, and, thus, was more valuable. (The thought brought up a Fiona Apple line: "What's so impressive about a diamond/Except the mining?") I remembered my deep irritation at a fan note in which a woman had praised me for writing like a man. And the double irritation when people compared my work only to other female writers, like Pauline Kael; I disliked it when people referred to me as a female or a feminist critic rather than a critic.

Soon after I got my job at *The New Yorker*, a few female writers with whom I was friendly wrote to me to say they were impressed that I had strutted into this big job and not folded under the pressure, which made me nervous, because it made me feel like I should have folded under the pressure. The career advice that I gave to young women was the same tactic that had helped me: You should walk into a big mid-career job pretending, inside your head, that you are Norman Mailer. A messy genius, but worth it! If you act like a polite associate editor in a beige cardigan, your voice will be small. If you pretend you're Norman Mailer, you can take up some space. Making a mess is what men get to do.

Maybe riding behind the wild-man—pulling myself up onto the saddle of the genius asshole artist—was proof that I could handle ugliness. Maybe handling ugliness was a trait that I admired. It was a good thing to be resilient, because then you didn't have to shut your eyes, shield yourself. You could take it all in instead of being the gatekeeper. It was a little strange, of course, to be a critic who hated the idea of being a gatekeeper.

I thought again about Woody Allen. I'm hardly the only teenage girl in the world who was a fan of his movies. They are, after all, movies *about* young women. And few other movies during that

period—in either the 1970s or the 1980s, during the eras of *Animal House* and the John Hughes films—showed us in quite this light. In the Allen movies, teen girls are not erotic Lolitas, not the gauzy lip-chewers of an Éric Rohmer story. They're not, by and large, ditzes or dupes or bimbos. They are instead *remarkable creatures*. They are miniature intellectuals from privileged backgrounds— clever, rich, well-dressed girls who might absorb an older man's excellent taste. In *Manhattan*, it's true, Mariel Hemingway is a bit blank, an innocent with perfect cheekbones, whose tears were pure. But there were other girls in the mix, too, among them the dirty, funny Juliette Lewis character in *Husbands and Wives*—a 1992 movie that got swamped by critical coverage during Allen's breakup with Farrow. That was a movie about an old man who left his wife for a younger woman, so it was regarded with suspicion, as nothing but a sordid confession poorly disguised as fiction.

Without watching these movies, it is easier to dismiss them simply as propaganda for Allen's sexual predilections. But watching them, it gets more complicated: Among other things, these are, in fact, movies about men who fall madly in love with middle-aged women—their peers—but get rejected by them. Those women (who are played by a cadre of amazing actresses including Diane Keaton, Farrow, and Judy Davis) are prickly, funny, demanding, messy, controlling, complicated, and intellectually accomplished figures. They're generally portrayed as preferable to younger women, but harder to hold on to. In *Manhattan*, Hemingway's wide-eyed Tracy is Isaac's rebound, not his first choice. (That was Keaton's Mary, who leaves Isaac for his married friend Yale.) In *Annie Hall*, Alvy, too, gets dumped by Annie, who grows beyond him, rejecting his tastes for her own.

In *Husbands and Wives*, Davis gets to choose between men her own age: Her thrilling bitch-queen character, Sally, with her sexual hang-ups and brick-red lipstick, becomes the fulcrum of a triangle with Liam Neeson and her estranged husband, who is played by

Sydney Pollack. Although Pollack's character leaves Sally for a younger aerobics instructor, he gets bored by her—and in a violent scene that feels even more shocking now, he physically drags his girlfriend away from a party where she embarrassed him by drunkenly defending astrology. Then he reunites with Sally, who breaks Neeson's heart. By the movie's end, it's Davis's Sally who's the clear winner: She knows that she's something special and she's *right*.

Davis's Sally also seems like an older version of Rain, Juliette Lewis's twenty-year-old character in the same movie. Unlike Tracy in *Manhattan*, Rain isn't a puppy dog who is content to watch W. C. Fields and eat Chinese food. She's a cocky Columbia University undergraduate student whose short story (with the absurd title "Oral Sex in the Age of Deconstruction") is so intimidatingly good that her professor, the Allen character, Gabe Roth, develops a crush on her. When Rain loses Roth's own novel in a cab, she is at first apologetic. And then, casually, almost in passing, she begins to scathingly critique her professor's writing, which strongly resembles the Woody Allen movie we're watching. She describes his attitudes toward women as "retrograde" and "shallow." She calls his ideas about marriage and adultery self-justifying—and, hilariously, compares the novel to Leni Riefenstahl's work: *"Triumph of the Will* was a great movie, but you despise the ideas behind it." And, eventually, we get the reveal: Roth's just one in a trail of older men Rain's been dating. In her hidden narrative, *she's* the messy, exciting, adventure-having person—he's just a comic walk-on. When Roth questions her, angrily, saying, "I'd hate to be your boyfriend, he must go through hell," Rain is unfazed. "I'm worth it," she explains, amused. Rain is a male fantasy, very likely. But she charmed me, too. Fantasies don't only go one way.

Such art could be viewed, if you were in a darker mood, as a cultural analogue to a sex predator's "grooming" of a younger victim: These were the stories that had shaped my expectations about

romantic love, after all. They certainly normalized the notion of older men dating teenagers—and since they were beloved hit movies, I assumed, without questioning, that the mores of *Manhattan* (for instance, that adult couples might take a friend's teen girlfriend to Elaine's, rolling their eyes but generally unoffended) were realistic. But maybe *all* art is grooming. Like street harassment, Allen's vision of the teen sophisticate was a form of praise, and few things embed themselves in you as deeply as a compliment. When the world is full of poison, being a food taster seems like a sucker's game.

I thought, among other things, about one of my favorite novels: John Updike's *The Witches of Eastwick*, a book so wittily malicious that, even decades later, it felt like an education in literary misogyny, a bracing ice bath. I had read it in 1984 during my freshman year in college, in my Woody Allen years, around the time I'd been marking up Roman Polanski's memoir, back when John Updike was the beaky blockbuster-writing genius who was on the cover of all the weekly news magazines (back when there were still weekly news magazines). A few months before his death, I interviewed Updike for a profile in *New York* magazine. We met in a fancy hotel suite in Connecticut, where we nibbled from a tray of elegant butter cookies. Updike was doing press for his final novel, which was a follow-up to *The Witches of Eastwick* titled *The Widows of Eastwick*, a novel in which the original characters were facing old age. The new book was terrible. Despite the fact that he was supposed to be out there plugging this sequel, the author himself described it, with endearing candor, as a commercial gambit.

I had no idea that Updike had lung cancer at the time. He answered all of my undermining questions with charm and what I described in the piece as "a certain satirical opacity." When he had written *The Witches of Eastwick*, in the early 1980s, he "rose to the bait" of his feminist critics, he told me. "People of my age are raised to be, sort of, chauvinists. To expect women to do the laundry and—it's terrible! I'm making you cry, almost! But I'm eager to

correct that as a writer, more than as a person. As a person, we always have chauvinistic assumptions. But a writer is supposed to be open to the world, and wise, and generous."

The original novel had aims that were both satirical and ideological: It was a book about the wicked liberation of divorce, thrumming with seventies-era anxiety about "women's lib." The witches are home-wreckers who neglect their kids, mystically dispose of their husbands, and revel in selfishness, until they finally trip themselves up, having fallen for the flattery (along with the ice-cold penis) of the devil. Yet it was also a book that female readers embraced. You couldn't help it, because the female characters were too *alive*, too well-formed—a miracle that only intensified once the movie adaptation came out in 1987, starring three glamorous movie stars, two of them middle-aged. That movie was a glossy eighties girl-power original, which largely stripped the material of its anti-feminist politics. But even in the anti-feminist book, the coven was irresistible, a trio of horny, funny single mothers—the sculptress, Alexandra; the writer, Sukie; and the cellist, Jane. Updike's portrait of these women, reveling in their newfound powers, was a special sort of intoxicant, not unlike the compliments paid to the trio by the devil character, Daryl Van Horne, who was an art collector himself and, also, a collector of artists.

There's a meta-argument tucked inside *The Witches of Eastwick;* it's an argument for the value of misogynist art about women. Early on in the story, Van Horne brings Alexandra, who sculpts naked goddess figures, to see his modern art collection. He shows off his prized possession, a Kienholz: It's a naked female figure, on her back, legs spread, made of chicken wire and flattened beer cans, with a porcelain chamber pot as the belly. Alexandra is offended. She calls the sculpture "rude, a joke against women." Van Horne insists that it is genius. "The tactility! There's nothing monotonous or preordained about it. . . . The richness, the *vielfältigkeit*, the, *you know*, ambiguity. No offense, friend Lexa, but you're a Johnny One-

Note with those little poppets of yours." When Alexandra reluctantly touches the sculpture, she finds "the glossy yet resistant texture of life." Whether she likes it or not, this garbage body is a mirror for her own. She can reject it but she can't dismiss it.

The late 1970s, as Updike remembered them, were "full of feminism and talk about how women should be in charge of the world. There would be no war. There would be nothing unpleasant, in fact, if women were in charge of the world. So I tried to write this book about women who, in achieving freedom of a sort, acquired power, the power that witches would have if there were witches. And they use it to kill another witch. So they behave no better with their power than men do. That was my chauvinistic thought."

I was charmed to hear Updike use the word "chauvinistic," that yellowing scrap of the old insult "male chauvinist pig," a rhetorical souvenir of ancient battles, ones that took place before my time. Writing, he told me, remained the most pleasurable thing in his life; it filled the time, it was easy and soothing. I nodded along. But the truth was, around the time of that interview, writing was, for me, painful. I had a baby and a two-year-old and was suffering from what was, in retrospect, a mild case of postpartum depression. As I struggled to transcribe his words, I was at a rented house on vacation with friends. They all went apple-picking, while I sat frozen, staring at my computer: I somehow had to complete a damning profile of an author who was among my biggest influences, to find a way to call my literary hero sexist without making myself a prude, a moralist, a scold. I was never satisfied with the results. After his death, the memory prickled with guilt: The project seemed pointless and a little like I had killed him.

Rereading the piece, however, I was struck by how cathartic our interaction had been, how powerful it was to have Updike not deny but actively embrace his own limits, to tell me, at the end of his life, that he couldn't really escape his own biases, that his only choice was to turn it into an artistic challenge. "To a misogynist,

it's bliss to write from a woman's point of view," he said. Of course, it's impossible to say how much the great novelist was making fun of me and how much he was making fun of himself: likely more than a small amount, on both counts. But it was comforting that my sexist hero, too, believed that his art should be bigger than its creator. That failed final book, the one about elderly witches whose artistic gifts had receded, a book that overflowed with scornful descriptions of women's aging bodies, and of their bad, failed art, the art they'd created in their waning years, is now forgotten. Back then, he described their physical plight as very much mirroring his own. "I've been spared baldness, but in a strong hotel light, you suddenly see your awful head that you never had to look at before."

As the weeks of November 2017 passed, I began to see my own awful head. Because I knew who was next. It was Louis C.K.

And as it happens, I knew something about Louis, something that was about to hit the press, that I *wanted* to hit the press. But with Louis C.K., I had always found it harder to detach myself. And while I was hardly the first or the most important person to praise his work—during his artistic rise over the past decade, it frequently felt like every men's magazine featured a worshipful portrait of the comedian as a philosopher-saint, often written by a man his own age or slightly younger—I felt tied to his reputation, specifically because I was a female critic, and a feminist, too, and not one of three thousand guys writing for *Esquire*.

In 2010, I wrote a mixed-to-negative review of the first season of *Louie*, dunking on it for self-pity. Seven months later, I wrote a profile of him for the TV issue of *New York* magazine, a positive profile, but one-half notch less sycophantic than the rest, I hoped. Yet each year, my admiration grew: Perhaps my most psychedelic rave ever was written about the third season of *Louie*, the first five episodes of which I binged in a state of bliss. I still thought about

those scenes, particularly the one in which Parker Posey sits on a roof ledge, her face shifting, elusively, from suicidality to love and back—her expression hard to read but impossible to look away from. The show could be didactic and, by design, it was self-indulgent: It was a one-man show, a sitcom made by an auteur, something new for TV. The final two seasons had agitated me in ways that I'd never been fully able to articulate. Still, Louis C.K. was a hero to me. His stand-up had a virtuosic filthiness that echoed Philip Roth and Woody Allen, but also many of my favorite female creators, like comics artist Aline Kominsky-Crumb. In a medium that was built on compromise, he'd spearheaded a model of production that was more capable of risk and failure, a kind of comedy that elicited anxiety, not just laughs. As a critic, I felt sure that tolerating that kind of discomfort was a positive thing.

In person, I'd had contradictory reactions to Louis C.K. I found him cold and manipulative, but also charming and hilarious. He was attractive in a masculine, working-class-Boston sort of way; he was butch and stocky, a former mechanic who had trained with a boxer. His TV persona, in contrast, was a homely, pathetic sad sack. These two dynamics meshed effectively, making him an extremely powerful guy whom people felt sorry for. Every year since 2013, I'd requested him for a panel at The New Yorker Festival. He always said no. Then, in 2016, he said yes. At the time, Louis was on a big career upswing. He'd gone back on the road as a stand-up, playing venues like Madison Square Garden—and although *Louie* was on hiatus, he was producing multiple new shows. Some of them were personal experiments, like the melancholic *Horace and Pete,* a self-funded series that he marketed through his own website on a subscriber model. Meanwhile, he'd thrown his clout behind a bunch of female creators, among them Tig Notaro, whose one-woman show about her cancer he'd helped to distribute, as well as Pamela Adlon, his co-star on *Louie,* with whom he'd co-created *Better Things.* I was booked to interview Louis at Town Hall in

midtown Manhattan, the biggest venue at which I'd ever done an onstage interview.

Several weeks before the panel, I got worried. There had been rumors online, mostly about one particular story: Louis was said to have masturbated in a hotel room in front of two female comedians, more than a decade earlier, at the Aspen Comedy Festival—and according to that story, he'd blocked the door so they couldn't leave. There was a linked rumor about another comedian, Jen Kirkman, who had recorded a podcast in which she talked about the double standards for female comedians who "worked blue," complaining about a comic who sounded a lot like Louis. But then Kirkman put out a statement that her words had been twisted—and she clarified, specifically, that Louis C.K. hadn't ever sexually harassed her. I didn't know what was real. But I was worried that Louis was using me as a cover, a feminist shield. The idea nagged at me, even as I prepared, rewatching his show.

So I started making phone calls. They came up dry, again and again. Every comedian I spoke to told me that she had read the rumors, but no one had any confirmation, some details were wrong, some of the names that had been named weren't correct—and as the panel got closer, it seemed likely that the story wasn't real. This was actually the second time I'd tried researching this topic: A year earlier, a colleague had asked for help looking into it. But I was getting more confident that it wasn't true. People kept encouraging me to do what I was planning to do, anyway, which was to ask questions about themes of sexual violence in Louis's comedy, to focus on the art, not the artist.

And then one day, a phone call paid off. A male comedy writer I knew, out in Los Angeles, got me in touch with a female comedy team, and they turned out to be *not* the ones people had most frequently name-checked online but a *different* team, a wild, goofy, adventurous pair of writers and performers named Dana Min Goodman and Julia Wolov—chick comics, best friends, and long-

time writing partners, who were originally from Chicago and whose specialty, much like Louis's own, was working blue, doing a filthy, outrageous act full of jokes about sex.

Dana and Julia spoke to me off the record, which in journalistic terms means they wanted to tell me what happened, but I couldn't tell anyone else or write about it. They weren't yet ready to go public with their story—for good reason, because they were scared of the repercussions. What they told me was that Louis had masturbated in front of them, in his hotel room, back at the Aspen Comedy Festival in 2002. The door wasn't locked, but who cares. They'd freaked out in response: They laughed and then they screamed, in shock, so loud that the people next door could hear them. And Dana and Julia *had*, in fact, told other people in the comedy world about this—in fact, they'd told them right after it happened, because it was such an outrageous story. "We'd told everyone we saw," they said. "We told the bellboys!" Talking about what happened, telling the story, had hurt their careers, they believed; and from what they told me, the blame lay not just with Louis but with Louis's manager, a powerful industry figure named Dave Becky, who represented (and still represents) many major figures in the comedy world. Becky had told their managers that they needed to shut up, they said. The Aspen Comedy Festival was supposed to be their big break. Instead, when they moved to L.A., they felt marked by scandal—and they'd hesitated to even approach anyone connected with 3 Arts, where Becky worked. Word was out. What's more, they told me, they weren't the only ones out there with a story about Louis C.K.

I liked Dana and Julia immediately. I believed they had been screwed over. I blew up. Furious, I planned to cancel the panel with Louis. I knew that canceling would cause a scandal. If I canceled, I wouldn't be able to explain the details of what Louis had done. Dana and Julia didn't want their names out; in the pre-Weinstein period, that felt like a life-destroyer—not worth the risk and, also, not likely to have any major effect. Maybe someday. The two com-

ics said they were okay with me either doing the panel or canceling it; they trusted me to make the right choice. But canceling felt right. It was the moral call, the braver one.

It was also the one I didn't make. Because after that initial reaction, step by step, as I made my reporting calls clarifying the details, looking into various stories, I got—and I am ashamed to say this—cold feet. The reporting that I was delving into, like many stories about sexual harassment, felt complicated. The events had happened years ago, before Louis's profile blew up, in a workplace with muddy boundaries, one I wasn't confident I understood. Not every detail could be confirmed; not everyone was comfortable talking; and, once in a while, there were questions I couldn't answer. The panel was coming up. And there was a middle way, because I was a critic, not an investigative reporter. I knew I couldn't ask Louis about these stories onstage, because that would only give him the chance to lie, as he'd done before to journalists. The story was incendiary; I didn't want to be the one to blow it up. And, of course, this path was easier for me. The ditch that I'd been digging my entire life was the one I fell into: my confidence, or maybe my hubris, about separating the artist from the art.

But, of course, I wasn't interviewing the art. Before the panel, I called Louis, as I always did with guests, to discuss topics of conversation. It was Yom Kippur, the Jewish day of atonement; I stepped out of services to speak with him, sitting on a stoop in Brooklyn, shivering in the sunlight. If you want to know what our talk was like, I can't tell you, because that, too, was off the record, but you could watch the episode of Lena Dunham's *Girls* called "American Bitch" and imagine how quickly I might be sedated by a line of bullshit and an embarrassingly effective level of making me feel sorry for him. (You could diagnose me with "himpathy," to use philosopher Kate Manne's term. It's a lingering condition that recurs.) The panel itself wasn't recorded, because Louis's representatives had turned down *The New Yorker*'s request to do so, not an uncommon decision from stand-up comics. Perhaps they

thought I'd ask some questions that I never asked. Still, as anyone who attended could tell you, it was a collegial enough event, with a few notably tense moments.

For my final clip, I showed the most troubling sequence from the final season. In it, Louie comes home and wakes up his crush, Pamela, who is babysitting his kids. He tries to kiss her. She says no. And then he begins wrestling with her, as she protests, mocking him, pulling away—until she runs for the door and he blocks her, penning her in with his arms. He's huge, she's tiny. Pamela squirms, disgusted, and finally gives in to his demand for a kiss, wincing as if she were a kid eating broccoli. When the clip ended, there was an uncomfortable ripple in the audience. I asked, "Was that an attempted rape?" Louis responded with an extended, messy, and illuminating answer. He talked about how much he and Adlon had laughed during the shoot. He said that someone had suggested, while on set, that it might get them in trouble online. He explained that it was a scene about the fictional Louie having a "dumb," "old-fashioned," "John Wayne" attitude, believing it was his job to "make something happen" sexually.

But Louis added, too, that the character he played sensed that the Pamela character *wanted* something to happen. He emphasized, several times, that Pamela was a tough person—both that the actress was tough in real life and that she was playing a tough fictional character—so tough that Louie's behavior wasn't a threat, even though she had a line saying, "This would be rape, if you weren't so stupid." I failed to ask a strong follow-up question ("So you're saying he knew she wanted it? She was too tough to traumatize?"). Then the audience questions were awful, all about what a great man Louis C.K. was. One question was, quite literally, "What does it feel like to wake up and know what a great man you are?"

Afterward, I felt relieved, because it seemed like I had handled a morally complex situation the best way I could. It was a bad time for many reasons, most of which had nothing to do with Louis

C.K.: It was one month before Donald Trump was elected president. The *Access Hollywood* tape emerged on the same day the panel was held. Later on, I told myself, when things were calmer, I'd write a thoughtful reported piece about misogyny and comedy, when I had time to get it right, to nail the facts down and put them in their context. But I didn't do that. Instead, every day for the next year, I felt worse. So if you're wondering who colluded with at least one man who did bad things: That would be me. I was five when I first became a fan of Woody Allen. I was in my mid-forties when I became a fan of Louis C.K., inflamed by my desire to see things in an ambiguous light, to dwell in gray areas, to jump past "we can't" to "can we?"

Is *Louie* still one of my favorite shows?

Here's the truth: My mind locks up whenever I think about the series. When I first began writing this essay, in late 2018, *Louie* was canceled, deleted: If you searched in the HBO or FX archives, Louis C.K.'s shows didn't come up. (There was one image of him on the FX site, but when you clicked "more," it looped back to the home page.) Then, while I was editing this piece, Louis made a surprise appearance at the Comedy Cellar. His act got an ovation, then a backlash, then a wave of support, and so on—and as of this writing, he's continuing to show up onstage, often without notice, rumored to be preparing a new special. He's defended and derided on various podcasts, a social experiment in action. I do own a DVD copy of his early show *Lucky Louie*, whose pilot includes a scene in which the Louie character's wife, played by Pamela Adlon, opens a hall closet and is shocked to find him inside, whacking off. But if I never saw *Louie* again, or Louis again, I'd still know the show by heart. I'm its creature, the way we are all creatures of the art we care about, even if we decide to throw it in a garbage can.

The most anxiety-provoking elements of the series—the show's fascination with masturbation as rebellion and compulsion, its solipsism, the ick factor—can't be sliced from the apple. If you don't eat the apple, there's a lot you can't know. Like Cosby, like Woody

Allen, Louis C.K. embodied a fantasy, and one designed not just
for men but for women. Like Bill Cosby, he embodied the fantasy
of the feminist genius who respected women—a divorced, middle-
aged man who did comic rants about how he preferred women his
own age. As with *The Cosby Show,* television got bent by *Louie,* per-
manently. The deal that he cut with FX was unique, at the time:
The network agreed to give Louis C.K. a small budget in exchange
for him refusing all network notes, letting him make every creative
decision without oversight. No female comedian could have got-
ten such a deal. But once Louis C.K. got it, it was possible. His
show became a catalyst for a wave of autobiographical comedies,
many by women, made by creators who were fascinated, just as he
was, by sexual compulsion and shame, forgiveness and blame.
This included shows by Lena Dunham (who dressed as Louis C.K.
for Halloween the year *Girls* debuted); Phoebe Waller-Bridge (who
called *Louie* her key inspiration for the first season of the feminist
series *Fleabag*); Michaela Coel, who created the rude, vaudevillian
Chewing Gum; Jill Soloway, who created the confessional *Transpar-
ent;* Amy Schumer (who, after a conversation with comedy writer
Jessi Klein, abandoned her conventional talk show concept and
texted her executive producer, saying, "Cancel my pitch, I want to
make my *Louie*"); Tig Notaro (*One Mississippi*); Louis's own cre-
ative partner Pamela Adlon (*Better Things*); Frankie Shaw (*SMILF*);
and Maria Bamford (*Lady Dynamite*). Après Louis, le déluge.

Louis's final work to debut in public was the movie *I Love You,
Daddy.* I saw that film during an early screening when, as many of
us present knew, the *Times* story was on its way. *I Love You, Daddy*
is a movie about the same subject as this essay: It's about the ques-
tion of how to deal with (collaborate with, be influenced by, reject,
embrace, denounce) male artists who have done bad things. In it,
a Louis-like TV showrunner meets his hero, a Woody Allen–like
film director, who begins to seduce the showrunner's teenage
daughter. The movie is a visual homage to *Manhattan.* But it's a
hollow work of art: a slick, empty, fake-sophisticated fable, whose

conclusion is the ultimate ethical easy out, "We're all perverts," a line that is delivered by a black teenage girl with a crush on the showrunner played by Louis C.K. When one character asks the Allen character whether he "really fucked that kid, like everyone says," the director laughs, then says approvingly, "You're the first person to come out and ask me that question." After the credits rolled, I stumbled home and slept for five hours, as if I'd been poisoned, which maybe I was.

A week later, the *New York Times* story broke. By this point in time, the accusations against Weinstein had already toppled the mogul and #MeToo was well under way. Dana and Julia—to whom I'd spoken as the process unrolled—knew that this was their chance to go public, at last. The *Times* story included enough women telling their stories to back one another up, so that none of them had to stand alone.

Within days, Louis's career appeared to be over. Distributors pulled *I Love You, Daddy,* before it ever debuted in the United States. Streaming services yanked his TV shows and comedy specials. Fans and critics began disavowing his work. My friend and fellow television critic Matt Zoller Seitz, who had written his own raves of *Louie,* argued that putting the comic's work aside was the correct response. "There's no reason to have qualms about stamping their work 'Of Archival Interest Only,'" he wrote, about disgraced artists in the post-Weinstein era. In a later conversation, he clarified: He doesn't think these men's work should be "deleted" or "canceled," exactly, but treated as a museum piece—historically relevant, but also toxic. The focus should be instead on "moving on to something new—not just new work, but a new paradigm for relationships in show business, and all business. The women who came forward opened themselves to being ostracized and re-traumatized. The only reason they spoke up is to make show business, and the world, safer and more humane. Time to listen."

I nodded when I read that. That was true. It was the compassionate response to the correct people—and it withdrew compas-

sion from those who had hogged more than their share, including from me. Zoller Seitz's final line mimicked the last line of Louis C.K.'s public statement, in which he confirmed that the accusations were true. "I have spent my long and lucky career talking and saying anything I want," he wrote. "I will now step back and take a long time to listen."

But there were other truths, too. One was that I didn't want to look away. My old method had been the sociopath's approach: Treat the artist and the art as separate. There had to be some way to write without blinders on, even if I couldn't imagine it yet.

I had been following the writer Laurie Stone on Facebook throughout the fall as the men fell. She wrote frequently about #MeToo, with a degree of personal confession that I've never been capable of, and also, a greater willingness to offend. She talked about her own experiences, including childhood sexual abuse. She also talked about the kind of mucky interpersonal dynamics that weren't so easy to label—about celebrating female sexual aggression, and also about the danger of painting the lives of women as nothing but victimization. One day, she wrote about the art made by bad men. "On whether it is kosher to engage with the art of people you don't like: If something turns you on, it turns you on," she wrote. "If you love something, you love it. If you find beauty somewhere others do not, you have found beauty. Nothing good is clean. Nothing interesting is pure. Beauty includes tension, contradiction that cannot be resolved, the comedy that life is complex and meaty and cellular and not transcendent. No tyrants, no gods, no purity, no bibles."

Feminist criticism, she argued, shouldn't steer around the art made by bad men. It should confront it. Feminist critics, she wrote, were obliged to think about "how conscious and unconscious expressions of patriarchal values mute, main and trivialize works of art. That is still our contemplation." I agreed with Zoller Seitz's argument. Stone's was the one that swayed me. When, later, I called Matt to talk about all of this, he sent me a beautiful essay by

the rock critic Ellen Willis, "Beginning to See the Light," which begins, "On November 7, I admitted I was turned on by the Sex Pistols." In it, she writes about a punk song full of woman-hate: "The extremity of its disgust forced me to admit that I was no stranger to such feelings—though unlike Johnny Rotten, I recognized that the disgust, not the body, was the enemy."

And when I thought back on those final two seasons of Louie— the ones that had seemed so alienating—they made more sense to me. Not as biography: No art is pure confession. But Louie had been a show that was haunted, from its early episodes, by visions of moral payback: It was a dark comedy about a depressed, paralyzed man, who was a pig about food and money, a former Catholic who, when he wasn't being a decent single father, was a shame-riddled fuckup who expected the ax to drop any day now. The show's violence had always been violence directed at Louie— which was something you could see, in retrospect, as a manipulative trick, a way of making a victimizer look like a victim. In one episode, a woman climbs up onto Louie's face, forcing him to give her oral sex; in another episode, he smacks a beautiful supermodel, and although it's an accident, as a result, he loses it all—his career and all his money. Louie's daughters mock him when he's beaten up by a woman. In the same season in which he forces Pamela to kiss him at the door, the Pamela character rapes Louie when he is wearing drag: She encourages him to put on a dress and makeup, then penetrates him, without clear consent, in a scene I could never rewatch, it's that uncomfortable.

On the show that Louis C.K. created, wrote, and starred in, he was a Charlie Brown, surrounded by kinky, scathing, boundary-violating Lucys. It was a self-pitying fantasy, but it was also, in its way, as prescient as Nostradamus. In hindsight, his show seems like an extended anxiety dream about what might happen if women turned the tables.

Then, in those final two seasons (which were filmed as the tides of rumor began to rise), Louis did something strange but interest-

ing: He made the Louie character less of a victim, more a man with power—and, often, a creep, a less likable persona for fans who had been trained to pity the sad sack. Suddenly, Louis was the pursuer. He was ogling and stalking women, or sometimes, seen more generously, he was active rather than passive, being honest about his desires. These were the episodes that many viewers, including me, found so alienating, in part because they were also frequently more pretentious, stagier, more didactic. But there was something real buried in the wreckage.

In Season 4, Louie pursued a woman named Amia who didn't speak English. He mooned after her, insisting that she was his soulmate. He behaved, in essence, as if he were in a romantic comedy; she acted much more as if she were in a Lifetime thriller. I can't read Louis's mind and that's not my job, exactly. There's no way to say how conscious he was about these themes, or how they were beginning to dominate the work. But something cold seemed to be seeping to the surface: a stain spreading, just as the show came to an end.

Soon after that season aired, in his self-funded series *Horace and Pete*, a melancholy drama about a family of bar owners, Louis wrote a scene that, in retrospect, was genuinely shocking. He devoted a whole episode to a person confessing to having masturbated in front of someone without clear consent. Once again, he'd switched the genders: For nine minutes, uninterrupted, the camera gazed directly at the tormented features of the great Laurie Metcalf, as her character unspooled, step by step, a sordid story about her father-in-law. They'd had an affair, one that began with her flashing him from the backyard, uncertain if she was disgusting him or turning him on. Finally, late in the story, the camera turned to reveal the face of the listener—the priest to this shame-soaked confession of sin—and the viewer saw Louis's face. His character, Horace, was revealed to be the Metcalf character's first husband, from whom she was long-divorced; she'd remarried and

they hadn't spoken in years. Horace asked, "Why are you telling me this?" That was the punch line, sort of.

It's a grueling scene to rewatch; I had to force myself to do it to fact-check this piece. Poignant and manipulative, it's a story about two compulsives desperately trying to explain their worst behavior, and then, finally, absolving each other, granting one another grace. "Forgive yourself," Laurie Metcalf's character tells Louis's Horace, who cheated on her with her own sister, years before. The Louis character gives his ex-wife a similar, if unspoken, absolution. When the episode came out, every critic praised it as the bravura experiment of an unconventional genius. Me too.

I can't see it that way, now: Rewatched, the sequence seems much heavier, more lurid, self-indulgent. What does it mean to be repelled by a show you thought you loved? When I look back, in 2018, late *Louie* seems like a show in which Louis repackaged his own confusion about sexual consent as a form of sophistication—and I worry that this was catnip for a critic who was eager to see ambiguity everywhere. Then again, my own responses don't make that much sense to me anymore, now that my heart has closed.

In *The Outline* in July 2018, Daniel Kolitz wrote a wonderful essay about a David Foster Wallace conference, capturing another fanhood as it was in the midst of adjusting to bad revelations about their hero. In it, he described the way that Wallace's aficionados—who ranged from critical academics to ordinary readers—have been struggling with a similar question: How should they read and write about Wallace's work, now that they knew the author had terrorized his ex-girlfriend, the writer Mary Karr? Responses varied widely. The conference attendees adored Wallace's novels, short stories, and essays; they wanted to be ethical, honorable people. They wanted to see the work they loved—fiction that was itself intensely concerned with morality—more clearly, too.

In the piece, Kolitz coined a phrase for what everyone around him seemed to be longing for: "a cogent and nuanced permission

structure." Permission to look, permission to praise or condemn. Permission to treat the work as something that was more than merely healthy or unhealthy. Permission to acknowledge the hard-to-label experiences that *New York Times* critic Wesley Morris—in a beautiful and searching essay about Bill Cosby, "cancel culture," and the morality of criticism—described as "what is messy and tense and chaotic and extrajudicial about art." Permission to see more deeply without having to ignore what was in front of your eyes. No such structure has emerged yet, but these are early days.

Back in the early 1990s, when I'd spend hours hanging out at Charis Books in Atlanta, the venue that had hosted the reading with Pearl Cleage, I had a friend at the counter. She was a funny, mouthy lesbian-feminist who kept on telling me true stuff that I believed was wishful thinking, *just rumors, where's the proof,* like that the singer Melissa Etheridge was gay. One day, my friend told me that for the next year, she was planning to read only books by women. I didn't argue, but privately, I scoffed. Why limit yourself that way?

Yet the truth is that, more than a quarter century later, my path through the year of #MeToo has required a similar discipline. Part of this has meant simply imagining what it might have been like if women's work had been the default setting back when I was growing up. What if the model of male genius (and most often, white, straight male genius) was not the force that the rest of us needed to get around, to go *through,* to become who we were? What if men had not been the vast majority of talk-show hosts, the talking heads, the auteurs, the rock stars, the comics? What if genius was harder to recognize whenever it wasn't wearing lipstick? What if I'd absorbed the style of feminism that younger women had been fomenting, these fiery days, more radical, less tolerant of certain compromises that my cohort found acceptable?

Women's voices had been pouring in on television, my specialty, for nearly a decade. In 2012, *Girls* and *Scandal* were novelties,

under enormous pressure to represent everyone. Both shows were celebrated but also slagged for their "unlikeable" heroines, misunderstood for their refusal to offer easy inspiration. Five years later, dozens of shows had emerged in their wake, from *Broad City* and *Orange Is the New Black* to *Top of the Lake*, *Fleabag*, *The Mindy Project*, *Lady Dynamite*, *Happy Valley*, *Jane the Virgin*, *Transparent*, *Crazy Ex-Girlfriend*, *GLOW*, *Insecure*, *Chewing Gum*, *Big Little Lies*, *Sharp Objects*, *Call the Midwife*, *CLAWS*, *One Mississippi*, *I Love Dick*, *Queen Sugar*, *Marvel's Jessica Jones*, *The Marvelous Mrs. Maisel*, *Dietland*, *The Bisexual*, *Russian Doll*, *Shrill*, *PEN15*, and many more. Some of these shows were better than others (a few I disliked), but that was progress, too. There were finally enough visionaries—enough egotists and eccentrics, enough philosophers, builders, nurturers, gurus, and gleeful chaos-slingers, all the flavors of "genius"—that no one aspirational female artist had to bear the hideous weight of the pioneer.

Often, the shows that spoke to me the most directly were those that were in conversation with the work of all those troubled male geniuses. They were the hair of the dog that bit me. The female artists who had risen in Louis's wake became the ones to critique him, to scribble on him and rewrite him.

My panel with Louis C.K. took place in October 2016. The next February, I watched a screener for the *Girls* episode "American Bitch." In it, the main character, Hannah, meets a famous dirty-talk novelist, who is played by Matthew Rhys. She plans to confront him about online rumors; then, as they talk, he alternately praises her and debates with her, until she slowly abandons that plan. By the episode's final scenes, Hannah's guard is down and Rhys's penis is out. His grand apartment bore a strong resemblance to the palatial Upper West Side pad where Louis lived when I wrote my profile about him. One wall showed a painting of Woody Allen as a Byzantine saint: He had a gold halo and held a gun to his head. I saw some parallels in the plot to *Louie*, too, like the fact that the Rhys character had a biracial child and black ex-

wife, from whom he was estranged. In one scene, the novelist's daughter played the flute; that, too, felt like a subtle shout-out to the scene in which Louie's daughter had played the violin for him and Amia. But maybe I was seeing things.

"American Bitch" debuted months before the Weinstein story broke, but it was a hint of what was coming, a sharp allegory about feminist collusion—about the lure of "himpathy" and the kind of story you could never tell, or at least, tell in full. Like *Rosemary's Baby*, it was a fable about deals with the devil, ones made in an Upper West Side Classic Six. For me, it was a killing-me-softly moment. I wrote a pretty decent column about "American Bitch," although I didn't mention Louis, because, among other considerations, I was hesitant to reduce a great episode to a blind item.

Then, in July, I watched a preview screener for another show I loved: Tig Notaro's *One Mississippi*, the stand-up comedian's semi-autobiographical comedy about a lesbian podcaster coping with her mother's death. The show was produced by both Louis C.K. and his agent, Dave Becky, the same manager who Dana and Julia believed had stood in the way of their careers. The episode, titled "I Can't Fight This Feeling," featured a more unambiguous Louis stand-in: a sleazy producer, a guy who keeps praising Tig for her "dark material," who masturbates beneath his desk during a business meeting. Like Dunham, Notaro was using Louis's trademark genre—the "traumedy"—against him. Unintentionally, the episode formed a perfect bookend with "American Bitch": Here, the focus was not on the Louis character, but on the women, and specifically, on the mindfuck of knowing something happened and having the man who did it deny it.

In the process, Notaro slashed the cord that tied Louis C.K.'s name to hers. In my review, I finally described the rumors in print, writing that they deserved investigation. Just after I closed the piece, the Weinstein story broke. The portal opened. At first, I thought this moment would be short-lived—that any exposé

needed to come out fast—but I was wrong. More than a year later, it's still unfolding, changing by the day.

The next May, in 2018, I went to see an off-Broadway show called *Nanette*. It was a one-woman show by Hannah Gadsby, a Tasmanian stand-up comic. All that I knew about *Nanette,* going in, was that it was some kind of "anti-comedy comedy show." It sounded like fun. Instead, the show ended up feeling like a bomb tossed into my house, right when my house needed some blowing up. I walked around mulling over *Nanette* in my head for weeks, recommending it, feeling challenged by it, adoring it, arguing with it, considering it obsessively, a fan. It changed me, maybe even neurologically, which is all you can ask from art.

The only time I'd seen Gadsby before, she was playing a version of herself on the lovely Australian show *Please Like Me,* which was created by Josh Thomas—another "traumedy," a beautiful one about a young gay man whose mother was institutionalized after a suicide attempt. That Hannah was a patient at the mental hospital, a deadpan Eeyore of a character, a wit who was paralyzed by depression. The actual Hannah Gadsby had a similar history: She was a soft-spoken butch lesbian who had been homeless and suicidal. But she wasn't paralyzed in real life. In fact, Gadsby was a hardworking stand-up whose productivity mirrored Louis C.K.'s own: Like him, Gadsby produced an hour of new material each year. A staple at the Melbourne International Comedy Festival, she was a comic's comic, as Louis had been early on, with an unusual specialty: She had a graduate degree in art history.

Nanette was something new for Gadsby. It was framed as a farewell to comedy, a kind of public career suicide, incendiary and experimental. The show began calmly enough, with the sort of jokes that Gadsby had been perfecting for seven years, a series of gentle self-mocking anecdotes about her early life: a fight she'd had at a bus stop with a man who thought she was flirting with his girlfriend; the story of how she came out to her family. Initially,

Gadsby delivered these gags with a stuttering self-deprecation, although her eyes flickered with some hidden emotion throughout. "I identify . . . as *tired*," she told us, a small line that got a big laugh.

And then, gradually, Gadsby began to flip these jokes open, as if they were watches, coolly explaining their mechanics. The mood shifted. The humor began to flicker, as if it were on the fritz. By the show's final moments, Gadsby had entered a state of undiluted rage as she poured out all of the details of the stories from the first half, the ugliness that she had edited out in order to make us laugh: a rape, a beating, the venomous homophobia that made her believe she deserved it. To transform her most painful experiences into jokes, she argued, she had had to injure herself, for her chosen art form. There was no room, in stand-up, for a "gender non-normal" (Gadsby's phrase) to tell her entire story. There was no space for her to get past the punch line—the one-two trap of joke-making—to the healing part, the catharsis.

Nanette was a show with a thesis, designed to provoke debate. But the experience of watching it made it feel like something else: It was the comedy of complicity. Every time Gadsby lobbed a punch line, we laughed, and then she analyzed our laugh; she noted when we went silent, too, observing the tension as it passed between the stage and the crowd, expanding the tension and then contracting it, a bold show of control. It was a physically challenging experience to watch *Nanette*; not unlike *Louie*, it was art made to trigger anxiety, not merely laughs. (As a critic, I thought that was a good thing.) People cried; at one show, they snapped along in activist-style applause; sometimes, they glared or looked away, as if feeling accused. Sometimes, they *were* accused: In each audience, Gadsby selected one man as an experimental subject to direct her story to. These men became a crucial part of her act.

About a half-hour in, Gadsby tore into the problem that had been troubling me, the problem of separating the artist from the art. "Why don't I *not!*" she shouted, as her pupils lit up with disgust. And then, when Gadsby dropped the skillful jokes and began

to make her case, she also threw off her cloak of stuttering charm, trusting the audience to go with her. We did.

I saw *Nanette* twice, off-Broadway. Then I interviewed Gadsby for *The New Yorker Radio Hour*. I was nervous about meeting her. With her tense grin and her gleaming eyes, Gadsby was a likable figure onstage but a fragile one, too, intimidating in the way that fragile people can be—I realized how worried I was about taking a wrong step. After all, I wasn't sure that I agreed with her on every point. I'd always loved harsh jokes, cruel jokes, including certain rape jokes—I'd spent my life, as a critic, defending just that kind of thing. (The old Sarah Silverman joke: "I was raped by a doctor. Which is so bittersweet for a Jewish girl.")

But the interview was a pleasure. In person, Gadsby was sharp, warm, and lovely, adding fascinating details to my understanding of the show, among them, the revelation that she had been diagnosed as autistic. "I wanted to say, *look what these kinds of brains can do*," she told me, about the development of *Nanette*.

A few weeks later, the Netflix special of the show came out. This version of *Nanette* struck me as slightly less effective when I watched it—maybe that was because I'd seen the show before, but to me, it lacked the punishing thrill of being in her presence, of reacting and responding to her ideas in real time, as if we were in a church service. It was still powerful, though. And nearly immediately, it became a viral phenomenon, a symbol of the larger feminist critique of the comedy world, part of the newest stage of #MeToo. Its creator, despite her original intention to piss people off so much that she'd wreck her own career, had become a global celebrity. The space left empty by Louis C.K., the man acclaimed by critics like me as a scathing comic philosopher, was suddenly filled by Hannah Gadsby.

Arguing with *Nanette* felt more invigorating than agreeing with other people's shows. My skin had prickled like mad, in particular, during Gadsby's climactic set piece about Vincent van Gogh and Pablo Picasso. "I *hate* Picasso," Gadsby announced. "And you can't

make me like him." In a brisk, satisfying diatribe, Gadsby pro-
ceeded to puncture every excuse that I made for the male artists
who had fascinated me—exploding, as if pricking balloons, the
myth of genius, the romanticization of madness, the notion that
there was a sort of troubled, disordered rule-breaking psyche for
whom abuse was inevitable, necessary, and maybe even a bit beau-
tiful. She painted a sympathetic but critical portrait of van Gogh:
He wasn't a mad genius ahead of his time, neglected by a cruel
public. In fact, his best work came less from his illness than from
his treatment—those sunflowers were inspired by the foxglove his
psychiatrist prescribed, which made him see bright yellow. If he
couldn't sell paintings, that was because he couldn't interact with
anyone, couldn't schmooze. It was his human connections—
particularly the compassion of his brother Theo—that made his
art possible, not his much-valorized alienation.

As for Picasso, he hated women. That was not such a contro-
versial statement. But for Gadsby, Picasso's hatred canceled out
the value of his paintings—and as she sketched out how she saw it,
she made the argument that Picasso's misogyny was *itself* a mental
illness. The difference was that misogyny was a sickness the world
excused. Picasso's mystique sold his art. She dwelled, with disgust,
on Picasso's seduction, when he was in his forties, of the seventeen-
year-old Marie-Thérèse Walter. She mocked Picasso's claim—
which was so similar to Polanski's claim about those private-school
girls—that he and Marie-Thérèse were ideal for each other. Like
Polanski, he had written that both of them, himself and his teen
lover, were "in their prime."

"I probably read that when I was seventeen. Do you know how
grim that was?" she fumed of that hard year, when she had been
vulnerable to the most hideous kind of exploitation. "There was
no view from my peak." It flashed me back to 1984, when I was
seventeen, earnestly marking up Roman Polanski's memoir, read-
ing John Updike, a passionate fan of Woody Allen. My life had
been much easier than Gadsby's; I was not, like her, afraid when I

was the only woman in a room of men. (I'd thrived on it.) Why did the show speak to me so directly, then? Part of it was her contagious anger. Part was her clarity, her willingness to draw lines where I kept trying to blur them. By the time Gadsby had come out as a lesbian, she pointed out, it was too late, because she was *already* homophobic, having soaked for so long in the prejudices of her family, her church, and her country—and that's how I felt, too, about the ideas I'd absorbed about art and genius, the ones that had formed my tastes, invisibly, impossible to see.

But, really, I think that it was Gadsby's refusal to charm that appealed to me. I'd spent my life fearing the role of the scold. I wasn't a stand-up comic, but I had a routine, too. So many of us do. There was a part of me that had always known how to tiptoe, tap-dance, to keep it light—to always calibrate my tone for fear that I would be viewed as a nag. *Nanette* was a show about the freedom that came from dropping that fear. She made the best case for embracing something a bit better than my inner Norman Mailer.

She modeled something else, too, even if that was not her intention. As discussion of her work began to spread, *Nanette* would get labeled many ways: as comedy, as anti-comedy, as a one-woman show. Certainly, it contained an argument for rejecting the art of men who hurt women. But it suggested the opposite approach, as well. *Nanette* was *itself* a form of arts criticism, after all—a passionate, informed work of analytical engagement with the art of terrible men. Through her granular, informed analysis of van Gogh and Picasso, Gadsby pushed the audience to see the artists through her eyes. Witchlike, she'd made them into her material rather than letting them turn her into theirs. "Hindsight is a gift," she chanted at the show's climax. "So stop wasting my time!" Her peak was now, she insisted. Looking back wasn't a bad thing. Struggling to see the frame all around you wasn't wrong. It was the only way to see the world more clearly.

In October, I saw Gadsby perform at a very different event, at

The Wing, a ridiculously swanky all-female work space that served rosé and had a bathroom labeled "No Man's Land." She opened with a joke about the fact that, in *Nanette,* she'd supposedly quit comedy. "I quit in the way that Louis C.K. said he was sorry, in the sense that I didn't really mean it." It got a big laugh. It was a clever line—a one-two punch line, a get-out-of-jail pass. That was what I wanted, too. Gadsby was, just at that moment, the hot new thing: She'd even performed at the Emmys. She was familiar enough that a month later, she'd be imitated on *Saturday Night Live.* Like Louis C.K., she had gotten famous in a way that made her a role model for an audience craving moral guidance. This was, for any artist, at once an opportunity and a risk.

Louis C.K. was performing again, too, more regularly. Soon, he'd do a seventy-minute set in France, once again the beloved auteur. His new girlfriend was a French stand-up comic. He was applauded on Long Island; he was heckled in Manhattan. During my final edits of this essay, a taped version of one of those Long Island gigs was leaked online. It was bitter, raging material, but also shockingly hacky. He made fun of the Parkland teen activists; he took lazy shots at millennials and made the kind of racist gags Louis had specifically set himself against, not long ago. "What are you going to do, take away my birthday?" he sneered.

Those of his fans who had clung, despite it all, to some foolish faith, who had believed, perhaps, that Louis C.K. might wait at least a year before starting over—that he'd speak directly into the problem, that he'd *own it,* somehow, that he'd find a way to make amends, or at least turn the truth into some kind of lacerating art, could see that that wasn't likely. Instead, the tide was pulling back from the shore. The portal seemed to be closing. Brett Kavanaugh was on the Supreme Court. We'd each have to figure out for ourselves where to draw that ethical line.

I had visited The Wing that night to look for an ending, but there wasn't one for me there. It's hard to find your footing as the ground is shifting. These days, we are all performing what a friend

of mine once called "the audit," struggling to reconcile the stories we used to tell ourselves with the ones we tell ourselves now. The fact that that's not possible doesn't make the process any less necessary. Woody Allen, the base coat to my comic sensibility, once wrote that "The wicked at heart probably know something." Grace Paley, a genius, had a different sort of wisdom: "You write what you don't know about what you know."

HOW JOKES WON THE ELECTION

How Do You Fight an Enemy Who's Just Kidding?

The New Yorker, January 23, 2017

After Donald Trump was elected president, in 2016, writing felt pointless—let alone writing arts criticism. Finally, at a Tim Hortons, during a Christmas visit to Canada, I managed to hammer out the section of this essay about Trump as a stand-up comic. The one section that I wish I could expand is about the relationship between TV news and TV comedy. Some days, watching Fox, it feels like the key to everything that has gone wrong.

Since November 8, we've heard a lot of talk about unreality, and how what's normal bends when you're in a state of incipient autocracy. There's been a lot written about gaslighting (lies that make you feel crazy) and the rise of fake news (hoaxes that displace facts), and much analysis of Trump as a reality star (an authentic phony). But what killed me last year were the jokes, because I love jokes—dirty jokes, bad jokes, rude jokes, jokes that cut

through bullshit and explode pomposity. Growing up a
in the 1970s, in a house full of Holocaust books, gigglii
Brooks's *The Producers,* I absorbed the impression that jo
Woody Guthrie's guitar, were a machine that killed fascist:
edy might be cruel or stupid, yet, in aggregate, it was the
stance. Nazis were humorless. The fact that it was mostly
who got to tell the jokes didn't bother me. Jokes were a supe
way to tell the truth—and that meant freedom for everyone.

But by 2016 the wheel had spun hard the other way: Now it w
the neofascist strongman who held the microphone and an arm
of anonymous dirty-joke dispensers had helped put him in office.
Online, jokes were powerful accelerants for lies—a tweet was the
size of a one-liner, a "dank meme" carried further than any op-ed,
and the distinction between a Nazi and someone pretending to be
a Nazi for "lulz" had become a blur. Ads looked like news and so
did propaganda and so did actual comedy, on both the right and
the left—and every combination of the four was labeled "satire."
In a perverse twist, Trump may even have run for president as pay-
back for a comedy routine: President Obama's lacerating take-
down of him at the 2011 White House Correspondents' Dinner.
By the campaign's final days, the race felt driven less by policy dis-
putes than by an ugly war of disinformation, one played for laughs.
How do you fight an enemy who's just kidding?

Obama's act—his public revenge for Trump's birtherism—was
a sophisticated small-club act. It was dry and urbane, performed in
the cerebral persona that made Obama a natural fit when he made
visits to, say, Marc Maron's podcast or Jerry Seinfeld's *Comedians in
Cars Getting Coffee.* In contrast, Trump was a hot comic, a classic
Howard Stern guest. He was the insult comic, the stadium act, the
ratings-obsessed headliner who shouted down hecklers. His rallies
boiled with rage and laughter, which were hard to tell apart. You
didn't have to think that Trump himself was funny to see this ef-
fect: I found him repulsive, and yet I could hear those comedy
rhythms everywhere, from the Rodney Dangerfield "I don't get no

...e to the gleeful insult-comic slams of Don Rickles
...uck," substitute "Pocahontas") to Andrew Dice Clay,
...en-up-it's-a-joke, it's-not-him-it's-a-persona brand of
...dominated the late 1980s. The eighties were Trump's
...e he still seemed to live. But he was also reminiscent of
...r comics who once roamed the Catskills, those dark and
...men who provided a cathartic outlet for harsh ideas that
...broke and reinforced taboos, about the war between men
...women, especially. Trump was that hostile-jaunty guy in the
...flappy suit, with the vaudeville hair, the pursed lips, and the
...are. There's always been an audience for that guy.

Like that of any stadium comic, Trump's brand was control.
He was superficially loose, the wild man who might say anything,
yet his off-the-cuff monologues were always being tweaked, per-
fected as he tested catchphrases ("Lock her up!"; "Build the wall!")
for maximum crowd response. On TV and on Twitter, his jokes let
him say the unspeakable and get away with it. "I will tell you this,
Russia, if you're listening—I hope you're able to find the thirty
thousand emails that are missing," he told reporters in July, at the
last press conference he gave before he was elected. Then he swept
his fat palm back and forth, adding a kicker: "I think you will prob-
ably be rewarded mightily by our press."

It was a classically structured joke. There was a rumor at the
time that Russia had hacked the DNC. At the same time, Hillary
Clinton's emails from when she was secretary of state—which
were stored on a private server—were under scrutiny. Take two
separate stories, then combine them: As any late-night writer
knows, that's the go-to algorithm when you're on deadline. When
asked about the remark on Fox News, Trump said he was being
"sarcastic," which didn't make sense. His delivery was deadpan,
maybe, but not precisely sarcastic.

But Trump went back and forth this way for months, a joker
shrugging off prudes who didn't get it. He claimed that his imita-
tion of the disabled reporter Serge Kovaleski was a slapstick take

on the reporter "groveling because he wrote a good story." ("Groveling," like "sarcastic," felt like the wrong word.) He did it when he said that Megyn Kelly had "blood coming out of her wherever"— a joke, he insisted, and he actually meant her nose. "I like people who weren't captured," about John McCain: That had the shape of a joke, too.

The Big Lie is a propaganda technique: State false facts so outlandish that they must be true, because who would make up something so crazy? ("I watched in Jersey City, New Jersey, where thousands and thousands of people were cheering as that building was coming down.") But a joke can be another kind of Big Lie, shrunk to look like a toy. It's the thrill of hyperbole, of treating the extreme as normal, the shock (and the joy) of seeing the normal get violated, fast. "Buh-leeve me, buh-leeve me!" Trump said in his act, again and again. Lying about telling the truth is part of the joke. Saying "This really happened!" creates trust between the comic and the people laughing, even if what the audience trusts you to do is to keep on tricking them, like a magician reassuring you that while his *other* jokes are tricks, *this* one is magic.

It could be surprisingly hard to look at the phenomenon of Trump directly; the words bent, the meaning dissolved. You needed a filter. Television was Trump's natural medium. And television had multiple stories that reflected Trump, or predicted his rise—warped lenses that made it easier to understand the change as it was happening.

No show has been more prescient about how far a joke can go than *South Park*. Its co-creators, the nimble libertarian tricksters Trey Parker and Matt Stone, could sense a tide of darkness that liberal comedians like John Oliver and Samantha Bee could not, because *South Park* liked to ride that wave, too. For two decades, *South Park*, an adult animated show about dirty-mouthed little boys at a Colorado school, had been the proud "anti-political-

correctness" sitcom. Season 19, which came out in 2015, was a meta-meditation on PC, and, by the season's end, one of the characters, Mr. Garrison, was running for president on a platform of "fucking immigrants to death." There was also a Canadian president that season, a character who emerged as "this brash asshole who just spoke his mind," the show explained. "He didn't really offer any solutions—he just said outrageous things. We thought it was funny. Nobody really thought he'd ever be president. It was a joke! But we just let the joke go on for too long. He kept gaining momentum, and by the time we were all ready to say, 'Okay, let's get serious now—who should really be president?' he was already being sworn into office."

Yet, as Season 20 opened, in September 2016, the show was doing precisely what a year earlier it had warned against: treating Garrison's Trump as an absurd, borderline-sympathetic joke figure, portraying him and Clinton as identical dangers, a choice between a "giant douche" and a "turd sandwich." Beneath that nihilism, however, *South Park* was on to something both profound and perverse. The fight between Trump and Clinton, it argued, could not be detached from the explosion of female comedy: It found its roots in everything from the female-cast *Ghostbusters* reboot to the anti-feminist Gamergate movement. Trump's call to Make America Great Again was a plea to go back in time, to when people knew how to take a joke. It was an election about who owned the mike.

In one plot, the father of one of *South Park*'s little boys is a misogynist troll who gets recruited by a global anonymous online army; in another, the boys and girls at the school split into man-hating feminists and woman-hating "men's rights" activists. Meanwhile, an addictive snack called Member Berries—they whisper "'Member? 'Member?"—fills the white men of the town with longing for the past, mingling *Star Wars* references with "'Member when there weren't so many Mexicans?" Mr. Garrison, as "Trump," rides this wave of white male resentment and toxic nos-

talgia. But the higher he rises, the more disturbed he is by the chaos he's unleashed. Desperate to lose, he imagines that if he finally offends his followers they won't vote for him.

Halfway through the season, Mr. Garrison's Trump appeared as a stand-up comic. As the crowd chants "Douche! Douche! Douche!" he struts onstage with a microphone, as cocky as Dane Cook. "So, I'm standing in line at the airport, waitin' in security because of all the freakin' Muslims," he begins, and then, when his fans hoot in joy, he tries for something nastier. "And the TSA security people all look like black thugs from the inner city, and I'm thinking, 'Oh, good, you're gonna protect us?'" When racist jokes get only bigger laughs, he switches to gags about sticking his fingers into women's butts and their "clams." Finally, some white women walk out. "Where did I lose you, honey?" he taunts them from the stage. "You've been okay with the 'Fuck 'Em All to Death' and all the Mexican and Muslim shit, but fingers in the ass did it for you. Cool. Just wanted to see where your *line* was."

As prescient as *South Park* could be, it clearly counted on Clinton's winning: A dirty boy requires a finger-wagging mom. After Election Day, the writers quickly reworked the show, and the resulting episode, "Oh, Jeez," exuded numbness and confusion. "We've learned that women can be anything, except for president," one character tells his wife and daughter. There were things *South Park* always had trouble imagining: It was complex and dialectical about male anger and sadness, and able to gaze with empathy into the soul of a troll, but it couldn't create a funny girl or a mother who wasn't a nag. That was the line *it* couldn't cross.

What it did get, however, was how dangerous it could be for voters to feel shamed and censored—and how quickly a liberating joke could corkscrew into a weapon.

In November, shortly after the host of *The Apprentice* was elected president, the troubled starlet Tila Tequila—herself a former

reality-TV star, one whose life had become a sad train wreck—blinked back onto the gossip radar. Now she was a neo-Nazi. On her Twitter account, she posted a selfie from the National Policy Institute conference, an "alt-right" gathering, where she posed, beaming a sweet grin, her arm in a Hitler salute. The caption was a misspelled "sieg heil." Her bio read "Literally Hitler!"

It was an image that felt impossible to decode, located outside the sphere of ordinary politics. But Literal Hitler was an inside joke, and it was destabilizing by design; as with any subcultural code, from camp to hip-hop, it was crafted to confuse outsiders. The phrase emerged on Tumblr to mock people who made hyperbolic comparisons to Hitler, often ones about Obama. Then it morphed, as jokes did so quickly last year, into a weapon that might be used to mock any comparisons to Hitler—even when a guy with a serious Hitler vibe ran for president, even when the people using the phrase were cavorting with Nazis. Literal Hitler was one of a thousand such memes, flowing from anonymous Internet boards that were founded a decade ago, a free universe that was crude and funny and juvenile and anarchic by design, a teenage-boy safe space. The original version of this model surfaced in Japan on the "imageboard" 2chan. Then, in 2003, a teenager named Christopher Poole launched 4chan—and when the crudest users got booted they migrated to 8chan, and eventually to Voat.co. For years, those places had mobbed and hacked their ideological enemies, often feminists, but they also competed for the filthiest, most outrageous bit, the champion being whatever might shock an unshockable audience. The only winning move was not to react.

In "An Establishment Conservative's Guide to the Alt-Right," two writers for Breitbart mapped out the alt-right movement as a patchwork of ideologies: There were "the Intellectuals," "the Natural Conservatives," men's-rights types, earnest white supremacists, and anti-Semites (whom the authors shrug off as a humorless minority), and then the many invisible others—the jokers, the vir-

tual writers' room, punching up one another's g.
take, this was merely payback for the rigidity of ic
"If you spend seventy-five years building a pseudo-relig
anything—an ethnic group, a plaster saint, sexual chast.
Flying Spaghetti Monster—don't be surprised when clever nir.
year-olds discover that insulting it is now the funniest fuck
thing in the world," the article states. "Because it is."

2016 was the year that those inside jokes were released in the wild. Despite the breeziness of Breitbart's description, there was in fact a global army of trolls, not unlike the ones shown on *South Park*, who were eagerly "shit-posting" on Trump's behalf, their harassment an anonymous version of the "rat-fucking" that used to be the province of paid fixers. Like Trump's statements, their quasi-comical memeing and name-calling was so destabilizing, flipping between serious and silly, that it warped the boundaries of ordinary discourse. "We memed a president into existence," Chuck Johnson, a troll who had been banned from Twitter, bragged after the election. These days, he's reportedly consulting on appointments at the White House.

Last September, Donald Trump, Jr., posted on Instagram an image of Trump's inner circle, which included a cartoon frog in a Trump wig. It was Pepe the Frog, a benign stoner-guy cartoon that had been repurposed by 4chan pranksters—they'd photoshopped him into Nazi and Trump drag to mess with liberals. Trump trolls put Pepe in their avatars. But then so did literal Nazis and actual white supremacists. Like many Jewish journalists, I was tweeted images in which my face was photoshopped into a gas chamber—but perhaps those were from free-speech pranksters, eager to spark an overreaction? It had become a distinction without a difference. The joke protected the non-joke. At the event that Tila Tequila attended, the leader shouted "Heil Trump!"—but then claimed, in the Trumpian manner, that he was speaking "in a spirit of irony." Two weeks ago, the Russian embassy tweeted out a smirking Pepe. The situation had begun to resemble an old story

CH

fake-news site, *The Onion:* "Ironic Porn Purchase
nic Ejaculation."

s a scene in the final season of *Mad Men* in which Joan and
gy, former secretaries, have risen high enough to be paired as a
reative team. It's 1970; the feminist movement finally has the pull
to be threatening. (Earlier, it was a punch line: "We'll have a civil
rights march for women," Peggy's left-wing boyfriend, Abe, said,
laughing.) They sit at a conference table to meet their new bosses,
three frat-boy suits from McCann Erickson. "Well, you're not the
landing party we expected," one of them says.

The account is Topaz pantyhose, a competitor of the newly
global L'eggs. "So they're worried that L'eggs are going to spread
all over the world?" one man says with a leer. "That wouldn't
bother me at all." It's a joke delivered past the women to the other
men, who chuckle and make eye contact. Peggy and Joan smile
politely. It goes on like that: The women's pitches slam against a
wall, because the men are one another's true audience. "Would
you be able to tell them what's so special about your panties?" they
ask Joan. She can be crude or elegant, she can ignore them, or she
can be a "good sport." But every path, she knows from experience,
leads to humiliation.

Afterward, Joan and Peggy stand in the elevator, fuming. "I
want to burn this place down," Joan says. They have an argument—
they fight about Peggy being homely and Joan hot, how each of
them dresses and why. The argument has the same premise as the
jokes: How men see you is all that matters. Knowing what's wrong
doesn't mean you know how to escape it.

I thought of that scene the first time I saw the *Access Hollywood*
tape, the one that was supposed to wreck Trump's career, but
which transformed, within days, on every side, into more fodder
for jokes: a chance to say "pussy" out loud at work, the "Pussy
Grabs Back" shirt I wore to the polls. In the tape, Billy Bush and

Trump bond like the guys at McCann Erickson, but it's when they step out of the bus to see the actress Arianne Zucker that the real drama happens. Their voices change, go silky and sly, and suddenly you could see the problem so clearly: When you're the subject of the joke, you can't be in on it.

The political journalist Rebecca Traister described this phenomenon to me as "the finger trap." You are placed loosely within the joke, which is so playful, so light—why protest? It's only when you pull back—show that you're hurt, or get angry, or try to argue that the joke is a lie, or, worse, deny that the joke is funny—that the joke tightens. If you object, you're a censor. If you show pain, you're a weakling. It's a dynamic that goes back to the rude, rule-breaking Groucho Marx—destroyer of elites!—and Margaret Dumont, pop culture's primal pearl-clutcher.

When Hillary described half of Trump's followers as "deplorables," she wasn't wrong. But she'd walked right into the finger trap. Trump was the hot comic, Obama the cool one. Hillary had the skill to be hard-funny, too, when it was called for: She killed at the Al Smith charity dinner in New York, while Trump bombed. It didn't matter, though, because that was not the role she fit in the popular imagination. Trump might be thin-skinned and easily offended, a grifter CEO on a literal golden throne. But Hillary matched the look and the feel of Margaret Dumont: the rich bitch, Nurse Ratched, the buzzkill, the no-fun mom, the one who shut the joke down.

On "The Waldo Moment," an episode of the British show *Black Mirror,* a miserable comic named Jamie is the voice behind Waldo, an animated blue bear whose specialty is humiliating public figures. His act is scatological and wild, in the tradition of Ali G and Triumph the Insult Comic Dog, as well as the meaner correspondents on *The Daily Show.* It's ambush comedy, taking the piss. But Jamie's bosses, who are hip nihilists with their eye on the bottom

line, see greater potential for profit: Online, an act like Waldo can go viral, jumping live from phone to phone.

As a gag, they run Waldo for Parliament, just as Stephen Colbert once started his own satirical super PAC. Jamie has no true politics—"I'm not dumb or clever enough to be political," he protests—but his crude attacks take off. He becomes a populist sensation, like Trump: He's the joke that's impossible to fight. The politicians he's attacking are required to be serious, both the Tory stuffed shirt and the young female Labour upstart, who is dryly funny in private but can't risk showing it in public. A blue bear doesn't need to follow rules, however. Since Waldo attacks phonies—and is open about his own phoniness, including the fact that he's a team effort—viewers find him authentic. Even a brilliantly acerbic chat-show interrogator can't unseat him, because Jamie's got so much more bandwidth. He's allowed to curse, to be stupid, to be angry—the fight is fixed in his favor, because all the emotion belongs to him.

"The Waldo Moment" came out in 2013. By then, viewers had spent years getting their news delivered via comedy, and vice versa. Jon Stewart was two years from retirement; Colbert would soon jump to CBS. Newspapers, starved of print ads, had died years before—or been shoved into the attention economy, where entertainment mattered most. Online, all clicks were equal. Breitbart got traffic off quasi-comical headlines; the conspiracy theorist Alex Jones screamed on his livestream like Sam Kinison. It was no great leap for paranoid delusions, like Pizzagate, or deliberate hoaxes, like the one about the pope endorsing Trump, to pass muster on Facebook, because the design made all newslike items feel fungible. On both the left and the right, the advertising imperative was stronger than the ethical one: You had to check the URL for an added ".co" to see if a story was real, and how many people bothered to do that? If some readers thought your story was a joke and others thought it was outrageous, well, all the better. Satire was what got traffic on Saturday night.

Black Mirror was a more humane show than *South Park:* It could imagine a funny woman in the world. But like *South Park, Black Mirror* could see far, but not all the way to the end. Waldo, who has come in second in the election, gets acquired by sinister global-capitalist forces, which recognize that his Pepe-goofy image is the ideal mask for fascist power. As a militarized police force rousts homeless people from an alley, Waldo gleams from billboards, his message having pivoted to "Hope." When the episode came out, it was divisive: Some viewers found it overly cynical in its portrait of the mob. Now it seems naive: The creators did not imagine that Waldo might win—or that the person controlling him might *want* to win. Like Mr. Garrison, like the shysters in *The Producers,* Jamie tries desperately to escape the prank persona that he's created. But when he shrieks "Don't vote for me!" the audience only laughs; when he flees the van in which he's performing, his boss takes over the voice of Waldo. It's only when Jamie threatens to disrupt the show, attacking the screen on which Waldo appears, and the blue bear orders the crowd to beat him up, that people stop laughing.

When Vladimir Putin was elected president in 2000, one of his first acts was to kill *Kukly,* a sketch puppet show that portrayed him as Little Tsaches, a sinister baby who uses a "magic TV comb" to bewitch a city. Putin threatened to wreck the channel, NTV, unless it removed the puppet. NTV refused. Within months, it was under state control. According to *Newsweek,* "Putin jokes quickly vanished from Russia's television screens."

Soon after Trump was elected, he, too, began complaining about a sketch show: *Saturday Night Live,* which portrayed him as a preening fool, Putin's puppet. His tweets lost the shape of jokes, unless you count "not!" as a kicker. He was no longer the blue bear. Instead, he was reportedly meeting with Rupert Murdoch about who should head the FCC. Soon, Trump would be able to shape deals like the AT&T/Time Warner merger, to strike back at

those who made fun of him or criticized him, which often amounted to the same thing. Fox would likely be Trump TV.

Last week, at his first press conference as president-elect, Trump made no jokes. He was fuming over the *BuzzFeed* dossier and all those lurid allegations worthy of *South Park*, the pee jokes lighting up Twitter. Only when he reminisced about his rallies did he relax, recalling their size, the thrill of the call and response. He almost smiled. But when CNN's Jim Acosta tried to ask a question about Russia, Trump snapped back, furiously, "Fake news!"—and the incoming White House press secretary, Sean Spicer, told Acosta that if he tried that again he'd be thrown out. Now, it seems, is when Trump gets serious. A president pushes buttons in a different sense. As Putin once remarked to a child, "Russia's borders don't end anywhere"—before adding, "That's a joke."

BREAKING THE BOX

LOVE, ACTUALLY

Jane the Virgin

The New Yorker, March 12, 2018

This entire book was inspired by an exchange I had with a young female staffer at *The New Yorker* who told me—with an embarrassed shrug—that all she watched were "guilty pleasures, like *Jane the Virgin*." I proceeded to deliver an extended, crazy monologue about how, no, that was one of the best shows on television, which she found either supportive or terrifying.

A few weeks ago, The CW aired a perfect episode of *Jane the Virgin*, directed by its star Gina Rodriguez. It had five plots, ranging from poignant to zany. Each scene was tinted in pastels, like a plate of macarons. There were two gorgeous dresses and three hot consummations, plus a cliff-hanger, several heart-to-hearts, and Brooke Shields getting attacked by a wolf on live TV. As usual, the world took all this perfection for granted.

Jane the Virgin, which debuted in 2014, is an extremely loose adaptation of a Venezuelan telenovela in which a poor teenager has the ultimate "whoops" pregnancy: She's accidentally impregnated via artificial insemination, then falls for the wealthy bio dad. For the American version, the creator, Jennie Snyder Urman, added a fabulous framing device—a Latin-lover narrator who punctuates his remarks with the refrain "Just like a telenovela, right?" An excitable fanboy who tosses out Twitter hashtags like confetti, the narrator (voiced by the very funny Anthony Mendez) works as a bridge to the globally popular genre, but he also helps link it to other women's "stories": the soap, the rom-com, the romance novel, and, more recently, reality television. These are the genres that get dismissed as fluff, which is how our culture regards art that makes women's lives look like fun. They're "guilty pleasures," not unlike sex itself. Women use this language, too—even Rodriguez, in interviews, has compared her show to red-velvet cupcakes and Justin Bieber.

In fact, *Jane the Virgin* is more like a joyful manifesto against that very put-down, a bright-pink filibuster exposing the layers in what the world regards as shallow. When the American version begins, Jane is twenty-three, living in Miami, and still a virgin, torn between her devout Catholic grandmother and her wild-thing mom, who had her at sixteen. Her soul mate, Rafael, is a roguish hotel heir—and the show gives him meaningful competition, in the form of a nice-guy detective, Michael, whom Jane eventually marries. But, in four seasons, the show has expanded far beyond that formative love triangle. Jane has been a single mom, a happily married woman, and a devastated widow. The virgin part disappeared in Season 3, the word scratched out every week in the titles.

Beyond these plot tweaks, however, the show made a bolder move, crosshatching the narrative with self-referential inventions, frame inside frame inside frame. Jane, her *abuela* Alba, and her mother, Xiomara, relax by watching telenovelas, just as the Gilmore girls once watched screwball comedies. Jane's ambition is to

write romance novels—and, when she goes to grad school, she spars with a romance-hating feminist professor, played by the show's frequent director, Melanie Mayron (Melissa Steadman on *Thirtysomething*). Jane's long-lost father, Rogelio De La Vega (Jaime Camil), is the hilariously vain star of the telenovela *The Passions of Santos* (and, for a while, of a reality show called *De La Vega-Factor Factor*, along with a matchmaker named Darci Factor). This season, the U.S. version of *The Passions of Santos* has been picked up—on the condition that it also features Rogelio's latest nemesis, America's sweetheart River Fields (Shields, naturally), star of *The Green Lagoon*.

The meta television show is hardly a new invention. And, in one sense, *Jane* is simply the latest in a tradition of ambitious shows that both emulate and deconstruct established TV genres, from *Mary Hartman, Mary Hartman* (daytime soaps) to *BoJack Horseman* (nineties sitcoms). But one of the striking things about *Jane the Virgin* is that it is never truly ironic, let alone condescending to its source material. It is a deeply heartfelt production, sweet without being saccharine, as well as sophisticated about and truly interested in all the varieties of love, from familial to carnal. It's a smart show that parents and teenagers can watch together—which, in a better world, might be a recommendation to a larger audience. Although it employs all the tools of high melodrama—evil twins, gaslighting—it doesn't have a camp sensibility. Instead, it ballasts the most outrageous twists with realistic emotional responses. How would you feel if your twin stole your identity and drugged you into paralysis, thus intensifying your postpartum depression? This is one show that will take your trauma seriously.

The performances are equally layered, particularly a breakout one by Yael Grobglas, as both Petra, Rafael's ex-wife, and Anezka, the aforementioned evil twin. A Czech street hustler turned glam hotelier, Grobglas's Petra glides from Carole Lombard daffiness to Grace Kelly hauteur, noir to slapstick to heartbreak, often within a scene. For two seasons, I kept forgetting that the twins were played

by one person, let alone one person acting like one character pretending to be the other character pretending to be the first character.

Without a marquee director in the credits, *Jane* rarely comes up in conversations about visually provocative television, but it should: It has an unusual optical density, somehow managing to be simultaneously meditative and manic. Spanish speakers, like Alba, get subtitles. But other captions bubble across the screen, to underscore plot points or to add visual punch lines: The "one hour later" that stripes a set of double doors cracks in half when a character walks through them. Rogelio's overeager tweeting provides entire subplots. When lovers text, words appear and disappear as they edit, letting us enter their thoughts.

And then there's the show's frequent backdrop, the Marbella hotel, a dreamy castle full of turquoise sofas. Color is a huge part of the show's appeal: Hearts throb pink when people are in love; Rogelio's lavender accessories are flags for his moods. Lacking the big bucks of pay cable, *Jane* turns The CW's limitations into advantages, making elegant use of the screen, often through a kind of flirtatious denial. When Jane gazes to her right during a dinner at the Marbella, her face blocks our view of the seductive text that Rafael has sent her. When the two finally make love, we get mere flashes of flesh in the shower: her arm, his back, her hip. "Come on, I can't show you everything," the narrator tells us. "We're not on HBO."

Despite that meta wisecrack, that sex scene is genuinely steamy, and not just because it's set in a shower: It's the consummation of an attraction that has lasted four seasons. Telenovelas have a long tradition as transmitters of social messages; in Mexico, the government used hit shows as vehicles to advocate for family planning. Our own government would surely deplore the messages *Jane* sends: Like the Netflix series *One Day at a Time*, it puts Latino im-

migrants, including undocumented workers, at the center of the story. It also goes deep on women's health, with plots that include Jane's struggle to breastfeed and a crisp, unapologetic story about abortion. Once in a while, there's a corny note of edutainment— a bisexual-boyfriend plot had this vibe—but it's a rarity.

Still, there's a tricky tension in the show between its family-time warmth and its fascination with sex itself, a subject that it has examined seriously, and increasingly graphically, in a way that many theoretically adult shows do not. *Jane* is respectful to the devout Alba (wonderfully portrayed by Ivonne Coll), who crumpled a flower and told Jane that that was her virtue, if she gave it away. But it's also an advocate for moving past shame. In that same perfect episode, the one in which Jane and Rafael finally get it on, there's a story in which Alba confesses the real reason that she ended things with her boyfriend, once he proposed: She's frightened of sex, having not had it for thirty years. "You get used to things—or not having things," she tells her granddaughter, in a moving, simple sequence. Jane argues that her *abuela* isn't, as she sees herself, "broken"—but her solution is not to tell Alba to jump in bed with a man but to take her shopping for a vibrator and some lubricant. In that montage of three sexual awakenings, the septuagenarian gets one of them. Refreshingly, the moment is not played for laughs: In Jane's world, sex, like love, is a bright color that everyone deserves to see.

RETURN OF THE REPRESSED

The Comeback

The New Yorker, November 17, 2014

An unappreciated minor miracle of a show that taught me a lot about TV-making.

HBO's *The Comeback,* which was co-created by Lisa Kudrow and Michael Patrick King, ran for one razor-sharp season, in 2005. Luckily, largely owing to HBO GO, the series outlived its cancellation. Among comedy cultists, it gained a reputation as the great lost cringe comedy, at once hilarious and heartbreaking, with Kudrow's Valerie Cherish, a washed-up sitcom star, the peer of Larry David in *Curb Your Enthusiasm* and David Brent in the British version of *The Office.* Like those two shows, *The Comeback* was done as fake cinema verité: It purported to be the "unedited footage" of a reality show that documented the production of a sitcom, *Room and Bored,* that Valerie hoped would make her a star again. Instead, she finds herself cast as Aunt Sassy, a dirty-joke sidekick. As the writers turn against her, Valerie steps into trap after trap, until, by the finale, she's so desperate to be liked that she stage dives into humiliation, signing vomit bags for reality fans.

Then, last year, a miracle happened: a resurrection. Ne decade after canning the series, HBO agreed to produce a co back of *The Comeback*—a second season with the same core c: The result, which debuted last weekend, is as spiny and audaciou as the original, but very different, because it isn't aimed at "celeb-reality" or network sitcoms, now dated targets. Instead, King and Kudrow go for something with more cachet: the auteurist pay-cable antihero series. In the first episode, as Valerie prepares to pitch a new reality series to Bravo, she discovers that there's already a show in development based on her life—*Seeing Red*, an HBO dramedy, created by her former nemesis, the sitcom writer Paulie G. It's a scripted re-creation of the terrible events of the original *Comeback*, but this time, from Paulie's perspective. Naturally, Valerie ends up starring in the show, as Mallory Church, in a red wig that looks exactly like her own red hair, insisting, once again, that the character she's playing is nothing like her.

It's important to note that every bit of this plot is absurdly self-referential, like a blind item of TV sitcom history. In the nineties, Kudrow starred on *Friends*, which inspired a lawsuit over a sexist writers' room whose members, like those on the fictional *Room and Bored*, blew off steam by fantasizing about the sexual humiliation of the show's actresses. *Seeing Red* is an HBO dramedy inside an HBO dramedy. Michael Patrick King was the showrunner for *Sex and the City:* when the self-involved Valerie spots a poster for that show in HBO's halls, she coos that now she'll be "one of the girls." (She hasn't seen "Lela Durham's *Girls*," but she's heard good buzz.) Bravo's Andy Cohen plays himself; Seth Rogen plays Seth Rogen, who plays Paulie in *Seeing Red*. When observers praise Valerie for her "real" looks and her "brave" performance, it echoes the coded praise that Kudrow received for *The Comeback*.

If you're a certain type of reader, this description may make you recoil—so "meta," so "ironic," so many "air quotes." *The Comeback* is, it's true, a scripted series about a reality series about a reality star making a scripted series about the time she made a real-

ow about a scripted series. It's less a hall of mirrors than a doscope, with each surface reflecting a TV set. But it's worth nembering that meta-comedy isn't a modern innovation: *I Love ucy,* the original sitcom, was a meta-comedy fueled by the contrast between Lucy Ricardo's desperation for fame and Lucille Ball's actual fame. In the decades since Lucy threw her first tantrum, the anger of TV writers, and their frustration at TV's limitations, has inspired a startling proportion of TV's best comedies. *Monty Python* mocked the pomposity of the BBC; *All in the Family* exploded *Father Knows Best; 30 Rock* took aim at NBC. *The Dick Van Dyke Show* was Carl Reiner's attempt to exorcise the experience of working on Sid Caesar's *Your Show of Shows,* and Dan Harmon's *Community* is, often enough, a show about how difficult it is to make *Community* with Dan Harmon. At their best, such shows double as manifestos against broken systems—they're do-overs for traumatized creatives, who, like Valerie, keep reliving the same painful story, hoping to find a better ending.

Certainly, that's part of what made the original *Comeback* so pungent: It was a denunciation of a new genre—the star-studded reality show—that fed on L.A. desperation and threatened the livelihood of writers. It was also a searing critique of the crazy-making environment for older actresses. Halfway through the first season, Valerie—whose complaints about crass gags alienated the men who wrote them—went to the writers' room, at 2 A.M., carrying cookies, hoping to make amends. As reality cameras peeked through the blinds, she caught a glimpse of the phenomenon that the director James Burrows (who played himself) described as "The Hate Show." The writers were miming rough sex with Valerie: One pulls an orange T-shirt over his head to simulate her hair while another bends "Valerie" over the table. The sole "girl writer" watches silently. Valerie's response is to act as if this wasn't happening—or, really, that if it was happening, it was no big deal. But her facial expression was cracked glass. It's the explicit form of Aunt Sassy's catchphrase: "I don't need to see that."

In the new season, Valerie faces similar pressures, but in an entirely different context. There is no writers' room anymore. Instead, Paulie G, who has been through rehab for heroin addiction, is a freshly anointed cable auteur, writing each episode himself, and directing, too, even though he has no experience behind the camera. Being on HBO gives Valerie, as well as her reality producer, the opportunity to get a big paycheck, plus tickets to the Golden Globes.

But "prestige dramedy" turns out to have its own humiliations. In *The Comeback*'s standout sequence, Valerie films the sort of graphic sex scene that's become a numbing cable convention. It's a two-minute-long, mostly wide-frame shot in which Valerie, clothed as Aunt Sassy, stands flanked by two naked porn actresses, who moan orgasmically; the moment is equally hilarious and excruciating. It's meant to paralyze the viewer, presenting a critique that doubles as the thing being critiqued. But Valerie also knows enough not to complain, and always to praise those naked girls: "So free! So beautiful, really." Her job, she's learned by now, is to be a good sport. Any hint of resistance might get her tagged as "difficult."

There are plenty of shows that this sequence echoes, but the one that immediately came to mind was Showtime's *Californication,* whose recent final season was also about a womanizing addict (David Duchovny, as the novelist Hank Moody) writing for an antihero series. Like the HBO show *Entourage* (which debuted a year before *The Comeback*), *Californication* was a meta-comedy that featured celebrities doing playful takedowns of their images, insider references to Hollywood decadence, and female characters who were friendly bimbos and feminist sharks, the latter of whom generally stripped down to reveal their inner bimbo. *Californication* became a toxic mess, reducing great actresses like Kathleen Turner to roles as one-note ballbusters. In the final season, the wonderful Mary Lynn Rajskub showed up in the mortifying guise of "girl writer" Goldie, who was whiny, allergic to everything, and

obsessed with the idea that she wasn't hot enough for the show-runner. It felt like the opposite of *The Comeback*: a season of television that happily fellated the corrupt system that it pretended to satirize. Only one of these shows is still on TV. Progress!

The original *Comeback* may have emerged too early, before the rise of the modern comedic antiheroine. But even among that sorority, Valerie is a creature unlike any other. With her Katharine Hepburn warble and her synthetic grin, Kudrow's Valerie is a marvel: Her performance continually veers toward cruel camp, and then shivers with vulnerability. Like Holly Golightly before her, Valerie is no phony, because she's a *real* phony. From a certain angle, even her narcissism begins to seem valiant—it's a stubborn resistance to an industry that wishes she'd disappear. If Valerie has had a lifelong staring contest with the camera, she won't be the first to blink.

SHEDDING HER SKIN

The Good Wife

The New Yorker, October 13, 2014

I've written about *The Good Wife* a few times; in another column, I called it "*The Wire* for the digital divide."

Unlike most art forms, a network TV series is always under construction. Each week, it reacts to us reacting to it, throwing out bids for higher ratings, or shoving popular couples into the spotlight, or ejecting actors caught in scandals. When it's a particularly thoughtful show, it also reflects the world beyond Hollywood. It's the rough draft that doubles as the published product.

At least, that's what TV used to be—these days, God knows, anything goes. Netflix releases whole seasons at once, greenlighted by algorithm; that's how we got Jenji Kohan's *Orange Is the New Black*. Amazon has become a patron of indie directors, with customers voting on pilots; that's how we got Jill Soloway's *Transparent*. Vimeo and Hulu are suddenly studios; the "anthology" series is back in vogue. On pay cable, Hollywood directors who once sniffed at TV offer up their names as marquee brands. Even the definition of an episode is in flux.

Perhaps that's why, as I clicked "Play" on the sixth season of *The Good Wife*, the CBS series that is the smartest drama currently

on the air, I felt a twinge of protective nostalgia. After a great season, the show didn't even get nominated for best drama at this year's Emmys (although the snub might be a point of pride: *The Wire* was never nominated for best drama). As sharp as *The Good Wife* is, it lacks nearly all the Golden Age credentials. The series's showrunners, Robert and Michelle King, a married couple, don't have a pugnacious-auteur reputation or Hollywood glamour. They're collaborative workhorses, producing twenty-two hour-long episodes a year, more than twice as many as their peers on HBO, FX, or AMC. (*True Detective* had eight episodes; *Fargo* ten.) Their series debuts every September, on schedule—no year-and-a-half-long hiatuses for them to brood about artistic aims. And on network television there are ads, and pressure for product integration, and the expectations of a mass audience (must be clear, must be exciting, must be familiar, must be appealing), and the strict rules that are implicit in corporate culture—all of which would be difficult even if CBS didn't keep bumping *The Good Wife* back by forty minutes for football.

Six seasons in, however, I've become weary of evangelizing for the show. Recently, I had lunch with an entirely charming TV-maker, who was educated and intelligent about many forms of television but had never watched *The Good Wife*, because, he admitted with a shrug, he perceived it as being "for women." Although he was a fantastic lunch companion, he's dead now. In any case, here's a primer, if you're a newcomer: In the first season, we met Alicia Florrick (Julianna Margulies), the wife of state's attorney Peter Florrick, who gave up her fledgling legal career to raise a family. When Peter was nailed for hookers and graft—Eliot Spitzer–style—Alicia became a working mother, a first-year associate at a Chicago firm called Stern, Lockhart & Gardner. She didn't get the job because she was exceptional: An old law-school friend, Will Gardner (Josh Charles), had promoted her over stronger candidates after she strategically flirted with him—a shady origin story that emerged slowly, over years. On *The Good Wife*, there is

ss without corruption. The higher Alicia climbs—winning
cond-year slot, making partner, leaving to start a new firm—
more compromised she becomes, and the more at ease with
ompromise. This applies to her marriage, also: It's too valuable
an asset for either spouse to abandon, even when they separate,
when he is elected governor, and when she has an affair with Will.
"You're a brand! You're St. Alicia," Eli Gold, her husband's chief of
staff, tells her, begging her to run for office. Yet, despite every-
thing, Alicia, an atheist, clings to her self-image as a heroine, a
moral person in a godless universe.

That's the big picture, but, episode by episode, the Kings have
shown themselves to be unusually flexible and pragmatic TV-
makers, taking risks, then backpedaling quickly when they fail, as
with a repellent *Fifty Shades of Grey*–ish plot about the firm's inves-
tigator, Kalinda Sharma, which was written out when the audi-
ence rebelled. The show's structure is classical, built on the model
pioneered by *The X-Files*: There are "case of the week" plots mixed
with season-long stories, which in turn echo within the larger arc
of Alicia's transformation—into what, we don't yet know. But *The
Good Wife* resists formula at every step. The Kings go grand, then
tiny, staccato to legato, turning network necessities into artistic
virtues. Pressures that crush other TV shows inspire clever work-
arounds. Take, for instance, the *SVU*-inflected cases that have
popped up in recent seasons—plots that could turn sleazy, like lu-
crative clients a firm takes to bankroll pro-bono work. Instead, the
Kings have found fresh angles on pulp material, blending such sto-
ries with their trademark ones about Silicon Valley and technol-
ogy, often using memorable characters like the creepy wife-killer
Colin Sweeney (the great Dylan Baker).

Such broader moments also act as camouflage for the show's
strength, its sneaky long-fuse subtlety, especially a technique in
which the Kings plant a story, bit by bit, then expose a pattern. One
of the most striking such plots occurred in Season 3, when Peter
Florrick, at that time the state's attorney of Cook County, had a

series of run-ins with black employees, none of which seemed like a big deal—only to have their firings suddenly seem, to those outside the office, to be evidence of institutional bias. The story was different from blunter TV portraits of racism: Peter didn't think of himself as bigoted, but his enemies weren't wrong. It was a smart take on the way that organizations can harbor racism without any individual being overtly hateful.

Last season's even more audacious arc was a timely satire of the NSA, Strangelovian in tone. As with the race plot, the idea had been planted in advance, in sequences that felt at first like comic side plots. When Alicia's teenage son's girlfriend, whose parents are Somali, weeps on his voicemail after they break up, her recurrent hang-ups are misinterpreted by the NSA as hints of potential terrorism—which gives the agency an excuse to eavesdrop on everyone linked to the Florricks. The entire fifth season was bracketed by scenes set in the NSA's blank cubicles, not among bigwigs but among nonentities: two Rosencrantz-and-Guildensternesque geeks who, when not trading viral videos, listen in on Alicia's calls. They get so caught up in the Florrick story line that they become, essentially, *Good Wife* fans. And while their spying is insidious, it isn't some grand conspiracy, as it might be on *Homeland* or *House of Cards*. The first tap simply leads to the second, which leads to a "three-hop" ruling, which leads to absolute surveillance of all things public and private.

Then, two-thirds of the way through last season, the Kings made a risky, potentially audience-alienating move: They killed off a central character, Will, Alicia's former partner and seeming soul mate. The decision was pragmatic: Josh Charles wanted out of the role. But instead of playing as cheap melodrama, his death reinvented the series. It destroyed the most obvious path to a happy ending. It also, daringly, broke *The Good Wife*'s link to a feminine TV narrative formula: the love triangle—the secret sauce for

many female fans. The episodes that followed felt wild and unpre-
dictable. Alicia spun out. She formalized her marriage as an "ar-
rangement." And, in a hilarious turn, she became addicted to a
cable drama, a series called *Darkness at Noon*, a satire of the AMC
series *Low Winter Sun* (although it suggested other ponderous dra-
mas as well). "People just think there are black hats and white hats,
but there are black hats with white linings. And white hats with
black linings," the show's existentialist hero droned to a mutilated
female corpse. "And there are hats that change back and forth
between white and black. And there are *striped* hats." Alicia binge-
watches the cable show with glazed eyes, drinking deeply from
her perpetual goblet of red wine.

The new season begins with an alarming change of venue:
Cary Agos, Alicia's law partner, has been thrown into prison, the
target of drug charges. Alicia is under pressure of a different type,
manipulated by multiple forces to run for state's attorney. ("People
think you're important enough to bribe," Eli Gold tells her, in
what might be the show's ultimate compliment.) There's a sudden
influx of new lawyers into her firm, including an African Ameri-
can attorney played by Taye Diggs and several female and minor-
ity staffers, who are drawn by the promise of a diverse start-up. It's
impossible to predict a plot arc after two episodes, but all signs
point to something involving Draconian drug laws, militarized
cops, the prison system, and perhaps a reexamination of the racial
questions the show raised, then neglected. At the center of all this
is the sinister Lemond Bishop, a character who bears a resem-
blance to *The Wire*'s Stringer Bell: He's a drug dealer with a public
life as a respectable businessman. He's also a man whose facade,
like Alicia's, falls apart when you follow the money.

The Good Wife will always have an element of fantasy: Among
other things, its Chicago features an unusual number of slinky
lesbians in uniform, the better for the noirish investigator Kalinda
to hook up with. But the series is also a model of how strict
boundaries—the sort that govern sonnets—can inspire greater

brilliance than absolute freedom can. In 2009, the show might have looked much like an empowerment procedural for the ladies, a *Lean In* fairy tale about a strong woman who would find her way. Instead, it's revealed itself to be a sneaky condemnation of pretty much every institution under capitalism. Marriage is one of those institutions, of course. And so is television.

CASTLES IN THE AIR

Adventure Time

The New Yorker, April 21, 2014

This is one of my favorite shows. It's also one of many brilliant animated series, including *BoJack Horseman, Archer, Bob's Burgers,* and *Steven Universe,* that rarely get enough credit for sophisticated television-making.

The animated series *Adventure Time,* now entering its sixth season on Cartoon Network, is the kind of cult phenomenon that's hard to describe without sounding slightly nuts. It's a post-apocalyptic allegory full of dating tips for teenagers, or like *World of Warcraft* as recapped by Carl Jung. It can be enjoyed, at varying levels, by third-graders, art historians, and cosplay fans. It's the type of show that's also easy to write off as "stoner humor," which may be why it took me a while to drop the snotty attitude, open up, and admit the truth: *Adventure Time* is one of the most philosophically risky and, often, emotionally affecting shows on TV. It's beautiful and funny and stupid and smart, in about equal parts, as well as willing to explore uneasy existential questions, like what it means to go on when the story you're in has ended.

If that sounds pretentious, there's a simpler way to watch the

show: as a cartoon about a hero who fights villains, with fun vio-
lence, fart jokes, and a slight edge of Bushwick cool-kid hipness.
When it began, in 2010, *Adventure Time* stuck more closely to a fa-
miliar formula, in which a good-hearted human boy named Finn
and his dog, Jake, a gruff-voiced wingman type, were brought up
as siblings. For no clear reason, Jake can stretch to any length and
alter his body, extending his front leg to make a bridge, blowing up
to mountain size, or turning himself into an armchair. Finn and
Jake's friendship has a classic nerd-and-his-id dynamic, a bit like
Calvin and Hobbes, in which a wild animal encourages his friend
to go on adventures and cheers him on with girls (among them,
the scientist-princess Princess Bubblegum). Online summaries
make it sound like a wacky romp: "Finn and Jake are assigned to
watch three magical beans; two of the beans are innocent, but one
of them is evil. . . . Eventually, one of the stalks produces evil pig-
lets, and Finn and Jake defeat the beings using a novel method that
involves ice cream."

But, as the series progresses, a backstory emerges. The candy-
tinted world we're seeing has a terrible history: While Finn is sur-
rounded by magical beings, virtually every other human appears
to have been killed or transformed during the Mushroom War,
which included, according to one unnerving voice-over, "frightful
bombs poised to bathe the land in mutogenic horror." As a baby,
Finn was left on a leaf, crying and alone. The other major charac-
ters have their own origin stories. The sociopathic Ice King, who
keeps trying to kidnap princesses and marry them, used to be a
gentle antiquarian named Simon, a personality he lost while fight-
ing mutants after the war, when a magic crown drove him crazy.
The punk-goth vampire Marceline has a mobster dad, who rules
an underworld called the Nightosphere, but she, too, wandered
alone in a postwar landscape as a child. At the age of seven, she
was rescued by Simon, but once he became the Ice King, he forgot
he ever knew her.

As with *The Simpsons*, the ensemble is enormous, allowing episodes to go off on detours and tell the stories of minor figures, such as the woozy Southern elephant named Tree Trunks; or the freaky Lemongrabs, lemon-headed maniacs who spend most of their time howling in frustration; or the friendly Korean-accented computer named BMO. In later seasons, these threads cohere into a broader cosmology; it includes an alternate time line, in which the bombs haven't yet exploded. Finn is the only character who ages in a normal fashion: He began as a twelve-year-old, but this season he's sixteen, and his relationships, and the show itself, have become deeper and (codedly) more sexual. There are moments when Finn's story feels suspiciously like a compensatory fantasy, invented to disguise a trauma that can't be faced head-on—as if it were the *Mulholland Drive* of children's television.

In interviews, Pendleton Ward, the show's creator, has laid out some of his influences, including the role-playing game that was the leisure-time activity of my own nerdy teen years, Dungeons & Dragons. Many of the villains, like the skeletal Lich, have visual origins in the old D & D "Monster Manual"; the plots include classic quest-style puzzles—find the gems, open the portal! In the hand-drawn pastel backgrounds and the characters' bubble eyes, there are hints of Japanese animation—Ward has cited the Hayao Miyazaki movie *My Neighbor Totoro* as an inspiration—but the aesthetic feels equally informed by the urbane squiggles of Felix the Cat, the jolting aggression of early Mickey Mouse cartoons, and the bratty buddy energy of series like *Beavis and Butt-Head* and *The Ren & Stimpy Show*.

No matter how jaunty the foreground, though, with its goofy shouts of "Youth culture forever!," the background keeps hinting at a ruined world, with missiles and abandoned technology everywhere. Bodies morph grotesquely—when Marceline's father gets angry, he transforms from a businessman into a demon with an ass face, a vertical orifice for a mouth and a tentacle beard worthy

of H. P. Lovecraft—and these ugly visions suggest both adolescent bodies and postwar mutations.

Yet *Adventure Time* has a gentle heart. Even characters like the ridiculous Lumpy Space Princess, a brash Valley Girl who is voiced by Ward, have layers. "Bad Timing," an episode from the fifth season, opens with an odd image: a large circle in the center of the screen, like a porthole. Peering into it, we can see Princess Bubblegum demonstrating her newest invention, a time machine called a "phasical sphere." When Bubblegum places this sphere over the circle, she seems to break the fourth wall, turning the TV into a lens. Then she shouts, "Now check it out! It's logging time."

What follows is a tragicomic fable in which Lumpy Space Princess, while on the rebound from a breakup, gets into her first real romance and, then, swamped by insecurity, wrecks it. As we peer at various scenes through the circle—Lumpy shrieking "You skunk! You pretty skunk!" at Bubblegum, then, later, tossing a root-beer Molotov cocktail at an imagined rival's castle—there's a strange flickering. In the corners of the screen are tiny creatures: two triangles fishing in a creek; a diamond doing curls with a dumbbell. These miniature dramas don't affect the story we're watching, yet we're forced to glance at them, like footnotes, or a silent chorus; they suggest some larger universe of loneliness and connection. In the final scene, after Lumpy has accidentally dissolved her boyfriend in the phasical sphere, she begs Bubblegum, "If he's gone, can you send me back, to before I met him? So I won't have to remember this heartache?" A tiny shape hovers nearby, seeming sympathetic. Bubblegum grants the request, and blue rivers spill from Lumpy's eyes. Just before the credits, the borders beyond the circle fade to black, and the small chorus disappears.

Of course, this strange description may leave you cold—like any trip, *Adventure Time* has a definite "you had to be there" quality. It's a dreamlike experience, and a druglike experience, and we all know how much people enjoy hearing other people describe

those. (Luckily, each episode is eleven minutes long.) But that's part of the show's freeing quality: Childlike, nonlinear, poetic, and just outside all the categories that the world considers serious, it's television that you can respond to fully, without needing to make a case for why.

DEPRESSION MODERN

The Leftovers

The New Yorker, November 2, 2015

One good way to get revenge on all the critics who panned your
first show: Make them sob while watching your second.

The second season of *The Leftovers*, on HBO, begins with a
mostly silent eight-minute sequence, set in a prehistoric era.
We hear a crackle, then see red-and-black flames and bodies sleep-
ing around a fire; among them is a pregnant woman, who is nearly
naked. She rises, stumbles from her cave, then squats and pisses
beneath the moon—only to be startled by a terrifying rumble, an
earthquake that buries her home. When she gives birth, we see
everything: the flood of amniotic fluid, the head crowning, teeth
biting the umbilical cord. For weeks, she struggles to survive, until
finally she dies in agony, bitten by a snake she pulled off her child.
Another woman rescues the baby, her face hovering like the moon.
Only then does the camera glide down the river, to where teenage
girls, wearing bikinis, are splashing and laughing in the water. We
are suddenly in the present, with no idea how we got there.

 It takes serious brass to start any television season this way:
The main characters don't even show up until midway through
the hour. With no captions or dialogue, and no clear link to the

first season's story, it's a gambit that might easily veer into self-indulgence, or come off as second-rate Terrence Malick. Instead, the sequence is ravishing and poetic, sensual and philosophical, dilating the show's vision outward like a telescope's lens. That's the way it so often has been with this peculiar, divisive, deeply affecting television series, Damon Lindelof's first since *Lost*. Lindelof, the co-creator, and his team (which includes Tom Perrotta, the other co-creator, who wrote the novel on which the show is based; the religious scholar Reza Aslan, a consultant; and directors such as Mimi Leder) have made a show that keeps trying to dramatize the grandest philosophical notions, the deep existential mysteries— like, for example, the origins of maternal love and loss—with an unabashed and searching curiosity, giving the audience permission to react to them in equally vulnerable ways. They're willing to risk the ridiculous in search of something profound.

At heart, *The Leftovers* is about grief, an emotion that is particularly hard to dramatize, if only because it can be so burdensome and static. The show, like the novel, is set a few years after the Departure, a mysterious event in which, with no warning, 2 percent of the world's population disappears. Celebrities go, so do babies. Some people lose their whole family, others don't know anyone who has "departed." The entire cast of *Perfect Strangers* blinks out (though, in a rare moment of hilarity, Mark Linn-Baker turns out to have faked his death). Conspiracy theories are rampant, as people lose their religion or become fundamentalists. The show's central family, the Garveys, who live in Mapleton, New York, appears to have lost no one, yet they're emotionally shattered. The mother, Laurie (an amazing Amy Brenneman, her features in a constant furrow of disgust), joins a cult called the Guilty Remnant, whose members dress in white, chain-smoke, and won't speak. The Guilty Remnant stalk the bereaved, refusing to let anyone move on from the tragedy. Meanwhile, her estranged husband, Kevin (Justin Theroux), the chief of police, has flashes of violent instability; as their marriage dissolves, their teenage children drift away, confused and alarmed.

That's the plot, to the extent that the show has one, but the series is often as much about images (a girl locked in a refrigerator, a dog that won't stop barking) and feelings (fury, suicidal alienation) as about events; it dives into melancholy and the underwater intensity of the grieving mind without any of the usual relief of caperlike breakthroughs. Other cable dramas, even ones about painful emotions, provide more familiar satisfactions, with stories about cops, mobsters, surgeons, spies. *The Leftovers* is structured more like explorations of domestic intimacy such as *Friday Night Lights*, but marinated in anguish and rendered surreal. The Departure itself is a simple but highly effective metaphor, suggesting multiple losses. In the real world, of course, people disappear all the time: The most ordinary death can feel bizarre and inexplicable, dividing the bereaved as often as it brings them closer. But *The Leftovers* also evokes, at various moments, New York after 9/11, and also Sandy Hook, Charleston, Indonesia, Haiti, and every other red-stringed pin on our pre-apocalyptic map of trauma. At its eeriest moments, the show manages to feel both intimate and world-historical: It's a fable about a social catastrophe that is also threaded into the story of a lacerating midlife divorce.

The first season of *The Leftovers* was challenging in its bleakness: A few elements (like a plot about the Garveys' son, who becomes a soldier in a separate cult) felt contrived, while others (especially the violent clashes between the Guilty Remnant and the bereaved residents of Mapleton) were so raw that the show could feel hard to watch. But halfway through Season 1, *The Leftovers* spiked into greatness, with a small jewel of an episode, "Guest." The story focused entirely on a seemingly minor character named Nora Durst (Carrie Coon), a Mapleton resident who has the frightening distinction of having lost her entire family—a husband and two young children. In one hour, we learned everything about Nora: what she does for work (collects "survivor" questionnaires for an organization searching for patterns), what she does at home (obsessively replaces cereal boxes, as if her fam-

ily were still alive), and what she does for catharsis (hires a prostitute to shoot her in the chest while she's wearing a bulletproof vest). She travels to New York for a conference, where her identity gets stripped away in bizarre fashion. But, as with that prehistoric opener, these revelations are delivered through montages, which drag, then speed up, revealing without overexplaining, grounded in Coon's brilliantly unsentimental, largely silent performance. When the episode was over, I was weeping, which happens a lot with *The Leftovers*. It may be the whole point.

The show's first season used up the plot of Perrotta's book, then added a final, fiery confrontation between the town and the Guilty Remnant. The second season of *The Leftovers* feels almost like a reboot, as we suddenly land in a new town, Miracle, Texas, and in the home of a new family, the Murphys, a couple played by Kevin Carroll and the excellent Regina King, whose daughter, Evie (Jasmin Savoy Brown), was one of the girls swimming in that river. Miracle, formerly known as Jarden, is a global anomaly: No one in the town "departed." As a result, the area has become a kind of spiritual theme park, hawking souvenirs to pilgrims. A self-styled prophet lives on an elevated platform in the center of town. A man sacrifices a goat in the middle of a diner. Soon, Kevin Garvey and Nora Durst—who are now a couple, with an adopted baby, and are accompanied by Kevin's teenage daughter—move next door to the Murphys. The initial three episodes keep shifting the story's perspective: In the first one, we get the Murphys' side of the story; then we get Kevin and Nora's; and the third pivots to Laurie Garvey, who has left the Guilty Remnant and is running recovery meetings for former members. The fourth returns to Miracle, where Evie seems to have disappeared, a troubling sign that the town is not a safe place after all.

When Laurie is not deprogramming cult members, she's trying to write a memoir, and her meeting with a publisher feels like a

meta-commentary on the show itself, with echoes of Lindelof speaking back to the viewers who criticized the finale of *Lost*, the hit ABC show that he co-created. The publisher insists on greater "clarity" in Laurie's writing, more explanation of the rules of her old cult: why the smoking, why the silence, what does the Guilty Remnant believe? Laurie glares, spitting her answer: "They believe the world ended." What more does he need to know? With its mystery that will never be solved, *The Leftovers* occasionally has a quality of repetition compulsion, as if Lindelof were working out old traumas in fresh forms. (Even that cavewoman prequel bears some resemblance to "Across the Sea," a divisive episode of *Lost*.) But if it's a therapeutic motivation, it's one that lends the show a certain wildness. *The Leftovers* isn't easy; it can be ugly and draining. But it steers straight into the spiritual skid that *Lost* took in its final season, then cuts a path to something original.

Unlike so many cliff-hanging exemplars of modern television, *The Leftovers* can't be binge-watched; it needs the space between episodes for recovery. But it is part of a growing set of TV experiments that have begun to feel like a parallel track to the past decade's celebrated dramas about masculinity and power. These ragged, meditative projects risk pretension and embrace inconsistency; unsurprisingly, they often attract small audiences. They include *High Maintenance* episodes like "Qasim," in which a fanatical life-logger reveals his obsessive rituals; certain experimental episodes of *Louie*, which blurs the boundaries of what's real and what's surreal; the French zombie drama *The Returned*, a dream-like poem about our desperation for our loved ones to return; the meditative *Rectify*, about a man released from prison; and the fantastically grim "White Bear," an episode of *Black Mirror* about voyeurism and justice. These are stories that respect the incoherence of the subconscious. They are less about narrative and more about the power of the uncanny image—the symbol that reverberates but refuses to spill its secrets.

SWING STATES

The Middle

The New Yorker, March 21, 2016

This column was written during the 2016 primaries, when the media was talking nonstop about "economic anxiety" and Trump was still a laughingstock. It became a game on Twitter to argue about how fictional characters would vote: Would Miranda Hobbes pamphlet for Bernie? Would the gang from *Always Sunny in Philadelphia* go full-on MAGA? After the column was published, Patricia Heaton—a never-Trump Republican—tweeted to assure me that the Hecks would never vote for Trump. Judging from later events, I believe they did.

Midway through the seventh season of ABC's family sitcom *The Middle*, Frankie Heck (Patricia Heaton), who works as a dental hygienist, gets a new boss: Dr. Sommer Samuelson (Cheryl Hines, from *Curb Your Enthusiasm*), a prosperity guru with perfect teeth. "Her story is capital-A amazing," gushes Dr. Ted Goodwin (Jack McBrayer), Frankie's former employer, whose practice Samuelson bought. "Her parents made pottery. And now she owns the thirteenth-largest dental chain in the country!" Reluctantly, Frankie attends a corporate convention in Des Moines—"all expenses paid," a novel concept. But once Samuelson cranks up the

dance music—"Tonight is tonight! Tomorrow is tomorrow! Believing is believing!"—Frankie drops all resistance.

"Are you tired of working yourself to death, and still not reaching your goals?" Samuelson yells, gyrating in a silver dress. "Are you tired of looking around and seeing everyone else get theirs and you not get yours?"

"I'd like to get mine," Frankie murmurs.

"Do you see those people on those fancy boats and planes and think *that should be me*? Well, that *can* be you. . . . You can earn your way into our Platinum Elite Club and be on a private jet as part of our Winner's Circle Retreat in Costa Rica! *Who's with me?*"

For days, Frankie giddily recites buzzwords as she and her husband, Mike (Neil Flynn), a manager at a limestone quarry, enjoy the honeymoon they could never afford. Only when the bill is slipped under the door does she realize that "all expenses paid" doesn't cover dry cleaning, champagne, and room-service ribs. In most sitcoms, this would have been just another goofy mistake. In *The Middle*, it felt, for a minute, like a throat-clutching moment of horror, the floor falling out from beneath Frankie and Mike's lives.

Finding comedy in lower-middle-class vulnerability is the gift of this long-running series, which, like Frankie herself, is a low-hype, hardworking, unflashy team player that gets way too little credit. The show debuted in 2009, the same year as *Modern Family*, also on ABC, which had a diverse cast—for the era—and a sleek mockumentary style. *Modern Family* hogged all the hype, while *The Middle* plugged along. In the next few years, ABC expanded its family-comedy block, which now features a set of smart and varied series, generally framed by voice-overs: There's the well-off African American family on *black-ish*, whose stories are narrated by the formerly poor dad, Dre; the 1990s Taiwanese American immigrants of *Fresh Off the Boat*, whose narration, by the tween son Eddie, was abandoned in Season 2; the eighties middle-class Jewish family of *The Goldbergs*, framed by the nostalgic youngest son, Adam; and this season's debut, *The Real O'Neals*, which is about

divorcing Irish Catholics in Chicago, narrated by their gay teenage son, Kenny.

Like those shows, *The Middle* is grounded in insights about parents and children, and it has traced, in touching and realistic ways, the paths of the three Heck kids: dorky Sue (the amazing Eden Sher), jocky Axl (Charlie McDermott), and Brick (Atticus Shaffer), a quirky kid on the spectrum. But it's Frankie's voice that guides us, and while at first hearing she might sound corny—like a Midwestern Christmas newsletter—her trademark is a ping of anxiety, the resentful fear that her efforts will never add up. The Hecks have had a few lucky breaks, like Axl getting a scholarship to play football. But their mortgage is underwater and they're in crushing debt, which they've agreed to ignore. They shop in the Frugal Hoosier's "Eat It Today" section. And two jobs are not enough: Frankie and Mike take extra gigs, for Christmas gifts and to contribute to a barely-there college fund for Sue. Eternally exhausted, both parents are borderline neglectful, "floating" holidays and flaking on carpools and skimping on therapy for Brick. One day, when Frankie tosses a spoon into the sink, the whole thing crashes to the floor, leaving a hole that the Hecks can't afford to fix.

The miracle of the show is that it's able to make this stuff funny: That sinkhole was pure slapstick, as was their solution of washing dishes in the shower. But beneath the warmth and the jokes, the show keeps cycling back to a tense marital debate. From Frankie's perspective, she and Mike would do better if they thought bigger, a story that she's picked up from multiple American philosophies, from Oprah on down. After she gets fired, in Season 4, she cries, "When one door closes, another opens," then slams into a locked glass door. Mike has no patience for such talk. To him, a job is how you make money. Sometimes you love one kid more than another. Marriage isn't about passion, it's about mutual toleration. Frankie argues that Mike has cut himself off from intimacy and excitement, but he sees it differently: no false hope, no disappointment! Part of the show's nuanced appeal is how it keeps shifting as

to which approach seems healthier: Mike's wry fatalism, which can seem like depression, or Frankie's manic, near-libertarian insistence that she is the master of her fate, which makes her fume when hard work leads nowhere.

In Barbara Ehrenreich's book *Bright-Sided: How Positive Thinking Is Undermining America*, she dissects the darker history of positive thinking, the cult of optimism that has, in recent decades, she writes, metastasized into "an apology for the crueler aspects of the market economy." *The Middle* is a sitcom-shaped meditation on this phenomenon, but it's not purely a critique. On the one hand, Frankie's beliefs do make her miserable and, often, hard on her family. (Her kids' adjectives for her: "lazy," "angry," "tired.") There are echoes of early *Roseanne*—the creators of *The Middle*, Eileen Heisler and DeAnn Heline, both wrote for the show—whose pilot episode satirized the dangerous New Age babble sold to factory workers: "If your mind can conceive it, and your heart can believe it, then you can achieve it." The affirmations Frankie clings to feel like curses when they don't come true.

On the other hand, there's Frankie's daughter, Sue, a lover of rainbows and unicorns, for whom positive thinking has been a life-saver. At nineteen, Sue is so devoted to the website kickingitteen-style.com that she once wrote her own version, Sue's Tips for Sue-cess. Now that she's at a local public college, a professor steers her away from turning in poems titled "A Recipe for Peace in the Middle East," pushing her toward critical thinking. Fellow students upset her with the news that cops can be mean. But rose-colored glasses protected Sue from what would have been a truly ugly adolescence had she absorbed the world's view of her: homely, mediocre, a nobody. She could have folded. Instead, she became self-reliant enough to back out of an engagement to her high-school boyfriend, a sure path to her mother's life. Sue's sweet-

ness is a type of moral strength, a force of Christian decency rare
for TV.

Although Sue's old enough to vote, we're unlikely to see her
first presidential election. Unlike the Norman Lear–inspired *black-
ish*, *The Middle* has never addressed real-life politics. (Including, sig-
nificantly, racial ones: it's set in a mostly white Midwestern area,
and although Axl's best college friend, Hutch, is black, when the
two are hassled by a cop Hutch's reaction is no different from
Axl's.) But the sitcom still manages to press on a modern eco-
nomic bruise, hard. After Super Tuesday, Trump voters were
described in the *Times* as being unified by one motivation: "a deep-
rooted, pervasive sense of anxiety about the state of the country,
and an anger and frustration at those they felt were encroaching
on their way of life."

On their worst days, that's the Hecks. While the neighbors give
Frankie the side-eye, she is driven crazy by a feral single mom, Rita
Glossner (played with hilarious ferocity by Brooke Shields), whose
family has all the pathologies the Hecks lack: drugs, violence, ab-
sent dads. A network sitcom can skirt the tough stuff: No Heck
ever uses bigoted language or talks about immigration, not even
Mike's prickly hermit of a father or his socially awkward brother.
But they're white, working-class Christians in a small town in a red
state. Frankie Heck is no xenophobe, but she's frustrated, over-
whelmed, and thirsty for inspiration. Could she be drawn to a
smiling orange demagogue who promised that she'd "get hers"?
She might. If Frankie longs for anything in her life, it's for some-
one to make America great again.

SMOKE AND MIRRORS

High Maintenance

The New Yorker, January 22, 2018

While I was working on this book, *High Maintenance* filmed an episode around the corner from me. I sat on a stoop and accidentally got into a shot.

The new season of *High Maintenance* opens with a modern moment of dread. In an episode called "Globo," a Brooklyn pot dealer—a character we know only as The Guy—wakes up with his girlfriend. The two are cozy and slovenly, joking about the ethics of sharing dreams. Then they check their phones. Something awful has happened: a terrorist event, perhaps, or the worst election ever, the details left vague. "I think I'm going to go to work early," The Guy says, staring at his screen. "Yeah," she says. "That makes sense."

"Globo" lasts just twenty-six minutes. And yet, somehow, in its spiky, elliptical, warmly observant way, as the camera floats without judgment from one thread to another, from bistro to crash pad to brownstone stoop—sometimes following The Guy as he delivers weed to customers, but just as often not—it manages to suggest an entire city looking for comfort. A fat man struggles to maintain his workout regimen, but each time he tries to post his

progress on Facebook he sees someone grieving and deletes the draft. A woman and two bros hook up at the McCarren Hotel, a decadent bubble far from the headlines. An exhausted immigrant waiter takes a long subway ride. Each plot gets an O. Henry twist, one funny, one filthy, one sweet. It never feels contrived, because the stories seem spontaneous, as natural as a train of thought. It's a remarkable achievement of narrative efficiency, fueled by humility.

That's long been the gift of this unusual series, which debuted in 2012 on Vimeo. The Web version of *High Maintenance* was the self-funded creation of a married couple: the grizzled, bug-eyed Ben Sinclair, who plays The Guy, and who until this show had mostly done cameos as homeless guys; and his then-wife, Katja Blichfeld, a casting director with a Rolodex full of similarly underused talents. For viewers accustomed to the rigid rules of TV formula, those early seasons felt visionary. Some episodes were just eight minutes long. Others were nearly silent, or spliced from tiny edits into montages. The series managed to be poetic without being pretentious—and although it was funny, it wasn't quite stoner humor. The visual trumped the verbal. Every episode told a new story.

After nineteen episodes, the series shifted to HBO. The transition was bumpy. You could see the money gleaming, heavily, on the screen. Episodes were longer; the pacing dragged. There were still several gems, particularly "Grandpa," a joyful episode from the POV of a dog, and the lovely "Tick," which combined two stories about eccentric parents. But the tone was uneven. Sinclair has said that, when he and Blichfeld ended things romantically, their series began to dwell on people extricating themselves from relationships. For whatever reason, a tinge of sourness—or self-loathing, or at least self-consciousness—had harshed the show's trademark mellow.

This new abrasiveness led to some daring experiments, like a story in which a gay man and his female friend degenerate from

codependence into rank pathology. But other scenarios were clunky, and, in a few cases, shadowed by something like white guilt. The show's early focus had been on a small slice of Brooklyn— a creative-class demographic adjacent to that of *Girls*, which is to say, people who use drugs without fear of the cops. Over time, the lens widened, but the results could be stagy, sometimes literally so, as in a sequence in which a crude, trash-talking black body-builder turns out to be a British Method actor. The frame distracted from the picture.

In the show's second season on HBO, airing this month, the ease is back, thank God, and the series feels, even in slighter moments, newly confident, with an increased ability to reflect a larger world in flux. Each of the five episodes sent to critics is worth watching. In one, Danielle Brooks (Taystee on *Orange Is the New Black*) plays an African American real-estate agent hoping to cash in on a changing Bed-Stuy. In another, two artists (John E. Peery and Candace Thompson) win a low-income-housing lottery and move into a Greenpoint co-op, only to discover that the amenities— a roof deck, a sauna—are available only to rich tenants. One screwball sequence takes place in Bushwick, where a feminist resistance group bubbles with racial anxiety, to the point that a white member sneaks off to the kitchen and, going through her Instagram contacts, begins panic-inviting women of color. Miraculously, none of these stories feel preachy—and often they kink into a joke, or a surreal image, or some other unusual narrative swerve. One episode has a snake that wriggles from one plot over into another. Two have fart jokes.

The show has always had a native sympathy for tricksters and hustlers, and, almost by definition, it's down to party. More recently, Sinclair and Blichfeld have shown a willingness to dwell on more uncomfortable aspects of its subject matter, too, especially in a dreamy episode in which The Guy lands in the ER, sneaking tokes when the nurses look away. The story includes a rare scene that actually qualifies as stoner humor: just two people, getting

high, killing time, giggling at jokes that make sense only to them. But it somehow manages to find the *High Maintenance* sweet spot anyway, emphasizing the way isolation and intimacy can overlap. It doesn't judge. But it doesn't look away.

In the five years since *High Maintenance* first aired, the anthology model has taken off, especially on streaming and cable. It lets creators mess around and frees viewers from the binge-watch. Still, the genre is not a guaranteed good time. Since 2011, Charlie Brooker has produced the digital dystopia *Black Mirror*, but his fourth season, on Netflix, is atypically spotty. (The "USS Callister" and "Hang the DJ" episodes work best.) Other anthologies include *Electric Dreams*, a Philip K. Dick adaptation on Amazon; the affably odd *Room 104*, by the Duplass Brothers, on HBO; and *Easy*, on Netflix, now in Season 2. The genre's influence is apparent elsewhere, too: One of the three good episodes in Season 2 of *Master of None* was a *High Maintenance* rip-off (or homage, if you want to be nice).

Of this cadre, the most interesting is *Easy*, because it's terrible. By rights, the show should be a Midwestern twin of *High Maintenance*. It's another portrait of a city: Chicago. The creator, Joe Swanberg, is an entrepreneurial upstart, whose specialty is mumbly domesticity. And the series uses superficially similar techniques, all glimpses and epiphanies and montages and gazes and tinkly music and improvisational dialogue, with the occasional dark comic twist. It also benefits from a remarkable cast, giving performances so strong that they elevate weak material. (Believe me, it is hard to pan a show that includes both Jane Adams, as Marc Maron's soft-hearted feminist crony, and Gugu Mbatha-Raw.)

Yet *Easy* stumbles, again and again. It's smug where *High Maintenance* is humble. It's formless where *High Maintenance* is graceful. It's twee instead of funny, with a misplaced confidence that all human behavior is worth watching. When a moral theme bubbles up—a frequent occurrence for such a chill, indie show—it's pe-

dantic. In the worst stories, like a truly irksome doubleheader about artisanal breweries, the characters resemble the *Portlandia* ensemble, minus the satire. But even the best are full of passionate banality. A three-day babysitting montage is sweet, then, finally, so idyllic that it verges on propaganda for egg-freezing. A feminist writer/sex worker has some fun, gonzo sex scenes, but her story goes nowhere, making her seem less like a person than like a set of talking points in lingerie. The standout first-season episode "Art and Life" is genuinely sexy. Over time, however, even the nudity gets old, with conventional guy-gaze voyeurism rebranded as liberatory hipness.

On *High Maintenance*, by contrast, the most alarmingly graphic sex scene has a purpose: It tests the viewer and sets up a reveal. As in the short stories of Grace Paley, the plotlessness is, finally, a higher form of rigor, at once a philosophy and a misdirect. In "Derech," one of the best new episodes, Anja, a writer for *Vice*, manipulates her way into a support group for former Orthodox Jews. The story feels as though it's about exploitation—until suddenly one plot collides with another, in which glitter-caked drag queens primp for a rave. There's a shocking, nearly violent climax in a bodega, where someone nearly dies. But there's also time along the way for a sing-along with lyrics about the actress Elisabeth Shue. As ever on the show, these detours aren't delays. You just don't know where you're going until you get there.

WHAT TINA FEY
WOULD DO
FOR A SOYJOY

The Trouble With Product Integration

New York magazine, October 5, 2008

I began the research for this piece assuming that most showrunners would have problems with inserting ads into their scripts—only to find they were some of the biggest cheerleaders for this economic model. It was the year of the recession; TV was already struggling to adjust to changes in advertising.

Since I wrote this essay, the pressure to integrate has only gotten more intense, on some of the most celebrated shows on television. And as more people think of themselves as brands, it gets harder to resist.

Dick Blasucci was worrying about the Toyota Yaris. Those days, the car was on his mind all the time.

Blasucci had written television comedy since 1980, but he'd never seen anything like the mess at *MADtv*. With lousy ratings, the Fox sketch show was the RC Cola to *Saturday Night Live*'s Pepsi:

no buzz, little profit. So the showrunner wasn't surprised when his bosses patched him in to a conference call with Madison Road, a broker for product integration—the latest fad in TV economics, the killer app meant to save TV from TiVo.

The deal they'd cut guaranteed four sketches for Toyota. Classic product placement, and if it kept them on the air, where was the harm? But then Blasucci started to get notes. Showing the Yaris wasn't sufficient, said the rep from Madison Road. The characters must praise the car's features: its roomy interior, its sleek lines. The writers pitched a spoof of a commercial, with a young couple making out in the Yaris, panting about its fuel efficiency. No, said Madison Road. Cut the parody bit. The skit should just feature the couple panting over the Yaris. They aired it—and Blasucci began to recognize he was part of "an experiment," a test of how far the sponsor could go.

Later that season, in 2006, Madison Road deputized Blasucci to create a sketch touting the NASCAR HotPass, a deal on DirecTV. To Blasucci's dismay, his job had become a crazy-making philosophical riddle. Was it possible to create truly funny, subversive comedy that would also sell Toyotas?

Still, the *MADtv* writers kept trying. You couldn't work in TV and be naive. Viewers were DVRing through commercials and buying ad-free DVDs. Besides, *MADtv* was just a goofy sketch show; nobody wanted to be the prima donna, throwing a big tantrum about integrity. "There was never any threat from the company saying, 'You're not coming back,' but you sense it. Just naturally, you don't want to be the guy to say, 'No, I won't do it!'"

Junior Mints. Lucky Strike. Coca-Cola.

These are strange days for television. *The Sopranos* ended only last year; during the mourning period, one could believe that this was not the end for David Chase's masterpiece but the beginning of a golden age. After years of being sniffed at as "chewing gum

for the eyes," TV had created a truly ambitious, universally admired series—*Scorsesian*! Now visionary auteurs could make the kind of art that no one thought TV could handle in the first place. *Mad Men, The Wire, 30 Rock* . . .

Audi. Home Depot. SoyJoy.

And yet, even as this era was dawning, something else had been going on, and it had, of course, to do with money, and the fact that there was no longer any logical way of making any. Long before Wall Street took a dive, the economic structure that had for so long supported television—SHOW, ad, SHOW, ad, SHOW, credits, AD, AD!—was dissolving in the heat of the new technologies. It was no wonder the products wanted *in*—into the scripts, into the hands of the characters, into the story.

T-Mobile. Staples. Chanel.

Meanwhile, reality television had begun its inexorable rise. The genre had, from the start, been built on integrated sponsorship. Objecting to *Project Runway*'s TRESemmé hair salon would be silly, like arguing that Rice-A-Roni corrupts *The Price Is Right*. But as these shows filled the schedule, they took the slots once reserved for scripted series. Each season (and seasons were dissolving, too, along with the notion of a time slot), it became harder to justify a series with a pricey cast and a team of actual writers.

Enter product integration, branded entertainment, and the new age of television economics. It's happened so gradually you may not have noticed—or, perhaps, haven't cared. American consumers take pride in their media savvy; they are too hip to be fooled, too jaded to be appalled. If two decades ago music fans raged when Nike co-opted The Beatles' "Revolution," these days the most "independent" musicians vie to be on *Gossip Girl*. James Bond drives a BMW, Carrie Bradshaw drinks SKYY vodka. When the U.K. culture secretary made a statement this summer warning that if product placement came to the BBC, it would "'contaminate' programmes," his outrage struck many American observers as frankly bizarre—so outdated, so naive, so very *British*.

Nonetheless, before it got distracted by last fall's strike, the Writers Guild of America had begun to lobby against the phenomenon. In May 2007, Phil Rosenthal, the creator of *Everybody Loves Raymond*, testified before the House. He showed a clip from *7th Heaven*, a three-episode arc in which characters gushed repeatedly over the pleasures of Oreos. The clip ended when a young man proposed to his girlfriend by handing her an Oreo. She twisted the top off, saw the cream-gunked ring within, and beamed: "I will!"

Later, Patric Verrone, the president of the WGA, defined "branded entertainment" for the FCC. He emphasized that it involves not merely sponsored props but elaborate interweaving of brands into scripts, ads indistinguishable from the show itself. "Most Americans, like the proverbial frogs in the slowly boiling water, may not notice how prevalent it has become. Yet Nielsen Media Research tells us that product integration has occurred more than 4,000 times on network prime-time television in 2006."

Since Verrone's testimony, that proportion has risen vertiginously, jumping 39 percent in the first three months of this year versus the same time period last year. Within the top-ten broadcast-TV shows, advertisers paid for 26,000 product placements in 2007. And in June, the WGA presented a startling proposal to the FCC, demanding that networks declare their sponsors in a banner at the bottom of the screen.

Many observers doubt the proposal will fly (the FCC hearings are now in session, with a decision possible as early as late October). That frog pot is already nearly boiling, after all; just a few more bubbles, and it's over the top. And television integration is merely one ripple in a larger trend that also extends to "highbrow" art forms. In the recent revival of the musical *Sweet Charity*, the line "I'll have a double scotch on the rocks" was changed (with Neil Simon's permission) to an order for "Cuervo Gran Centenario." Damien Hirst designs for Levi's. This summer, Sprint ran a satirical contest offering customers twenty bucks to "sell out" by integrating their own home-video YouTube clips.

Yet unlike music and movies, which have become expert at incorporating products (many musicians are practically brand magnets), television is still in the experimental stage—just starting to show results. Jak Severson, the managing partner for Madison Road, described the goal this way: "The audience cannot notice the integration but must remember it."

Of course, open your eyes and the brands are right in front of you. Jack Bauer drives a Ford Expedition. *Desperate Housewives'* Gabrielle sells the Buick LaCrosse. On *Weeds,* Nancy praises her Prius and sips from an "It's a Grind" coffee cup. (Everyone on set drank "It's a Grind," so they made a deal for the company to provide fresh-brewed coffee in exchange for the placement.) In a crisis, *24*'s Chloe shouts that their network can't be under attack, since "the Cisco system is self-defending"; Cisco showcases the clip on its website.

Sometimes these twists are clever, as when *The Office*'s Dwight took a job at Staples. And sometimes not: In *The New Adventures of Old Christine,* a character screamed in rage when a friend said he'd never heard of Home Depot: "It's the biggest home-improvement store in the world," he shouted. "It's the greatest place on earth!"

Two years ago, Nielsen created a division devoted to tagging brands and testing for consumer response. Its researchers concluded that effective integrations combine several elements. The show and sponsor must be a perfect match. Characters should praise the brand's features—and then an ad should appear at the commercial break, cementing the association. The goal is to "move the needle," to get a measurable economic effect. Everyone in advertising knows the history of failed experiments (subliminal advertising, for one), so networks are eager to determine which integrations motivate, rather than annoy, consumers.

For like a wedding ring in a creamy Oreo, truly aggressive integrations can create queasy juxtapositions. On ABC's *All My Children,* for example, a Campbell's soup deal rippled through Pine Valley like a tornado, if a tornado could be co-sponsored by Wom-

en's Heart Health Month. Characters working for the show's fictional cosmetics company strutted their stuff in a red-dress fashion show, with the real-life Campbell's as a sponsor, plugging its heart-healthy line. And throughout the network's daytime lineup, characters struggled with cardiac afflictions. (*The View* was involved in the project, too, but no one there went quite that extra step.)

But then, this was a soap opera, contrived by definition. In the prime-time schedule and on cable, power can slide in many directions, depending on a show's prestige and ratings—and lately, showrunners have begun to seize the reins, as with *The L Word* creator Ilene Chaiken, recently quoted in *Ad Age* touting her ability to place brands. According to Marti Noxon, an executive producer of *Private Practice*, networks now introduce a list of "friendly" brands before the writing begins. There is even a subset of shows produced by the brands themselves, acting as their own studio, as with two specials by Axe body wash that aired on Spike and MTV. For the viewer, there's no way to discern what's a prop, what's a paid integration, and what's just a writer freely referencing a brand, but that's the point—after a while, suspicion contaminates every close-up.

And then there's *30 Rock*. Like its late cousin *Arrested Development*, *30 Rock* is that unsettling thing, a critic's darling, a minority taste with minority ratings. (When it first won an Emmy, Tina Fey, the show's creator, executive producer, and lead actress, thanked the sitcom's "dozens and dozens of viewers.")

30 Rock is the best show on network television. And half the pleasure of the series is its dazzling self-referentiality, the way it acts as an allegory for what it's like to make TV right now. Fey—herself the first female head writer at *Saturday Night Live*—plays Liz Lemon, the showrunner of *The Girlie Show*, a second-string sketch-comedy series with middling ratings, not unlike *MADtv*. Lemon considers herself an artist (or at least a "creative"), but she also wants her show to be a hit. In the first episode, she reluctantly accepts a new star (a popular, erratic comedian named Tracy Jor-

dan, played by erratic comedian Tracy Morgan) and a new title, *TGS with Tracy Jordan*. She also meets her new boss, Jack Donaghy (Alec Baldwin), GE's vice president of East Coast television and microwave-oven programming.

At its heart, the sitcom is a platonic romance between these two workaholics, the nerdy purist writer and the suit who pushes her to see the big picture. What makes the show funny, and timely, and terrifying, is that on *30 Rock*, Liz Lemon always loses.

When I talk to television showrunners, everyone mentions *30 Rock*. After all, it has the best jokes on television about product integration. In the show's fifth episode, Donaghy talks with Lemon about integrating brands. "I'm sorry, you're saying you want us to use the show to sell stuff?" Liz asks.

JACK: Look, I know how this sounds.
LIZ: No, come on, Jack. We're not doing that. We're not compromising the integrity of the show to sell—
PETE: Wow. This is Diet Snapple?
LIZ: I know, it tastes just like regular Snapple, doesn't it?

The scene was paid for by Snapple. After it ended, there was a commercial for Snapple.

Tom Fontana is one among many TV writers who adored that scene. The creator of unorthodox series like *Oz* and *Homicide: Life on the Street*, Fontana has never been pushed to integrate brands, but he says he would be open to it. His defense boils down to three points: verisimilitude, nostalgia, and necessity. A character who orders Wild Turkey is different from one who orders Basil Hayden's. If you can monetize that realism, why not?

The distinction, he tells me, is not whether you do it but whether you do it well. "Is there finesse?" he asks. He also points out that *30 Rock*'s ironic jokes aren't really so modern; in fact, he just saw an episode of *The Jack Benny Show* that did something similar. His assistant sends over the disc.

"My sponsor called me," says Benny, swaying before the curtain. "And my sponsor—he's an awfully nice fella—he told me that he had a feeling—you know, he likes my show, he likes my TV show very, very much. But he had a feeling that I wasn't doing the integrated commercials. . . . And after all, my sponsor is paying the bills, you see, and he has the privilege of making suggestions."

Benny pauses thoughtfully. "Of course, I don't have to *take* the suggestions. I have the privilege of quitting." Split-second beat. "But I don't want to *abuse* the privilege, so . . ."

Other writers share Fontana's nostalgia. This is merely the return to an old model, they reassure me; it's the very model you can see forming historically on *Mad Men* (another series that, like *30 Rock*, both references product integration and weaves real brands into the plot, such as Heineken, one of the show's sponsors). The key is to do it in ways that don't harm the story, that even improve it—then take the money and use it well. "Better casting," Chris Dingess, a writer for *Reaper*, effuses. "Sets that don't look like sets!"

Yet at times ambivalence does creep in. When J. J. Abrams created *Felicity*, product placement wasn't an issue. He fought for realism as the network erased brands, a process called "Greeking." By the time of *Alias*'s third season, in 2003, the world had changed. Abrams cut a deal with Ford. He didn't mind using the car, but Ford insisted the characters shout, "Quick, to the F-150!" Abrams cringes at the memory and says he hopes to avoid such deals in the future.

But others see such ambivalence as a luxury. Joe Davola, an executive producer of *One Tree Hill*, calls from his cell as he's whizzing in his car through Los Angeles. He's the creative partner of Mark Schwahn, the showrunner of *One Tree Hill*. Davola tells me he and Schwahn eagerly sought sponsors, including Sunkist. The Gatorade logo is on "the towels, the cups, the cooler" for the series' fictional basketball team. Sunkist sponsored the tour of a musician character—and when the actor went on an actual tour, it was also sponsored by Sunkist. Another character sold her cloth-

ing line to Macy's. (*One Tree Hill*'s adolescents have conveniently grown up to be entrepreneurs, helming fashion lines and music labels.)

The series won't do anything its audience finds "phony," Davola insists. But advertisers "like us because we're cooperative. We know who these people are—from Sunkist, from Cingular—and the network encourages that. I don't see the issue. If your show is struggling, and it wasn't one of the top-twenty shows, and this would keep it on the air, what would you do?"

Charles Rosen co-founded an ad firm called Amalgamated, but his background is in independent film. A few years back, his old colleagues might have seen him as a sellout, Rosen says. "Before this shift, they didn't really give a shit what we had to say. You were fortunate if they said, 'Hey, here's a Tom Cruise movie, pay what you have to pay to get your stupid box of Kleenex in.'" Then distribution models changed. "The entertainment world started to— was forced to—entertain brands as part of their communication."

An activist for liberal causes, Rosen has a special interest in pairing do-gooder brands with like-minded "creatives," as with ads created by indie musician Devendra Banhart for Fat Tire, pastoral spots that "moved the needle" for both musician and beer. In this spirit, he brokered a deal between Ben & Jerry's and Stephen Colbert on the ice cream flavor "Americone Dream"—one of several deals Colbert, in the guise of his right-wing blowhard character, has participated in. He (or "he") also shilled for Doritos. Like Tina Fey, Colbert has tapped into a strikingly effective style of integration, at once ironic and literal—he is a celebrity doing ads that parody celebrities who do ads.

I tell Rosen about the WGA's proposal to the FCC. He's stunned—and offended. "Really? That ain't gonna happen. Dude, they just got out of a strike and now they want to bite the hand that's feeding them?" I explain that Verrone advocates a bold

banner disclosing a show's sponsors. And, frankly, Rosen kind of loses it.

"He wants it during *30 Rock*—'This line brought to you by Snapple'?!"

Rosen leans forward. "But you know what? Just do a better job integrating! If you're really an artist, go fucking paint a picture or write a book or do something that's fully about art. My realization in the film business was it was not about art. My passion was independent film. To say I'm going to support filmmakers whose voices are never heard. Bullshit! And if these writers think that they have some sort of integrity that's above Snapple, they're kidding themselves, and the shows will not allow for it, the producers will not allow for it, and the networks will not allow for it, and it's really defeatist. They should say that their challenge is to be as good at it as *30 Rock* or *Talladega Nights*—or *Wayne's World* umpteen years ago."

Rosen calms down a bit. "You know, the first movie I ever produced was a film called *Chocolate Babies*, which was about black, HIV-positive drag queens. And I loved it, and it was important, and it was funny, and it was awesome. And my mentor said, 'Charles, if you're ever going to make it, you better figure out that there's a huge country between New York and L.A.' And I'm like, 'I don't want to know that! I want to make gay, black films'—and here I am as a heterosexual, white Canadian Jew. The film was great. But horrible box office. We won every gay film festival, we even won Berlin. It doesn't matter; it didn't sell any films, and we were in the business of selling. *That's* what business we're in."

The best product-integration joke on *30 Rock* isn't the one paid for by Snapple. It's the one paid for by Verizon.

"Are you all right?" Liz asks Jack. "Never mind," Jack replies, glancing at his phone and heading for the door. "These Verizon Wireless phones are just so popular, I accidentally grabbed one

belonging to an acquaintance." "Well, sure," Liz replies, her voice strangely chipper. "'Cause that Verizon Wireless service is just unbeatable! If I saw a phone like that on TV, I'd be like, 'Where is my nearest retailer so I can get one—'" Fey stares at the camera with a tight grin. "Can we have our money now?"

I want to talk to Tina Fey about that joke, but her management won't set up an interview. So I ask her co-writer Robert Carlock, via email, how he responds to criticism that they're having their cake and eating it, too. "In our thirty-six episodes, we've done product placement only three times," Carlock writes. Though they regularly make pop-culture jokes, "the vast majority of our references are actually creative decisions with no quid pro quo."

When there *is* quid pro quo, he adds, "in TV the head writers are also producers. If we are having and/or eating any cake, it's only because we are succeeding in serving both the creative and the financial. And isn't that what TV is all about?" Fortunately, "some companies are willing to pay to be part of the joke."

The email ends, "If you mention Papa John's Pizza in this article, I get $40. I'll give you $10."

A few weeks later, Fey gives a quote to *Entertainment Weekly* clarifying her show's philosophy. "We called [our deal] out really hard to let people know. If it's a commercial, you're going to know it's a commercial."

But that's simply not true. The three integrations I know of on *30 Rock* are Snapple, Verizon, and SoyJoy. I didn't realize SoyJoy was an integration, though—I assumed it was a joke, like Sabor de Soledad, Liz Lemon's favorite snack. Then a few weeks later, I saw a SoyJoy tank top in *Us Weekly*. I googled it, and sure enough: "SoyJoy. Fortified with optimism!"

I call Lisa Herdman, the national television buyer at RPA, the advertising agency that handles the SoyJoy account. She's piqued that I'd mistaken SoyJoy for a fake product. "Do you watch television?" she asks. "We've run our spots everywhere that any female eighteen to forty-nine would watch!"

The SoyJoy integration was part of a larger media buy, she explains, linked with NBC's Green Week. SoyJoy produced 40-second "green tips." It sponsored Bravo's *Top Chef*. And on *30 Rock*, since the script for the episode in question—which centered on a fictional reality series called *MILF Island*—was already written, the writers inserted SoyJoy into a B-plot, in which Liz Lemon's co-writer Pete gets his arm stuck in a vending machine. The brand was also the fictional sponsor of *MILF Island*. At one point, we hear its slogan in the background, contrasting with Pete's state of despair. "That was the week 'fortified with optimism' was locked and loaded for us," Herdman tells me. "And we encouraged them to get that on there somehow."

But Herdman was most enthusiastic about SoyJoy's next appearance, on *The Closer*, where the heroine, Brenda, is trying to develop healthier eating habits. "She reaches into her purse, offers it to her friend, and he says, 'No, thank you.'"

Does Brenda's friend make fun of the product? "Oh, no, no, no, no," Herdman says—on *The Closer*, SoyJoy hoped for more control. "The people at *The Closer* saw the *30 Rock* episode, and their first attempt at an integration was that Brenda goes to a vending machine. And honestly? You can't get SoyJoy out of a vending machine. There's something about the weight of the product. We allowed *30 Rock* to do that, but now we don't want people to think they can go to vending machines to get SoyJoy." Her voice is serious. "You know, we're adamant that they don't use the word 'bar.' Because it's not a bar. When they presented the idea that Brenda was to taste it and offer it, I was like, as long as he doesn't say, 'Ew, gross.' We're targeting females, so for a male to decline is not a horrible thing, although we'd love for everyone to eat it."

It occurs to me that the *30 Rock* integration was a failed experiment. After all, the product looked to me (a woman eighteen to forty-nine!) like a punch line. The Pete B plot was the weakest element of an otherwise funny episode—and worse, a male character reached for the SoyJoy.

"Yeah, honestly, I had my own idea of exactly how I wanted it," Herdman tells me. "My initial thought was, *Let's get it to Liz Lemon*. There's a study somewhere that says soy is beneficial to menopausal women. So I had written it up that—who's the page? Kenneth. That Kenneth was handing it to Liz Lemon, saying, 'Ooh, someone might need some soy.' But they're not going to take what I say. It's Tina Fey. And she's brilliant."

Keith Powell plays a minor character on *30 Rock*, Toofer, the uptight black writer from Harvard (he's a "two-fer"). He admires Tina Fey for her ability to alchemize her experiences, he tells me. "I think that's what Tina's relationship really is, figuring out how to exist as an artist in the corporate world. NBC gives notes. And Tina, instead of fighting it or giving in to it, Tina uses it."

But although he loved the Verizon bit, Powell does mention one experience that troubled him. "American Express paid us a tremendous amount to do spots during the commercial breaks. Little mini storylines to stop people from DVRing through. And at some point, some of the cast members started saying, 'Are we doing a commercial or are we filming *30 Rock*?' "

Powell sounds conflicted as he speaks about these ads, the "interstitials." (The industry also calls them "podbusters.") Using the show's characters in ads was ingenious, he says. But Powell, who has done successful commercials, knows they generally pay a noncompete clause, to ensure actors can't pitch a competing product. The cast members discussed the lack of compensation, but nobody seems to have complained. He circles back: "I do want to make it clear that I think we need product integration. If Verizon didn't pay us to say 'Give us the money,' we wouldn't be on the air. They've created an environment where they can show any product and people find it funny. I'm glad it's my show that figured this out!"

Comic Judah Friedlander also plays a writer on *30 Rock*. He,

too, wasn't sure what the deal was with those interstitials. Some-times, he says, "there's integration going on and I don't even know it. Maybe if you're a huge star, you can say no. Where I'm at, you pretty much do it if they tell you."

A few days later, I find myself gazing at an American Express magazine ad featuring Tina Fey. The image is hypnotically appeal-ing. In it, Fey sits on the floor of her messy office, with her ador-able toddler, looking smart and intense. Like Apple, like Ben & Jerry's, like 30 Rock, Tina Fey is herself a brand that women eigh-teen to forty-nine might find seductive. She's the working mom (who plays an iconic single woman), the girl nerd with power, ca-pable of getting chick-centric comedies green-lighted in this Apa-tow age. She zapped Aaron Sorkin; she zinged Sarah Palin. Bitch is the new black.

If Tina Fey thinks it's okay, who am I to disagree?

Then something interesting crops up on the Internet, a different type of experiment. It's by Joss Whedon, creator of Buffy the Vam-pire Slayer. I'd last seen Whedon on the set of Firefly, a Fox space Western about a group of rebels fleeing a corporation that gov-erns their universe. The series premiered in 2002, in retrospect the year everything changed. Joe Millionaire was about to become a monster hit. DVRs were new; DVDs were a big deal; online TV hadn't happened yet, but it was on the horizon. Aired out of order, Firefly was canceled after eleven episodes despite a fanatical online following. Yet it was a surprise hit on DVD, enabling Whedon to make a movie. Serenity won raves but flopped at the box office. So it goes.

Whedon is about to launch Dollhouse, a new series on Fox. But in the interim, he's whipped up a pet project, a labor of love that is also a stab at a new kind of TV economics—and a response to the paralysis he witnessed during the writers' strike. It's a musical

called *Dr. Horrible's Sing-Along Blog*, forty-two minutes long, filmed in six days, starring Neil Patrick Harris as Billy, an anarchist nerd who dreams of being a supervillain. Quirky and hilarious, it streamed free for a week online (crashing the server the first night). Then it went onto iTunes, debuting at No. 1. A DVD launches this fall. A tech blogger ran the numbers and concluded Whedon might make real money. This could "signal the beginning of the end of television as the medium of the least common denominator and the beginning of the profitable niche market," the blogger wrote, applauding a "freemium model" enabling cult creators to get funding directly from their audience.

I ask Whedon about *30 Rock*. Like Fontana, he's a fan. He thought the Verizon joke was fantastic. But he adds a caveat: You can only do that joke once. "You can't do it again and be cute, because then it's a different type of shilling. Eventually you realize the reason they're making a joke is because there's something abhorrent going on."

I tell him about the SoyJoy deal. He's troubled; he hadn't realized that was an integration. (He also hadn't realized it was a real brand.) But it's the American Express podbusters that really set him off. "My wife and I get very angry. We invest in the reality of the show! And this is one of the ways they're picking apart the idea of the narrative, keeping you from knowing if it's a show or not."

It's not just one series or one network, he points out. Everybody does it, and the strike added almost nothing to his colleagues' ability, or willingness, to push back, not merely against integration but against the way storytelling itself has been corroded—by required "webisodes," the insistence that writers blog every impulse, even the erosion of the end credits. "They want to take the story apart so they can stuff it with as much revenue as they can. And ultimately what you get is a zombie, a stuffed thing—a non-show."

Asked to use a particular phone, Whedon might say yes. "If we need to talk about the wonder of that phone? I don't know." Tele-

vision is a mass art, requiring compromise, pragmatism, he knows—but the line creators draw should not be about "How coolly can I do this? The most artful can be the most unethical."

> LIZ: So, we wrote a product integration sketch.
> JACK: Good.
> LIZ: But we wanted to run it by you first, because it's about how GE is making us do this, and we were kind of hoping that the GE executive in the sketch could be played by you.
> JACK: Oh, I get it. The whole self-referential thing: Letterman hates the suits, Stern yells at his boss, Nixon's "Sock it to me" on *Laugh-In*. Yeah, hippie humor.

Which is more naive: Whedon's belief in the radical power of storytelling—or the notion that every integration is acceptable, as long as the suits and the creatives stay friendly?

Could Whedon's experiment really suggest an alternative to the Branded Universe? I want to believe in that possibility. But I know there's another future, and it's by far the more likely one, especially now that the economy has crumbled for real. In this version, that creative riddle that stumped Dick Blasucci on *MADtv* has been solved. It is indeed possible to create subversive comedy that also sells Yarises. On most TV series, brands are woven indiscernibly into each plot twist—while on others they are referenced openly, with tremendous finesse, because there's no longer any distinction between what's funny and what moves the needle. Characters are designed as shills or consumers from day one. Shows themselves are brands, actors are brands, and so are songs and sodas, and these entities link and detach with the elegance of acrobats. No one will see a distinction between a scriptwriter and a copywriter—least of all an audience member—because that frog has boiled beyond recognition.

Welcome to the new Golden Age, fortified with optimism.

IN LIVING COLOR

With *Black-ish,* Kenya Barris Rethinks the Family Sitcom

The New Yorker, April 25, 2016

I set up this profile via Direct Message on Twitter, never contacting ABC. Kenya Barris was a terrific interviewee, game even during the tricky fact-checking process, when we had to talk to his parents about the violence in his childhood. The one detail that I'm sad I had to cut for space was the running bet Barris had with his writers that Trump would win the nomination and then the general election. He wasn't thrilled to be so prescient.

Kenya Barris, the creator of the ABC family sitcom *black-ish,* slumped on a sofa in his airy home, in Encino, California, his eyelids drooping with fatigue. In the nearby media room, his two young sons, Beau and Kass, played *Minecraft* on an Xbox. In the kitchen, his wife, Rainbow, who was pregnant with their sixth child, made popcorn. Out in the hall, their three daughters—aged ten, fourteen, and sixteen—yakked and giggled. The family was getting ready to watch the West Coast airing of "Hope," an episode about police racism that, at varying times, Barris had described to me as both "the one that ruins me" and "maybe my

most important episode." Once, with a resigned shrug, he had said, "Well, the toothpaste is out of the tube."

Like most breakthrough sitcoms, *black-ish* is built on autobiography. It's narrated by Andre "Dre" Johnson, a black ad executive played by Anthony Anderson, who has jumped, as Barris did, from inner-city poverty to bourgeois wealth, only to find himself flummoxed by his brood of privileged, Obama-era kids. Tracee Ellis Ross plays his wife, who, like the real Rainbow, is a biracial anesthesiologist nicknamed Bow. With a joke velocity approaching that of *30 Rock*, the show, brassy and shrewd, stands out for its rare directness about race and class. As Barris likes to put it, whereas *The Cosby Show* was about a family that happened to be black, *black-ish* is about a black family.

In its first two seasons, the show scored laughs from such subjects as whether black parents spank more and how different generations use the N-word; there was a plot about the knowing nod of recognition black men give one another. One hilariously nervy script satirized Martin Luther King Day. (Andre, Jr., admits that he's never read King's speech, explaining, "I always kind of zone out when people start to tell me about their dreams.") Some viewers, especially black ones, have been put off by the show's title, with its cheeky implication that some people are less black than others. But Barris told me that he was glad he'd resisted ABC's suggestions to sanitize it, titling it *The Johnsons*—or, absurdly, *Urban Family*. Michelle Obama has called *black-ish* her favorite television show.

Until "Hope," however, the show hadn't tangled with real-world politics. During Season 1, in 2014, Barris pitched a story based on the arrest of the African American professor Henry Louis Gates, Jr., for breaking into his own home. At the time, the Ferguson riots were streaming live on the Internet; ABC asked him not to do any jokes about cops. By 2015, the national outcry about police brutality had become too loud to ignore—and *black-ish* was getting raves as part of a newly diverse TV landscape. Over

the December holidays, Barris holed up in the studio attached to his home, bingeing on Red Bull and "probably some Adderall," and hammered out "Hope."

The episode opened with Marvin Gaye's "Inner City Blues (Make Me Wanna Holler)" and a scene borrowed from Barris's life: Beau, watching the Ferguson riots on television, had asked his parents, "Why are these people so mad?" What followed was a classic TV "bottle episode," set in one location: In their living room, the family debated the acquittal of a cop who'd repeatedly Tasered an unarmed black man. Their arguments were punctuated by jokes about Dre's father having been a member of something called the Black Bobcats. ("We were Panther-adjacent.") The episode felt haunted—and was made more vital and angrier—by the killing of twelve-year-old Tamir Rice in Cleveland. While Barris was struggling with the script, the Ohio prosecutor announced that a grand jury would not indict the cops who shot Rice. Barris still gets distressed talking about the case. "You know, twelve is young," he said, his voice cracking. "That's somebody's baby still."

Eight-year-old Beau, who was wearing pajamas printed with pine trees, hopped onto his father's lap. While another ABC sitcom, *Modern Family*, played on the TV, interspersed with promos for "Hope," Beau held his father's iPhone, watching a nature video about predators.

"It escaped!" Beau called out, looking up at his dad excitedly. "Mouse can swim?"

"What?" Barris said, confused. Forty-one years old, he has amused, hooded eyes and pockmarked cheeks. Blue-green tattoos peek out from his collar.

"Mouse can swim?"

"No, mice can't swim—they can, like, paddle," Barris said, laughing.

In the video, a mouse was in a river, being tormented by a fish. "That's mean, now," Barris said. "That's sadistic."

"Why are they mean?" Beau asked.

"Guys do that sometimes. It's a bad way to be."

"It's gonna escape. Look!" Beau said.

"It didn't escape," Barris said gently. But Beau kept seeing something different.

"Yes," he insisted. "It did."

The exchange felt peculiarly congruent with the episode we were about to watch: a meditation on just how much black parents should protect their children's innocence about the American justice system. Barris, who had been thrown against cars by cops and seen friends choked during arrests, had devoured Ta-Nehisi Coates's book *Between the World and Me,* an anguished manifesto addressed to Coates's son; the book was both quoted and displayed in the episode. (Barris asked Coates to do a cameo, but Coates declined.) The show's climax came when Dre begged Bow to remember how thrilling it had felt to watch the Obamas walk into the White House for the first time—and how terrified they were that the first couple would be assassinated. "Tell me you weren't worried that someone was gonna snatch that hope away from us, like they always do," Dre said. Silent footage was spliced into the scene: the Obamas, smiling, youthful, a model American family.

The table read for "Hope" had been cathartic; afterward, Laurence Fishburne and Jenifer Lewis, who play the Johnson grandparents, made speeches thanking Barris for writing it. But Barris knew that the episode was odd—not especially funny and possibly pedantic. "I played it for friends, and no one's going to say they don't like it to your face," Barris told me. "But the reactions have been mixed." He worried that it might be perceived as agitprop, a Black Lives Matter episode; although he supported the movement, he wasn't a fan of the idiom. "It's alienating," he told me. "No civil rights movement has gotten anywhere without the help of white liberals."

These worries were intensified by some Westeros-style drama at Disney, which owns ABC. A week earlier, Barris's strongest ally—the network's president, Paul Lee, the British executive who

had bought *black-ish*—had been ousted. Ben Sherwood, the president of Disney–ABC Television Group, replaced Lee, who is white, with Lee's deputy, Channing Dungey. She became the first black network president in history, a benchmark that got gushing press. But Barris didn't know Dungey; he had no idea what to expect. It wasn't a great moment for an episode to misfire with the show's audience, which is three-quarters nonblack. On Monday, Barris said, he had called ABC to make sure that its promos prepped viewers for, "as much as I don't want to say this, a 'very special episode.'" He added, "They did a good job."

Now that the East Coast airing was over, it was clear that "Hope" was a phenomenon: It was trending on Twitter and being GIF'd and quoted and hallelujahed for its embrace of the Norman Lear tradition of political theater. "So many people I went to school with, that I hadn't talked to since elementary school," Barris marveled, reading his email. He looked for negative responses, too: "On Facebook, I got scared, because I saw people saying, 'I'll never watch the show again.' That's the last thing I need right now."

Barris's sixteen-year-old daughter, Kaleigh, came in, holding her phone up, and said, "I read so many comments about people crying—people saying it was one of the most inspirational shows they ever watched." Her younger sister Leyah furrowed her brow: "But they haven't seen it yet!"

Barris cracked up. "On the East Coast!" he said. "Leave it to Leyah to shoot it down. This house is a hornets' nest."

As "Hope" began, Kass curled against his mom on a sofa, the girls reclined in black leather armchairs, and Beau sat cross-legged near his father, eating popcorn. The show opened with a newsreel-like montage—the Iran-hostage crisis, JFK's motorcade—that culminated with the sweet, smiling face of Trayvon Martin.

They watched the episode, which ended with Ruby, Dre's mother, spray-painting BLACK OWNED on the family's garage. As the credits rolled, there was a silence. "Kaleigh, what's the matter?"

Barris asked. "I just feel sad," she said, looking at her feet. "Did it bum you out?" "Yeah." His daughters began unspooling their responses, with Kaleigh describing how self-conscious she felt when they were the only black family in nice restaurants—how people stared at them. She hated the fact that her younger brothers would need to learn defensive tactics to deal with cops. "I feel like I have to tell my brothers that, regardless of how they're treating you, regardless if you're doing anything wrong, with the police you comply, because he's an authority—he has this gun on him, he could kill you."

Turning to Beau, Barris said, "What jokes did you like?" His son picked a scene in which the Johnsons bickered about takeout menus: "I liked it when we"—for Beau, there was no distinction between the Johnsons and the Barrises—"were all talking over each other." The family laughed at how well the show nailed their raucous style. Six-year-old Kass was fast asleep, and Barris carried him up to bed.

Barris and Rainbow first dated when he was sixteen and she was fourteen, a basketball player and a cheerleader attending sister-and-brother Catholic high schools in Los Angeles. Rainbow accidentally got pregnant by Barris when she was twenty-two and a medical-school student in Boston, after she flew out to visit him in Los Angeles. In between, they broke up and dated mutual friends while attending Clark Atlanta University. Both had been inspired to apply to the school by two intoxicating portrayals of historically black colleges: the 1987 *Cosby* spin-off *A Different World* and the 1988 Spike Lee movie *School Daze*. Lee's film, especially, had jolted Barris: He'd never seen anything like its dance-off between "jiga-boos" and "wannabes," its brazen display of intra-black tension. Lee impressed him as a new kind of black artist, an impolite innovator with a voice supple enough to "talk about things that felt very personal to me but make everyone else interested in them."

Barris studied film, dreaming of becoming "the new Spike Lee." But he was also drawn to black sitcoms, which proliferated after the success of *Cosby*. For a while, the boom seemed like a lasting phenomenon: Will Smith beatboxed as *The Fresh Prince of Bel-Air* on NBC; on *A Different World*, activists, premeds, and Jack-and-Jill princesses sparred and flirted. In 1990, the Fox network launched a slate of black-centered programming, including the celebrated sketch show *In Living Color*. In 1994, though, the show was canceled, along with *The Sinbad Show, Roc*, and *South Central*, as Fox rebranded for mainstream—meaning white—audiences. In the late nineties, black comedies were repeatedly subjected to this form of TV gentrification: They were launched on upstart cable networks, like UPN and The WB, then canceled, or shunted to BET, when the networks whitened up their programming. In 1999, the NAACP lamented a "virtual whiteout" on television. As Kristal Brent Zook writes in her 1999 book, *Color by Fox*, network executives were uneasy not just with black casts and writers but with "black complexity": They bumped black creators for white producers, pushing for the most risk-free, formulaic comedy.

In 1998, Barris, working with several other aspiring TV writers, shot footage for a documentary about this phenomenon, calling it *Film Noir*. Among the people Barris interviewed were Felicia D. Henderson, who wrote for the sitcom *Moesha*, and a co-creator of *Moesha*, Ralph Farquhar—Rainbow's uncle. Before they could finish it, however, Barris and his partners ditched the project, fearful of alienating employers. "We didn't want to fuck ourselves before we began," he said. But Henderson became his mentor. She helped Barris get a slot in the Paramount Writers Program, a diversity initiative, and hired him to write for *Soul Food*, a series she created for Showtime. During the years it aired, from 2000 to 2004, it was the only black-family drama on television.

To Barris's mother, Tina, TV writing seemed like a crazy gamble for a college-educated black man. In fact, right after he graduated from Clark Atlanta, she'd hooked him up with a job as the

press secretary for an L.A. councilman, Nate Holden. "I was wearing these Men's Wearhouse suits, hating my life," Barris told me, laughing. She was furious when he quit to try stand-up comedy and writing. Barris has always been devoted to Tina, who raised him and his three siblings, mostly on her own, in Inglewood, in poverty-ridden South Central L.A. Tina divorced Barris's father, who was physically abusive, when Barris was five; six years later, his father won a settlement after losing a lung in an industrial accident. Half the money went toward supporting the children, enabling Tina and the kids to move to middle-class, integrated Hancock Park and allowing Barris to attend private school.

Though he hung out at The Comedy Store, Barris says that he wasn't much of a stand-up performer: "There's a certain don't-give-a-fuckness that you have to have as a comic. I don't have that. At my core, I'm shy." But he was an empathetic observer, a strong joke writer, and, as Rainbow puts it, a natural "hustler," able to sell ideas and to crack closed systems. After working on *Soul Food*, he helped broker a reality-TV deal for his best friend since childhood, the model Tyra Banks. The show, *America's Next Top Model*, became a hit, with Barris as its co-creator and producer. (He still gets a cut of the profits.)

After a year, he returned to scripted TV. He initially wrote for shows aimed at an African American audience, such as *The Game*, about the wives of football stars. But when he jumped to sitcoms on The WB and NBC, with predominantly white writing staffs, he hit a wall. Barris was often the "diversity hire," and dryly describes himself as a "beneficiary-slash-victim" of such initiatives. In some writers' rooms, such as the one for a short-lived WB sitcom called *Like Family*, he made lifelong friends. But wherever he worked he was a cultural outsider—the one writer who didn't know who Neil Young was. "Any mistake that you make is amplified," Barris recalls of the experience. Barris quotes W.E.B. Du Bois when talking about the "double-consciousness" that a black person develops in a white world, but he also describes acquiring chops specific to

comedy writers: He learned how to use jokes to build bridges and defang put-downs. "I beat 'em with funny," he says. When a colleague kept comparing the colleges they had attended, Barris recalls, "I was like, 'It doesn't really matter where you went to school, because right now I'm looking at you across the table. So kudos to Harvard! Because we make the same money.'"

His grimmest experience was on *Listen Up*, a 2004 CBS sitcom starring Jason Alexander as a sports journalist, with Malcolm-Jamal Warner in a supporting role. The showrunner was Jeff Martin, a former writer for David Letterman's show and a *Harvard Lampoon* alum who wrote for *The Simpsons*. It was a slow poisoning; Barris knew that the room didn't like him. When they wrote a story about the mother of Warner's character—an educated football player from New York—the white writers pitched the mother's lines as those of a fat black woman with a Southern accent. Barris recalls, "I was like, 'Wait, where is she from? How much does she weigh?' It wasn't even done maliciously—it was just, 'This is how a black woman sounds.' It was such a wake-up call."

One day, Barris argued with Martin over the seventies Norman Lear series *Good Times*, which is about the Evanses, a poor black family living in the Cabrini-Green housing project in Chicago. Martin said that he wished he'd been born into the Evans family, because it was "rich in love." Barris blew up: "Dude, you would not have liked to be in the fucking family on *Good Times*. You're saying that from such an entitled place! You missed the whole point of the show." Barris's contract wasn't picked up—the Hollywood equivalent of being fired. (Martin said that his comments were "likely ironic," adding that he's happy for Barris's success. "His sensibility didn't fit my show," he said. "But saying someone didn't capture the voice of *Listen Up* isn't much of an insult.")

Barris wrote pilot after pilot, trying to crack the formula that would put him in charge. *Black-ish* was his nineteenth attempt. Three got produced but didn't make it to air. By this time, he and Rainbow had married. She'd moved back to L.A., restarted med

school—she couldn't transfer credits—and had two more daughters. The marriage was sometimes strained, and many of Barris's pilots mined tensions at home. One was about a married man torn between his wife and his partying friends; another came out of a marriage-therapy session in which the counselor told Barris and Rainbow that they needed to reboot their relationship, as if they'd never met, to suit their adult, not adolescent, selves.

Barris calls black-ish his best and most honest iteration of these pilots. Dre and Bow, former high school sweethearts, have four kids: the Instagram-addled Zoey, the proud nerd Andre, Jr., and the mismatched twins Jack and Diane (who are named for the John Cougar Mellencamp song—one of Barris's favorites). Dre's parents are divorced; his mom, Ruby, is fiery and smothering, and his dad, Pops, judges him for not "whupping" his kids. Despite his success, Dre feels ill at ease living in an upper-middle-class, largely white suburb—and at sea as a father. Andre, Jr., is obsessed with Dungeons & Dragons and wants a "bro mitzvah"; Zoey is a queen bee whose white friends use the N-word. Bow is an Ivy League graduate with a white hippie dad. If blackness is so easily detached from Dre's prized codes of urban authenticity, what does that make him?

In the show's original conception, Dre was the diversity hire on a network sitcom, which Barris based on Listen Up. ABC asked him to change the workplace to an advertising agency, in part, Barris acknowledges, to facilitate product integration. (He says of an episode in which Dre buys Zoey a Buick, "It was a commercial, dude.") Tyra Banks calls Barris one of the most nostalgic people she knows, and, though black-ish isn't set in the past, it's studded with flashbacks to Dre's Jheri-curled childhood—brief scenes with the stinging clarity of Chris Rock's Everybody Hates Chris. The show's psychic engine is Dre's sense that the past isn't past, for him and for all African Americans. In an episode about Dre's yen for high-end sneakers, he explains, "Think about it. If you didn't get a paycheck for four hundred years, when you did finally get one, you

might want to spend it." At the same time, *black-ish* pokes fun at Dre's tendency to see antiblackness everywhere. He fumes that it is racist to ask if he can swim—but he can't swim.

Barris worked on the pilot with the African American comic Larry Wilmore, whom ABC proposed as a co-showrunner. Wilmore, who wrote for *In Living Color* and created *The Bernie Mac Show*, knew plenty about what he calls the "ethnic cleansing" of nineties TV. But by 2014, TV executives were biting again. Shonda Rhimes's Shondaland empire was a ratings machine, led by *Scandal*, the first network drama since 1974 to star a black woman. Racial critiques of *Girls*—and the simultaneous rise of Black Twitter—had scared executives into at least paying lip service to diversity. On cable and streaming, shows like *Orange Is the New Black*, with an ensemble that was black and brown (and, just as shocking, butch, fat, and trans), were thriving; creators like Mindy Kaling were becoming popular brands. A Nielsen report found that black viewers watched 37 percent more TV than other demographics. It seemed like the right moment for an idea-driven sitcom about race that, as Wilmore saw it, felt daring and distinct, with "brilliant colors, flashy character choices, bold strokes."

There was a bidding war for *black-ish*. Barris, who'd imagined placing the show in the cable-prestige jewel box of FX, went for the money and the mass audience—and the pressure to produce twenty-four episodes—of ABC. When Comedy Central offered Wilmore a talk show, Barris asked to partner with the white writer Jonathan Groff, an executive producer on *Happy Endings*, a cult sitcom that featured an interracial couple. For Barris, Wilmore's departure was scary but also an opportunity. "People knew I was the voice behind this," Barris said. "That's how you make yourself invaluable."

A writers' room procrastinates as much as a writer. On a recent Monday afternoon in Burbank, *black-ish* staffers stared at a moni-

tor on the wall, giggling at a YouTube video of a cheetah eviscerating an ostrich. They spent ten minutes talking about the difference between Iceland and Greenland. But this aimlessness was a pose, as the table kept looping back, struggling to "punch up" bad dialogue in the season ender.

A high-concept finale was becoming a tradition for *black-ish*: Season 1's featured a flashback to the Cotton Club of the 1920s. This year's installment, "Good-ish Times," included a meticulous parody of the seventies sitcom that Barris had argued about with his old boss. When the show starts, Dre is anxious about corporate layoffs, especially because Bow is expecting their fifth child. He falls asleep watching a rerun of *Good Times* and dreams that he's Keith, the football-playing boyfriend of Thelma, the show's teen daughter, and that he is terrified to tell her parents (played by Pops and Ruby) that he's got their daughter pregnant. Andre, Jr., plays J.J., the pencil-necked geek famous for shouting "Dy-no-mite!" *Black-ish* is filmed in the modern single-cam style, but the dream sequence would be a multi-cam shot, before a live audience. The conceit played off Dre's terror of falling back into poverty and his nostalgia for both his childhood and the sitcom that reflected it. Not coincidentally, the plot mirrored Barris's adult life, which was bookended by two unplanned pregnancies—the one that led him to marry early, and Rainbow's current pregnancy, which had come after nearly two decades of marriage.

The table read had been a dud, possibly because the writers felt uneasy constructing multi-cam jokes, with their hard, vaudeville beats. There were false starts; there were worries that some gags were mere "high-jinksing." Someone pitched a diabetes joke: Maybe Florida, the *Good Times* matriarch, could say about a dog that bit her, "I would have lost my big toe, had the sugar not already taken it." Another writer wondered if nonblack viewers would get it. "Is that too deep a cut?" Barris said, polling the room. It was fine, he decided: *30 Rock* made jokes about the same subject.

A writers' room, in Barris's experience, is the "cool kids' table,"

an aggressive display of social prowess, disguised in jokes. He and Groff were joined by such veterans as Gail Lerner, who worked on *Will & Grace,* and Yvette Lee Bowser, who created *Living Single.* It was far more diverse, in gender and in race, than most sitcom rooms; down the street, the *black-ish* set had a crew dominated by people of color.

Still, Barris had his own diversity hire, whose salary was drawn, in part, from a Disney corporate fund: Damilare Sonoiki, nicknamed Dam, a twenty-four-year-old African American Harvard alumnus and former *Lampoon* editor. Like Barris, Sonoiki had grown up in a violent neighborhood, in Houston, and transferred to a private school. He had just submitted his first script, which showed promise, but he wasn't entirely at home in the room. As the work dragged into the night, Sonoiki, who had a jacket on, tugged its hood over his head and pulled its collar up, until only his eyes peeked out. At one point, he suggested capping some banter with a sour punch line: "Unlike you, bitch." When the other writers brushed it off, Barris turned his head to Sonoiki. "You just had a win," he chided him, sotto voce, referring to the script. "Feel the room. Don't say something like that."

A few minutes later, Barris himself made a pitch that fell flat. He suggested that Florida should offer the family dessert by saying, "I want to make you something that I learned from the white people I work for—a kind of meal after dinner." The other writers stared at Barris blankly, but he kept adding dialogue: "What? Sugar water?" The premise didn't entirely make sense (wouldn't poor kids know what dessert is?) and there were nervous giggles. Suddenly, Barris laughed at his belly flop—and skillfully reversed the dynamic. "So. Much. Confused!" he shouted, planting his hands on the table, then sending the room into hysterics with an instant replay: "I was looking at you, Lindsey, thinking you would save me, you would get this, you were on my side. But there was *nothing.*" Yet even as he mocked himself Barris kept pitching the bit, selling the surreal notion of a family so poor that they'd never had

dessert. "The little meal that white people eat after dinner?" Magically, another writer offered a punch line—"Breakfast!"—and the table burst into applause. "Folks, we have one joke," Groff announced.

The table scrambled to craft it into a multipart "run": "Breakfast?" "No, it's sweet." "Sugar eggs?"

"Sweet night breakfast?" Barris said. Maybe the table was so tired that the writers had become slaphappy, but "Sweet night breakfast?" won a big, goofy laugh—it was the sort of curveball construction that suited *black-ish*. There were still doubters in the room. But the next day, when the scene was shot, "Sweet night breakfast?" killed.

Two days later, the writers had a flare-up over "relatability," that network bugaboo. Barris was in and out of the room, and while he was gone, the writers discussed the character of Vivian— a black nanny, played by Regina Hall, who gives Dre a case of "black white guilt." She'd been introduced in an already filmed episode, but Peter Saji, a younger black writer, objected to her presence in future scripts: It might make the Johnsons seem too privileged. The idea began to harden in Barris's absence.

When he returned, one of the writers presented it as a structural issue: Wouldn't it be more efficient to give Vivian's jokes to Grandma Ruby? Barris argued that Ruby—a zany character who makes remarks like "Not now, hybrid!" to her biracial daughter-in-law—had begun dominating the show, even though she doesn't live in Dre's house. "On set this week, it was un-fucking-comfortable," Barris said. "Nothing but Ruby! We have to be careful—she's not the mom, she's the grandma. Tracee has gotten us this far."

Eventually, Saji explained his underlying objection. His own family, he said, would find a nanny an alienating concept. Didn't viewers prefer to think that the parents "do it all"?

Barris frowned. "She's having a baby," he said flatly. "She has four kids. She's a full-time doctor. He works full time. How are these kids getting to soccer practice?" He was bugged enough

that he returned to the subject later: "That 'accessibility' thing, it bumps me—it bothers me." The families on *Modern Family* live in multimillion-dollar houses and have nannies, he pointed out.

"With us, it's like, 'How can they afford something?'" Barris said. "It's the honest version of what this family would have." If he had to present the "most palatable" version of the family, in order to be less threatening, he said, "I don't even want to tell that story."

When Barris speaks with the most passion, it's about his mother. In a single year, he told me, Tina "left an abusive marriage, got divorced, lost her house in a fire, and my little brother died—of cancer, of leukemia, in her bed, you know?" He went on, "And she still had four kids to raise. She said, 'If I didn't have you guys, I would have just packed my bags and run away.'"

The character of Ruby, who is so close to Dre that she threatens his relationship with Bow, was obviously inspired by Barris's mom. But Barris told me that Tina also inspired the Laurence Fishburne character, who is impossible to please. While I was on the set, Barris talked to her at least once a day on the phone—asking after her health, letting her know that he was appearing on *Nightline* to discuss "Hope." "She was like, 'You weren't on much,'" he joked. "I said, 'Oh, really? Thanks, Mom. When have you been on *Nightline*?'" And yet he clearly adores her, admires her, and is intimidated by her—he worries about pleasing her with every decision he makes. She never accepted welfare, he told me: They took subsidies like government cheese, but she worked three jobs—bartender, selling Mary Kay and Amway, hocking insurance for Golden State Mutual—while studying for the real-estate broker's exam. She saved up loose change in a jar, then spent it all to surprise him with a new bike. Eventually, she invested in low-income real estate, collecting the rent herself, with a snub-nosed pistol in her pocket.

The death of Barris's younger brother, David, nearly wrecked

her. She hovered over Barris, who had asthma, keeping him home whenever the pollen index rose. (As an adult, he is a huge hypochondriac: He once called Rainbow in a panic, convinced that he had SARS.) At seven, Barris got warehoused in a special-ed class with the Orwellian name the Opportunity Room. When the school psychiatrist suggested that his mother put Barris on Ritalin, she refused, and instead got him into a progressive black private school, the International Children's School, which was sponsored by Bill Cosby. The pressure Barris felt to succeed increased when his beloved older brother, Patrick—who had won academic and athletic scholarships to USC—began using cocaine and received a diagnosis of schizophrenia; Patrick dropped out, and now lives at one of his mother's properties.

When Barris was six, Tina moved her kids into a new house— one that his violent father wasn't supposed to be able to find. One night, Barris, who was afraid of the dark, heard noises. He wanted to get in bed with his mom, but she'd been training him to stay put; she said that he'd get a spanking if he didn't go to sleep. Barris sneaked out anyway, scared. When his mom realized there was an intruder, she yelled at Barris to go into her room and shut the door. He peeked out: His dad had broken through his bedroom window, and his mom, holding a gun, was backing up, as his father moved toward her. Then Tina took a deep breath, closed her eyes, turned her head away, and shot at his father five times. "Pow pow pow pow pow," Barris recalls. "She kept clicking. And he, like, barreled past her—and damn near broke the door off the hinges. I hear 'Rrrrrrowrrr' as he tears off." His mother sat down and sobbed. "And she's like, 'Go get the phone, go get the phone!' It was one of those long cords and she said, 'Push zero.'" When the police arrived, Barris remembers feeling not afraid but embarrassed. "The police officer was so nice to me. He was saying, 'Show me your room.'" As many run-ins as Barris has had with the cops, he says, they sometimes are there for you "at the worst moments of your life."

At the hospital, his father, who'd been hit once in the stomach, was headed into surgery, handcuffed to a gurney. Too fearful of him to press charges, his mother fled, with her kids, to New York for a year. She took Barris to counseling, but he felt that the incident hadn't actually damaged him. "I don't know if I was just, young, whatever, but part of me felt like, He lived. You know what I'm saying? He got what he deserved. It's almost like, 'Good for my mom!' Because he never messed with her again . . . and she kind of claimed her power back. I'm glad that I was there with her. It made us very, very close. She always was like, I'm so sorry. And she was worried that she was gonna raise, like, a psychopath! But it was—that was a story I would tell the room. And every writer would be like, 'What the fuck did he just say?'" Being honest about the unsanded edges of his life, Barris says, lets others be honest, too. It's key to good comedy. "I think it's that aggregate of situations that make you who you are. This is a reality, and this is what happened."

He says of the shooting, "You don't pull a trigger that many times unless you're trying to—you know. I think she'd suffered through so much, and she was so scared that she was like, 'If I'm gonna do this, I have to do it.'"

"Good evening, I'm James Earl Jones," Laurence Fishburne intoned in a familiar oceanic boom. "Welcome to 'Black Omnibus.'" Fishburne, wearing an Afro wig and a broad-lapelled blazer, stood in front of a ceremonial African mask. Barris and an assistant director, E. Langston Craig, were nearly gasping with excitement. It was a tiny cutaway joke in the "Good-ish Times" episode, an absurdist reference to a PBS show that aired for twelve episodes in 1973—the deepest of deep cuts, a hat tip to a beautiful bit of lost black TV history.

"Man, I don't even care if nobody gets this," Barris said. "I swear to God, it's the entire reason to do this show."

He was less pleased at how things were going during another scene—the family fight that triggers Dre to dream that he's in *Good Times*. Around the kitchen table, the Johnson kids cheerfully describe their big-ticket summer plans. The twins are going to Hunger Games Camp and need expensive bows and arrows. Dre loses his temper, telling his kids that summer is supposed to be for miserable jobs—like the ones he had.

To goose the scene, Barris retreated with Anderson, and when they started rolling again, the actor improvised zingers. "You never had to ask a white lady if you could pump her gas!" Anderson sputtered at the kids. And then: "You never had to take care of a pigeon coop for food stamps!" As Anderson reeled off increasingly baroque variations, the crew cracked up: "You never had to take care of a pit-bull puppy! . . . sell baking soda to the dope house! . . . sell curl activator door-to-door in the Mexican neighborhood!"

During prep for the next take, Barris told me that these riffs—none of which made the final cut—were based on stories that he and Anderson had shared. Barris used to approach white women at gas stations and ask them if he could pump their gas. ("It was a little threatening," he told me sheepishly. "Three black nine-year-old boys on Huffy bikes.") Anderson, whose mother grew up in the Chicago project where *Good Times* is set, sold curl activator. Barris frequently embeds his scripts with veiled biography: In another episode, Dre warns Pops not to give his drink to Ruby, because "she shot you the last time she had gin."

Later, over lunch, Anderson and I talked about his character. Andre, he said, is "a hundred percent Kenya, a hundred percent Anthony." He and Barris had "instant kinship": Both were born in South Central, were "first-generation successful," and had kids in private school. "Not only is my son the only chocolate drop in his class, he was the only chocolate drop in his grade for three and a half years," Anderson said. A notch pricklier than Barris, Anderson has a pugnacious charm and a low tolerance for nonsense:

After "Hope" aired, he sparred with critics who called the show racist. As a boy, he'd loved *Good Times*, particularly John Amos's portrayal of the dignified and hardworking James Evans, who reminded him of his own father.

Like Anderson, many members of the production share Barris's class-jumping biography. "I was born and raised on the border of Ferguson, and it's goddamn personal," Jenifer Lewis, who plays Ruby, said of the police-brutality themes of "Hope." She didn't watch *Good Times* growing up, because it felt painfully close to her own life. The writer Yvette Lee Bowser has a similar background, and Fishburne describes Barris as a younger-brother figure.

Tracee Ellis Ross is the outlier: The child of Diana Ross, she was educated in Switzerland and on the Upper East Side. When the show started, her character veered dangerously close to cliché: the sighing mom-wife with the baby-man husband who gets all the laughs. After a few episodes, however, Barris and his writers tapped into Ross's comic charisma—her goofy grin, her Lucille Ball–ish gift for being at once glamorous and ridiculous. Barris told me that Ross didn't always agree on the direction of her character. They'd argued about her dialogue in "Hope," in which Bow kept making the case, to an almost blinkered degree, for letting "the justice system do its job." But Ross told me that Bow was a rewarding role, precisely because the show emphasized Dre's perspective on the world. Her performance had to be emotionally rich enough to give Bow "wholeness."

Barris bridled at online criticism he'd seen directed at Dre. He said, "It was as if they were trying to say that a black man couldn't be both blustery and lovable"—that Dre couldn't be loved as people had loved Ralph Kramden. He saw the criticism as similar to early network notes suggesting that he make the Johnson house smaller. Wisely, these tensions had been written into the scripts. In one episode, "The Gift of Hunger," Dre worries that his kids have been spoiled by cushy lives. Then he realizes that the children, by

having a flamboyant, easily angered father like him, have been dealt a different kind of obstacle. In voice-over, Dre says, "I'm a lot. And if they could get past me, they could get past anything."

Barris himself is old-school in certain ways. He opened every door as we passed through the set. He insisted that I text him after I drove back to my hotel, to confirm that I had arrived safely. He wants to make more money than his wife; it was important to him that she take his name. He's prone to theories about how men and women are "wired." The biggest fight the writers' room ever had was about Barris's desire to own a gun, which led to an episode in which Dre wants to buy one to protect his family. At one point, during the debate over the black-nanny character, he told his staff, "Honestly, I regret not having spanked my kids." (He won't change his policy for the new baby, though: "He's not going to be the Spanked One!")

Groff said that he's asked Barris if Dre wants to be a modern man but falls short. No, Barris said: Dre is who he says he is. "I still believe a little bit that changing gender roles have hurt relationships," Barris said. Many of his mentors have been women; he regularly hires women as collaborators—and half the black-ish writers are female, a rarity for a sitcom. But Tyra Banks told me that she spent years talking to Barris about the tensions between men and women, in a rolling debate about gender and power. It's possible, Barris said, that his nostalgia for old-fashioned breadwinner masculinity stems from the fact that his mother was "so far away" from identifying with the feminist movement. "My mom was a man and a woman—she had to be," Barris said. "And I so wanted to have my mom have someone open a door for her, pull a chair out, take the trash out for her."

One night in March, Barris and Rainbow—he in a tuxedo, she with her hair in two slim braids—attended an awards ceremony for the American Black Film Festival, to be aired on BET. *Black-ish* won for

best TV comedy, *Straight Outta Compton* for best film. The presentation was dominated by proud speeches about the power of black Hollywood. But our table erupted in laughter at the evening's rudest joke—one that was cut from the telecast. Jamie Foxx claimed that he had no clue why people were protesting the lack of Oscar nominations for African Americans. Foxx, an Oscar winner, said, "I called Denzel and said, 'What's this all about? I mean, hashtag What's the Big Deal? I mean, hashtag Act Better!'"

On the drive home, Barris and Rainbow kept giggling about "hashtag Act Better!" Barris told me, "I've got to be honest— I don't know if this was the right year for a protest of the Oscars." He argued that it was counterproductive to have a "black slot": "It just dilutes it." Like any film-studies major, he had finicky opinions about the year's movies. He enjoyed *Straight Outta Compton*. But was it Best Picture material? He noted, "The Ryan Coogler movie that truly deserved a nomination wasn't *Creed*. It was *Fruitvale Station*." On the flip side, Idris Elba, the star of *Beasts of No Nation*, had been robbed. The problem was far bigger than the Oscars: When African Americans were starved of opportunity, they were forced to celebrate art merely because it existed, to be cheerleaders instead of individuals with distinct, even iconoclastic, tastes.

Barris was particularly frustrated with prominent black figures who, to his mind, supported schlock. "I believed in Oprah for so long!" he moaned, as Rainbow smiled in recognition of the rant to come. "You know, Oprah is probably three weeks away from having a British accent. She was the purveyor of style and class." But when Winfrey's cable channel, OWN, began failing in the ratings, she'd partnered with Tyler Perry—the purveyor of gooey church-lady theatricals. "I know that Oprah has taste! She cannot think that those shows are good."

Barris clearly wants commercial success himself: He'd love to oversee a slate of TV shows, as Norman Lear did, and he has been working on multiple film projects. He co-wrote the script for the new movie *Barbershop: The Next Cut*. He's developing a *Good Times*

film and a comic version of *Shaft*. He's got a deal to make a new ABC pilot—a sort of buddy-comedy version of one of his favorite shows, *Veep*, with characters based on Donald Trump and Al Sharpton. The next three years, he said, were crucial—his shot to establish a legacy that couldn't be wiped out if the industry mood shifted.

Unlike the movies, television now featured enough shows by and for and about people of color that it had become possible to draw comparisons. Barris is both excited by and competitive with NBC's *The Carmichael Show*, another Lear-inflected black-family sitcom, which was co-created by his friend Jerrod Carmichael. He admits that he's biased against Fox's *Empire*—a camp rap melodrama that's been creaming *black-ish* in the ratings—but he also doesn't think it's good. "Just because someone's handicapped, doesn't mean he's not an asshole," he said. "I can't call this dude a dick because he's in a wheelchair? Same thing—just because someone is black and they do something, doesn't mean it's dope."

At the ABFF awards, a presenter joked that ABC stood for Another Black Channel—a hoary joke that left Barris stone-faced. But he does express pride in the network's deep bench of creators of color. According to Barris, John Ridley, the creator of the drama *American Crime*, encouraged him to secure a long-term deal with ABC, and Shonda Rhimes advised him on social-media strategies, including getting his cast on Twitter. Television is the vanguard medium now, Barris believes—he's a binge viewer who is offended "on a primal level" by TV writers who don't watch TV. But, regardless of the medium, he is most attracted to art that is "proprietary," a word that Barris uses to describe not only early Spike Lee but also ambitious TV, from Jill Soloway's *Transparent* to Damon Lindelof's *The Leftovers*, from *Broad City* to *Mr. Robot*. What rankles him is talent wasted: The funniest, meanest joke in "Hope" is Ruby's claim that the guy Tasered by the cops deserved it, because he'd been selling copies of Lee's *Chi-Raq*.

Rhimes watches *black-ish* with her tween daughter. She ticked

off her favorite bits: the N-word episode; the "white Greek chorus" of Dre's office; the grandparents who are "not these saintly black parents—they're divorced and hate each other's guts." She described Barris as "very kind," "very quick-witted," and "kind of shy." When Rhimes, who can be shy herself, first met Barris and Larry Wilmore, they disarmed her with what Wilmore describes as an imitation of a racist Mickey Mouse, squeaking in horror at the idea of a Disney show called *black-ish*. She told them to keep in touch, and, unlike many creators she'd offered to help, they followed up.

Solidarity, she said, was the only way to cope with the fragility of being a Hollywood pioneer. "There's no way to achieve any kind of voice if you're the only," Rhimes said. "That's how women become the bitch and how people of color become 'weird.' Inclusion means more than 'eight white guys and a person of color.'"

On my last night in L.A., I joined Barris at the Soho House in West Hollywood. He was having a dinner meeting with Bashir Salahuddin and Diallo Riddle, the comedy team that created "Slow Jam the News" for Jimmy Fallon. Like Barris's diversity hire, Dam Sonoiki, whom they knew, they had gone to Harvard. African American men on the verge of forty, they looked handsome in thick-cable sweaters. Barris slouched in ripped jeans and a sweatshirt—an outfit I'd seen him wear on the red carpet. His sneakers were always impeccable: Growing up, he'd saved his money for fancy ones, which he cleaned with a toothbrush. He now had a closet devoted to his collection. Running down his forearms were two tattoos: the word "Choices" on the right, "Decisions" on the left. His mother had told him that black people made too many decisions—selecting from socially constrained options—and not enough choices.

Riddle told me that he and Salahuddin had met Barris once before: "He gave us some advice, but we didn't take it." He wouldn't

clarify, so Barris filled me in: He told them that they should seek out an amenable "white guy" to work with. It would build a bridge to top executives, who were almost universally white. "That guy can be an ally," Barris explained. "A translator."

Salahuddin and Riddle were feeling burned: They'd spent four years developing a show called *Brothers in Atlanta* for HBO, which ultimately rejected it. They were looking for a "rabbi," they said, someone who knew about network TV. What you wanted, they all agreed, was a crew, a squad—like-minded friends who could jump in to "punch up the funny." Barris spoke longingly about the comedic collective that Judd Apatow had built, and said that he wanted to create something like it—"a contemporary, racially eclectic, gender-eclectic, experience-eclectic salon." He listed people with whom he'd like to collaborate, including Lena Waithe, who plays the laconic black lesbian on *Master of None*. Isolation, Barris suggested, might have been the problem for the comedian Dave Chappelle: When his Comedy Central show fell apart, he had no community to gather around him.

We ate pomegranate ice cream, and the conversation, as it often does in L.A., veered into black-ops financial territory, such as the advantages and disadvantages of a several-year network pickup. Salahuddin was newly engaged, and they talked about marriage. Barris told them about a turning point in his life, when he was in his late twenties, clubbing. One evening, he came home drunk from Xenii, a members-only club, and found Rainbow asleep at the kitchen table. She was pregnant with their second daughter, nursing their first baby, sleeping while sitting up, her medical textbook open in front of her. He realized that he couldn't be "that guy" anymore. It wasn't easy for him to have a family so young, he told Salahuddin and Riddle, but it saved him: It made him ambitious.

After dinner, Barris and I headed to the bar. Before ordering drinks, he said, he wanted to do a sweep of the room—if any black people were around, he half-joked, he'd know them. In fact, when

we sat down Barris was approached by Jay Ellis, an actor on *Insecure*, an upcoming HBO comedy created by Issa Rae. Barris also greeted Steve Levitan, the white showrunner of *Modern Family*, who congratulated him on "Hope." The bar had a spectacular view: The Pacific twinkled in the distance. Barris told me that he had spent a lot of time here during the first season of *black-ish*. Just as his show was becoming a hit, he and Rainbow separated for six months, living apart and dating others. Larry Wilmore and Anthony Anderson also broke up with their wives during the show's first season; only Barris and Rainbow reunited. They both felt a strong need to live up to the radiant image of their best selves, as portrayed on the show. "I think it's part of why we wanted to have another kid," Barris told me. "To relaunch into what's important."

Rubbing his close-cropped hair, he said, "I've fucked up so much, gotten so many second chances." As a teenager, he had a frightening flirtation with gang life. In his twenties, when his daughters were little, he said, he wasn't around enough. "I sold weed," he said. "I got caught cheating." Earlier, he told me that he wanted the show to represent the life of an imperfect couple, not idealized figures. But there's a built-in tension to *black-ish*: the burden placed on black stories, and on the artists who tell them, to be not merely good but inspirational. In one of this season's best episodes, "The Johnsons," other parents keep calling Dre and Bow and the kids "such a beautiful family"—praise that floods Dre with fear. He and Bow grew up trying to be the Cosbys; everyone knows what happened there. "It's just one show," Pops says of *Cosby*. "That's just it, Pops—we get so few chances!" Dre says, in voice-over, as the screen cuts to the *Cosby* opening credits, except that it's the Johnsons turning those iconic dance moves. "And when we do something and we do it well, it's special! And when we mess it up, we mess it up for everyone coming behind us. It's like we're carrying everybody's dreams on our back."

The longing to see a positive portrayal of black life feels particularly fraught as Obama leaves office, and as Trump's openly

racist rhetoric attracts followers. Although Barris's early life was punctuated by police violence, his ugliest memory, Barris said, was something a cop told him when he was sixteen: "You know, no one will care if you die." A network sitcom could never address anything quite so raw, he knew. Even the most topical sitcom isn't an op-ed; it's more like Silly Putty that's been pressed against Page 1. But, although "Good-ish Times" had many more jokes than "Hope," it shared a stark central insight. It found dark laughs in the dialectic of striver psychology, as the Evans family flips between two equally extreme reactions to racism and poverty. One minute, they're fatalistic to the point of self-sabotage; the next, they're spouting affirmations of empty hope—"Tomorrow's gonna be a better day!" They might in fact be "rich in love." But their lives are all decisions, no choices.

In April, Barris's family went on a vacation that could be taken only by people at the pinnacle of success. During a visit to New York, they saw *Hamilton*, not once but twice. They also flew to Washington for the White House Easter Egg Roll, and were part of a VIP group who met the president and the first lady. "That's our family," President Obama told Barris, about *black-ish*.

Not everything went smoothly. After four hours at the White House, Barris, tired, insisted that they leave. Once they were outside, Kaleigh got a text from Anthony Anderson's son: They'd just missed Beyoncé and Jay Z. Barris's daughters were furious at their dad; tears formed in Leyah's eyes. When he saw those tears, Barris lost it: "You just met the president!" They apologized. Barris stayed mad. But he was also inspired. "I texted Groff and said, 'We have to use this next season.'"

IN PRAISE OF SEX AND VIOLENCE

TO SERVE MAN

Hannibal

The New Yorker, June 29, 2015

I still can't believe they ran a show this outrageous and beautiful—
this sick and strange and destabilizing—in a network time slot.

I stopped watching *Hannibal* in Season 1, after a corpse was carved
into a cello, its vocal cords splayed like strings, then "played." I
stopped watching again when Dr. Frederick Chilton, played by
the redoubtable Raúl Esparza, got his guts tugged out of his ab-
domen, like red-sauced linguini, while he was still conscious. I
stopped watching when an acupuncturist drove a needle through
an eyeball, and again when a man's leg was roasted and fed to him.
Each time, the decision felt like a sane and, maybe, ethical posi-

tion. Enough nihilism, enough torture, I thought. Enough serial killers glamorized as artists and geniuses.

But that righteous high never lasted. I kept sneaking back, peeking through my fingers—a glimpse here, a binge there—either numbing myself or, depending on one's perspective, properly sensitizing myself. Gradually, my eyes adjusted to the darkness. By midway through Season 2, *Hannibal* felt less like a blood-soaked ordeal than like a macabre masterpiece, pure pleasure and audacity. With hints of David Cronenberg and Michael Mann, David Lynch and Stanley Kubrick, it has a formal ambition that is rare for television. It reflexively turns the ordinary into the alien and vice versa. Corpses pile onto a nightmarish totem pole; bees pour out of eye sockets; men swallow songbirds whole. Over time, patterns emerge, revealing an uneasy meditation on intimacy, the vulnerability of the human body, and the power of art—its ability to make us crave something we thought we'd find disgusting.

It's possible, of course, that I love the show because it confirms my worst suspicions about food culture. For those who haven't seen *The Silence of the Lambs* or read Thomas Harris's novels, from which the story is adapted, the basic plot is this: Hannibal Lecter, played with waxwork hauteur by Mads Mikkelsen, is a brilliant psychiatrist who commits hideous murders. He takes "trophies" from the bodies—a liver here, a heart there—then cooks and serves them to unwitting guests. (Most episodes feature dazzling cooking montages, notorious for making viewers hungry, then making them feel guilty.) His justification is that he "eats the rude," like David Chang, but with slightly less rigid ethical boundaries. Hannibal is quite a catch: He plays the harpsichord and the theremin, he's a natty dresser, and he knows his Dante. By day, he's a libertarian life coach for his patients' Jungian shadows, often manipulating lesser serial killers into covering his tracks—in this universe, as on *Dexter*, serial killers are as common as daisies.

Hannibal's opposite number—his love interest, basically—is the tetchy, delicate Will Graham. Played by the sad-eyed Hugh

Dancy, Will is a criminal profiler for the FBI whose pathological empathy is far more crippling than Hannibal's lack of the stuff. When he visits a murder scene, he enters a fugue state and becomes the killer, imagining the crime while murmuring the show's mantra: "This is my design." The two men circle each other seductively—best friends and homoerotic nemeses, client and therapist—each getting inside the other's head, sometimes literally. Last season ended with Hannibal gutting Will with a kitchen knife after stroking his cheek—a moment of symbolic penetration that sent the show's fans, self-proclaimed Fannibals, into raptures. This season, the third, Hannibal gave Will, who survived, a valentine: a man's corpse that he had pulverized, then sculpted into the shape of a human heart and displayed in a church, like a holy relic.

None of this is treated even mildly realistically, and yet it's not exactly camp, either. As the show's creator, Bryan Fuller (the wizard behind the dreamlike *Wonderfalls* and *Pushing Daisies*), has suggested, *Hannibal* is a show that regards spectacle with a sort of worship. When *Hannibal* began, it mimicked the structures of network cop procedurals, but the show has long since shed that carapace, not unlike the way Hannibal shrugs off what he calls his "person suit," the demeanor that lets him pass for normal. In a recent interview on RogerEbert.com, Fuller explained that, when he hires directors for the series, he tells them, "This is not an episode of television. This is a pretentious art film." His willingness to risk looking outré and avant-garde (on NBC, of all places!) is part of a larger trend on television, inflecting series that range from *American Horror Story* to *True Detective, The Leftovers, The Returned, The Strain,* and *The Knick.* Some of these shows are better than others, but they all live and die by their devotion to that old Freudian concept of "the uncanny." Among that company, *Hannibal* stands out for its ability to risk absurdity and self-seriousness, only to emerge with something gloriously strange and profound,

in the realm of opera and poetry. When Will examines that heart sculpture, for instance, it folds open, ventricles falling to the floor, and then walks toward him on twisted, black, nightmare legs, transforming into a demonic elk.

And, despite the gore, there's a disarming fairy-tale quality to the world of *Hannibal,* in part because the murders, with few exceptions, lack the misogynistic underpinnings of real-life serial killings, or even the snappy kink of Harris's books. No one is raped on *Hannibal,* even in a fantasy; instead, the victims get repurposed as mushroom farms. When female characters get hurt—whether they're shot or shoved out a window or, in one case, sliced finely, like garlic—there's little gendered sadism to the act. Graphic sexual violence isn't inevitably exploitative; sometimes it's a welcome force for realism. But, in the arms race of suffering on television, *Hannibal's* elision works as a small, idealistic promise to viewers: While anything can happen, that one thing won't.

Murder, on the other hand, is up for grabs—and treated with brazen disrespect. On *Hannibal,* corpses are fungible art supplies, like clay or oil paint, in sequences in which bodies are stitched into frescoes or twisted into grotesque displays. Skin is stretched into wings, corpses are bent into apiaries, belladonna is planted in heart cavities. It would be easy to see such choices through a cynical lens, as shock effects: Nietzsche is peachy, but sicker is quicker. It certainly makes the show a tough one to recommend to strangers. But these images coalesce into metaphors for mortality and loss. A teacup breaks and then comes back together; we see that it's like a skull shattering, which in turn reflects a grieving man's wish for time to go backward. Tears are stirred into martinis. A woman's corpse is sewn into a horse's womb, and after she's cut out, the doctors feel a heartbeat in her torso; they slice her open and a live blackbird flies out. Symbols overlap eerily, as senses do in synesthesia: A heartbeat is a clock tick is a drumbeat. The arch dialogue

has the same multiplicity, with ordinary idioms taking on sinister resonance, from "the one that got away" to "the devil you know." "You smoked me in thyme," one victim remarks, as he's served a dish of himself.

In one of last season's most spectacular scenarios, a black male corpse is discovered in the river, coated in resin. The man had escaped from an art project built by a serial killer Hannibal had never met: He'd torn himself out of a mural comprising dozens of corpses of varying skin tones—racial diversity reinterpreted as pigment, people reduced to brushstrokes. When Hannibal climbs a ladder to the top of a corn silo, he looks down and sees a pattern: From above, the curled bodies form an eye. The image suggests outrageous ideas: One eye gazing at another, God at his creation, his creation back at God, through the open pupil of the building's roof. Hannibal calls down to the killer, "I love your work."

The scene was so outlandish that it made me laugh out loud. It also felt like a reminder of the show's own double consciousness about what it means to watch from a distance, to admit that we're voyeurs who enjoy foie gras and veal. (There are moments when one suspects the show is sponsored by PETA.) For anyone who watches modern television, Hannibal may seem familiar: He's another middle-aged male genius with a fetish for absolute control, like Don Draper and Walter White and Dr. House and Francis Underwood. Astrologically speaking, he's a Sherlock with Lucifer rising. But, mainly, Hannibal suggests the fantasy of the uncompromising television auteur: He's the perfectionist who cares only that every detail of his vision be realized, no matter what sacrifices that might require. This is his design.

As Season 3 begins, the show has entered a state of feverish theatricality, adding frame upon frame, underlining its own artificiality: In one flashback, Hannibal recites the magic words "Once upon a time," and a red velvet curtain fills the screen. A fugitive from justice, Hannibal has fled to Europe, where he's been riding motorcycles, sipping champagne, killing people in order to steal

their curatorial positions, and posing as man and wife with his former therapist, Bedelia Du Maurier (the deliciously chilly Gillian Anderson, speaking so low that their scenes are like whisper contests). It's not entirely clear whether Bedelia is his hostage or his co-conspirator. "Observe or participate?" he asks, after he bludgeons a man with a bust of Aristotle in front of her. "Are you at this very moment observing or participating?" "Observing," she whispers, a tear streaking her face. It's one of many exchanges that seem designed to challenge the viewer's role but also suggest that we should stop fooling ourselves. Bedelia doesn't hurt anyone, but she is too curious to look away. Like anyone who can't stop watching *Hannibal*, she's decided that what he offers is too good not to have a taste.

TRAUMA QUEEN

Law & Order: Special Victims Unit

The New Yorker, June 10 & 17, 2013

This show is *also* women's culture, whether we like it or not.

Fifteen years ago, the rules changed when it came to sexual violence on cable television. With *Oz* and *The Sopranos*, television creators began to include rape, child molestation, and even torture as story elements. Dr. Melfi was raped by a stranger on *The Sopranos;* Gemma was gang-raped on *Sons of Anarchy;* Joan was raped by her fiancé on *Mad Men.* These shows weren't averse to using graphic imagery for a queasy jolt, as on *Game of Thrones,* but they were also aiming for something deeper, a confrontation with real-life pain, done with adult directness.

But all the while, on network television, another show was addressing sexual violence through a very different lens—the episodic crime procedural. Like *The Sopranos, Law & Order: Special Victims Unit* launched in 1999. It was a spin-off of Dick Wolf's popular NBC crime series, with the familiar *cha-chung* sound and torn-from-the-headlines plots. But this iteration was pure red meat, dedicated to an NYPD unit investigating sexual crimes. (The original title was the blunt *Sex Crimes.*) It starred a powerhouse pair of actors: the tough, warm-eyed Mariska Hargitay as Olivia Benson,

a detective who was conceived in a rape, and Christopher Meloni, who was best known as a sexually predatory sociopath on *Oz*, as her partner, Elliot Stabler. Together, they became a team as potent as Scully and Mulder, with a prickly chemistry that reflected shifting, unspoken notions of them as victim and predator, protector and protected.

When the original *Law & Order* debuted in 1990, it starred no women; only under pressure from NBC did Wolf cast actresses (mostly stunning assistant district attorneys). In contrast, *Law & Order: SVU* felt like a woman's show, at once prurient and cathartic, exploitative and liberating—with an appeal much like that of the old Lifetime channel, that pastel-tinted chamber of horrors. The audience was two-thirds female, young women for the most part—the same demographic that drives fan fiction, romance novels, and vampire stories. "Oh, you enjoy this, do you?" an angry john says in the *SVU* pilot. "Is this how you get your rocks off?" He's talking to some detectives, but he might as well have been addressing viewers, for whom the show's pulp appeal was addictive and shameful.

But why am I using the third person? I've done my share of marathon-watching, soaking in the show's titillating misery and puzzle-solving shortcuts. (If you recognize an actor, you can bet he'll be the culprit.) Even bad episodes—and there are plenty—hold my interest. It's fun to check off the clichés: the rotten rich kids, the weaselly husbands, the witnesses who won't stop planting shrubbery while the cops question them. When I was pregnant, my unsavory addiction felt something like pica, the disorder that causes people to eat dirt and fingernails.

SVU shares a certain amount of methodology with Nancy Grace, another television figure who feeds off tabloid scraps. This season included a script that was a pastiche of recent campus rape stories, opening with a hot drunk girl being assaulted by frat-boy predators. Although the episode ended on a stirring note, with silent protesters holding the school's administration accountable for

a cover-up, along the way it wavered uneasily, as *SVU* often does, between PSA and pornography. Cinematic sex has always worked that way: When you record something, you create a fantasy. At its greasiest, *SVU* becomes a string of rape fantasies, justified by healing truisms.

On the other hand, a fantasy is a place in which the world is controllable. That's the appeal of all fiction, but it's even more strongly the allure of pulp. As in a dream, *SVU* takes the grisly stories that dominate the news—Steubenville, Delhi, the U.S. military, the torture house in Cleveland—and it reorganizes them, reducing the raw data to a format that viewers can handle. You can pause an episode, you can laugh at a bad guy. The cheesiness (*chachung!*) is itself a reassurance. For young women, who are endlessly bombarded with warnings of how to avoid assault, watching can feel like a perverse training manual. What is it like to be cross-examined about your sex life? Is there any way to foil a home invasion?

For survivors, there may be something validating about seeing one's worst experiences taken seriously, treated not as the B story but as the main event. But the show also has a strange therapeutic quality for any woman, a ritualistic confrontation with fear: It might upset you to watch one rape story, but it thickens your skin to watch a million. (As Bart Simpson once put it, "If you don't watch the violence, you'll never get desensitized to it.") And, of course, the show is also a fantasy about something else, something largely out of reach: an incorruptible legal system, in which the police are eternally in the rape victim's corner.

After fourteen seasons, *SVU* is in crisis. The sole survivor of the *Law & Order* line, it's got competition not only from cable but also from network shows like *The Following* and *Hannibal*. In 2011, the playwright Warren Leight became the showrunner, and, after contract negotiations failed, Meloni left the series. None of the new

cast members has quite his magnetism, although the Broadway
star Raúl Esparza is a major asset as the dandyish ADA Rafael
Barba. "Objection!" Barba announces, when someone accuses
Benson of being a man-hater. "Argumentative. And ridiculous."

As with any network procedural, the quality varies. A story
based on Rihanna devolved into a bilious, puritanical fantasy of a
pop star getting murdered. A few backstory episodes fell flat. De-
spite the show's feminist bona fides, it's striking how many stories
have retrograde themes. In one, a classic "bad rape victim"—she
lies, she cheats, she dresses trashily—is redeemed because she's a
good mom. In another, a workaholic detective murders a kinder-
garten teacher because she got what the cop couldn't: a proposal
and a baby. The dialogue can lean hard on stereotypes. "Detective
Rollins, I'm Hashi Horowitz," a lawyer who might as well be
named Jewy Jewowitz announces. "The guy who's going to get
you out of this mishegoss."

Yet even flawed stories can be saved by great guest perfor-
mances, including the one by Patricia Arquette as an aging hooker,
Denis O'Hare as a tormented priest, and, in one of the season's
standout chillers, Hope Davis as a worried mother and the great
child actor Ethan Cutkosky as her sociopathic son. The show has
long made use of red herrings, hooking its audience with a
"splashy" plot in order to make a political point, as in an episode
that starred the real-life rapist Mike Tyson as a death-row prisoner
and an icily good Ed Asner as a pedophilic summer-camp director.
In the first act, the plot played off the Jerry Sandusky scandal, but
it became, by the final scene, a story about poor black prisoners
deprived of decent legal representation. Other episodes have used
the same type of bait-and-switch to raise awareness about rape in
the Congo and the backlog of unexamined rape kits.

Still, none of this would work if it weren't for Hargitay's Ben-
son, a Xena with empathy, the woman created from—but not de-
stroyed by—rape. The worse the stories get, the stronger she
becomes; it's the show's unspoken dialectic. Which made it all the

more alarming when, in this year's finale, the series broke its own rules, not by putting Benson in danger but by leaving her there. When I saw the opening shot—of Judith Ivey, pointing a camera in Central Park—my heart sank. Sure enough, the plot was drawn from the horrific recent rape of an elderly bird-watcher, but, even for *SVU*, the dialogue was gruesome overkill. Then it ended with a cliff-hanger: Olivia being held at gunpoint by a sadist, which left us to imagine her being brutalized until the next season begins. It felt like an imitation of another kind of television—*Scandal* or *Homeland*—and, instead of a meaningful risk, a betrayal. For all *SVU*'s excesses, we expect it to keep one promise: No matter how bad things get, the story will end.

GRAPHIC, NOVEL

Marvel's Jessica Jones

The New Yorker, December 21 & 28, 2015

Any excuse to write about *Buffy the Vampire Slayer, Season 6.*

"I promise that I won't touch you until I get your genuine consent," the sinister Kilgrave (David Tennant) announces on *Marvel's Jessica Jones*, the latest tentacle to emerge from the Marvel universe. It's a villain's line, but it's also one that carries a throb of multiple meanings. It's Kilgrave's vow not to hurt a woman whom he's already brutalized. It's delivered as if it were a romantic seduction. And it seethes with modern ironies, as if culled from a freshman handbook aimed at preventing sexual assault.

Jessica Jones (played with a traumatized glare by Krysten Ritter) has, like her peers, supernatural gifts, among them extreme strength and the ability to jump enormous heights. (Her flying abilities aren't quite there yet.) But she's damaged goods, as the jerks might put it, having been scarred by her time in the good-guy business, when she was coerced into becoming Kilgrave's girlfriend. Using mind control, Kilgrave kept Jessica in a state of total submission—dressed up like a pretty trophy, exploited as a sex toy, continually smiling at his command. In the aftermath of this nightmare, she's found a gig more suited to her jaundiced mind-set:

noir private eye. Holed up in her apartment, binge drinking, Jessica is a hostile basket case, barely keeping her PTSD in check, while she spends her nights tracking the ugly adulteries of strangers, confirming her dark view of the world.

In this state of nihilistic freefall, she gets involved with a beautiful fellow superhero, Luke Cage (played by Mike Colter, best known as Lemond Bishop from *The Good Wife*—an actor with so much sexual gravity he could be his own planet). She tests the loyalties of her oldest friend, Trish (Rachael Taylor), who is a talk-show host and a former child star; Jessica also does investigatory gigs for a corporate attorney (a nicely metallic Carrie-Anne Moss), who is going through a bitter divorce from her wife. But Kilgrave still lingers on the fringes of Jessica's life, wreaking havoc. His crimes are chilling: No matter what he says, his words get taken literally, as commands, compelling innocent people to stab themselves or to abandon their children, shove their arms into whirring blenders or never, ever blink. But it is always Jessica who is his real target, and his crimes are intended to send messages to her— a courtship, in his eyes.

In early episodes, Jessica is a bit of a drag: She's like the self-image of every brooding brunette, a hot punk Daria in shredded Citizens of Humanity jeans and red lipstick. But whenever the plot snaps her together with her horrifying ex, it springs to life, suggesting disturbing ambiguities about the hangover of abuse. Kilgrave raped Jessica, but since he did so using mind control, rather than physical force, the scenario emerges as a plastic, unsettling metaphor, a violation that produces a sense of collusion. Mind control is a roofie, but it's also an addiction. It's mental illness; it's domestic violence. At times, the psychological scars that Kilgrave leaves on his victims, who gather in a support group, suggest the result of an extreme political ideology, the sort that might cause a soldier to commit atrocities that would never have occurred in isolation. It's any mind-set that causes you to do something against your nature—a guilty burden but, also, for some, an eerie escape

from responsibility. Jessica hates Kilgrave, so why, when he requests a selfie of her smiling, does she send him one? She has strategic reasons. But to the world it looks as if she were flirting—and that's what he keeps telling her, too.

It's a particularly effective form of gaslighting, since he has cast her in a popular narrative, one that shows up in many forms these days, in books and movies, and particularly in stories aimed at and embraced by female audiences. Is it really such a reach for Kilgrave to insist that Jessica will succumb to him in the end? Tweak Kilgrave's banter, and he'd be a wealthy vampire who desires Jessica above any other woman, a man who is literally irresistible, as in *Twilight*. Wrench it again, and they'd be role-playing *Fifty Shades of Grey*.

"I am new to love," Kilgrave tells Jessica. "But I know what it looks like. I do watch television." Much of the reason their dynamic works is because of Tennant's layered performance, which suggests a grotesque innocence beneath Kilgrave's sadism, a distorted belief that this is true romance. It's the ultimate in entitlement: He deserves Jessica because he desires her, which means that her own desires are just obstacles. (He won't even take responsibility for the brainwashing, arguing that his supernatural powers are actually a burden: "I have to painstakingly choose every word I say. I once told a man to go screw himself. Can you even imagine?") At times, their relationship reminded me of the Jonathan Coulton song "Skullcrusher Mountain," in which a supervillain regards his hostage as a mysteriously recalcitrant date. "I made this half-pony, half-monkey monster to please you," he croons. "But I get the feeling you don't like it. What's with all the screaming? . . . Isn't it enough to know that I ruined a pony making a gift for you?"

Of course, a modern TV show needs to be more than go-girl feminist to be any good. (If you doubt that, check out the disaster that is the pilot for Amazon's *Good Girls Revolt*.) And, truth be told,

Jessica Jones wasn't entirely my jam. It took five episodes for me to get interested—three too many, in these days of television glut. Only after the seventh and eighth did the cruel and clever plot twists (which include graphic torture) become truly gripping. In the early episodes, the pacing was logy and the action muddy, with several subplots that itched to be trimmed or recast.

Still, right away I could tell what was firing up so many viewers, particularly online: In the world of Marvel Comics, a female antihero—a female anything—is a step forward. But a rape survivor, struggling with PTSD, is a genuine leap. The fact that *Jessica Jones* is Marvel's first TV franchise starring a superpowered woman—and that it was created by a female showrunner, Melissa Rosenberg—amounts to a pretty limited sort of artistic progress. But the show doesn't need to be perfect in order to deepen the debate. In a genre format that is often reflexively juvenile about sexuality, *Jessica Jones* is distinctly adult, an allegory that is unafraid of ugliness.

As I watched Jessica and Kilgrave spar, another show kept coming to mind: *Buffy the Vampire Slayer,* the comic-book-inflected series that made me into a television critic and was airing around the same time that the original Jessica Jones comic-book series, *Alias,* came out. *Buffy*'s most divisive season was its sixth, when the villains weren't the show's traditional "big bads" but extremely little ones: three comic-book-loving nerds, Warren, Jonathan, and Andrew, who began as minor characters, precisely the type of geeky guys who bicker over the merits of TV adaptations of Marvel comics. Their gang, the Trio, was a goofy lark, designed as much to catch the attention of the superpowered Buffy as it was to defeat her. Only over time did they slide, in increments, into real crimes, attempted rape and murder. And, like *Jessica Jones,* the show was less obsessed with pure-cut violent misogyny than with

the queasy intersection of seduction and mind control, with fantasies about overriding consent and the excuses that abusers make for their worst acts.

On *Buffy*, this coercion took many forms, using overlapping occult metaphors: There was a Buffybot sex doll, a memory-wipe magic spell, and a supernatural roofie that Warren designed to turn his ex into his sex slave. The kinky, and also mutually abusive, relationship between Buffy and her bad-boy vampire boyfriend, Spike, kept shifting back and forth in meaning, with coercion and violence, exploitation and role play, combining into a toxic mess. Many viewers resisted these plots, finding them off-putting or, as Tumblr might have phrased it had it existed in 2001, problematic. But, in retrospect, that *Buffy* season, in all its gaudy perversity, its willingness to shock, feels underestimated. On *Buffy*, the truly dangerous people were the weak and resentful: That was the kind of person (often but not always a man) so ravenous for control that he'd embrace evil rather than risk rejection.

Since *Buffy* aired more than a decade ago, that season has struck me as remarkably prescient, a rare confrontation with intractable questions of sex and power. Gamergate—the corrosive online cultural movement—might as well have been founded by the Trio. Bill Cosby is nothing if not a vampire. The on-campus movement against sexual assault lives on the fault line of these stories, with the grayer area of blackout drinking at the center of a national debate. Even the recent revelations about the "boy-next-door" porn star James Deen feel related. He has been accused both of raping his girlfriend and of manipulating the rules of consent on porn sets, enabling him to abuse women in front of an audience. It all seems like a replay of the same nightmare scenario: Say yes to anything and you've signed away your right to ever say no. "I want everything to be my fault," one female character says on *Jessica Jones*. "Means I have some control." When the alternative is radical vulnerability, who can blame her?

L.A. CONFIDENTIAL

Behind the Candelabra

The New Yorker, June 3, 2013

A celebration of the depths beneath the surfaces.

I n Dave Hickey's 1992 essay "A Rhinestone as Big as the Ritz," the critic made a case for the neglected legacy of Wladziu "Lee" Liberace, superstar pianist and sometime cultural punching bag. Liberace's joyful opulence, his disciplined showmanship, made him "a genuine rhinestone, a heart without malice," Hickey argued. By spinning his flamboyant personality into fame, he managed to "Americanize the closet, democratize it, fit it out with transparent walls, take it up on stage and demand our complicity in his 'open secret.'"

Steven Soderbergh's fabulous biopic *Behind the Candelabra*, on HBO, is a standing ovation for that argument, painting a nervy, empathetic portrait of a lifestyle (a word that actually fits the bill here) that might easily be seen as macabre. *Candelabra* hardly skimps on the grotesqueries—there's a scene in which a plastic surgeon rotates Liberace's ear to a soundtrack of the pianist's own ragtime music—but it's rooted in a love story, not only between Liberace and his young partner, Scott Thorson (on whose memoir the film is based), but between the creators and the period they

portray: Hollywood, post-Stonewall, pre-AIDS, a few years before any major star was "out." It's a culture teetering on extinction, first because the "gay plague" soon eroded the ability of figures like Rock Hudson to keep their sexuality private, and then because of what followed: the triumph of a social movement predicated on proud visibility. Yet there's no room here for *Boys-in-the-Band* self-loathing: As the man who invented the convention of winking into the camera, Soderbergh's Liberace is confident that, in some more significant sense, he's got nothing to hide. His was a closet that had its own pleasures, particularly since he had the resources to decorate it to his specifications.

"I call this 'palatial kitsch,' " Liberace declares as he shows off his home to Scott, a blond hunk played with dopey sweetness by Matt Damon. "Don't you just *love* that?" Liberace sweeps through the mansion in a translucent ankle-length lounging robe with a Nehru collar, and he clearly gets a kick out of his stardom and everything he owns and controls—a confidence that is narcotic to Scott, who grew up in a series of foster homes. In many ways, theirs was a typical Hollywood marriage: A powerful star spots a young blonde, drapes her in jewelry, foots the bill for plastic surgery to suit his fetishes, and makes promises of security that ping all her daddy issues. To further amplify the May-December vibe, he's her sugar daddy, the one who calls her Baby. She's sweet on animals, and dabbles in music, but mostly she's on call 24/7, at once his accessory and his pet. At first, they have a blast—cuddling, sipping champagne in a hot tub with solid-gold fixtures. But in the long run, they have sexual issues: He wants it, she doesn't. (She was never in it for his body, after all.) She gets hooked on diet pills. He proposes an open relationship. She hocks her jewelry. He calls her a gold digger. The star finds himself a new blonde—this one colder-eyed—and it all blows up in court.

The difference, of course, was that, because they were two men, Liberace never called Scott his husband. He was his "chauffeur," right through the humiliating tabloid headlines that mocked

post-breakup lawsuit as a case of ▯
ver came out. (When he won a lawsu▯
▯ a review that implied he was gay, he a▯
phrase: "I cried all the way to the bank.") One scene ▯
insane charade of a deposition, during which Liberace ▯
his lavish gifts as mere perks for an assistant. In happier days,
offered to adopt Scott, an idea that everyone mocked. ("Really, y▯
can adopt someone you're fucking? That's a great law," Scott's
drug dealer says.) But it had a poignant legal logic: Without mar-
riage, fatherhood could make their love public and official. "I want
to be everything to you, Scott," Liberace tells him, as the two
snuggle in bed. "I want to be father, brother, lover, best friend.
Everything. You know I love you. . . . Maybe all those years, all
those foster homes, maybe I'm your real family." Scott practically
leaps into his arms.

There's been a long, headache-inducing debate about the ques-
tion of straight male actors "playing gay"—whether it'll ruin ca-
reers, whether audiences will find the actor hot, and on and on. It's
a nonsense issue that social progress has begun to render irrele-
vant, and Michael Douglas's spectacular performance as Liberace
demonstrates a rarely discussed benefit. Freed from his trademark
macho sulk, Douglas gains all sorts of unexpected charisma—he's
genuinely funny and surprisingly sexy, even with his toupee off,
looking like an unshelled tortoise. His eyes lit with amused intel-
ligence, Douglas's Liberace is your classic "bossy bottom," a glee-
ful narcissist who treats his hangers-on as a mirror (sometimes
literally; he pressures Scott to get plastic surgery to look like a
younger version of him). And yet, the man's a charmer. He's play-
ful, even when he's selling the world a line. In bed, the two have
loving, affectionate exchanges, candid about their histories. Lib-
erace jokes with Scott about the rumors—ones he encourages, of
course—that he's engaged to the Olympic champion Sonja Henie.
"As if I would marry an ice skater," he scoffs. "Please. I mean, those
thighs!"

., and often very funny, about Liberace's sex-
_n he pursued without seeing any contradiction
_nd his devout Catholicism. He has a penis implant,
_nd late in their relationship, he pressures Scott to take
_t seem crazy for a closeted star, like sneaking into a sex
in ankle-length matching furs. When the camera captures
_berace peeking over a booth with a grin, the movie doesn't
pathologize his good time—from one perspective, he's a sex ad-
dict; from another, a madcap adventurer. During an argument
about what Scott will and won't do in bed, Liberace does a hilari-
ously profane imitation of the couple as a gay Ricky and Lucy.
"Why am I the Lucy?" Scott complains. "Because I'm the band-
leader," Liberace explains, with impeccable logic. "With the *night-
club act.*"

Damon is excellent as Scott, a vulnerable Rocky Horror, right
down to the gold lamé skivvies. And I have no idea what Rob Lowe
did to his pretty *punim* to turn himself into the sick Dr. Startz, an
insidious plastic surgeon and pill-pusher, but he steals every scene
he's in. (One of the film's best moments is a shot of his eyes blink-
ing drunkenly from above his surgical mask as he slices into Scott's
face.) Cheyenne Jackson has a tiny, delicious turn as Scott's bitter
predecessor; the wonderful Scott Bakula lounges around in tight
jeans and a mustache the size of a small dog. Soderbergh's entire
production is impeccable, from the makeup—which traces Lib-
erace's face-lift and illness as well as Scott's transformation from
young buck to Frankenstein's monster with a chin dimple—to the
glittering cinematography, including re-creations of Liberace's
stage act. There are scenes, particularly during the breakup, that
will be catnip for drag queens, but Soderbergh's overriding per-
spective is neither arch nor cruel. The camerawork, peering from
doorways down empty, opulent halls, captures the paradox of pa-
latial kitsch, its blend of liberation and claustrophobia. For all that
aesthetic razzle-dazzle, *Candelabra* has an underlying restraint.
When Liberace's much catered-to mother dies, Scott asks him

how he feels. "I'm free," Liberace snaps, then strides away—a moment that is undersold, not underlined.

Bret Easton Ellis recently published a screed in *Out,* a lament against the constrictions of what he calls "The Gay Man as Magical Elf": the out celebrity who is so wholesome, so spick-and-span, that he's a credit to his sexuality. Hollywood has an even stronger insistence on commercial heroism, to the point that Soderbergh couldn't get funding to make this project at a movie studio; only cable television offered him the freedom to be fully adult. *Behind the Candelabra* succeeds precisely because it doesn't care much about health or what constitutes a good role model—it shows respect for a complicated marriage simply by making it real.

WHAT ABOUT BOB?

The Jinx

The New Yorker, March 23, 2015

I wrote this column before I'd seen the finale, in which they nailed Robert Durst with that notorious "I killed them all" bathroom tape. The news came through as a *New York Times* "Breaking News" alert, igniting a debate about spoilers—and further blurring the line between new and fiction.

I n *The Jinx*, a six-episode HBO documentary series, the director Andrew Jarecki investigates Robert Durst—multiple-murder suspect, Manhattan real-estate scion, and shark-eyed master of the throwaway epigram—and emerges with evidence that might put him in jail. This isn't the first time that Jarecki has suggested Durst might be guilty: In 2010, he directed a feature film called *All Good Things*, in which Ryan Gosling, as Durst, commits every bad act that Durst has been accused of, plus a few bonus ones, like the implied bludgeoning of a lovable husky. *All Good Things* wasn't great, probably because it was inspired by the facts of Durst's life, few of which seem plausible as fiction. This is a man, after all, who, long after the mysterious disappearance of his first wife, Kathie, fled to Galveston, Texas, disguised himself as a mute woman, and then, while out on bail for the murder of a neighbor—whose

corpse Durst dismembered with a bow saw—was arrested for shoplifting a chicken-salad sandwich at a Wegmans. (At the time, Durst had thirty-eight thousand dollars in his car.)

But even if *All Good Things* got a 32 percent rating on Rotten Tomatoes, it impressed the one critic who counted. Upon its debut, Durst—who was independently wealthy, out of prison, and in no clear need of further publicity—contacted Jarecki and agreed to be interviewed. I haven't seen the finale of *The Jinx,* so you'll have to discern for yourself whether this decision was worth it for Durst. For Jarecki, it paid off in spades. *The Jinx* is wickedly entertaining: funny, morbid, and sad, at once exploitative and high-minded, a moral lasagna of questionable aesthetic choices (including reconstructions of ghastly events) and riveting interviews (of Durst, but also of other eccentrics, like his chain-smoking, hot second wife). The series acts as an extension of the legal process and as a type of investigative journalism. For viewers, however, it's primarily a noir striptease, flashing revelations one by one—a method that has proven appeal to viewers who like to feel both smart and titillated. Guilty as charged.

Clearly, I'm not alone, judging by the smash success of *Serial,* a podcast hosted by NPR's Sarah Koenig, which examined the case of Adnan Syed, who was convicted in 2000 of the murder of his ex-girlfriend. The creators of *Serial* were, in turn, inspired by *The Staircase,* from 2004, an eight-part TV series about the trial of the novelist Michael Peterson, who was accused of killing his wife; it was filmed by the French director Jean-Xavier de Lestrade, who added a two-hour addendum in 2012. In the past several decades, true-crime documentaries have emerged as a kind of secondary appeals system, among them Errol Morris's *The Thin Blue Line;* the three *Paradise Lost* movies; and the damning *Deliver Us from Evil,* in which Amy Berg got a pedophile priest to confess. The first two projects got their subjects out of prison; the third one helped put the priest back in.

These projects have an afterlife online, where amateur detec-

tives reinvestigate both the crimes and the documentaries them-
selves. Look up *The Staircase* and you'll discover critiques of its
filmmaker's bias and, also, strangely convincing theories suggest-
ing that an owl killed Michael Peterson's wife. *Serial*, too, had its
critics, but part of the appeal of the podcast was its transparency:
Koenig placed her anxieties center stage, even when this risked
making her appear credulous or uncool. Jarecki, who wears a goa-
tee so sketchy that it might as well be another suspect, could easily
seem like a questionable figure, given his slick ability to plug his
films as studies in ambiguity (his others include *Capturing the Fried-
mans* and *Catfish*, which he produced). He's a showman, it's true,
but he wins our trust with a few wise choices, among them folding
in enough material about two victims—Kathie Durst and Susan
Berman, an old friend of Robert Durst's who was shot execution-
style in Los Angeles—that they become more than chalk outlines.
Yet, perhaps inevitably, the most watchable participants are the
bad apples.

This is particularly true of Durst. He's an indelible character,
mesmerizing in his strangeness: He's parchment-skinned, blinky-
eyed, lizardlike, but he has a quality of fragility, too, along with a
disarming, if often peevish, directness. When he feels misunder-
stood, a Larry David–like querulousness creeps into his voice. He
answers questions about whether he hit Kathie (yes, he did—but,
hey, it was the seventies) with a candor that no sane or diplomatic
individual would use. Maddeningly, this makes him seem open,
even when he's almost certainly lying. Much of the pleasure of
watching *The Jinx* is simply being immersed in the stubborn il-
logic of Durst's worldview, which is often less cagey than surreal.
Asked why he lied to the police about his behavior on the night
that Kathie disappeared, Durst explains that he thought if he of-
fered up a false alibi (one easily exposed) he'd be left alone. Then
again, he wasn't wrong: One of the lessons of *The Jinx* is that you
don't need to be a brilliant criminal to get away with a terrible
crime. You just need a cop who never follows up, plus the money

for a legal team that's savvy enough to play to the sensibilities of a Texas jury.

There is, of course, a queasy undercurrent to any show like this: We're shivering at someone else's grief, giggling at someone else's crazy. Many of the best documentaries have this ugly edge, which may be why we cling to the idea that their creators (or, at least, those not named Werner Herzog) are as devoted to truth as to voyeurism. (Documentarians don't get paid enough to do it for the money.) Yet in this context, there's an uneasy, funny-awful solemnity in this speech, from a Galveston detective: "Nobody deserves to be killed. Their head cut off. Their arms cut off. Their legs cut off. And packaged up. Like garbage." When asked whether he purposely shaved his eyebrows while on the run, Durst's response is impeccable as both humor and logic: "How do you accidentally shave your eyebrows?" At times, the moral of *The Jinx* seems to be that an air of dry wit, however inappropriately leveraged, is likely to win you allies.

It's illuminating to compare the methods of *All Good Things* with those of *The Jinx*: Both show footage of Durst as a happy child, swimming with his mother, and the adult Durst saying, "She died a violent death." In *The Jinx*, the footage is wrenching because it's presented as real: The voice-over is audio from the Texas trial, played over grainy home movies. Then these images (scored with eerie singing saw) segue into an overtly reconstructed flashback, one that shows Durst's mother's suicide: a grotesque image, jolting the viewer with its tackiness. The transition was unsettling enough to make me wonder whether those home movies, too, had been a reconstruction. At the same time, there was something useful about the coarseness of this technique, which was Jarecki's own "tell." It was a reminder that everything in a documentary is contrived, even one with a fancy HBO imprimatur. The most sincere people still know they're talking to a camera.

Against this Barnum-like theatricality, spontaneous gestures stand out. There's a poignant scene in which Durst is found not guilty of his neighbor's murder: He turns to his lawyer and says, uncertain, "Did they say 'not'?" The most unsettling example comes in the fourth episode, when Jarecki suggests that he and Durst take a break from discussing his testimony in Texas. Durst has confirmed that his lawyers hinted he could answer specific questions about the dismemberment with "I don't know"; that way, he'd sound less coldhearted. As soon as the filmmaker leaves the room, Durst, who is still wired for audio, lowers his head and mutters a sentence to himself: "I did not knowingly, purposefully lie," he says, and then pauses, considering, to add a word: "I did not knowingly, purposefully, intentionally lie. I did make mistakes."

Durst was rehearsing the interview, the way one might rehearse one's testimony—but does that make him seem more guilty or just more realistic about documentaries? His lawyer tells him that his microphone is hot. Durst is fascinatingly unconcerned. He says again, "I never intentionally, purposefully lied. I made mistakes." Then, with the shrug of an honest man, he adds what might be the tagline for the series: "I did not tell the whole truth. Nobody tells the whole truth."

THE AMERICANS IS TOO BLEAK AND THAT'S WHY IT'S GREAT

The New Yorker blog post, March 18, 2015

The rare ambitious drama to nail the landing.

In last week's episode of *The Americans*, a woman in a fake marriage—Martha, a secretary at the FBI—began to understand the truth about her life. The surveillance equipment that she had snuck into her workplace, at her husband's request, had been discovered. Back at home, that husband, "Clark," a man who was, in reality, Philip Jennings, a Russian spy, began spooling out the usual hypnotic, reassuring spiel about their bright future as soul mates. This was the potent drug he had used to keep her on the hook for years, despite the fact that Philip was never around, the two of them lived separately, and he was unwilling to have kids. "If you're asking me, do you think things will get better?" Philip, as Clark, said, peering through his nerd glasses, "then the answer is yes."

As any viewer of *The Americans* knows, the answer to that question is almost certainly no. Martha wasn't in the mood, she told Clark, for the wine he was opening—but, really, she meant, for the talk itself. Her face, downcast, suggested something awful, which was that the anesthesia was wearing off. It was the beginning of

the end of a powerful arc about intimacy and betrayal that began two seasons ago. But Martha's was just one of many plots on *The Americans* that is hard to imagine with a happy ending: There's the one about the teenager Philip is seducing; there's the one about the recovering alcoholic whom Philip's wife, Elizabeth, has been befriending, hoping to ensnare her in espionage; there's the one about their daughter, Paige, an idealistic young Christian who is being stealthily recruited, by her own mother, to become a spy; there's the one about their son, an innocent, blind and open to the killers who are raising him. There's the one about the fate of Philip and Elizabeth's marriage—a deep bond between two well-trained fakes—and the one about the fate of the Soviet Union itself, which is due to collapse soon, not long after the show's eighties setting.

The Americans is a bleak show that ends each episode with heartbreak. It's also a thrilling, moving, clever show about human intimacy—possibly the best current drama out there (at least of the ones I've been able to keep up with). Dread is its specialty and also its curse; it's what makes *The Americans* at once a must-watch and a hard sell. This is a surprising conundrum because, judging by a plot summary, the series sounds like it should be a fun watch for anyone. It stars two attractive actors, Keri Russell and Matthew Rhys, as married spies with secret lives. By day, they pretend to be mild-mannered travel agents raising kids. By night (and sometimes by day; they have great babysitters), they put on crazy wigs, have sex with other people, participate in complex espionage schemes, and occasionally murder someone. There are memorable "eww" scenes, too, including a brutal sequence involving amateur dentistry and another in which a corpse was folded, with alarming realism, into a suitcase. But *The Americans* refuses to do what similar cable shows have done, even some of the good ones: offer a narcotic, adventurous fantasy in which we get to imagine being the smartest person in the room, the only one free to break the rules. Instead, *The Americans* makes the pain linger.

Is there any other cable drama that, presented with a plot in

which a middle-aged man is forced, as Philip has been this season, to seduce a beautiful, eager fifteen-year-old girl, would not make that idea hot, a fantasy for viewers to get off on, even while it allowed us to theoretically disapprove of the idea? Getting a double message like that across wouldn't be hard: Just paint the girl as a slut or a dummy so we care a bit less. Age her up a year or two— harden her. Make the situation titillating, make it her fault, don't make it so *upsetting*, make it funny, make your antihero better than all other men in the world, so that perhaps it's actually okay for him to have sex with her; maybe those who oppose it are prudes. Or don't let it really be happening at all; make it just a dream sequence—but, still, use images of her body, to create a nifty fetishistic JPEG. There are many ways to have your transgression and eat it, too.

Instead, on *The Americans*, we see Kimberly for who she is: needy and callow, but mostly vulnerable, desperate for tenderness and attention—nobody we can simply write off as jailbait. She's got "daddy issues," but they're not an excuse for Philip's actions; in fact, they make what he's doing worse. Naturally, Kimberly gets under Philip's skin, so he keeps trying to put her at a distance, the way you need to in order to exploit a person. As he talks to Elizabeth about what's happening, he's alternately contemptuous and tender, protective and dismissive. In a spectacular episode two weeks ago, the two ended up in Kimberly's father's empty mansion. Standing on the balcony, stoned, she opened up to him. Her burbling speech, beautifully delivered by Julia Garner, was all skinless bravado. She talked about her dead mother's garden, where she and her brothers used to plant vegetables. She talked about her father, who was never home, and his new socialite wife, who was also never home. Later, in the gleaming kitchen, the two of them, stoned, mixed Rocky Road and Jiffy Pop, throwing it at each other and giggling. It was a sweet evening; only our deeper knowledge made it a horror show.

Later, when Philip went home, he seemed drained and de-

pressed. In flashbacks, we saw what he couldn't help thinking about: the training that both he and Elizabeth had, back in Russia, when he first learned how to pull off this kind of operation. He had been an idealistic teenager himself at the time. In those flashbacks, as he slept with strangers, his experience wasn't portrayed as a sexy fantasy, either, but as a form of institutional abuse. He had been as vulnerable as Kimberly, as plastic as Paige, another kind of mark. Philip talked to his wife about these memories, about how he had learned to "make it real"—to fake intimacy with a stranger until it felt organic. "Do you 'make it real' with me?" she asked. "Sometimes," he confessed, then pulled her close. "Not now."

That's *The Americans'* version of a love scene. It's what makes this season a quiet beauty, worth the bleakness it delivers. It's also what makes it an original show, despite sharing outlines with other action dramas. Many of the most popular antihero shows—even the great ones, like *Breaking Bad* and *The Sopranos*—are about power, about what it means to be the boss. *The Americans* is about loss of control. That's what intimacy is: When you're known, you're in danger. To be loved, you have to be known. In the final scene of last week's episode, Philip decides to tell Elizabeth a secret he has been keeping and, as they lie in bed, spooning, it seems likely that he's making a terrible mistake. The more she knows, the more she has to use against him. But, like Kimberly, he can't help it. He has to believe that it's real.

RIOT GIRL

Jenji Kohan's Hot Provocations

The New Yorker, September 4, 2017

Unlike Barris, Kohan was reluctant to do this profile. She's a private person; she is also aware that she is not the world's most diplomatic individual. Luckily, she came around—and ended up being a highly enthusiastic guide to Los Angeles during the reporting process.

Devon Shepard met Jenji Kohan, the creator of *Orange Is the New Black* and *Weeds,* twenty-four years ago, when they were writers for the NBC sitcom *The Fresh Prince of Bel-Air.* Shepard, a former stand-up comedian, got into the business serendipitously, after he made fun of a square-acting producer at a black barbershop in Los Angeles, who then hired him. Kohan, who had recently graduated from Columbia, was a rung down from Shepard—a "baby writer," in Hollywood lingo. But "she was fun, a whole lot of energy, a sponge," he said. Kohan wanted to learn dominoes, the "loud and outrageous" street version, and they began playing bones in an office they shared, trading stories about growing up black in South Central and Jewish in Beverly Hills. "I

made the room cool," Shepard said. "People were like, 'What's going on in there?'"

This was in 1993, a year after the L.A. riots, and at *Fresh Prince,* which starred Will Smith as a Philly street kid sent to live with rich relatives, the writers' room was a toxic mess. The staff—which included Smith's bodyguard and his cousin—kept crazy hours and fought nonstop. There were cruel pranks: Someone peed in a colleague's bottle of tequila. Kohan was one of two female writers, and the only white woman. Her nickname was White Devil Jew Bitch. Shepard was one of her few allies.

After *Fresh Prince,* they lost touch. In the mid-nineties, he wrote for *MADtv,* and she wrote for *Tracey Takes On . . .* —two wild, subversive sketch-comedy shows. Then, in 2004, Shepard's agent handed him a script for a cable series about a pot-dealing single mother. One of the characters, a black supplier named Conrad Shepard, echoed elements of Devon Shepard's life story: Devon had dealt weed, even while working on *Fresh Prince.* He loved the script, which had no writer's name on it, and told his agent, "I gotta be on this show." The agent asked him if he knew the creator: Jenji Kohan. Shepard said, "Do I fucking *know* her? If your white ass don't put me in the room, I'm gonna choke the shit out of you."

Shepard wrote for *Weeds* for three years. Kohan was a dream boss, he said, because she was just as curious, energetic, and easily bored as she had been on *Fresh Prince.* "Jenji has ADD," he said. "It was like having a class clown as your boss." The writers played hours of online poker, and to open things up, Kohan issued weird challenges: "She would say, 'I want you to end each scene with a curse word and then start with a curse word.' Or 'Have someone hold a cup, and then have a cup go through the whole episode.'" Shepard was used to being pigeonholed; at job interviews, he was told, "If we add a black character, we'll call you." To his frustration, many people thought he was responsible for the black dialogue on *Weeds,* but he actually wrote more scenes for the white

main character, who was played by Mary-Louise Parker. Kohan wrote for all the characters, including Conrad and Heylia, another African American supplier. In Shepard's view, empathy and talent outweighed identity. Outsiders could sometimes take bigger risks, because they were less constrained by the burdens of representation. "The person inside the party is always going to have a different perspective than a person looking in the window," he said.

To break up the monotony, he and Kohan playacted an imaginary TV show called *Djembe*, about an African man who was married to a white suburban woman. The gag eventually made it into an episode. The premise was that Djembe couldn't speak, and so he communicated only by banging on a drum. "You would have thought we were all fucking crazy and racist," Shepard said, cracking up at the memory. "We were just so free."

Shepard, who is now an executive producer of *Legends of Chamberlain Heights* on Comedy Central, was thrilled to witness Kohan's breakout. He knew that she'd "gone through hell" for years after *Fresh Prince*. Shepard told me, "Here was Jenji's problem. And I mean this in a good way. She's a weirdo, and a nerd, and all these things. You can't just put that kind of person in any fucking room. She had to be a showrunner! She had to be in charge. Anything else would put that fire out."

Kohan has a story that she likes to tell about Shepard. "I remember Devon coming into the writers' room," she said. "He yelled, 'I can write a motherfucking *Frasier*! But they will never let me.' That sticks with me so vividly."

We were in the backyard of the house that *Weeds* built, having drinks by a firepit. Kohan and her husband, Christopher Noxon, bought the estate, in the Los Feliz neighborhood of Los Angeles, during the show's fourth season, four years before she created *Orange Is the New Black* for Netflix, establishing herself as a rarity: a two-hit auteur. *Weeds* was Kohan's payoff after a dozen years of

frustration, but it began as one of many scattershot pitches—desperate attempts to jump from network to cable, to "trade money for freedom," as she saw it. Her pitch was only four words: "suburban widowed pot-dealing mom." The series lasted eight seasons, garnering twenty Emmy nominations and two wins.

As *Weeds* was ending, *Orange Is the New Black,* an adaptation of a memoir by a Smith-educated WASP who went to prison, became Kohan's off-ramp. The two shows share a sensibility. As Kohan put it, "I'm fascinated by people interacting with the Other—forced to interact with people they'd never have to deal with in their day-to-day lives." Her specialty is exploring "crossroads," which are often found in underground economies. "Attraction or repulsion, it's great for drama," she said. "It's something that interests me in my life. I want to meet all sorts of people, not to live in my bubble. And, right now, the world is just 'Everyone back to their corners.'" In the Trump era, Kohan sees an urge to hunker down with one's own, "to just put your loudspeaker up and say, 'This is me, and this is my worldview, and I don't want to know from yours.'"

Kohan and Noxon, a freelance writer who is also what the couple calls the "domestic first responder," bought the house from a family who'd been wiped out by Bernie Madoff's Ponzi scheme. The place spills over with Kohan's finds from thrift shops—she described her scavenging habit, which she developed in her teens, as "a treasure hunt, urban archeology." She owns Berrie figurines, trivets, vintage spectacles, polyurethane grapes ("my vineyard"). The house, with its screening room and its backyard "art barn," has something in common with Kohan's shows, emphasizing zestful world-creation over beige tidiness. It's also the warm family space that she had always longed for. Marriage wasn't a goal, but she knew she wanted kids. On the kitchen wall, there were Post-its with scrawled quotes from the kids: "Sukkot Bien!"; "Don't get sucked into Bubbie's nonsense." Her son Oscar, who is twelve, lay sprawled on a sofa, watching *The Office*. His seventeen-year-old

brother, Charlie, was heading to Columbia in the fall; his fifteen-year-old sister, Eliza, was in Manhattan with Noxon for the summer, doing an internship at a theater. Kohan would join them soon and begin shooting Season 6 of *Orange*, in Queens.

Kohan, who is forty-eight, grew up five miles from the Los Feliz house, on a street just inside the zoning boundary for Beverly Hills schools. Her father is Buz Kohan, who was known (at least inside their family) as the King of Variety. A TV writer from the Bronx, he moved to L.A. to write for *The Carol Burnett Show*, and came to occupy a Hollywood niche, working on such specials as *Gene Kelly: An American in Pasadena* and *Night of 100 Stars*. Her mother, Rhea, published two dark comic novels around 1980. Jenji's twin brothers, Jono and David, are five years older. Although Jenji entered the industry first, David had the first hit: In 1998, he created *Will & Grace* with his writing partner Max Mutchnick. According to Kohan, whenever she has a speaking event, her mother always asks the same question: "How much of your success do you attribute to genetics?"

When I visited Kohan, she had bright-pink hair that was fluffed out like a dandelion. She wore cat-eye glasses coated in glitter; her dress was navy blue and covered with tiny white swans. She's a warm conversationalist but also a moody one, suspicious of cant, with an almost self-destructive refusal to defer to the diplomatically empty idioms of the media-trained television executive—she'd rather tell a story that makes her look bad, if it's true or funny. She's somehow cocky and humble at once. When people praise her neon-funky style, her reflex is to quote her mother, who told her, "If you can't fix it, decorate it." With little rancor, Kohan explained that her mother was sexist: She liked boys better, told Kohan that women were inherently less funny, and delivered lines like "I'll buy you those expensive jeans when you're thinner." When Kohan was a teenager, Rhea dragged her to several plastic surgeons, but Kohan refused to undergo any procedures. Rhea

once offered her uppers from a shoebox. When Kohan asked her how old they were, she snapped, "They're pills, not cheese!" (Rhea denies this.)

Kohan's childhood had gilded streaks: Gene Kelly appears in her bat-mitzvah photographs. After she argued to a teacher that a Michael Jackson lyric could be read various ways, her father helped her get a supportive affidavit from the pop star, whom he'd met while working on a Jackson 5 special. In Kohan's telling, she was an eccentric, perpetually unsatisfied child who became furious whenever anyone tried to shut down her right to free speech—she felt patronized by adults. She described her brothers as wild boys, "dirty and open," who enjoyed corrupting their kid sister. The twins turned their mom's "Hawaiian modern" home into the neighborhood party house. "They'd show Super 8 pornos on the wall," Kohan said. "They had a band, Midnight Fantasy, and their bassist had pot." One day, an arms dealer who lived down the street threatened to kill the bass player, who, he said, had gotten his son into drugs. Rhea told the bass player to flush his stash. At family dinners, Jenji was silent, lest she get knocked down in the brutal style of a writers' room: David told me that whenever Jenji ventured a joke, he'd shoot back, "Is that an example of fifth-grade humor?"

Despite Kohan's upbringing, show business wasn't a given. She applied for a job in a writers' room mainly because a boyfriend told her that she couldn't get one. "He said I had more of a chance of getting into Congress than I did of writing for TV!" she said. What followed was a dozen years of stunted ambition and Hollywood sexism. She had her "tit grabbed"; her name was taken off a script. Once, when she was pregnant and about to have a job interview, her agent advised her to wear a big shirt and eat candy, so that the showrunner would think she was just fat. After a pitch meeting for *The Larry Sanders Show*, her agent told her that the show's star, Garry Shandling, wasn't comfortable working with women. "I was fired from everything," Kohan said. One boss let

her go with "some horrible sports analogy," like "'You bring in the home run, but we need a team player every day.'" In 2003, CBS picked up her pilot *The Stones,* a sitcom about divorced parents, but studio executives didn't trust her, she said, so they put David and his partner in charge. The show lasted six episodes and wrecked the siblings' relationship for years.

Kohan did end up writing for an astonishing array of network hits, among them *Friends, Mad About You,* and *Gilmore Girls,* along with HBO's *Sex and the City* and a few not-great sitcoms where she had good bosses, such as Peter Tolan, who was "an asshole to the right people." But throughout it all, she was desperate to oversee her own show and control her hours. She wrote more than fifteen pilots. She married Noxon in 1997 and gave birth to Charlie two years later, and even female-run sets, she found, were often unfriendly to parents. She wanted a career like that of her role model, the British comedian Tracey Ullman, a dazzling talent who headed a healthy room, and who was "funny and smart and civilized" but also "a good mom with a fun marriage."

Finally, in 2004, Showtime bought *Weeds.* But even that was a fight. *Weeds* was a dirty, strange comedy about a young widow, Nancy Botwin, who becomes a drug dealer in Agrestic, a fictional California suburb. In the aftermath of *The Sopranos* and *The Shield,* Kohan forged a breakthrough antiheroine: Nancy was a shoe-craving, manipulative MILF, whose race and class lent her entrée to sub-rosa worlds. *Weeds* was kinky on multiple levels, freely merging comedy and drama; it also had a racial baldness that rubbed some viewers the wrong way. Several characters were inspired by friends Kohan made while playing dominoes on the Venice boardwalk in the years after *Fresh Prince:* a cadre of older black and Latino men, including former basketball players and drug dealers. During the O.J. trial, Kohan told me, the guys on the boardwalk "would be like, 'Motherfucker is guilty'—and then the police would walk by and they would be, 'No justice, no peace!'"

Her bosses didn't really get *Weeds:* Lionsgate came on board to

produce the show after Showtime bought the concept, and the executives, especially Bob Greenblatt, were uncomfortable with its twisted morality. Greenblatt sent Kohan endless script notes. "I'd write back, note by note, for pages," she said.

"Finally, he wrote back a short email that just said, 'Fine, do what you want.' . . . And I took it as carte blanche." There was another problem, one she learned to work around mostly by using a "talent whisperer" who still works for her: For much of the show's run, she was barely on speaking terms with its star, Mary-Louise Parker. Once, Parker threw a script at Kohan, shouting, "My mother can't watch this!" Kohan shot back, "I don't write it for your mother." (Parker could not be reached for comment.)

Despite such tensions, *Weeds* was a hit, and although it never got the acclaim that some prestige-cable bigs did, it had its own rude verve, a destabilizing female protagonist long before *Girls* or *Scandal* and a portrait of drug dealing before *Breaking Bad*. In the final seasons, the plot took risks that it couldn't sustain; Kohan began hunting for a fresh project—and when she optioned *Orange Is the New Black*, it developed so fast that the two shows overlapped. "I always love the new baby," she told me regretfully.

Orange, which Netflix first released in 2013, was based on a memoir by Piper Kerman, who went to prison in Connecticut for crimes that she committed with her ex-girlfriend, a heroin smuggler. Despite its lively title, the book was muted and ideologically earnest, with nonintrusive portraits of Piper's fellow inmates. Kohan saw an opportunity to expand that material with bawdier, more bravura storytelling, with women of every background, sexual identity, and ethnicity shoved into close proximity. Like Nancy Botwin, Piper was a rich, white female criminal. But what was re-velatory was the world around her: dozens of brown and black faces, fat inmates and butch dykes, old women with wrinkles and paunches—a cast of female unknowns who on other shows would be no more than extras. In Kohan's universe, they would get to be loud, to be funny, to get naked, to have sex without being beauti-

ful, and to be at the story's center. The trans actress Laverne Cox played the trans inmate Sophia Burset, a year before Jill Soloway created *Transparent*.

Orange shared with *Weeds* a volatile blend of comedy and drama—a dilemma for the Emmys, which, from year to year, gave *Orange* nominations in different categories. A series that released entire seasons at once, it was included in Netflix's debut launch of original content, back when streaming was an experimental model. Because the show was comedic, female, and sex-centered, critics found it easy to patronize: The *Times* snootily compared it to *Gossip Girl*. But, like *The Wire*, *Orange* was a game changer, courting empathy and discomfort, titillation and sobs, often in the same scene. It was a soapbox for policy debates—about prison privatization, solitary confinement, mental illness—but it was allergic to pedantry. The emphasis was on the individual; extended flashbacks, in the manner of *Lost*, provided psychological context for both inmates and guards. The theme, in Kohan's words, was: "You are not your crime."

At the firepit, Kohan said she was thinking of quitting TV. She might let her hair go gray; she wanted to travel; working on such painful material was depressing. ("Why didn't I write this Hawaii show?" she moaned the next day in her office. "I've not been smart personally about taking this shit on.") She'd recently had a setback: HBO had rejected a pilot that she'd co-written about witches, directed by Gus Van Sant, called *The Devil You Know*, which she had imagined as a kind of "Inglourious Basterds of Salem"—the coven would win. Worse, her kids were leaving home. Even Oscar, whom she called "my surprise *Weeds* baby," was turning twelve. "Showrunning is like a pie-eating contest, where the prize is more pie," she told me, quoting a friend, and added that she and Shonda Rhimes have scheduled a lunch to discuss such feelings. (This was a month before Rhimes ordered a fresh batch of pies, cutting a major deal with Netflix.) Matthew Weiner, the creator of *Mad Men* and a friend of Kohan's, had recently texted her photos of Paris,

where he was filming a new show, and it made her ache. "He has written himself into Paris, and I have written myself into prison," she said. She emphasized that her suffering wasn't remotely comparable to that of someone who is incarcerated. Nevertheless, she said, "my daily thoughts are of injustice and of horror, and I do have certain regrets about it."

Kohan's fantasies of retirement, however, contradicted nearly everything else she told me. *Orange Is the New Black,* which had an ambitious but flawed fifth season, was about to begin its sixth year of production—her first script was due, and she was contractually obligated for seven seasons. Meanwhile, she'd been pitching as madly as she had before *Weeds,* experimenting with godmothering projects for her writers. Her first such collaboration, *GLOW,* a playful Netflix show about female wrestlers, would debut that week, on June 23. It was created by Carly Mensch, from *Weeds,* and Liz Flahive, from *Nurse Jackie,* but it was a very Kohan concept, with a neon-bright, polyglot female ensemble.

Kohan was also co-writing a *Teen Jesus* pilot—a kind of *Wonder Years* about the Savior—in collaboration with Mensch's husband, Latif Nasser, a Canadian radio producer who is a secular Muslim. "I like that the Jew and the Muslim are writing the script," she joked. She was trying to sell *American Princess,* a rom-comish pilot by the actress and comedian Jamie Denbo, about a socialite who joins a Renaissance faire. And Kohan was seeking a buyer for *Backyards,* about Latino punk teens, which had been conceived by Carolina Paiz, a writer on *Orange.* Kohan had other ideas, too, including a bilingual show about a family-owned Korean spa, and another about an L.A. family that goes globe-trotting.

She couldn't explain why she was both contemplating quitting and leveling up to the role of super-showrunner, in the tradition of Rhimes and Ryan Murphy. But she could define what had driven her this far. "I finally found a word for it," Kohan said. "Have you ever seen *Chef's Table?*" The show, on Netflix, had an episode about a woman from a family of fish distributors, whose relatives told

her that women couldn't be restaurateurs. "And she's the foremost female kaiseki chef in the world!" Kohan exclaimed, grinning. "She said, 'There's a term in Japanese, kuyashii.' And she said, 'It means, "I'll show you." ' "

A few years ago, Kohan bought the Hayworth Theatre, near Los Angeles's MacArthur Park, a rundown revival theater where she used to see movies with her mom. Rumor had it, she said, that the theater had been owned by Rita Hayworth's father, and when I told her that this sounded glamorous, she reminded me of Hayworth's story by cracking, "Well, he probably fingered her in every room in the place."

Three years ago, Linda Brettler, an architect who is married to Matthew Weiner, began renovations. The result is a spectacular set of offices, with one floor for production and two for post-production. (There's also a nursery, complete with toys and a changing table.) Kohan is thinking of turning the old auditorium into a venue for performances, like the L.A. institution Largo. The new neighborhood was an adjustment. "Someone shit in our doorway the first time we moved in," Kohan told me. "They stole my mailbox. They stole the mezuzah! We just keep cleaning it up." As for the mezuzah, she joked, "It's puzzling. Maybe they thought, Oh, this is the Jews' magic thing."

Next to Kohan's office, with its loft bed and its framed African American alphabet cards ("'S' is for Soul Sister"), is the *Orange* writers' room. When I visited, the place looked like an artsy pre-school crossed with a rehab center: There was a "comfort sweater" for anyone who felt vulnerable, plus a long table piled with markers, coloring books, and Kinetic Sand, along with such self-help books as *The Five Love Languages* and a memoir by the prison activist Susan Burton. Plot points for Season 6 were scribbled all over the walls. Kohan oversees each script, but her co-producer, Tara Herrmann, often runs the room. Although Kohan has never been

given a diagnosis of ADD, she gets why Devon Shepard used that description. "I have a hard time focusing," she told me. "That's why the toys are there—so I have something to color."

Almost all the writers are new. Last season, Kohan and Herrmann acknowledge, went somewhat pear-shaped. Season 4 had ended on a heartbreaking note: A key character, the black lesbian Poussey Washington, a gentle iconoclast with prospects for a life after prison, was killed by an inexperienced white guard. A riot broke out. Season 5 traced the riot: Thirteen episodes covered three tumultuous days, during which a set of African American characters, led by Poussey's friend Taystee (the wonderful Danielle Brooks), tried to negotiate for improvements in the prison. The season ended strong, and it made daring structural leaps—one of Kohan's trademarks on *Weeds*—but it felt coarser, too, and more violent, with slack midseason pacing that led some viewers to stop watching.

Kohan and Herrmann described the problem in similar terms. "We had lost a bunch of the original writers," Herrmann said. "It wasn't anyone's fault. It was just a new dynamic—people were attached to the characters as viewers, not as creators." Kohan described some plots as "fan fiction." She often spoke, with nostalgia, of the show's "O.G. writers," among them Nick Jones and Sian Heder, who now worked on *GLOW*, and Lauren Morelli, who had her own Netflix deal. After Season 5, only two writers were rehired.

The new crew included sitcom veterans, a playwright, a refugee from the procedural *Bones*, and a novelist, Merritt Tierce, whom Kohan met at MacDowell, the artists' retreat in New Hampshire. (Kohan meant to write fiction, and instead rewatched *The Days and Nights of Molly Dodd*, a quirky, genre-blending cult series that was one of her formative influences.) Many of the writers had crazy interview stories: Kohan is infamous for asking inappropriate questions. Years ago, after reading a twisted writing sample from Morelli, Kohan asked her, "So, were you interfered with?"

Morelli, unsure that she was hearing correctly, looked to Herr-mann, who clarified: "She means 'Were you molested?'" (Morelli wasn't.) "I tend to be an id," Kohan told me.

Kohan, who is not on Twitter, received some scorn on the so-cial network after a photograph of the Season 5 writers' room, showing mostly white faces, was posted. The new room was more than three-quarters female, and included a gay man, an Indian Ca-nadian woman, an African American man, a Guatemalan woman, and an Asian American female writer's assistant. There were no straight white men. Kohan is resistant to all such accounting; she refuses to cheerlead for numerical diversity. Writing, she argues, is an occult skill, a gift of invention and empathy, which few people possess and which can be nurtured but not taught.

It's a perverse irony that *Orange*, which was initially hailed as a progressive breakthrough—a show that celebrated the stories of poor inmates, many of color—got caught up in a tense conversa-tion about racial representation behind the camera. Ryan Murphy, the creator of such shows as *American Horror Story*, now promises viewers that women will direct half of a season's episodes. There's a swell of criticism directed at shows about black people that were created by white people—most recently, *Confederate*, an if-the-South-had-won-the-Civil-War fantasy that HBO is developing. Kohan bristles at such debates. When networks hire writers, she acknowledged, "There is a close circle in terms of getting access, if you're outside of the clique." She continued, "There should be an effort made. But, in the end, I just want talent." She told me a Hol-lywood legend about Redd Foxx firing the white writers for *San-ford and Son*, and then, upon reading a new script, yelling, "Bring me my Jews! Bring me my Jews!"

"If there's one thing I believe, it's against fundamentalism," she told me. She doesn't care if her characters are likable; she believes that the friction of offensiveness can push a debate forward. Kohan herself has a variety of impolite opinions. We debated whether the situation of Rachel Dolezal—the white activist who presented

herself as black—might be analogous to transgender politics. At another point, Kohan argued that, if we are not our crimes, this is true for sex offenders, too, including Donuts, a guard on *Orange*. "Is he a rapist and that's all he is?" she said. When asked about the notorious 2004 lawsuit that exposed crass behavior by the writers of *Friends*, Kohan said that there's no point in suing a writers' room: "You just have to quit the job." (Her argument was mainly pragmatic, she added. In Hollywood, writing a new pilot reinvents you.) Over lunch one day, the writers discussed Bill Cosby's trial; Kohan was largely quiet, but eventually chimed in, "I wonder if people are having trouble now enjoying"—infinitesimal pause— "Jell-O pudding products."

She rolls her eyes at feminist talk of "the male gaze." Although she and Jill Soloway, the creator of *Transparent*, have known each other for years, their artistic philosophies split at the root: It's notable that Soloway's company is called Topple, for "topple the patriarchy," and Kohan's is called Tilted. Three years ago, when Soloway was launching a "transaffirmative-action program" for her writers' room, they sparred on a panel that I moderated; Kohan said that trans people had been interviewed by her staff, but she insisted that a great writer can channel any identity. Years later, although Kohan's values hadn't budged, she had to admit that Soloway's diversity effort had paid off, launching the trans writer Our Lady J, who was behind last year's best episode of *Transparent*. Both showrunners are feminist provocateurs, but Kohan relishes being a mischief-maker and, sometimes, a smutty ringmaster. She lobbies performers for more nudity. Once, she told me, she wanted a shy actor to do a full-frontal scene; her producer, who was reluctant to ask the man, convinced Kohan that the guy had a forked penis.

Uncharacteristically for a modern cable impresario, Kohan has little interest in anything "cinematic," barring occasional one-time visual flourishes. (Each *Weeds* season finale echoed the style of a

famous director: Tarantino, Hitchcock, Almodóvar.) In an era in which Jane Campion and Steven Soderbergh make TV, Kohan told me, "This isn't a director's medium! It's not auteur territory. *I'm* the auteur in television." Her origins were in sitcom rooms, not indie-movie sets, she said, and she wanted faces, and enough coverage to edit, not fancy tracking shots.

Kohan has a deep, occasionally prickly aversion to even a hint of censorship, which goes back to her childhood. In fifth grade, she wrote a play in which an Asian character brought Sleeping Beauty a gift of egg foo yong. The white boy playing the Asian role improvised slanty eyes, leading a Chinese American teacher to cancel the play. "And I went crazy," Kohan said. "Yes—it's totally offensive! But he was also nine or ten. If you want to have a cultural-sensitivity discussion, great. But to say, 'You're bad, you offend me, this play cannot go on'—fuck you. Then I was supposed to write a letter of apology, and I refused." Her mom backed her. Kohan described her attitude on these issues as old-school, "very ACLU."

And yet as resistant as Kohan is to anything that strikes her as political groupthink, the show she runs has been deeply responsive to modern conversations about race and power, responding with humanity and nuance to the shifting zeitgeist. In 2012, when *Orange* began production, prison reform was a bipartisan movement. By Season 4, Black Lives Matter had become prominent; Season 6 may make references to Trump's ascent. Like *Weeds*, *Orange* has grown bleaker each year, as the show has developed a caustic clarity about systemic racism, prison privatization, and the sadism of guards. (Piper Kerman complained, Kohan told me, that the show's guards were unrealistically kind.) *Orange* was not one privileged prisoner's story, Kohan said, and that had never been the aim: "I like an ensemble. It's gluttony—I like a little piece of this, a little piece of that." The show's broad sympathies, its willingness to explore every perspective, have alienated some viewers: Some

were unwilling to get inside the head of Healy, the bigoted white male counselor; others, especially some African American female viewers, saw Poussey's death as trauma porn. Kohan was rankled by some of these critiques, but she's willing to poke bruises: "Good, go and argue about it."

As Piper receded into the ensemble of *Orange*, a different character, Taystee—black and poor, not rich and white—took center stage. A bubbly jokester in the first season, Taystee eventually became the acting secretary for the warden, Joe Caputo. Poussey's death radicalized her, however; suddenly, she could see how her white boss's "niceness" had blinded her—in a crisis, his sympathy went to the man who killed her friend Poussey. Kohan told me that these shifts weren't abstract political changes—they simply followed the story. "This is going to sound woo, but I'm from L.A.," she said. "Things have a destiny, and you want to see them fulfill their destiny. We don't go in saying, 'How are we going to deal with the black characters?' We say, 'What are we going to do with Taystee or Janae?'" Kohan was intent on dramatizing how power worked, but she was also resolute about character being key, not ideology: "Otherwise, it's an issues class. It's an entertainment, and you have to be mindful of that."

While I was visiting Kohan's office, she met with executives from Amazon. Lifetime had delayed in picking up *American Princess*, the Renaissance faire show, and Kohan wanted to shop it elsewhere. Netflix, Amazon, Facebook—she's open to all comers. As they discussed *Princess* and Kohan talked up her many protégées, Tara Herrmann, the *Orange* co-producer, noted that Kohan gets bored in the later seasons of her shows.

"I like giving birth," Kohan said, shrugging.

"Literally and figuratively," Herrmann said.

Kohan pitched her idea of a show about a Korean spa, which she hoped to write with a Korean partner. It would touch on themes of immigration, she said—not just the Korean family who owns the place but the Latino employees who clean it.

"A lot of nudity," Joe Lewis, Amazon's head of comedy, drama, and VR, remarked.

Yes, Kohan said. She described visiting a Korean spa in Queens that was very "accepting," with people "every color under the sun" in hot tubs on the roof. One time, she'd seen "Orthodox boys from Monsey," in Upstate New York, ogling women in bikinis.

Lewis emphasized that Amazon, as a global company, was seeking diverse, experimental voices and was eager to acquire shows set in other countries. Earlier in the meeting, Kohan had mentioned her concept about a family that travels around the world. Lewis looped back to it. "The travel thing—if you wanted to do it, we would do it today," he said.

"Really?" Kohan said. "I have all the characters, and I have a beginning, and I have a secret that we're not telling the audience."

"The answer is yes," Lewis said.

"All right, I gotta get out of the *Orange* swamp," she said.

Negotiations were soon in progress—it was a potential show for her to do a few years from now, another off-ramp, another new baby. Retirement would have to wait.

The next day, June 22, Kohan went to the doctor to get beta-blockers for the premiere of *GLOW*. Later, as we entered an un-fancy nail salon, she said, "I have trouble taking care of myself." But by the time of the screening she had gone glam: Her nails were a color called Hologram, and she strutted the pink carpet in a blousy peasant dress in rainbow colors. After the show, Kohan, accompanied by Charlie and Oscar, headed to the premiere party. It was an especially exciting night for Oscar, who has a cameo in the pilot, as a tween thug who screams, "Fuck you, Nancy Reagan!" It was also the first time that Kohan's sons had attended one of her professional events—normally, her wingman was her daughter, Eliza. At dinner the previous night, Charlie had told me that he didn't love *Orange*—in fact, he'd dropped his mother's show

midway through Season 2. "I had a problem with Piper—I didn't like her," he said. "And there was this way that every time it got dramatic it would go the other way. I thought it sold itself out."

"You're one of *those*," his mother told him fondly. She complains that when men tell her they like the show, they inevitably add, "I watch it with my girlfriend." Eliza was the family's *Orange* superfan.

Before the screening, Carly Mensch and Liz Flahive gave a speech thanking "Mama Jenji." Mensch was postpartum, just as Kohan had been for the *Weeds* premiere. Afterward, Charlie was sweet to his mom, knowing that it had been hard for her to cede control, to be the one giving notes that got ignored. "I could see your touch on it," he said.

The *GLOW* party was decorated like a neon locker room from the eighties. "Heaven Is a Place on Earth" played on the loudspeakers. As Kohan mingled, I chatted with two of her O.G. *Orange* crew, the filmmaker Sian Heder and the playwright Nick Jones. They marveled at their early, disorienting days under Kohan: She had everyone build ornate Lego models of prisons and go on extended hikes. Even after they broke the story for Season 1, they struggled. "One script would be like *30 Rock*, another like *The Shield*," Heder said. Heder felt especially anxious about writing a script that centered on Sophia Burset, the trans inmate. Every activist she called told her that it was a huge mistake to portray a trans character as a prisoner—at the very least, she should be wrongly convicted. Kohan encouraged Heder to stop soliciting outside opinions: She needed to write.

"Sian certainly voiced those concerns," Kohan told me later. "They all did. Her name was going to be on it, and trans was becoming a hot-button thing. But you can't be a totem and a person at the same time. I just kept saying, 'This is the *character*, this is the *person*. This is this trans person.' The message is: You gotta be fearless. If you get too wishy-washy and try to serve too many mas-

ters, you get nothing. You write in a vacuum and you hope it works."

"She buys people's complete collections of things!" Eliza complained to me. She was sitting on a space-age chair in the family's new apartment in the West Village. "We have a room filled with a collection of Eight Balls—"

"Those Eight Balls were collected over time," Kohan said.

"All those *marbles*. You did not collect those marbles."

"I bought jars of marbles from all different places," Kohan said, calmly. "That's why they're in all different jars. It's a collection of jars of marbles. It's not a collection of marbles." She is a maximalist, she said: "Look, I feel better when there's bulk. I think bulk is beautiful. I love a lot of something."

Kohan adores Los Angeles, which she has gotten to know using the twin algorithms of "thrifting and food": She and her husband sometimes drive their pit-bull mutt, Gail Feldman, to a neighborhood they've never visited, then explore it on foot. Right now, however, Noxon was hot for Manhattan. He and Eliza had been in the half-decorated apartment since late May, among trippy velvet sofas and coasters bearing the message "Don't Fuck Up the Table." Kohan, as usual, was overwhelmed by work, and shuttling between coasts: She was on deadline for her *Orange* script; she was scouting locations; she was preparing to help Mensch and Flahive get going on the room for Season 2 of *GLOW*.

Kohan and Noxon, who met at an adult kickball game, have been married for nearly twenty years. Noxon has published two books. The first was *Rejuvenile: Kickball, Cartoons, Cupcakes, and the Reinvention of the American Grown-up*. His second, *Plus One*, was more fraught: It was a beach read about a cable showrunner's husband, who, feeling emasculated, acts out. Kohan wasn't thrilled, but Noxon argued that it was his story, too. The impulse might be

understandable, given the cannibalistic nature of their circle's creativity: In addition to Weiner, they are close with Chris's sister Marti Noxon, a TV writer whose show *Girlfriends' Guide to Divorce* has a character loosely based on Chris. But, whatever stress *Plus One* generated, the family is affectionate and eccentric, with shared comic rhythms and a self-conscious fascination with the awkwardness, the flawed wokeness, of their own L.A. set.

Eliza launched into a story about a seminar on racist language at her school, which began with a PowerPoint slide that read "White People: We're Not Always Awesome." Her school was also fighting a trend called "area codes": Boys rate girls with three digits, for their face, body, and "DTF"-ness (politely: sexual eagerness). At a school assembly, Eliza said, a girl had declared that it was wrong to rate girls, that rating girls must stop, "and someone in the crowd said, 'Shut up, 7!' "

The family exploded with laughter. "That's the perfect number," Kohan marveled. "I recognize that it's reductive and sexist," Chris added. "But on a scientific level, I admire its specificity."

Similar stories have been worked into Kohan's art. In a potent *Orange* flashback, Janae, back when she was a public school student, tears up as she watches an all-white *Dreamgirls* at an elite private school—a plot inspired by a mostly white production of *The Wiz* at Eliza's summer camp. But Trump's election victory has made issues of race and privilege far less abstract; it was a traumatic event for all of them. Just after November, Noxon was in Memphis promoting *Plus One,* the prospect of which—as he scribbled in a sketchbook—felt "stupid" and "inconsequential." Noxon is also an illustrator, and in a burst of energy he produced a graphic story presenting the civil rights movement as an inspiration for the resistance. He posted it online, and it went viral. Soon, he had a new book to write, titled *Good Trouble.* He was just back from being arrested at a healthcare protest in Washington, D.C.

Noxon is a Democrat, but Kohan is a registered Independent. "I'm not a Republican," she said. "But I think the Democratic

Party is a mess, in a lot of ways. And I don't necessarily like an af-
filiation." For all her aversion to being preachy, she calls her work
a form of activism. "I think my ideology isn't that fuzzy, in the
things that are approached on the show—and, while I don't have
time to be an activist, I can be an agitator." She recalled attending
a Clinton Foundation meeting in which a speaker described stud-
ies showing that babies whose mothers talk to them a lot develop
stronger language skills—and then told her, "You could put this in
your show." That idea was translated into Kohan's idiom in Season
2: A prisoner whose daughter has recently given birth crudely tells
her, "Talk to the baby, so she doesn't grow up stupid."

Matthew Weiner met Kohan more than a decade ago at the school
their children attend. They became close friends, and play pinochle
together with their spouses. Kohan talks Weiner off cliffs of self-
doubt. "Don't worry about running out of story," she once told
him. "There's always more." Kohan's decision to burn down
Agrestic, in Season 3 of *Weeds*, became Weiner's watchword for
artistic daring while writing *Mad Men:* It gave him the confidence
to divorce Betty and Don, to start fresh without fear.

Weiner told me that Kohan rarely gets enough credit as a pio-
neer. "She's braver than I am," he said. "She's a truly iconoclastic
person who does not believe in BS. She's a deep feminist, she's a
humanist, she's very educated, but she's really—and so quietly,
without putting her personality in front of her work—she has
consistently talked about what's fair, about race, before anybody,
about the trans world before anybody. About class, about privi-
lege!" Her gift, he said, was to write about difficult subjects with-
out jingoism, with a rich sense of psychology. She was ten years
ahead of everybody.

He's also inspired by her attitude toward criticism. During *Mad
Men*, he recalled, he got frustrated by "people thinking I was a sex-
ist when I was writing about sexism." For Kohan, however, "the

white guilt, all of it, it's all funny to her—you know, it's just deli-
cious to her that people are going to be upset." They share a phi-
losophy: that it's crucial not to give in to the impulse of wanting to
please viewers, that it's better to take the leap that might agitate
people, if it can get you to a new place.

In an email, Shonda Rhimes praised Kohan's kindness and can-
dor, calling her one of the few showrunners with whom she can
talk honestly about career strategy: "She's the person I went to
and said, 'Tell me everything you know about Ted Sarandos'"—
a top executive at Netflix. Rhimes had just launched *Grey's Anat-
omy* when she met Kohan; she had been a *Weeds* fangirl, but when
she heard about *Orange* she was "suspicious": "It seemed to be a
show about a rich white woman's prison struggles, written by a
white woman, when we know that white women are not the ma-
jority of people being victimized, forgotten, and destroyed by the
prison system." But, she went on, "the moment you watch the
first episode, you know that the show is actually about women. All
women . . . And there are stories told on that show from the per-
spectives of women of color—and trans women and lesbians—
that I don't think I'd ever seen before."

I visited the set of *Orange* in early August. Kohan had finally
finished her script, and filming was underway. She had other good
news: Lifetime had green-lighted *American Princess*, the Renais-
sance faire show. The previous weekend, Kohan and Noxon and
two of their kids had visited Upstate New York with Jamie Denbo,
the show's creator, to scout for stories at a Renaissance festival.

"Did you see the ring that Chris bought me in Oswego?" Kohan
said, holding out her hand. I peered: It resembled a melted bronze
dragon. "It's a couple giving each other oral sex. See? She's leaning
over his cock; he's on her pussy." Romantic, I told Kohan. "He
knows me," she said.

Orange Is the New Black is not *Entourage*, the kind of fantasy
series in which people bounce back from bad luck. In Season 6,
past actions have repercussions; the new plots will be set in a

maximum-security prison, with worse violence and uglier out-comes. Kohan, who calls herself a "cultural, book Jew," takes a Talmud class, and she had been mulling over one of its themes: "How do two contradictory truths occupy the same space?" The actresses were returning from their hiatus, and they greeted Kohan effusively on the new set, with its isolated cells. Kate Mulgrew, who plays Red, the Russian cook, gave her a gift-wrapped copy of Roxane Gay's *Hunger.* Adrienne Moore, who plays Black Cindy, talked about a recent trip to Berlin.

When Mulgrew and I talked in her dressing room, the actress, best known as Captain Janeway on *Star Trek: Voyager,* described the thrill, after a long career of "very, very little golden stuff," of find-ing a creator so "unorthodox and unafraid." Danielle Brooks, sim-ilarly, called Kohan a "dope queen." *Orange* was Brooks's first TV job, straight out of Juilliard. In the premiere episode, which begins with a shower scene, Taystee pulls off Piper's towel, saying, "Damn, you've got nice titties—you've got them TV titties." Brooks, who is from a Christian family in South Carolina, "prayed on it" and nearly declined the role. But she told me that she's grown to trust Kohan, grateful for her "deep care for disenfran-chised women."

Adrienne Moore, too, grew up in a Southern Christian family, but eventually moved to New York to study acting. (Kohan told me that she clumsily assumed that several cast members were am-ateurs, as with *The Wire,* until they mentioned Juilliard: "Okay, you're a really good actress and I'm a racist.") In Season 3, Black Cindy converted to Judaism, in a scene that was a surprise tear-jerker. Kohan wrote it as comic, but Moore played it emotionally, drawing on her own history. These kinds of dynamics have shaped the show throughout its run: After the Latina actresses spoke up, the writers gave their characters specific ethnicities—and the Do-minicans became distinct from the Puerto Ricans and the Mexi-cans. (Some performers chose to play cross-nationality: Flaca is Mexican, but is played by a Dominican American.)

One point of contention hovered: Kohan thinks it's realistic that black inmates would use the N-word, but the cast resisted. Moore told me that it bothers her when the word is used as racial shorthand in pop culture. Kohan told me, "You can tell when things are just not worth it. I want them to do great work and have a good experience—and they are putting their bodies out there. There are certain lines where I'm like, 'Just fucking say it.' And lines where I'm like, 'Okay.'"

Kohan values rude humor to the point that she sometimes veers into the language of the right. An offensive joke, she told me, "is not going to melt you!" Cindy Holland, who green-lighted the show for Netflix, told me that, though Kohan is collaborative, she'd learned to "never give her a note on a joke, because she'll double down." When I expressed qualms about the jokes made by the show's Nazi inmates, Kohan said, "I'm shocked by what comes out of people's mouths outside a PC bubble. I want to represent it." The inmates, she said, "are trying to be funny, and it's not funny, and they think it's hysterical—and that's kind of a punch in the head. I like that they made you uncomfortable." An unsettling scene should be "like a Weeble that doesn't fall down, that just keeps tottering."

In one of Season 3's best gags, a cost-cutting executive at the prison describes a "Jewish problem"—too many inmates ordering expensive kosher meals—then notes that he has found a cheaper source for soap. A colleague shoots back, "Is it the Jews?" It's crass, a shocker, perfectly delivered. But an even better punch line follows: The employee is reported to HR and fired. In the private-prison industry, it seems, exploiting inmates is business as usual, but breaking a speech code is a crime. Netflix airs in Germany. Although the streaming service cleared the bit with its lawyers, Kohan was strongly urged to cut it: In Berlin, Holocaust jokes are verboten. She kept it in.

The last time I spoke to Kohan, she was finally on vacation—though not a real vacation, since she was polishing new *Orange* scripts. She was in New England, staying at Shonda Rhimes's country house. Kohan's plate was heaped with pie. *GLOW* had gotten a second-season pickup, and she was prepping for *American Princess.* Carolina Paiz's *Backyards,* however, had hit a snag: There was a competing show about Latino teens. Kohan wanted to be supportive of her disappointed writer, but it was hard. She knew that Paiz had "spilled her guts into this thing," but added, "I've spent my life building bibles for things that get tossed out—it is brutal, but it teaches you to move on."

Mostly, however, she had been watching the Charlottesville riots. Two days earlier, Kohan had described her work to me as a cathartic rebellion within a quiet life. "It's fun to create fireworks and see oohs and aahs," she had said. Battle could be exhilarating, controversy was fun. Now she was rattled, finding both the Nazi marches and Trump's response "terrifying, appalling." She said, "I intellectually understand where these people come from—hate always comes from pain, to a certain extent. Doesn't make it okay."

When I asked for her response as a free-speech absolutist, she struggled. "Right," she said. "I never want to say that people can't say how they feel, including their hatred." But this was about intimidation as well as speech, she recognized. "It is a call to action for the complacent, to stop letting these fringe hate-mongers have the floor," she said with emotion. "I don't think the answer is 'You can't say that'—but you're not entitled to take over city streets and start shit." On some of her most foundational issues, she felt at sea. "I think there's a hard line here of 'This is unacceptable.' So that feels uncomfortable—that isn't something that's in my wheelhouse, that's not part of my worldview."

The green lights for new shows hadn't entirely raised her spirits. "I'm a depressive, a dysthymic," she said. "So I have to sum-

mon sunshine. I don't come by it easily." What she longed for was the time to wander, to observe, to collect and absorb, to "fill her tank." She was relishing time with her kids. In her work, however, she described herself as drowning—going underwater, then up, under, then up, like a witch being dunked. We'd sat together at the Renaissance festival, in the late afternoon, watching a dunking: torture turned into vaudeville, making tired families giggle and cheer. "I would like to find a little more pure joy!" she said, as if she were conjuring a path into the future, one she had yet to imagine. "I'm traveling in dark waters right now."

A DISAPPOINTED FAN
IS STILL A FAN

Lost

New York magazine, May 28, 2010

Like "The Long Con," this essay was written quickly, in response to the divisive finale of a popular series. Like my pan of *The Marvelous Mrs. Maisel*, it won me a wave of mail from fellow "haters." But while it was a cathartic piece to publish, it always gives me a twinge upon rereading, because there's something cruel about analyzing how a show that you loved declined, no matter how on-target it may feel.

Just over a week ago, as the *Lost* finale loomed, the faithful made preparations. We baked "smoke monster" cakes; we watched cats on YouTube explain the plot. But mainly, we read interviews with the creative team of Carlton Cuse and Damon Lindelof (affectionately known to the online horde as Cuselof or Darlton), the showrunners who had, under creator J. J. Abrams, overseen one of the most interactive TV hits in history, a show designed to be mob-solved, scavenged for symbolism, and adored.

They were preparing us. In each interview, with a mix of humility and defensiveness, they repeated that they had "done the best they could." They had focused on the characters. And we, the viewers, shouldn't expect answers to everything—some we'd learn on DVD, others would never be resolved. So please stop asking about the four-toed statue. Let it go.

This kind of expectation management is, by now, a baseline responsibility of anyone steering a major TV sensation, and it's no easy task. Some (Aaron Sorkin) are driven crazy and write entire television series in response to audience critiques; others (David Chase) push back, brilliantly. But like a lot of genre writers, the *Lost* creators had always been more-forthcoming figures, warm and reassuring, regularly urging the audience that we, as fans, should trust them, and that we should be patient, that while there was no time to explain right now, if we hung on, all would finally be revealed.

Yet as the seasons passed, Darlton were also clearly unnerved by their most passionate devotees, who were busily compiling databases, freezing images for hints and clues, and generally acting like a particularly deranged, faintly Aspergian breed of forensic detectives. In 2007, Lindelof argued that "the really good critics" were fans at heart. "I find there is a very rare instance where your fan brain is having one reaction and your critical brain is having another. The level at which questions are asked of us is polarizing. You can tell it's personal. If they don't like it, it's like they're offended in a way."

Real fanhood, in other words, is, at its purest level, love. As in Corinthians, fanhood is patient, kind, not rude, etc. (It is also not easily angered and it keeps no record of wrongs.) The Fan of Faith is superior to the Fan of Science, and while it's natural to have questions, the ideal viewer should behave less like a nagging critic and more like a soul mate, supportive and committed even when doubts creep in.

At one point, during a *New York Times* panel on the Thursday night before the finale, Lindelof made this romantic-relationship metaphor explicit. In response to a question about fan disappointment, he described a first date that begins with the wrongheaded question "Are you going to disappoint me?" "Just see how it works out!" said Lindelof, in the voice of the show-slash-date. "If you're going to fall in love with somebody, you have to put aside that fear of disappointment."

Then again, if you build a show to be loved, heartbreak is always a risk. I'm a serious *Lost* fan—I watched every episode, I recapped the show online for years, I'm one of the fools who combed Egyptology sites to determine whether that damned statue was Tawaret or Subek—and yet I'm also someone who now thinks of the show as a failure. That fact doesn't erase the pleasure I got from Locke's orange-peel grin, but it does change the context. Because like so many, I hung on long after I had doubts: through cage sex, through the successful (but in retrospect nonsensical) time-travel gambit, through those great sequences among the Dharma hippies and into the drippy realm of the last season's alternative-reality time line (aka the Sideways Universe), in which the characters learned and grew. This wasn't a first date, after all; it was a six-year marriage. You don't just give up.

In the run-up to the finale, Lindelof posted on Twitter, expressing his love for the fans. But he also sent out a message directed at some online video artists I had never heard of: "But Fine Brothers? You shat on the show and that is not cool. I hereby revoke your status as 'fans.'" Lindelof's followers offered support, but there was also this: "I'm as big of a fan as you can be, and I think Fine Brothers couldn't have put it better. A disappointed fan is still a fan."

I spent the afternoon watching the Fine Brothers videos, of course. They were, as it turns out, hilarious: sharp, prickly satires "acted" out by action figures. In each one, characters from *Heroes*,

Twilight, *Battlestar Galactica*, and other genre hits invaded the *Lost* universe to make rattled critiques. (In one, Spock simply started screaming, "I refuse to live in a place without logic!") With their *South Park*–style brass, a few of the satires were more fun to watch than the Season 6 *Lost* episodes, many of which boil down in my memory to bathetic baseball monologues and lines like "I don't like the way English tastes on my tongue."

To Lindelof, the Fine Brothers weren't fans anymore. To me, their clear agitation and radical engagement with every element of the story meant they were the most dedicated kind of fans: They cared enough to be pissed off. And who was to blame for that?

What made *Lost* fail? It's possible Cuselof's story was simply so Byzantine no one in the creative team could connect the dots, even with a two-year head start. It definitely didn't help that the show shifted from a diverse cast to the repeated tableaux of white guys bickering about fate while the female characters were either shot or (worse) congealed into bland love interests. But to me, one central problem—which we had hints of early on, back when the show was still pulling off one masterful structural coup after another—was that the series had become obsessed, in both overt and unconscious ways, with manipulating its own relationship with its fans, alternately evading and reflecting their critiques, and then finally satisfying them in the most condescending possible way, with sentimental sleight of hand.

Built as it was from videogame aesthetics, comic-book plots, and science fiction, *Lost* had always included witty internal acknowledgments of its own geek appeal, including characters who acted as stand-ins for *Lost* fans. Hurley began the series as an actual character, but he quickly became our avatar: the sci-fi geek, full of *Star Wars* references, loyal and positive, like Cuselof's ideal. In contrast, Arzt, the wicked fan, was a science teacher full of gripes, but

he hilariously blew to bits in Season 1. Later, we got snarky Miles and Frank Lapidus, an outsider who made bemused remarks about the melodramas around him.

This was fun in the early seasons, when Darlton felt like they were in communion with their audience, but as the show began its final slide, these characters increasingly operated more as venting devices for fan frustrations—a way for the writers to let us know they heard us, but also to joke about logic problems or clichés instead of addressing them. The snarky chorus stood in contrast to the main ensemble, which, with a few exceptions, devolved from archetypal (but layered) characters into action figures, their aims narrowing, like videogame heroes, to a single goal: Find Sun, find Jin, find Claire, return to the island, get off the island.

Then, in the run-up to the final season, Cuselof suddenly inserted a shocking new framing device, a tactic that radically simplified their entire series: the twin dei ex machina of Jacob and the Man in Black. We'd gotten hints of Jacob's existence earlier (Who was that man in the cabin? *Who?*), but Cuselof's reveal went beyond exposing the wizard. It redefined everything we'd watched as a game played by manipulative gods. Jacob smirked and wore Jesus robes. His brother, the Man in Black, was the evil Smoke Monster. While the pair were not named Cuse and Lindelof, it was hard to ignore the resemblance, since *Lost*'s characters—like its fans—had been revealed as the pawns of narrative overseers who spoke in riddles, were hard to trust, and continually reassured them to be patient, the end was near.

Within that endgame, Cuselof introduced the MacGuffin to end all MacGuffins: a glowing pool of embarrassing special effects, unexplainable because, as we learned in another meta line, "every question will just lead to another question."

The peculiar thing about all this was that throughout its seasons, one of *Lost*'s most appealing ambiguities had been that, for all those debates about science versus faith, the show had never been in the camp of credulous trust. It was an island full of con

men and women, after all, emotional seducers (from Sawyer to Ben to Nikki and Paulo) who fleeced those who believed in them. John Locke, the show's Man of Faith and its most original character, was wrong again and again, and, in the end, died confused and despairing. His was an uncompromising plot within a show that increasingly pulled its punches, giving once-complex characters sacrificial and heroic outcomes. Jacob himself turned out to be in thrall to a lying, manipulative parent. On *Lost*, saying "trust me" was a red flag.

And yet, we had to trust Cuselof: That's what a good fan does.

Then came the finale, which amounted to a moving, luminous, tear-inducing, near-total bait and switch.

Now, I realize many people enjoyed the finale. The episode was visually lyrical. It was audacious, in its way. It was almost radically crowd-pleasing, designed to be viewed with the fan brain, not the critic brain. With its witty structure, it allowed the creators to download fusillades of old clips: montages that in the literal sense stood in for each character's memories, but also worked as sentimental flashbacks for fans, reminding us of how much fun it had been to watch *Lost* itself. Meanwhile, on the island, we endured a series of thrilling but nonsensical unpluggings and then pluggings of a Freudian sinkhole. When the plot and the island stopped shaking, Hurley, the Good Fan, was handed the keys to the donkey wheel, as if he were being trusted to protect the legacy of the show itself.

I don't have a heart of stone: The acting in the otherwise terrible finale was so good that in several cases (the reunion of Sawyer and Juliet) it made the endless romantic pairings desperately poignant instead of numbing. (Although not with Charlotte and Daniel: Lose the skinny tie, dude.)

But when those warm feelings wore off, it was hard to ignore the unsettling message we'd received, which was that nothing in the series had actually mattered. That mysterious island? The one we'd obsessed over for six years? We should remember it, as

through a happy mist, as the place where our characters learned to love one another.

As for the Sideways Universe—featuring tweaked variations on each character's story—that was also not important, at least not in any detail. It was a mystical way station, like weak fan fiction with a therapeutic kick. Most of the Sideways stories boiled the survivors' stories down to morals like "Love your family" and "Believe you are a good person," and if we wanted to enjoy the show, we needed to accept these truisms as closure for story arcs rather than Oprah-tinged parodies of them.

Finally, in the last fifteen minutes, the writers—in an emotionally powerful and also mawkishly manipulative turn—gathered our characters in an interfaith church, the antechamber to heaven. There Jack's father, now a loving guide (rather than an abusive drunk), told him, and us, to let go. No wonder it was touching: It was grief therapy directed at us as fans.

The sad thing, really, is that this wave of nostalgia, however powerful it was in the moment, sunk the show it was meant to mourn. Once upon a time, *Lost* faced outward, toward the world. In its early seasons, it wasn't just dumb, feel-good fun; for all the fantasy trappings, it had resonant, adult themes, ones set in the context of a global community traumatized after a plane crash. Post-9/11, the show spoke, for a while, more thoughtfully (or at least less angrily) than *24* to the moral questions that unsettled many Americans: Why does everyone consider themselves the "good guys"? Is it ever okay to torture? How do we choose, and should we trust, our leaders?

But by the end of its run, *Lost,* for all its dorm-room chatter about good and evil, had become something different: It was a hit series about the difficulties of finding an ending to a hit series. Cuselof had a deadline for years, which should have allowed them to pace out their puzzle's solutions. Instead, we got cheesy temple

vamping and a bereavement Holodeck. It became a show about placating, even sedating, fans, convincing them that, in the absence of anything coherent or challenging, love was enough.

The day after the finale, Lindelof tweeted again, in the soothing cadences of a preacher: "Remember. Let go. Move on." Hey, Lindelof: done.

MR. BIG

How Ryan Murphy Became the Most Powerful Man on TV

The New Yorker, May 14, 2018

I began reporting this profile on the set of *The Assassination of Gianni Versace: American Crime Story* and didn't finish it until more than a year later, on the set of *Pose*—in fact, the process took so long, I wrote the Jenji Kohan profile in the interim. Luckily, that gave me the breadth to capture an outsize personality during a period of radical change in his life, as he ascended to something resembling Norman Lear-dom.

Ryan Murphy hates the word "camp." He sees it as a lazy catchall that gets thrown at gay artists in order to marginalize their ambitions, to frame their work as niche. "I don't think that when John Waters made *Female Trouble* that he was like, 'I want to make a camp piece,'" Murphy told me last May, as we sat in a production tent in South Beach, Florida, where he was directing the pilot of *The Assassination of Gianni Versace: American Crime Story,* a nine-episode series for FX. "I think that he was like, 'It's my tone—and my tone is unique.'" Murphy prefers a different label: "baroque."

Between shots, the showrunner—who has overseen a dozen television series in the past two decades—elaborated, with regal authority, on this idea. To Murphy, "camp" describes not irony but something closer to clumsiness, the accident you can't look away from. People rarely use the term to describe a melodrama made by a straight man, he argues; even when "camp" is meant as a compliment, it contains an insult, suggesting a musty smallness. "Baroque" is *big*. Murphy, referring to TV critics (including me) who have applied "camp" to his work, said, "I will admit that it really used to bug the shit out of me. But it doesn't anymore."

We were outside the Casa Casuarina, the Mediterranean-style mansion that the Italian fashion designer Gianni Versace renovated and considered his masterwork—a building with airy courtyards and a pool inlaid with dizzy ribbons of red, orange, and yellow ceramic tiles. A small bronze statue of a kneeling Aphrodite stood at the top of the mansion's front steps. In 1997, a young gay serial killer named Andrew Cunanan shot Versace to death there as the designer, who was fifty, was returning from his morning stroll.

The previous day, Murphy had filmed the murder scene. Cunanan was played by Darren Criss, a star of Murphy's biggest hit, *Glee.* I'd visited the set that day, too, arriving to find ambulances, cops, and paparazzi swarming outside. There was a splash of red on the marble steps. Inside the house, Edgar Ramírez, the Venezuelan actor playing Versace, sat in a shaded courtyard, his hair caked with gun-wound makeup, his face lowered in his hands.

Now Murphy was filming the aftermath of the crime, including a scene in which two lookie-loos dip a copy of *Vanity Fair* into the puddle of Versace's blood. (They sell the relic on eBay.) The vibe was an odd blend of somber and festive; a half-naked Rollerblader spun in slow circles on the sidewalk next to the beach. Murphy, who is fifty-three, is a stylish man, but on set he wore the middle-aged male showrunner's uniform: baggy cargo shorts and

a polo shirt. He has a rosebud mouth, heavy features, and c
cropped vanilla hair. He is five feet ten but has a brawny air
command, creating the illusion that he is much taller. His broth
is six feet four, he told me, as was his late father; Murphy thinks
that his own growth was stunted by chain-smoking when he was a
rebellious teenager in Indiana.

Murphy's mood tends to shift unexpectedly, like a wonky
thermostat—now warm, now icy—but on the *Versace* set he made
one confident decision after another about the many shows he
was overseeing, as if skipping stones. He also answered stray
questions—about the casting for a Broadway revival of *The Boys in
the Band* that he was producing, about a grand house in Los Ange-
les that he'd been renovating for two years. "Ooh, yes!" he said,
inspecting penis-nosed clown masks that had been designed for his
series *American Horror Story*. He approved a bespoke nail-polish de-
sign for an actress. A producer handed Murphy an updated script,
joking, "If there's a mistake, you can drown me in Versace's pool!,"
then scheduled a notes meeting for *American Crime Story: Katrina*,
whose writers were working elsewhere in the building. Now and
then, Murphy FaceTimed with his then-four-year-old son, Logan,
who, along with his two-year-old brother, Ford, was in L.A. with
Murphy's husband, David Miller.

"I never get overwhelmed or feel underwater, because I feel like
all good things come from detail," Murphy told me. It's what got
him to this point: the compulsion, and the craving, to do more.
"Baroque is a sensibility I can get behind," he said. "Baroque is a
maximalist approach to storytelling that I've always liked. Baroque
is a choice. And everything I do is an absolute choice."

Murphy's choices, perhaps more than those of any other show-
runner, have upended the pieties of modern television. Like a wild
guest at a dinner party, he'd lifted the table and slammed it back
down, leaving the dishes broken or arranged in a new order. Sev-
eral of Murphy's shows have been critically divisive (and, on occa-

, panned in ways that have raised his hackles). But he has produced an unusually long string of commercial and critical hits: audacious, funny-peculiar, joyfully destabilizing series, in nearly every genre. His run started with the satirical melodrama *Nip/Tuck* (2003), then continued with the global phenomenon *Glee* (2009) and *American Horror Story,* now entering its eighth year, which launched the influential season-long anthology format. His legacy is not one standout show but, rather, the sheer force and variety and chutzpah of his creations, which are linked by a singular storytelling aesthetic: stylized extremity and rude humor, shock conjoined with sincerity, and serious themes wrapped in circus-bright packaging. He is the only television creator who could possibly have presented Lily Rabe as a Satan-possessed nun, gyrating in a red negligee in front of a crucifix while singing "You Don't Own Me," and have it come across as an indelible critique of the Catholic Church's misogyny.

When Murphy entered the industry, he sometimes struck his peers as an aloof, prickly figure; he has deep wounds from those years, although he admits that he contributed to this reputation. Nonetheless, Murphy has moved steadily from the margins to television's center. He changed; the industry changed; he changed the industry. In February, Murphy rose even higher, signing the largest deal in television history: a three-hundred-million-dollar, five-year contract with Netflix. For Murphy, it was a moment of both triumph and tension. You can't be the underdog when you're the most powerful man in TV.

On that sunny afternoon in South Beach, however, Murphy was still comfortably ensconced in a twelve-year deal with Fox Studios. On FX, which is owned by Fox, he had three anthology series: *American Horror Story; American Crime Story,* for which he was filming *Versace,* writing *Katrina,* and planning a season based on the Monica Lewinsky scandal; and *Feud,* whose first season starred Susan Sarandon as Bette Davis and Jessica Lange as Joan Crawford. For Fox, he was developing *9-1-1,* a procedural about first re-

sponders. He had announced two shows for Netflix: *Ratched*, a nurse's-eye view of *One Flew Over the Cuckoo's Nest*, starring Sarah Paulson; and *The Politician*, a satirical drama starring Ben Platt. Glenn Close was trying to talk him into directing her in a movie version of the Andrew Lloyd Webber musical *Sunset Boulevard*. Murphy was writing a book called *Ladies*, about female icons. He had launched Half, a foundation dedicated to diversity in directing, and had committed to hiring half of his directors from underrepresented groups. And, he told me, there was something new: a series for FX called *Pose*, a dance-filled show set in the 1980s.

It was no mystery which character in his current series Murphy most identified with: Gianni Versace himself. Versace was a commercially minded artist whose brash inventions were dismissed by know-nothings as tacky, and whose openness about his sexuality threatened his ascent in a homophobic era. Versace, too, was a baroque maximalist, Murphy told me, who built his reputation through fervid workaholism—an insistence that his vision be seen and understood. "He was punished and he struggled," Murphy said, then spoke in Versace's voice: "Why aren't I loved for my excess? Why don't they see something valid in that?"

Shortly before I left Miami, Murphy and I drank rosé at a South Beach restaurant. "A double pour," he told the waiter. "It's Friday." We talked about *Pose*, which is set in the drag ballroom scene in New York during the Reagan era and the AIDS crisis. Many people knew of this world through Jennie Livingston's 1990 documentary, *Paris Is Burning*, or Madonna's "Vogue" video. In 2015, Murphy approached Miramax, the distributor of *Paris*, and bought an eighteen-month option; he met with Livingston, who introduced him to the surviving subjects of her movie and, later, recommended a variety of queer consultants. Murphy initially intended to base characters on the people in the documentary: queer performers of color who competed for trophies in such categories as Executive Realness. These drag queens, trans dancers, and female impersonators lived in sorority-like groups that had names like the

House of Xtravaganza and were overseen by older "mothers"—
a family for people who often had been rejected by the ones they
were born into.

In 2016, an independent producer tipped Murphy off to a simi-
lar project. Steven Canals, a thirty-six-year-old Afro-Latino queer
screenwriter from the Bronx, had written *Pose*—a fictional pilot
set in the eighties ballroom world, featuring a gay and trans en-
semble. Nobody in Hollywood was biting. Murphy attached his
name and FX signed on. Murphy, Canals, and Murphy's main cre-
ative partner, Brad Falchuk, reworked the pilot and added a new
character: Donald Trump, in his Master of the Universe days.
Murphy was committed to getting *Pose* on the air that summer. He
planned to create a writers' room filled with trans people, many of
them newcomers to TV.

I told Murphy that the series sounded like a cool risk. "It's not
a risk at all," he said, frowning. "I know instantly that it's a hit." He
explained, "There's something for everybody—and there's some-
thing to offend everybody. That's what a hit *is*." He foresaw a
broad demographic: "You, me, the young people who love nostal-
gia, the fourteen-year-old girl who is watching Tom Holland dress
in drag and dance to Rihanna."

Murphy gave me a copy of the reworked pilot, and on my way
to the airport he texted, "On a scale of 1 to 10—10 being master-
piece, 1 being awful—what do u give pose?" When I tried to
change the subject, to maintain journalistic distance, he texted
back, "Ha!" And then: "I know one day you will tell me." And
then: "I am guessing a 9." And then: "With the potential for a 10!"

Murphy has long been a connoisseur of extremes and hyper-
bole, games and theatricality. He rates everything he sees and rev-
els in institutions that do the same—the Oscars are a kind of
religion for him. In Miami, at dinner with the *Katrina* and *Versace*
writers, he played a high-stakes game in which he was forced to
immediately choose one person in his circle over another; he de-
murred only when the choice was between Jessica Lange and

Sarah Paulson. His go-to question is "Is it a hit or a flop?," and he asked it about every show that came up in conversation as I observed him giving shape to *Pose*, from scouting locations to editing dance footage. (He has other stock phrases. "What's the scoop?" is how he begins writers' meetings. "Energy begets energy" explains his impulse to add new projects. "That's interesting" sometimes indicates "That's worth noticing" but just as often means "That's infuriating.")

Murphy's first show, *Popular*, which debuted in 1999, was, in fact, something of a flop, lasting only two seasons on the teen channel The WB. It is such a painful memory for Murphy that, last year, when the Producers Guild of America honored him with its Norman Lear Achievement Award, he didn't include the show on the placard listing his productions. Like *Glee*, *Popular* was a high school comedy. It featured rat-a-tat dialogue ("Shut your dirty whore mouth, player player!") and a Gwyneth Paltrow–obsessed cheerleader with webbed toes. It baffled the network, which wanted something closer to *Dawson's Creek*.

Murphy recalls a fusillade of homophobic notes: A fur coat made by anally electrocuting chinchillas was deemed "too gay," and the producers were okay with the show's few homosexual characters only if they suffered. "I don't think they understood who they had on their hands," the actress Leslie Grossman, who played the web-toed Mary Cherry, recalls. She fondly remembers *Popular* as "a show by gay men in their thirties for gay men in their thirties." In one meeting, a WB executive imitated Murphy, flopping his wrists and adopting a fey voice. (Both hurtful and inaccurate, Murphy pointed out: He inherited a low, rumbling voice from his father.) The final season of *Popular* included an insubordinate homage to *What Ever Happened to Baby Jane?*

In 2003, on the more welcoming network FX, Murphy had his first hit: *Nip/Tuck*, a twisted plastic-surgery medical procedural spiked with satire about a looks-obsessed culture. He pitched the show, about a competitive friendship between two Miami doctors,

as a tribute, in part, to one of his childhood obsessions: the Mike Nichols film *Carnal Knowledge,* which he saw as a love story about two straight men. "Nobody ever got the connection," he told me. "I loved that movie ten times more than *The Graduate.*" The catchphrase of *Nip/Tuck* was "Tell me what you don't like about yourself." Even at FX, whose president, John Landgraf, was eager to nurture auteurs, Murphy fought with his bosses constantly. He spent hours debating Landgraf about the limits of good taste (understandably—one *Nip/Tuck* plot was about a yogi demanding a penis reduction because he couldn't stop fellating himself). *Nip/Tuck* got terrific ratings, but Murphy bridled when some viewers saw him as glamorizing plastic surgery. He believed that he was sending a feminist message by "hiding the vegetables in the cotton candy," he told me.

In 2008, toward the end of *Nip/Tuck*'s run, Murphy filmed a labor of love—*Pretty/Handsome,* a pilot about a closeted trans gynecologist, played by Joseph Fiennes, who lives in Darien, Connecticut, with his wife and kids. This was six years before *Transparent,* long before trans activism became a mainstream cultural force. In the pilot, Fiennes treats a married couple: a trans man, played by Dot-Marie Jones, and a trans woman, played by Alexandra Billings, who later appeared on *Transparent.* The pilot was kinky and original, laced with the dark humor of *Nip/Tuck* but humanistic beneath its arch surfaces. FX passed. Murphy didn't speak to Landgraf for ten months.

Yet this failure was soon followed by the Fox series *Glee,* which, in 2009, transformed Murphy into not merely a showrunner but a full-on celebrity. The show was a high school musical that put queer kids, weird girls, and underdogs in the lead roles. Its musical sequences—football players, in tights, dancing to Beyoncé—became iconic. *Glee* had the surreal verve of *Popular,* rendered more heartfelt, a beacon to oddballs everywhere. Both *Nip/Tuck* and *Glee* ran for multiple seasons, and had intense fan bases, but they also flew off the rails: *Nip/Tuck* became a Grand Guignol in

its twists; *Glee* got preachy and self-indulgent. As Brad Falchuk told me, "We do such amazing Seasons 1 and 2. It's Season 3 that terrifies me."

In 2011, Murphy, feeling constrained by the teen-beat rhythms of *Glee*, hit on a radical scheme for a new show. Called *American Horror Story*, it would be set in a haunted house in L.A.; the plot would resolve after one season, with all the characters dead, then reboot, recasting many of the actors in new roles. Intuitively, he'd solved the structural problem that had plagued even his strongest creations. Now each story could end—even unhappily. The first season, known as *Murder House*, was defiantly strange, with a miserable married couple, a black-leather-suited gimp, Jessica Lange as a glamorous mother of monsters, and a ghostly maid who switched between looking like a young tramp and an old crone. It evoked *Rosemary's Baby* and other social-commentary horror movies of the sixties. It also revived Lange's career—and, over time, Murphy built a repertory company of stars, many of them older women, such as Kathy Bates and Angela Bassett, or openly gay performers like Zachary Quinto and Sarah Paulson.

But critics, particularly online, treated *Murder House* as outré junk. (*The Guardian* called it "the Marmite of TV shows"—the kind of thing you either loved or loathed.) When the series was being pitched, its slogan was "the House always wins," but, rather than stick with the haunted-house concept, Murphy and his partners, Falchuk and Minear, rebooted the setting as well. Season 2, *Asylum*, was set in a mid-century mental hospital run by nuns. It was a caustic masterwork, a pulp manifesto denouncing the institutional torture of sexual minorities by the government, the Church, and the medical establishment. The show featured a whip-wielding nun, carnival pinheads, a closeted-lesbian investigative journalist, and a serial killer with Holocaust lampshades. It got a better reception than *Murder House*, but was still treated as a curiosity, particularly by viewers who expected a purer camp experience. In the *Times*, Mike Hale complained, "*Asylum* would be

better off if Briarcliff Manor had more furniture for [the actors] to chew."

In 2014, FX aired an anthology show by Noah Hawley, *Fargo,* a reinterpretation of the Coen brothers' movie. The first season was beautiful but empty, as violent as *American Horror Story* but more misogynist. Yet *Fargo* was anointed the best show of the year— and, on occasion, celebrated in tones suggesting that it had revived the anthology model. A 2015 *Wall Street Journal* article on the trend mentions Murphy's work only in passing, arguing that the "format's broader promise paid off" with *Fargo* and HBO's *True Detective.* Murphy repeatedly suffered such slights in his career, as his work was eclipsed by that of people he dismisses as "dowdy, middle-aged, white-male showrunners writing about dowdy, middle-aged, white-male antiheroes." He loved *The Sopranos,* but its progeny drove him nuts. Those shows were seen as weighty, worldly, universal. His were regarded as frivolous diversions.

Murphy's productivity only grew in response, in a kind of defiant inventiveness. He often says that his drive stems from the AIDS era. "I always thought I would die from sex," he told me. "So I had to get more done." But that doesn't really account for his workaholism; there are plenty of fifty-three-year-old gay men of my acquaintance who didn't become charismatic showrunners working seven days a week. Murphy is unapologetically mass-market: He has no interest in doing independent films that attract small audiences. He's proud never to have made, as he puts it, "the long Sominex hour that ends in gray and a fadeout." For Murphy, what marks his work is the desire to pull outsider characters in, to make a gay kid or a middle-aged woman a protagonist, not a sidekick. But his biggest strength is his strangeness, his allergy to the dully inspiring, and his native attraction to the angriest characters— a quality he traces to "the Velvet Rage," referring to the title of a 2005 book about the fury gay men feel in a straight world. Although Murphy's work shares some parallels, in its rude humor and sexual candor, with that of modern female showrunners like

Shonda Rhimes and Jill Soloway, he's not especially close to them. (Murphy feels that they've snubbed him on the occasions when they've met.) His favorite directors are Steven Spielberg, David Fincher, Hal Ashby, and Mike Nichols. Fincher is his role model, he says, for his darkness and control, and for the fact that he "doesn't give a fuck" what people think of him—something that Murphy yearns for but has not been capable of.

Ryan Murphy was born in Indianapolis in 1964. Many gay men of his era have awful coming-out stories, involving years of closeted self-loathing. Murphy was never "in." He was the sort of altar boy who fantasized not about the priesthood but about becoming the pope. ("If I cannot rise to the top of my profession," he said, mimicking himself as a child, "I absolutely will not go!") When he was four, his beloved maternal grandmother, Myrtle, and his mother, Andy, took him to see Barbra Streisand in *Funny Girl*. Murphy left the cinema in a state of bliss. "I was like"—he snapped his fingers and grinned at the memory, imitating a preschooler having an epiphany—"'That's it! I'm *gay*. And I'm going into show business.'" When he was twelve, his parents vetoed a plan to turn his bedroom into a red-painted "portal to hell." As a compromise, he renovated it as a tribute to Studio 54: chocolate-brown shag carpeting, matte olive-colored walls, a mirrored ceiling, a shrine to Grace Kelly.

Murphy's mother and father were busy with work—his mother doing corporate PR, his father running circulation for a local newspaper. Grandma Myrtle lived down the street, and the two became a team. She'd make black-tar coffee, and Ryan would sit on a stool in the bathroom while she put on her face, telling him about her favorite things: Rudolph Valentino, John Wayne, vampires. They shopped for antiques; they had a regular date at a local tearoom. "She had my back," Murphy said—and he adopted her enthusiasms, like the horror show *Dark Shadows*. Murphy's parents and his brother had darker hair. He had the blond, Danish look of his maternal grandfather, who, according to family lore, was related

to Hans Christian Andersen—a claim to stardom, in his view. "You're special," his grandmother told him. "Don't let them tell you you're not."

Myrtle's influence infuriated his father. A taciturn Irish Catholic jock, Jim Murphy was disturbed by what he perceived as Ryan's alien quality. He would wake him up late at night, take him to the kitchen, and ask him unanswerable questions: "Why don't I see myself in you?" He beat him, too—something that was common in his neighborhood. "It was Irish working-class Indiana," Murphy said. "The kid down the street was also beaten, with leather belts, for being over curfew." His father, though, was trying to beat his sexuality, his difference—his taste—out of him. When Ryan was small, he stole a red high-heeled shoe from Woolworths; his father smacked him in the face. (More reasonably, he made him apologize to the manager.) When Ryan was ten, he watched *Gone with the Wind* on television. During a commercial break, his father heard him reciting the Wilkeses' barbecue scene in the bathroom and asked Ryan why he was performing the girl parts. Ryan replied, "Because they're the better parts"—and his father backhanded him across the bathroom. By that point, Ryan had developed armor. Brushing himself off, he icily asked his father if he could continue watching the movie.

His relationship with his mother was different, but not much better. (Murphy compares his mother to the boundary-violating one depicted in Carrie Fisher's *Postcards from the Edge*.) He traces his obsession with control to a bad memory of a Christmas pageant in which he'd been given the role of a Christmas tree. Murphy was determined to make a splash: A girl was planning an electrified outfit, and he wanted to compete. Every day, he nervously reminded his mother to get a Butterick sewing pattern and the material for a costume. She reassured him that she'd done it— until the day of the pageant, when she handed him a garbage bag with armholes. Although he was only in first grade, he recalls having the revelation that he couldn't trust anyone; he'd have to do

everything himself, or risk humiliation. His friend Bart Brown thought Murphy was exaggerating, until later, when Brown became close to Murphy's parents, and got Andy to acknowledge that the incident had happened—an enormous relief to Murphy, who often felt gaslighted by his family's denial of past events. (Murphy's mother told me that she remembers the story, but differently: She didn't own a sewing machine and was embarrassed that she wasn't good at crafts.)

At fifteen, Murphy had his first love affair, with a man in his twenties. He was a celebrity to Murphy, having starred in a high school production of *Oklahoma!* "He had a burgundy Corvette, and he was a lifeguard, and he would pick me up, and, for our dates, we'd have Chinese food, and we'd go wash the car at the you-wash-it-yourself thing," Murphy said. "And we'd drive around, listening to Christopher Cross singing 'Sailing.' It was the height of glamour." That summer, when Murphy was at choir camp, his mother found a cache of love letters. She asked Murphy's boyfriend over for a Coke, and, as Murphy put it, "was like, 'No, no, no.'" Terrified, the boyfriend cut off contact. Murphy was grounded, and the family began group therapy. (Last year, Murphy looked up his old boyfriend: "I said, 'I think about you all the time. Do you remember me?' And he was like, 'Are you kidding? I see you on TV all the time. You were so sweet.'")

Although Murphy raged for years about his parents' response, he now has sympathy for their reaction: "I would do the same thing, no matter what the sexual orientation of my child. A fifteen-year-old boy dating somebody who was older? I didn't really understand it until I had kids." His heartbreak also led to something positive. To Murphy's surprise, the therapist listened to him and took his side: "He told my parents that I was precocious and that I was smarter than they were, and that if they didn't leave me alone, I'd end up leaving town and never talking to them again."

Murphy turned his upbringing into an origin myth, as we all do—and, as only some do, into art. On *Glee*, he gave his story a

326 I LIKE TO WATCH

happy ending: In one plotline, a working-class dad learns to love his Broadway-obsessed gay son. On *Pose*, there's a less happy version of the conflict: A teenage boy, a talented dancer, gets beaten by his father with a belt, and their break seems irreparable. In real life, when Murphy's father died, in 2011 at the age of seventy-three, the two were still largely estranged, but Murphy made sure that he got excellent medical care. On his deathbed, his father sent Murphy a letter of apology. Murphy could read only half of it before stuffing it in a kitchen drawer.

In New York, in November, *Pose* was in full gear. On a windy Brooklyn pier, as "Ain't Nothin' Goin' On But the Rent" boomed, Murphy filmed dancers voguing in acid-washed jackets and Kangol hats. "Yasss!" he yelled. "Use your space!" Murphy loves the cold. He was wearing a faux-fur parka and cargo pants with thigh panels made of purple plastic.

Near some footage monitors, Steven Canals, the show's co-creator, showed me an article that he'd been reading on *Paste*: "Paris Is Still Burning: What if We Loved Black Queers as Much as We Love/Steal from Black Queer Culture?" Canals grew up in the Bronx and spent a decade as a college administrator before going to film school. His partner, the artist Hans Kuzmich, is trans. "Sometimes I can be a little militant, as a queer person of color," Canals told me, about the writers' room. "I don't have the luxury to take those identities off." He was exhausted after plotting out scripts with a team of four: the African American trans author and activist Janet Mock; the *Transparent* writer Our Lady J, who is white and trans; Murphy; and Falchuk, who is white and straight. When Canals first met Murphy, he raised concerns: Would Murphy treat the characters in *Pose* as full people, not jokes or freaks? Murphy got it, Canals said: "I knew that I was not going to be just a brown body in the room."

Murphy approached.

"Hello, Mutha," Canals said.

"Hello, child," Murphy said.

Murphy is "the mother of the House of Murphy," Canals joked. "He's super-regal, but he doesn't have a bougie attitude. It's grounded fabulosity."

In the pilot script, Blanca, an idealistic member of the fictional House of Abundance, is sick of having her ideas stolen by her house mother, the imperious Elektra, and starts a rival house. Since I'd read it, however, some changes had been made: Trump was out, replaced by a cokehead Trump Organization executive played by James Van Der Beek. "Nobody wants to see that fuckhead," Murphy said of Trump, swatting his hand as if brushing off a fly.

Even without a role in the show, Trump was inescapable. He had tweeted out a ban on trans people serving in the military; reports soon emerged that the Centers for Disease Control and Prevention had barred employees from using the word "transgender" in official documents. Murphy knew that *Pose* would receive political scrutiny—a precondition for any series about such a vulnerable community. *Paris Is Burning* was criticized for exploiting its subjects; Jill Soloway, the creator of *Transparent*, was under fire for casting Jeffrey Tambor in a trans role; even the beloved RuPaul soon sparked pushback for suggesting he might not allow trans women on *RuPaul's Drag Race*. "You can't underestimate the power of social media to shame a business," Murphy said.

He generally considers this a good thing: Phenomena like Black Twitter have goaded TV into being smarter about race and power. Some of his other shows had been criticized as insensitive, including *Coven*, a voodoo-drenched season of *American Horror Story* set in New Orleans. Murphy was determined that *Pose* be above reproach: authentic, inclusive, nonexploitative. The show, he bragged, had 108 trans cast or crew members, and 31 LGBTQ characters. It employed trans directors, too, including Silas Howard, from *Transparent*. Murphy was giving his profits to pro-trans causes. On a

promotional panel, Murphy put Canals, Mock, and the actresses in the front row, not Van Der Beek. "It's television as advocacy," Murphy said. "I want to put my money where my mouth is."

Meanwhile, conflict was emanating from an unexpected angle. Jennie Livingston, the director of *Paris Is Burning*, felt excluded from the process. It was a messy situation, likely inflected by Murphy's concerns about the optics of being associated with another white creator. After much wrangling, Murphy gave her a paid consulting-producer credit and the opportunity to direct if the show was renewed. But maybe a flare-up of this sort was to be expected. Debates about who owned what had always been central to the ballroom scene. The performers strove for "realness," doing flawless imitations of *Vogue* covers and *Dynasty* divas, in costumes often procured by shoplifting. (The pilot of *Pose* features a hilarious dramatization of a legendary heist of Danish royal finery from a New York museum.) The dancers' moves were, in turn, stolen—or celebrated, depending on one's perspective—by the mainstream world, with Madonna, the empress of appropriation, transforming the subculture into a lucrative trend. In the *Pose* pilot, Elektra delivers a speech that serves as a sly defense of this kind of magpie creativity: "Just because you have an idea does not mean you know how to properly execute it! Ideas are ingredients. Only a real mother knows how to prepare them."

The casting sessions for *Pose* had unsettled Murphy: Many of the trans actors lacked health insurance and bank accounts; nearly all had stories about sexual violence. But he didn't want to make the show too gritty or downbeat. Charmed by the "butterfly" loveliness of his cast, he was interested in "leaning in to romance instead of degradation"—and making something hopeful and "aspirational." *Pose*, he theorized, might even be family-friendly, something that was a little hard to imagine about a series that included scenes at the Times Square sex emporium Show World.

Often, talking about *Pose* led Murphy into reveries about *Glee*, another show that had been designed to give queer kids characters

they could root for. "Against all odds, the quote-unquote 'fag musical' became a billion-dollar brand," Murphy recalled. More than once, he asked me if he should revive *Glee*. "The power of it, the power of being able to show youth and joy," he mused. "I would much prefer to live in worlds like that."

In midtown, I'd seen an audition of a modern ballroom "Icon," Dominique Jackson, who read for Elektra. In the scene, Elektra has her nails done by her rebel "child," Blanca, whose political activism she finds absurd. "You're a regular transvestite Norma Rae," Jackson sneered, her cheekbones sharp as knives.

Jackson, a trans model who appeared on the reality show *Strut*, was born in Tobago and left home in 1990, at the age of fifteen. When she went through her gender transition, her mother, who is religious, "took a step back," she told Murphy and his team, softly adding, "Right now, I have to love her from a distance." Jackson's ballroom elders ended up raising her, back when she was a homeless immigrant doing sex work. Jackson, in turn, had mothered more than thirty "children." She spoke fondly of elders from the scene before hip-hop's ascendance, elegant queens who lived in cockroach-infested apartments but put on full contour makeup for a trip to the grocery store: "It was really like a Caribbean family—they never let you know the real thing of what was happening."

"You're so amazing, and a star," Murphy said. Elektra, he told her, was his favorite role—the one he acted out in the writers' room.

Before Jackson left, she thanked Murphy for *American Horror Story: Coven*, particularly for a scene in which a witch named Myrtle cries out "Balenciaga!" during her death throes. Falchuk and Minear had written a lot of the show, Murphy told her, but that moment was all him. "I knew that people would love it," he told her. "Because that's what I would say if I was burned at the stake."

Murphy's first celebrities were nuns. Every year, his family invited one to tag along, in their green Pinto, on their vacation to St. Petersburg, Florida. When night fell, Murphy would interview the

"nun du jour": "Have you ever kissed a boy?"; "Do you think you'll go to hell?" He was captivated by their fashion. In the wake of Vatican II, some experimented with a half-cap or a shorter skirt, but others still wore a full habit.

The wannabe pope steeped himself in Catholic rituals, gazing at the stained-glass windows of St. Simon the Apostle Church in Indianapolis, marveling at stories of saints eating lice or scabs. "Then I read that the pope had the cleanest, purest heart in the world, so I would practice," he said. "And I would wake up and say, 'How long can I go without committing any sin whatsoever?' And I would last, like, three hours. I couldn't wait to say something bitchy or eat something I wasn't supposed to, or have impure thoughts about boys. So I quickly abandoned that."

Instead, he pursued journalism, a field that welcomes all these impulses. He had been accepted by a film school in California, but his parents' income was too high for him to receive financial aid, and although his mother and father gave his brother, Darren, tuition money, they told Ryan that he was strong enough to make it on his own. He obtained a journalism degree at Indiana University while working three jobs, including selling shoes at a mall, and aggressively pursuing newspaper internships. On his first day as a crime reporter in Tennessee, he made the disastrous decision to wear a white suit, Tom Wolfe–style, to a murder scene. At *The Miami Herald*, he insinuated himself into the Styles department and wrote a profile of Meryl Streep, insisting that the newspaper pay for the rights to an Annie Leibovitz photograph. (The other interns hated him.) At *The Washington Post*, his colleagues' reaction was equally poor when he rejected what he considered dull assignments, saying, "No. I want Bob Woodward to be my mentor!" Nevertheless, he relished the opportunity to be near Stephanie Mansfield, a poison-pen profiler who'd "sweep in, all ambition, smelling feminine and amazing."

There were missed opportunities, here and there, for the glamorous life. During college, he flew to New York to interview for a

Rolling Stone internship. Chain-smoking Kools, he wore a lavender WilliWear tank top, and was so emaciated that, as he puts it, he "looked Biafran." He got the job, but it was unpaid, so Murphy couldn't take it. He spent the night with a wealthy acquaintance, whose boyfriend caught Murphy in their bed: There was drama, and a declaration of love. Murphy still wonders if he should have taken the opportunity to be a kept man—the express lane to the "white penthouse apartment" he longed for.

Instead, he landed in L.A., becoming a prolific, witty freelancer for newspapers and magazines, including *Entertainment Weekly*. In 1990, he wrote for *The Miami Herald* a complex profile of a tetchy Jessica Lange, calling her "tungsten beneath silk." He interviewed Cher so many times that she grew concerned. At the time, he was living with Bill Condon, a filmmaker who, two years after they broke up, won a best-screenplay Oscar for the movie *Gods and Monsters*. Murphy felt like a stifled househusband, submerging his ambition in garden design and dinner parties. As an escape plan, in 1995, he wrote a romantic comedy, *Why Can't I Be Audrey Hepburn?* He sold the screenplay to Steven Spielberg. Many major actresses read for the lead.

In their garden, Murphy recalled, "I designed this outdoor cage where we had these lovebirds." He went on, "And I came home, and Bill was in the backyard, and I looked in the cage. And these lovebirds were called Auguste and Harlow, and Harlow was gone, and I was like, 'What happened?' And he said, 'I went to clean the cage, and she flew away.' And I was like, *That's my sign*. And I turned around, and I got in my car, and I drove to the Chateau Marmont, and I checked in and I lived there for six months—until my business person said, 'You've spent every dime and you have to leave.' So that was the beginning of my Hollywood career." Condon remembers the end point differently: While visiting Laguna Beach with Murphy, Condon got caught in a riptide—and when he thought he saw a flash of hesitation on Murphy's face, as if he might let him drown, he knew that the relationship was over.

Spielberg never made the movie, but Murphy was undaunted. "He exuded this air of certainty that I had never really witnessed in Hollywood before," his friend Bart Brown said. "Not arrogance— confidence. But he had no poker face. He couldn't disguise himself. Right away, I was like, 'Who is this guy?'"

In early December, at the Connelly Theater on East Fourth Street, Murphy filmed the ballroom competitions, some of which had made-up themes, such as "Weather Girl." A panel of judges sat on the rickety stage, among them various Legends from *Paris Is Burning* and a dancer from the "Vogue" video. They held up signs: "10," "10," "10." It was a joyful, anarchic atmosphere: Even the writers kept breaking out in dance competitions. Dominique Jackson was all glammed up, smiling, in a poofy yellow hat: She'd won the role of Elektra. While she was doing a big monologue, Murphy threw her a new line that got laughs: "My first rule as queen will be to bring back the guillotine!"

One afternoon, Murphy, who was wearing a "Sade" baseball hat, insisted on playing nothing but Sade, even when Canals and Mock begged for Destiny's Child. While he was in the ballroom giving the actors notes, the *Times* posted its latest exposé of Harvey Weinstein's serial abuse of women; it focused on the "complicity machine" enabling him, including agents at CAA. When Canals, sitting near a bank of monitors, read the name of Bryan Lourd, one of Murphy's agents, he gasped and held up his phone to show Murphy's assistant. Lourd had declined to comment to the *Times* on whether he had known of Weinstein's alleged abuse of women, citing client confidentiality.

Murphy sat down and read the article. When I asked him for his reaction, he said, simply, "I'm loyal to my friends," then added that he didn't believe that any of his agents would facilitate abuse. Lourd was the father of one of Murphy's stars, Billie Lourd; Gwyneth Paltrow, one of Weinstein's accusers, was a close friend of Murphy's, and was engaged to Brad Falchuk. Murphy had finally made it to Hollywood's core; now lava was pouring out.

None of the #MeToo revelations were truly shocking, Murphy told me, if you knew your history. It was the dank underside of the "razzle-dazzle"—systemic abuse that had been romanticized as "the casting couch." Murphy had his own #MeToo stories. When he was young, an older boy had molested him; as an adult, he'd been hit by an ex-boyfriend. We spoke about the scandal-sheet stories that had shadowed the young cast of *Glee:* suicide, a heroin overdose, charges for domestic battery and for possessing child pornography. He expressed regret for the intensity of the environment, but no surprise. "It's sad, but it's also Hollywood," he said. "Nobody comes here because they're healthy. Nobody, nobody I know, was parented well who is a successful Hollywood person. Or who's willing to endure that. You're just trying to fill up some huge hole."

Personal loyalties aside, he was grimly satisfied by the changes in the air—even, at times, exhilarated. He was certainly not sorry to see the straight-male leaders of his industry falling down: the bad-boy director James Toback; the slob-comic Louis C.K., Murphy's fellow-auteur at FX, whom he found unfriendly. "The whole point is to bring the next group of people," he said. "Kick all the old white fucks out and bring in the new people."

All the people on the *Pose* set had projects in their pockets. Silas Howard, the director, told me about a great idea for a punk-rock road-trip movie set in the nineties. Janet Mock had a pitch for "a trans *Felicity*." Everyone wanted to get heard and get funded.

During a pause in filming, Murphy and Mock talked about Murphy's desire for *Pose* to be aspirational. What could that word mean for characters who had often led painful lives?

Murphy said, "We've shot a lot of scenes that are emotionally very dark—"

Mock broke in, "But you do want to see Blanca have a moment of happiness and glamour and have her posing and be victorious."

Murphy turned to me. "Janet and I were talking earlier," he said. "And I was like, 'I don't think we should kill people on the

show—I love them too much.' And she was like, 'You almost have a responsibility to crush your audience. To say, "You love them? Well, look what's happened when you don't get involved." ' "

Murphy had told me that he likes his writers' rooms to be pragmatic, not self-indulgent or therapeutic. But the *Pose* room was host to raw confessions about surgical transitions and "survival sex"—"deep, third-level" conversations, as Canals put it, that helped them create story lines. Murphy's recollection of his father smacking him for shoplifting a red shoe ended up in the third episode. The challenge was to make those experiences fit in the context of the eighties, among characters who likely had a different social-justice framework than that of their creators, and who might identify as drag queens or female impersonators, and not as trans. And, as with any story designed to send a message, there was a risk of crossing the line between uplifting and didactic.

Mock told me, "In my eyes, an 'aspirational' piece is not just the glitter; it's the question of how do these characters use their creativity to fill in gaps in their lives—to be bridges for each other in a world where there are no safety nets."

Early in his career, Murphy gained a reputation in the press as a control freak, all zingers and shade. He viewed this perception, not incorrectly, as homophobic, but he also knew that he'd helped create it. To journalists, he played the glamour monster: "Rarefied. Superficial. Interested in money and fame and clothes and not—I wouldn't really let anybody into my heart." When he was preparing to publicize *The People v. O. J. Simpson*, John Landgraf of FX told him to drop the snob act, and he has tried to do so, although his attempts to be down-to-earth can be funny. ("Now I could give a fuck—give me a black James Perse T-shirt and I'm good.") He can't explain his behavior. "I mean, why did I wear a white three-piece suit to a crime scene? *Why?* I was at that point more interested in facade. And controlling something. And then, I think, a lot changed when I had kids, and I was like, 'Fuck, I can't control anything.' "

Murphy still savors aspects of his old reputation: a show is only as good as its villain, he told the *Pose* writers, who call him Elektra. He informed me that he's a temperamental triple Scorpio—a warning that doubled as a brag. Murphy is a fan of the *Real Housewives* franchise, and is friendly with many of its stars. He so adores Norma Desmond, the aging diva of *Sunset Boulevard*, that he jokes about wanting to direct episodes while using only her lines. He has nothing but disdain for the screenwriter whose body is found floating in Desmond's pool. "It's like 'Good, he deserved it.' He lied to her. He should've told her the truth about that script. And he should've made the script good!"

Murphy is aware that his "relentless output" is sometimes viewed with suspicion. "The word 'prolific' is a dirty word, like 'camp,'" he said. "Like, 'Why can't he be like David Chase and do one thing?'" Murphy is both sensitive to criticism and sensitive to the criticism that he's sensitive to criticism. He tries to avoid reviews but knows the name of every TV critic. When the writer Miriam Bale wrote a feminist critique of *Feud*, then tweeted, "I want to hit Ryan Murphy over the head w/ a can of Bon Ami" (a *Mommie Dearest* reference), he obtained her email address and asked her to give him a call. He was astounded by my suggestion that this was manipulative. He is convinced that if reviewers knew him personally, they'd be more sympathetic to his work. This is true, but it's also crazy.

Murphy's method of simultaneously overseeing multiple shows is unusual, no doubt, but energy begets energy. He is intensely organized, with a plan for each hour: If you just do one small thing after another, he told me, you can create something immaculate and immense. He doesn't get colds, he said; every few weeks, he has an IV drip of vitamins. And though he brims with ideas—I once witnessed him unfurling a truly nutty subplot, for *The Politician*, involving Mossad agents—writing is not his existential passion, as it is for some TV creators. He's no keyboard introvert; he's a ringmaster who loves spreadsheets. He's a self-saboteur,

too, devising the perfect marketing campaign, then alienating critics with a blast of hauteur. "I have a hubris problem," he told me, with humility. "I keep thinking that I'm past it, but I'm not past it."

Murphy is also a collector, with an eye for the timeliest idea, the best story to option. Many of his shows originate as a spec script or as some other source material. (Murphy owned the rights to the memoir *Orange Is the New Black* before Jenji Kohan did, if you want to imagine an alternative history of television.) *Glee* grew out of a script by Ian Brennan; *Feud* began as a screenplay by Jaffe Cohen and Michael Zam. These scripts then get their DNA radically altered and replicated in Murphy's lab, retooled with his themes and his knack for idiosyncratic casting. He generally directs the first episode or two. He's deft with titles. During an editing meeting for *Pose*, he issued two dozen notes: Cut half the dialogue, insert a wider street shot. The show's executive producer, Alexis Martin Woodall, told him that the editor would need three days to make the changes. "No," Murphy said flatly. Woodall explained that the editor's newborn baby was in the hospital. Murphy's eyes widened. He granted the extension, then rattled off exacting, well-intentioned advice about antibiotics and the flu season. "Listen to Dr. Murphy! That baby needs to live through March!" he announced, leaving everyone slightly flabbergasted.

The People v. O. J. Simpson: American Crime Story, which aired in 2016, was the first Murphy production to receive a perfectly sexy blend of high ratings, critical raves, Emmys, and intellectual prestige. He had been hunting for material after HBO declined to pick up *Open*, a sexually graphic pilot about polyamory; his agent Joe Cohen alerted him to a miniseries about the Simpson case, which Fox had been developing with the screenwriting team of Larry Karaszewski and Scott Alexander, until an executive change left the project in limbo. Murphy's name got the show an all-star cast and a big budget. "He was lending us his machine," Karaszewski told me, although he noted that he and Alexander had written the first two scripts and outlined the next four. Nina Jacobson, one of

the show's producers, described a deeper involvement. Murphy, she said, had agitated for emotional directness; among other things, he'd zeroed in on a few lines of dialogue about Johnnie Cochran being racially profiled by cops, and turned it into a full scene.

Murphy can be touchy about the acclaim that the series received, describing its success, dismissively, in ad-speak: "It's that rare four-quadrant show. You feel like you're eating Doritos, but the vitamins are hitting." He added, "The only part of *O. J.* that was truly me was Marcia Clark. But it was an experiment in constraint, and that was the side of me that critics love the most—when it's the side of me that I love the least."

His multitasking benefits greatly from the freedoms of cable and streaming: He has zero nostalgia for the twenty-two-episode network grind of a show like *Glee,* in which "halfway through Episode 15 you had nothing left to say, the actors were sick, the writers were sick, and it was fucking oatmeal until the end." He favors eight or ten episodes, often with a small writers' room, as with *Pose.* He writes scripts for some shows, whereas for others he gives notes; on a few projects, like his HBO adaptation of Larry Kramer's play *The Normal Heart,* he's very hands-on. "We left blood on the dance floor," Murphy said, affectionately, of his three-year collaboration with Kramer. *Versace* had one writer, Tom Rob Smith. But Murphy provided close directorial, design, and casting oversight, and he had a strong commitment to the show's themes, particularly the contrast between Versace and Cunanan, two gay men craving success, but only one willing to work for it.

Murphy does have a bad habit of sloughing off ownership when it's convenient. I asked him about a complaint against *Glee* by the musician Jonathan Coulton, whose acoustic reinterpretation of Sir Mix-a-Lot's "Baby Got Back" was imitated, without credit, on the series. (Coulton is a friend of mine.) Murphy said that he was barely involved in *Glee* by then, and had left it up to Fox's legal department. He did say that he would handle the matter differently

now: "There's a difference between what's legal and what's ethical."

Even as Murphy has matured, he can still be a tempestuous figure. A black-and-white thinker, he cuts ties with people when he feels betrayed: In 2015, he ended his professional relationship with one of his oldest friends, Dante Di Loreto, who was the president of Ryan Murphy Television. At the same time, Murphy has established a profound intimacy with his closest colleagues, often by strengthening relationships that began as "two scorpions in a hatbox"—his grandmother Myrtle's expression. It's his own House of Abundance.

Falchuk and Murphy call themselves brothers. Murphy describes Landgraf, his *Nip/Tuck* antagonist, as his surrogate father. And Landgraf clearly views Murphy in a paternal light, to the point that if what he said about him were printed it would sound sappy. (Landgraf may be the one TV executive who swells with pride at how effectively his protégé resisted his notes.) Similarly, Murphy was once quoted as saying that his dear friend Dana Walden—the head of Fox Television Group, and the godmother of Murphy's children—had "properly mothered" him. "I was very offended!" she said, laughing. "I'm twenty-eight days older than him."

Unlike most TV writers, Murphy remains unambiguously fascinated by celebrity, savoring events like the Met Ball, where he was thrilled to be manhandled by a tipsy Madonna. His writer Tim Minear joked that Murphy's "What's the scoop?" line is an undermining conversational cue: "You just had dinner with Lady Gaga— *that's* the scoop!" But Murphy also simply loves actors, and roots for their success. Murphy called Jonathan Groff after the debut of his new series for Netflix, *Mindhunter,* and got weepy, thrilled that Groff, who is openly gay, had been cast in a role that had "electric and real" heterosexual sex scenes. Sarah Paulson is grateful for the "rare sunshine" that Murphy has cast on her career, giving her a wild range of roles, from conjoined twins to Marcia Clark. Paul-

son has fond memories of filming one of the most daring scenes in *Asylum:* a brutal conversion-therapy sequence in which her character, a lesbian, masturbated while receiving electric shocks. "It just doesn't occur to me to say no to him," she said. "It's a superpower of his."

On occasion, Murphy fantasized to me about taking a break: Perhaps he would take a two-month vacation, or delegate more to others. But, in January, on the day he received the Norman Lear Achievement Award, we had brunch at Barneys in Beverly Hills—at his regular table, in the center of the room—and he acknowledged that it would likely never happen. After having children, he said, "I thought I would become much less driven and calmer, stay at home and make a strudel. No, I became even more insane and driven by a mission." It reminded him of something he'd once read about a man who couldn't wait to turn thirty, when he'd be less interested in sex, and then, as he aged, kept changing the number—to forty, then fifty. "My sexual passions are not that big," Murphy said. "But that idea of waiting for something to die down, or at least go from a rolling boil to a simmer, is something I've looked forward to my whole life, and it's never happened. And I've just decided I'll just go to my grave with that thing."

His anger hadn't fully dissolved, either. "The thing that I get the most angry about is being misunderstood," he told me. "And about control—the deep wounds. Everything else—eh. But I have a very volcanic, quick temper. So sometimes I'll just be as calm as a placid lake for six weeks and, suddenly, out of nowhere, there's this roar that comes out, and it is like dropping a nuclear bomb. And I'm aware when I'm doing it, and people are"—he widened his eyes, pulled back—"plastered up against the wall. And when it's done I feel like I've released something, and I'm like, 'Let's go back to it!' And they're like, 'What?' But I've had that since I was a child. The eruptions were much more frequent. I'm not proud of it, but it's also—that's who I am."

He'd had a conflict that week with a colleague. "I'm like, 'I'm

not mad at you at all.' It's like that scene in *Mommie Dearest* where Joan Crawford yells at the maid, 'I'm not mad at you, I'm mad at the dirt.'" It disturbed him, however, that he intimidated people. "I think that they confuse my genetic coldness, being a Danish person, for scrutinizing them in some way." The higher he's climbed, the more aware he's become of how easy it is to abuse power. He told me that he's determined to raise others up, particularly those who felt as excluded as he had. He worried, sometimes, that critics were right about his early work: Perhaps it had lacked "soulfulness," and he'd gone in too hard for shock value. When I praised the filmic technique of a rape scene in *Asylum*, he told me that he would never make something like that now; becoming a father had changed his tolerance for violence. "I just don't want to put that in the world," he said.

At the same time, he knew that he wouldn't be where he was without having fought for what he wanted. "I'm very aware that if you take out your bad mood on people who have no equity you're kind of an asshole," he said. "But I also don't think you become successful, particularly in Hollywood, without having the ability to yell, loudly, 'This is not what I want!'"

Falchuk said that it had been part of his "life journey" to learn from Murphy's more assertive style of masculinity—his ability to push past resistance in order to achieve his vision. Falchuk was curious to see how the Netflix deal might change Murphy. "We still have conversations about 'feuds' and 'fatwas,' as he calls them, with people. I'm like, 'Is there a place for forgiveness? Are we at war with Eastasia?' But he needs an enemy to fuel him." Falchuk doesn't mind if his name isn't on everyone's lips. "If I was someone who did want that, I wouldn't be working with Ryan—there's no room for two of him there," he said. "I have a great life. I go home every day happy, happy, happy." Falchuk wishes only for Murphy to feel the same way: "I would love if he could enjoy his success more."

Bart Brown, Murphy's old friend, told me charming stories about Murphy at his least guarded—riffing on Melanie songs, taking road trips up the California coast. Murphy's self-confidence helped Brown fight his own self-loathing, Brown said. After years of working in Hollywood, Brown, a bohemian with a beard, has become an "intuitive"—an emotional healer. "We're surprisingly unkind to one another," he said of the gay men of L.A. "In this generation, I think we are all a little damaged." He finds it particularly wonderful to see Murphy take joy in having a family, something that once seemed like an impossible dream for gay men. "David grounds him," he said. "Which is a good thing, because his career is not slowing down."

David Miller's romance with Murphy began in 2010, nearly fifteen years into their friendship. They were both in New York at the time, and Miller asked him to dinner, saying, "I want a date." Murphy canceled his plans. "It was kind of like—I don't want to say, 'Game on,' but we knew what was up, because we'd flirted over the years," Miller told me. "We were at an age where we were both serious about wanting a relationship, wanting children."

The two had met in 1996, at a West Hollywood Adjacent restaurant called Muse, a stylish hangout for gay men during an era when people had to stay closeted at work. Bryan Lourd was often there, as was Madonna. Miller, who grew up in L.A., was awed by Murphy's swagger: He didn't care who knew he was gay. By the time they got together romantically, they'd seen each other's lowest moments. They were married, in 2012, on the beach in Provincetown, with just an officiant present. Miller has a tattoo on his calf depicting a lighthouse and the wedding date, July 4.

Miller, an athletic cowboy type, barely recognizes celebrities, and cares very much about sports. He once took Murphy to a football game; Murphy wore a Tom Ford overcoat and read *Vogue* the whole time. Miller's own path to self-acceptance ran through rehab; he hardly remembers the nineties, which, he said, is a bless-

ing. Dana Walden called Miller a "decent, soulful person" who is well matched with Murphy, in part, because he has no interest in seizing the spotlight.

The year they married, Murphy produced a Norman Lear–style sitcom loosely based on their lives, *The New Normal*, which lasted only a season, on NBC. At first, Miller was wary of having their lives portrayed. But as he watched the show—which featured their Burmese dogs and their Range Rover but only specks of their true selves—he changed his mind. In retrospect, Miller wishes that the show had been not less but *more* autobiographical, making the emotional world of one gay couple accessible to a larger audience.

Six months after they were married, they had Logan, through a birth surrogate. He is a funny, bossy, volcano-loving boy who trailed after Murphy and me during a tour of their Los Angeles house, eager to show me a view of his favorite tree. In 2015, Murphy and Miller had Ford, a quiet, watchful child. As an infant, he had trouble breathing, leading to a visit from first responders, an incident that helped inspire *9-1-1*. When Ford was eighteen months old, Miller took him for a routine checkup. The doctor found a mass the size of a tennis ball in Ford's abdomen. Miller called Murphy, who raced over.

After Murphy heard the news, he vomited, and couldn't stop all day long. He had never experienced such a loss of control. Eventually, Miller called a nurse, so that Murphy could be rehydrated. "When you hear your son has cancer, your first thought is of death," Miller said. The couple was lucky: Ford's tumor, a neuroblastoma, hadn't spread, and after surgery he didn't need radiation or chemo. But there were two anxious years of scans and follow-ups. "I'm just glad I was sober," Miller said. "I can't imagine going through it without having a clear head."

Aware of their good fortune as wealthy parents, they have funded a floor at Children's Hospital Los Angeles, which, Miller said, doesn't "turn anybody back, insurance or not." Initially, Murphy kept the story private, but then they decided that it could be

helpful to other families if they talked about it. "It just takes the stigma out of it," Miller said. "To realize, 'Oh, other people are going through this.' You see hope. Just because your child has this doesn't mean he is going to die."

Murphy's Los Angeles home, a Spanish Colonial formerly owned by Diane Keaton, has deep shelves for the art and design books—about Titian, Goya, Damien Hirst—that he consults for inspiration. In a living room, there is a Doug Aitken piece called "Buffalo"; a Keith Haring painting is mounted over Murphy and Miller's bed; an erotic Ruven Afanador photograph is tucked near the bathroom, away from the family area. Each morning, Murphy makes his bed, meticulously, a ritual that he's performed since childhood. (He often makes Logan's bed, too, because his son argued that his father has more fun doing it.) The family will soon move to the place that Murphy has been renovating—a sprawling ranch house with plenty of white space. Their current neighborhood is too central, Murphy told me: Tourist buses go by. A famous gay couple with children is a target.

Miller and I leafed through their wedding album while Murphy watched *Willy Wonka & the Chocolate Factory* with Logan. When Murphy reemerged, I proposed that we look at his father's letter, something he'd suggested doing a few days earlier. "This will be so good for your story," he said, walking to the kitchen.

At first, he couldn't find it—the envelope was buried deep in the drawer. He riffled through old photographs and DVDs as he and Miller apologized, mortified by what seemed to be the only disorganized thing in the house. Finally, Murphy pulled it out: two pages that his father had typed while in the final stages of prostate cancer.

Murphy had me read it first and describe it to him. It was a distressing experience. The letter was certainly apologetic, expressing sorrow about the distance between them, but the tone was abstract—with strange inaccuracies, like a rebuke for skipping a family wedding that Ryan said he did attend. I lir father thanked

him for the financial help that he had provided during his illness. He expressed disappointment at having not been informed when Ryan had visited Chicago, to appear on *Oprah*. He didn't mention beating Ryan as a child, but he said that he regretted not understanding Ryan's dreams, for responding to them with anger, perceiving them as personal insults.

"That's true," Murphy said. He told me a story about one of those vacation trips to Florida. While the nun snoozed in the back seat, his father asked the boys what they wanted to be when they grew up. Darren said that he wanted to be a firefighter, stay in Indiana, and always live near his mom and dad. (This came to pass, in part: Darren works as a magistrate judge in Indiana, and lives, with his family, three miles from their mother.) Ryan said that he wanted to go to Hollywood and be a star and have a mansion and never return to Indiana. His father pulled the car over and slapped him, horrifying his mother and embarrassing her in front of the nun.

Murphy looked down at the letter, as if gazing off a cliff. "If I ever had to write a letter like this to my child, I would honestly die," he said, glancing up. He had hoped that it would be a "true mea culpa," but it only made him sad: "It's all just a tragedy and a mystery." He had struggled to view his parents with compassion—as flawed people, like him, who did their best. He'd tried to maintain ties with his mother, too, to let her be a doting grandmother to his children, as Myrtle had been to him. But not all wounds heal. "It's very weird when your own parent thinks of you this way," he marveled, putting the letter down. "As if an unapproachable celebrity."

Last August, Murphy was working at home on a script for *Pose* when the news broke that Shonda Rhimes, the creator of *Scandal* and *Grey's Anatomy,* had signed a hundred-million-dollar, four-year deal with Netflix. Murphy recalled, "And my agent wrote and said,

'It is now the wild, wild West, and you have the biggest gun in town.'"

Murphy's contract at Fox was scheduled to expire this July. But, in December, Disney announced plans to buy Fox and its subsidiaries, including FX. Various corporate suitors, including Netflix and Amazon, began offering him creative freedom and riches unheard of in TV. CAA's Bryan Lourd and Joe Cohen handled the negotiations.

He chose Netflix, in part, because he was impressed by the company's vision for the medium: data-driven, global, immediate, funded by subscriptions, not ads. There was history there, too. Ted Sarandos, Netflix's chief content officer, told me that *Nip/Tuck* was the first show the service had streamed while it was still airing.

Netflix is coy about ratings, but Sarandos said that sizable "taste-based clusters" enjoyed Murphy's brand of "humor and sexiness and danger." "We're not going to ask him to round off his edges," he said. When the news broke, Twitter began to speculate. Would there be greater consistency to a Ryan Murphy series released all at once? A new pacing to a show unbroken by ads? Some questioned why his deal was three times as big as Rhimes's. I texted Murphy my congratulations. "Thank u," he texted back. "Nerve wracking and weepy." He and Miller had been celebrating at a restaurant, but he got very emotional and worried that it looked as if they were having an argument, so they left. In an email, he joked, "My Velvet Rage has suddenly been monetized."

Later, in New York, on the set of *Pose*, he told me about his tentative programming plans. Netflix needed more LGBTQ content, he said, like a glossy gay soap opera, a show in the tradition of *The L Word* but "aspirational"—"not poor people eating pad thai." He would make movies, too: He'd been talking to Julianne Moore. He was interested in documentaries, and was considering collaborating with Paltrow in "the wellness space." He said, "I would watch an entire hour about adrenal collapse." He'd be get-

ting his own row on the Netflix home page, as if he were a genre: "Sci-Fi Thrillers," "Cerebral Indies," "Ryan Murphy." He'd spent enough years in the writers' room, he told me. He loved the idea of expressing an even grander kind of creativity, like a studio head—or the pope.

A few weeks after the deal was made, Murphy, on a private plane from Los Angeles to New York, was cuddled up in a gray boiled-cashmere sweater immense enough to qualify as a trench coat, accessorized with a Georgian mourning necklace. Miller was also on the plane, sitting across the aisle; he was wearing a jaunty fisherman's cap and watching *Pose* on a laptop. Murphy kept stealing glances at him. "I'm watching him watching it," he said.

"He's up to the end of the first act," Murphy told me, as we chatted about Olivia de Havilland, who was suing him for the gossipy portrayal of her on *Feud*. (She lost the case.) He admitted that it hadn't been fun when *The Good Wife* satirized him, in an episode about the copyright-infringement case brought by Jonathan Coulton. We were returning from a momentous occasion: a staged interview with Barbra Streisand, an experience that he had found more nerve-racking than the Emmys. When Miller finished *Pose*, he told Murphy that he liked it, especially the way that the pilot dealt with the characters' vulnerability. Murphy smiled mischievously at Miller, who was lounging, his cap tipped low. "I can't take you seriously when you look like Charlotte Rampling in *The Night Porter*," he told him.

Murphy's upcoming roster had changed. The scripts for *Katrina* had been abandoned, the writers laid off; the season would now be based on Sheri Fink's book *Five Days at Memorial*. After running into Monica Lewinsky at an Oscars party, he was having second thoughts about doing her story. (Later, he had second thoughts about his second thoughts.)

A new idea had bubbled up, however, as he absorbed the #MeToo crisis. The show would be called *Consent*—potentially, a new *American Crime Story*. It would follow a *Black Mirror* model:

Every episode would explore a different story, starting with an in-
sidery account of the Weinstein Company. There would be an
episode about Kevin Spacey, one about an ambiguous he-said-she-
said encounter. Each episode could have a different creator. The
project sounded fascinating, but it had emerged at a liminal mo-
ment: Murphy was no longer fully at FX but not yet set up at Net-
flix. The Netflix deal would officially begin in July. "That's the
great thing about popes," he said later, when we talked about who
would run his old shows. "When one dies, you get a new pope."
Pose—a sweet experiment in releasing control, in opening the door
to new voices, new kinds of creators—would be his final series for
FX, whether it turned out to be a hit or a flop.

In the meanwhile, Murphy had scored a ratings bonanza with
Fox's *9-1-1*, a wackadoo procedural featuring stories like one about
a baby caught in a plumbing pipe. It was his parting gift to Dana
Walden. *Versace* had been, by certain standards, a flop: lower rat-
ings, mixed reviews. Artistically, though, it was one of Murphy's
boldest shows, with a backward chronology and a moving perfor-
mance by Criss as Cunanan, a panicked dandy hollowed out by
self-hatred. After the finale aired, a new set of reviews emerged.
Matt Brennan, on *Paste*, argued that *Versace* had been subjected to
"the straight glance"—a critical gaze that skims queer art, denying
its depths. "Even critics sympathetic to the series seem as uncom-
fortable with its central subject as the Miami cops were with those
South Beach fags," Brennan wrote.

Murphy was reading a new oral history of Tony Kushner's *An-
gels in America*, in which, in one scene, Roy Cohn denies being gay
because, he barks, homosexuals lack power: They are "men who
know nobody and who nobody knows." The line echoes one in
Versace. A homeless junkie dying of AIDS tells the cops, bitterly,
why gay men couldn't stop talking about the designer: "We all
imagined what it would be like to be so rich and so powerful that
it doesn't matter that you're gay."

In Miami, Murphy said that he disliked being labeled a gay

showrunner: "I don't think that, in the halls of Fox, I'm ever thought of as a gay person. I'm thought of as a whole, a person with responsibilities who is a businessperson and a leader and a creator." In late May, Murphy is scheduled to receive a star on the Hollywood Walk of Fame—the ultimate gratification for the boy who turned his bedroom into Studio 54. At last, he knew everybody and everybody knew him.

As the plane began a turbulent descent, a flight attendant walked down the aisle to reassure us. I made sick jokes about the plane crashing, and the kinds of headlines that would result. "Please, please, don't talk about it," Murphy said. He looked out the window, watching New York's glittering surfaces tilt back into view. He reached across the aisle, searching for Miller's hand.

ACKNOWLEDGMENTS

I am deeply grateful to my editor at *The New Yorker,* the redoubtable Willing Davidson, who kills self-indulgent adjectives on two coasts. To David Remnick, a perfect boss and a mensch. To Daniel Zalewski, Alumni Hall's greatest Madonna stan and also the editor of the three profiles in this anthology—not to mention the person I called when I was watching "The Pack."

A big thank-you to my book editor, Ben Greenberg, my guide to the insanity of publishing a book. To my agent, Suzanne Gluck, who cuts to the heart of the matter. To the whole team at Random House—Jess Bonet, Maria Braeckel, Gina Centrello, Barbara Fillon, Susan Kamil, Leigh Marchant, my publicist Dhara Parikh, Tom Perry, Molly Turpin, Andy Ward, Theresa Zoro—and especially to production editor Loren Noveck. To Adam Moss, a culture vulture mastermind. To Sue Dominus, my ally, boss, and inspiration at *Nerve;* to Jodi Kantor, who encouraged me to write about television at *Slate* and *The New York Times;* to Jared Hohlt, Hugo Lindgren, Mary Kaye Schilling, Raha Naddaf, and Lauren Kern, my editors at *New York* magazine; and to Adam Sternbergh, who is wrong about *Scrubs.* A special thank-you to the team of

fact-checkers and copy editors at *The New Yorker*, whose labors save me, improve me, and keep me honest every week (and a particular shout-out to Fergus McIntosh and Rob Liguori, who fact-checked the two new essays in this book).

To my inspiring colleagues at *The New Yorker*, among them Hilton Als, Jelani Cobb, Masha Gessen, David Grann, Patrick Radden Keefe, Ariel Levy, Kathryn Schultz, and Paige Williams. Special thanks to the wonderful Laura Miller, who gave me invaluable early feedback on "Confessions of the Human Shield," as well as A. O. Scott, Wesley Morris, Andrew Marantz, Willa Paskin, and Jia Tolentino, who questioned my assumptions in useful ways. I owe my life to Margaret Lyons, who called me out on some pretentious *narishkeit* in "The Big Picture." To Taffy Akner, Selina Alko, Christine Connor, Kirsten Danis, Tyler Foggatt, Michelle Goldberg, David Gutman, James Hannaham and the Office Hours gang, Karen Hill, Anna Holmes, Bob Kolker, Sasha Nemecek, Katha Pollitt, Lydia Polgreen, Sean Qualls, Claire Raymond, Laurie Gwen Shapiro, Rebecca Traister, Ellen Umansky, and Nancy Young, all of whom listened to me whine. To Twitter, same. To my extended family, including my father, Bernie, who loves *Outlander*, and my late mother, Toby, who helpfully observed of *M*A*S*H*'s Hawkeye Pierce, "That guy's an asshole." And to my fellow TV critics, including but not limited to Matt Brennan, Dave Fear, Mark Harris, Linda Holmes, Laurie Penny, Troy Patterson, James Poniewozik, Joy Press, Alyssa Rosenberg, Mo Ryan, Matt Zoller Seitz, Alan Sepinwall, Millicent Somer, Sonia Soraiya, June Thomas, Alissa Wilkinson, Jason Zinoman, and my friendly neighborhood auteurist nemesis, Richard Brody. (And to anyone I accidentally left out, my apologies!)

To my amazing husband, Clive Thompson, who brought me coffee and Advil and saw me through multiple brainstorms and breakdowns. He is extremely metal in all senses.

A final acknowledgment to Maria Salazar, who I wish was around to see what's on TV today.

INDEX

A

ABC, 40, 89, 196–98, 211, 223, 224, 226, 232, 233, 244
Abrams, J. J., 26, 214, 305
Access Hollywood tape, 141, 166–67
Acosta, Jim, 170
"Across the Sea" (*Lost*), 196
Adams, Jane, 205
Adlon, Pamela, 136, 140–42, 145
Adventure Time, 187–91
Adventures of Ozzie and Harriet, The, 126
Alexander, Jason, 231
Alexander, Scott, 336
Ali, Shahrazad, 122–23
Alias, 214, 263
All Good Things, 270–71, 273
All in the Family, 36–47, 178
All My Children, 211–12
Allen, Woody, 62, 65, 67, 72, 100, 107–10, 112, 121, 123, 128–32, 136, 141–42, 149, 154, 157

Ally McBeal, 26, 50
Almodóvar, Pedro, 293
Amazing Race, The, 82
Amazon, 98, 181, 205, 262, 294–95, 345
AMC, 182, 185
American Beauty, 92
"American Bitch" (*Girls*), 139, 149–50
American Black Film Festival, 242–44
American Crime Story, 244, 316
American Crime Story: The Assassination of Gianni Versace, 313–16, 318, 337, 347
American Crime Story: Consent, 346–47
American Crime Story: Katrina, 315, 316, 318, 346
American Crime Story: The People v. O. J. Simpson, 334, 336–37
American Express, 219, 221
American Horror Story, 46, 105, 251, 291, 315, 316, 321–22, 327
American Horror Story: Asylum, 321–22, 339, 340

American Horror Story: Coven, 327, 329

American Princess, 288, 294, 300, 303

American Psycho (Ellis), 117

Americans, The, 61, 105, 275–78

America's Next Top Model, 230

Amos, John, 241

Anderson, Anthony, 224, 240–41, 247, 248

Anderson, Gillian, 61, 254

Animal House, 130

Annie Hall, 112, 130

Apatow, Judd, 46, 92, 220, 246

Apple, Fiona, 75, 129

Archer, 187

Archie & Edith, Mike & Gloria (McCrohan), 39

Ariano, Tara, 18

Arquette, Patricia, 92, 258

Arrested Development, 212

"Art and Life" (*Easy*), 206

"As I Listened to Archie Say 'Hebe' . . ." (Hobson), 42

"As I Read How Laura Saw Archie" (Lear), 42

Ashby, Hal, 323

Aslan, Reza, 193

Asner, Ed, 258

Atlanta, 126

Atwood, Margaret, 116

Austerlitz, Saul, 37, 46

B

Backyards, 288, 303

Bad Behavior (Gaitskill), 75

Bad Fan Theory, 36, 38

"Bad Timing" (*Adventure Time*), 190

Baker, Dylan, 183

Bakula, Scott, 268

Baldwin, Alec, 213

Bale, Miriam, 335

Ball, Alan, 26

Ball, Lucille, 78, 178

Bamford, Maria, 142

Bananas, 107, 112

Banhart, Devendra, 215

Banks, Tyra, 230, 232, 242

Banshee, 61

Barbershop: The Next Cut, 243

Barr, Roseanne, 78

Barris, Beau, 223, 225–28

Barris, David, 237

Barris, Kaleigh, 227–28, 248

Barris, Kass, 223, 227, 228

Barris, Kenya, 126, 223–48

Barris, Leyah, 227, 248

Barris, Patrick, 238

Barris, Rainbow, 223, 224, 227–32, 234, 238, 242–43, 246

Barris, Tina, 229–30, 237–39, 242, 245, 247

Barthes, Roland, 17

Baryshnikov, Mikhail, 54

Basic Instinct, 117

Bassett, Angela, 321

Bates, Kathy, 321

Baumgold, Julie, 68

BBC, 60, 178, 209

Beasts of No Nation, 243

Beavis and Butt-Head, 189

Becky, Dave, 138, 150

Bee, Samantha, 161

"Beginning to See the Light" (Willis), 145

Behind the Candelabra, 265–69

Benny, Jack, 67, 213–14

Berg, Amy, 271

Bergen, Candice, 55

Berle, Milton, 4

Berman, Susan, 272

Bernie Mac Show, The, 233

Best of Everything, The (Jaffe), 75–76

BET, 229, 242

Better Things, 136, 142

Between the World and Me (Coates), 226

Beverly Hills 90210, 18

Bewitched, 37

Beyoncé, 81, 84, 248
Big Brother, 17, 85
Big Little Lies, 149
Billings, Alexandra, 320
Bisexual, The, 149
black-ish, 126, 198, 201, 223–27, 231–45, 247
Black Lives Matter, 226, 293
Black Mirror, 167–69, 196, 205, 346
Blackman's Guide to Understanding the Blackwoman, The (Ali), 123
Blair, Elaine, 78
Blasucci, Dick, 207–8, 222
Blichfeld, Katja, 203, 204
Bloom, Rachel, 83
Boardwalk Empire, 57
Bob's Burgers, 187
Boe, Eugene, 67
BoJack Horseman, 20, 173, 187
Bonanza, 37
Bones, 290
Boosler, Elayne, 69
Borstein, Alex, 99
Boss, 88
Bowser, Yvette Lee, 235, 241
Bradford, Patricia, 69
Bravo, 17, 81, 218
Breaking Bad, 36, 38, 278, 286
Breitbart, 164–65, 168
Brennan, Ian, 336
Brennan, Matt, 347
Brenneman, Amy, 193
Brent, David, 176
Brettler, Linda, 289
Bright, Susie, 117
Bright-Sided: How Positive Thinking Is Undermining America (Ehrenreich), 200
Brinkley, Christie, 70
Broad City, 95, 101, 149, 244
Broadway Danny Rose, 112
Brooks, Danielle, 204, 290, 301
Brooks, Mel, 159
Brosnahan, Rachel, 98, 99, 101

Brothers in Atlanta, 246
Brown, Bart, 325, 332, 341
Brown, Helen Gurley, 62, 71
Brown, Jasmin Savoy, 195
Brown, John Mason, 5
Bruce, Lenny, 64, 66–67, 98, 101
Buffy the Vampire Slayer, 3, 4, 6–13, 21, 26, 220, 260, 263–64
Bunheads, 100
Bunting, Sarah D., 18
Burgess, Tituss, 103
Burrows, James, 178
Burton, Susan, 289
Bush, Billy, 166
Bushnell, Candace, 51

C

Caesar, Sid, 178
Califia, Pat, 117
Californication, 179–80
Call the Midwife, 101, 149
Camil, Jaime, 173
Campbell's soup, 211–12
Campion, Jane, 22, 60, 293
Canals, Steven, 318, 326–28, 332, 334
Capturing the Friedmans, 272
Caramele, Kim, 93
Carlock, Robert, 102, 103, 217
Carmichael, Jerrod, 244
Carmichael Show, The, 244
Carnal Knowledge, 320
Carol Burnett Show, The, 283
Carroll, Kevin, 195
Carson, Johnny, 37, 64, 65, 67, 69–70, 72
Carter, Chris, 26
Cartoon Network, 187
Catfish, 272
Cattrall, Kim, 50
CBS, 36, 37, 40, 41, 168, 181, 182, 231, 285
Chaiken, Ilene, 212
Chappelle, Dave, 246
Charis Books, 123, 124, 148

Charles, Josh, 92, 182, 184
Charlie Rose, 6, 7, 15, 19
Chase, David, 11, 25, 26, 27, 29–31, 35, 38, 48, 54, 208, 306, 335
Chef's Table, 288–89
Cher, 331
Chewing Gum, 142, 149
Chocolate Babies, 216
Chu, Arthur, 106
C.K., Louis (see Louis C.K.)
Claws, 101, 149
Clay, Andrew Dice, 160
Cleage, Pearl, 122–24, 127–28, 148
Cleaver, 38
Clinton, Hillary, 160, 162, 163, 167
Close, Glenn, 317
Closer, The, 218
CNN, 170
Coates, Ta-Nehisi, 76, 226
Cochran, Johnnie, 337
Coel, Michaela, 142
Coen, Ethan, 109
Coen brothers, 322
Cohen, Andy, 177
Cohen, Jaffe, 336
Cohen, Joe, 336, 345
Cohn, Roy, 347
Colbert, Stephen, 168, 215
Coll, Ivonne, 175
"College" (The Sopranos), 10, 35
Color by Fox (Zook), 229
Colter, Mike, 261
Comeback, The, 176–80
Comedy Cellar, 141
Comedy Central, 91, 233, 246, 281
Community, 178
Condon, Bill, 331
Confederate, 291
Coogler, Ryan, 243
Coon, Carrie, 194
Cooper, Dennis, 115
Cooper, Gary, 28
Coppola, Francis Ford, 11
Corbett, John, 52

Cosby, Bill, 43, 67, 72, 100, 111, 125–27, 141, 142, 148, 238, 264, 292
Cosby Show, The, 125–27, 142, 224, 229, 247
Coulton, Jonathan, 262, 337, 346
Cox, Laverne, 287
Craig, E. Langston, 239
Crawford, Joan, 316, 340
Crazy Ex-Girlfriend, 83, 101, 149
Creed, 243
Criss, Darren, 314, 347
Cronenberg, David, 250
Cubitt, Allan, 60
Cummings, Whitney, 95
Cunanan, Andrew, 314, 337, 347
Curb Your Enthusiasm, 176, 197
Cuse, Carlton, 305–6, 308–11
Cutkosky, Ethan, 258
CW, The, 83, 171, 174

D

Damages, 57
Damon, Matt, 266, 268
Dancy, Hugh, 250–51
Dangerfield, Rodney, 159
Dark Shadows, 323
David, Larry, 79, 176
Davis, Bette, 316
Davis, Hope, 258
Davis, Judy, 130–31
Davis, Kristin, 50
Davis, Miles, 123–24, 128
Davola, Joe, 214–15
Dawson's Creek, 17–18, 319
Days and Nights of Molly Dodd, The, 290
De Havilland, Olivia, 346
de Man, Paul, 42
Deen, James, 264
Deliver Us from Evil, 271
Denbo, Jamie, 288
"Derech" (High Maintenance), 206
Dern, Laura, 79
Desmond, Norma, 335

Desperate Housewives, 211

Devil You Know, The, 287

Dexter, 250

Di Loreto, Dante, 338

Dick, Philip K., 205

Dick Van Dyke Show, The, 178

Dietland, 149

Different World, A, 125, 127, 228, 229

Diggs, Taye, 185

Diller, Phyllis, 93

Dingess, Chris, 214

DirecTV, 208

Disney-ABC Television Group, 226–27, 345

Divorce American Style, 39

Dr. Horrible's Sing-Along Blog, 221

Dodd, Molly, 50

Dolezal, Rachel, 291

Dollhouse, 220

Doucet, Julie, 95

Douglas, Michael, 267

Drennan, Daniel, 18

Du Bois, W.E.B., 230

Duchovny, David, 179

Dumont, Margaret, 47, 167

Dumplings, The, 23

Dungey, Channing, 227

Dunham, Lena, 38, 63, 72, 74–76, 78, 95, 139, 142, 150

Duplass Brothers, 205

Durst, Kathie, 270, 272

Durst, Robert, 270–74

DVDs and DVRs, 4, 13, 88, 220

Dworkin, Andrea, 113–14, 116, 117, 122

Dynasty, 113

E

"E Unibus Pluram: Television and U.S. Fiction" (Wallace), 19

"Earshot" (*Buffy the Vampire Slayer*), 9

Easy, 205–6

ECHO, 18

Ed Sullivan Show, The, 67

Ehrenreich, Barbara, 200

Ehrlichman, John, 44

Elba, Idris, 243

"Elder Sister, The" (Olds), 73

Electric Company, The, 3

Electric Dreams, 205

Ellis, Bret Easton, 117, 269

Ellis, Jay, 247

Emmy Awards, 14, 98, 182, 212, 282, 287, 313, 336

Empire, 244

Enlightened, 74, 79–80

Enter Talking (Rivers), 66, 69, 70, 72

Entertainment Weekly, 92, 217, 331

Entourage, 100, 179, 300

Ephron, Nora, 93, 101

ER, 7

Esparza, Raúl, 249, 258

"Establishment Conservative's Guide to the Alt-Right, An," 164

Etheridge, Melissa, 148

Everybody Hates Chris, 232

Everybody Loves Raymond, 210

F

Facebook, 144, 168, 227, 294

Falchuk, Brad, 318, 321, 326, 329, 332, 338, 340

Fall, The, 60–61, 105

Fallon, Jimmy, 70, 245

Falwell, Jerry, 114

Family Guy, 46

Fargo, 182, 322

Farquhar, Ralph, 229

Farrow, Dylan, 108–10

Farrow, Mia, 108, 109, 121, 130

Fashion Police, 72

Fat Albert and the Cosby Kids, 126

Father Knows Best, 126, 178

FCC (Federal Communications Commission), 23, 169, 210, 215

Felicity, 17, 214

Female Trouble, 313

Feud, 316, 336, 346

Fey, Tina, 92, 102, 103, 106, 212, 215, 217, 219, 220

Fields, Totie, 69

Fiennes, Joseph, 320

Film Noir, 229

Fincher, David, 87, 89, 90, 323

Finding Me (Knight), 104

Fine Brothers, 307, 308

Fink, Sheri, 346

Finley, Karen, 115

Firefly, 18, 220

Fishburne, Laurence, 226, 237, 239, 241

Fisher, Carrie, 324

Five Days at Memorial (Fink), 346

Flahive, Liz, 288, 296, 297

Fleabag, 142, 149

Flynn, Gillian, 57

Flynn, Neil, 198

Following, The, 257

Fonda, Jane, 71

Fontana, Tom, 26, 213–14, 221

Ford Motor Company, 214

Fosters, The, 105

Four Arguments for the Elimination of Television (Mander), 6

Fox, 18, 69, 126, 158, 160, 170, 207, 220, 229, 244, 316, 320, 337, 345, 347

Foxx, Jamie, 243

Foxx, Redd, 291

Franzen, Jonathan, 6, 15

Free to Be . . . You and Me, 84

Freedom of the Press Award, 43

Fresh Off the Boat, 198

Fresh Prince of Bel-Air, The, 229, 279–81

Friday Night Lights, 194

Friedlander, Judah, 219–20

Friends, 177, 285, 292

Fruitvale Station, 243

Fukunaga, Cary Joji, 57

Fuller, Bryan, 251

Funny Girl, 323

FX, 23, 61, 141, 142, 182, 233, 314, 316–20, 322, 333, 334, 345, 347

G

Gadsby, Hannah, 151–56

Gaitskill, Mary, 75, 115

Game, The, 230

Game of Thrones, 8, 59, 105, 255

Gandolfini, James, 27, 30, 32

Garner, Julia, 277

Gates, Henry Louis, Jr., 224

Gay, Roxane, 301

Geimer, Samantha, 119, 121

Gellar, Sarah Michelle, 7

Gene Kelly: An American in Pasadena, 283

Gentleman's Agreement (Hobson), 42

Getting Even (Allen), 107

Getting On, 103

Giamatti, Paul, 91, 95

"Gift of Hunger, The" (*black-ish*), 241–42

Gilmore Girls, 26, 100, 285

Girl, The (Geimer), 121

Girl Most Likely To . . . , The, 66

Girlfriends' Guide to Divorce, 298

Girls, 46, 63, 74–79, 103, 139, 142, 148–50, 204, 233, 286

Glamour magazine, 116

Glazer, Ilana, 95

Glee, 46, 314, 316, 319, 320–21, 325–26, 328–29, 333, 336, 337

"Globo" (*High Maintenance*), 202

GLOW, 101, 149, 288, 290, 295–97, 303

Godfather, The, 11, 26

Gods and Monsters, 331

Goldbergs, The, 198

Goldblum, Jeff, 95

Golden Girls, The, 49

Good Girls Revolt, 262

"Good-ish Times" (*black-ish*), 234, 239, 248

Good Times, 231, 234, 240, 241, 243

Good Trouble (Noxon), 298

Good Wife, The, 59, 181–86, 261, 346

Goodbye, Columbus (Roth), 68

GoodFellas, 26, 27

Goodman, Dana Min, 137–39, 143, 150

Gore, Tipper, 115

Gosling, Ryan, 270

Gossip Girl, 209, 287

Grace, Nancy, 256

"Grandpa" (*High Maintenance*), 202

Grantland, 58

Green Acres, 40

Greenblatt, Bob, 286

Greenwald, Andy, 58

Grey's Anatomy, 300, 344

Grobglas, Yael, 173

Groff, Jonathan, 233, 235, 236, 242, 248, 338

Grossman, Leslie, 319

Group, The (McCarthy), 75

"Guest" (*The Leftovers*), 194–195

H

Haldeman, H. R., 44

Hale, Mike, 321–22

Half, 317

Hall, Regina, 236

Handler, Chelsea, 95

Handmaid's Tale, The (Atwood), 116

"Hang the DJ" (*Black Mirror*), 205

Hannibal, 46, 249–54, 257

Happy Endings, 233

Happy Valley, 149

Hargitay, Mariska, 255, 258

Harmon, Dan, 178

Harrelson, Woody, 57–59

Harris, Neil Patrick, 221

Harris, Thomas, 250, 252

Hawley, Noah, 322

Haynes, Todd, 80

Hayworth, Rita, 289

Hayworth Theatre, Los Angeles, 289

HBO, 10, 13, 25, 48, 49, 55, 56, 75, 79, 88, 141, 176, 177, 179, 182, 192, 203–5, 246, 265, 270, 273, 285, 2 291, 322, 336, 337

Head, Tony, 7

Heaton, Patricia, 197

Heder, Sian, 290, 296

Heisler, Eileen, 200

Heline, DeAnn, 200

Hemingway, Mariel, 130

Henderson, Felicia D., 229

Henie, Sonja, 267

Herdman, Lisa, 217–19

Herrmann, Tara, 289–91, 294

Herzog, Werner, 273

Hickey, Dave, 265

Hicks, Bill, 7

High Maintenance, 196, 202–6

Hill Street Blues, 5

Hines, Cheryl, 197

Hirst, Damien, 210

Hitchcock, Alfred, 128, 293

Hitler, Adolf, 164

Hobson, Laura Z., 42, 43

Hoffman, Dustin, 111

Holden, Nate, 230

Holden, Stephen, 10

Holland, Cindy, 302

Holland, Tom, 318

Holofcener, Nicole, 80

Home Depot, 211

Homeland, 184, 259

Homicide: Life on the Street, 7, 57, 213

Honeymoon Motel, 109–10

Honeymooners, The, 40, 41

"Hope" (*black-ish*), 223–28, 241, 244, 247, 248

Horace and Pete, 136, 146–47

Hotwives of Orlando, The, 86

House of Cards, 59, 87–90, 105, 184

House of Lies, 57

How to Get Away with Murder, 105

Howard, Silas, 327, 333

Howard Stern Show, The, 62–63

Hudson, Rock, 266

Hughes, John, 130

u, 181, 8613
nger (Gay), 301
Husbands and Wives, 130–31

I

"I Can't Fight This Feeling" (*One Mississippi*), 150
I Love Dick, 149
I Love Lucy, 178
I Love You, Daddy, 142–43
I Spy, 126
In Living Color, 229, 233
Insecure, 149, 247
Inside Amy Schumer, 91–96
Intercourse (Dworkin), 117, 126
It's Always Sunny in Philadelphia, 46
Ivey, Judith, 259

J

Jack Benny Show, The, 213–14
Jack Paar Tonight Show, The, 66
Jackson, Cheyenne, 268
Jackson, Dominique, 329, 332
Jackson, Michael, 284
Jacobson, Abbi, 95
Jacobson, Nina, 336
Jaffe, Rona, 75
Jaffrey, Sakina, 89
Jane the Virgin, 101, 149, 171–75
Jarecki, Andrew, 270–74
Jay Z, 248
Jeffersons, The, 37
Jessica Jones (see *Marvel's Jessica Jones*)
Jinx, The, 270–74
Joan Rivers: A Piece of Work, 64
Joe Millionaire, 82, 220
Johnson, Chuck, 165
Johnson, Joyce, 76–77
Johnston, Kristen, 55
Jones, Alex, 168
Jones, Dot-Marie, 320

Jones, Nick, 290, 296
Journal of Communication, 43
Justice for All, 40

K

Kael, Pauline, 17, 129
Kaling, Mindy, 95, 233
Kane, Carol, 103
Karaszewski, Larry, 336
Karr, Mary, 147
Kartheiser, Vincent, 95
Kavanaugh, Brett, 156
Kavner, Julie, 101
Kazan, Elia, 42
Keaton, Diane, 130, 342
Kelley, David E., 26
Kelly, Gene, 284
Kelly, Grace, 323
Kelly, Megyn, 161
Kemper, Ellie, 103
Kennedy, Flo, 93
Kennedy, John F., 44
Kerman, Piper, 286, 293
Kerouac, Jack, 76
King, Martin Luther, Jr., 224
King, Michael Patrick, 176, 177
King, Michelle, 182–84
King, Regina, 195
King, Robert, 182–84
Kinison, Sam, 168
Kirby, Luke, 98
Kirkman, Jen, 137
Klein, Jessi, 93, 142
Knick, The, 251
Knight, Michelle, 104
Koenig, Sarah, 271, 272
Kohan, Buz, 283
Kohan, Jenji, 181, 279–304, 313, 336
Kohan, Rhea, 283–84
Kohen, Yael, 69
Kolitz, Daniel, 147–48
Kominsky-Crumb, Aline, 95, 136

Kovaleski, Serge, 160–61
Krakowski, Jane, 103
Kramer, Larry, 337
Kubrick, Stanley, 250
Kudrow, Lisa, 176, 177, 180
Kukly, 169
Kushner, Tony, 347
Kuzmich, Hans, 326

L

L Word, The, 212, 345
Ladies (Murphy), 317
Lady Dynamite, 142, 149
Landgraf, John, 23, 320, 334, 338
Lange, Jessica, 316, 318, 321, 331
Larry Sanders Show, The, 284
Lasser, Louise, 45
Lassie, 40
Lauer, Matt, 128
Law & Order, 105, 256
Law & Order: Special Victims Unit, 255–59
Lear, Herman, 39, 40
Lear, Norman, 16, 23–24, 36–46, 126, 201, 227, 231, 243
Leder, Mimi, 193
Lee, Paul, 226–27
Lee, Spike, 228–29, 244
Leftovers, The, 14, 22, 192–96, 244, 251
Legends of Chamberlain Heights, 281
Lehrer, Tom, 65
Leibovitz, Annie, 330
Leight, Warren, 257
Lemonade, 81, 84
Leno, Jay, 70
Leonard, John, 41
Lerner, Gail, 235
Lestrade, Jean-Xavier de, 271
Letterman, David, 65
Levi's, 210
Levitan, Steve, 247
Lewinsky, Monica, 316, 346

Lewis, Jenifer, 226, 241
Lewis, Jerry, 73
Lewis, Joe, 295
Lewis, Juliette, 130
Leyner, Mark, 6
Liberace, Wladziu "Lee," 265–69
Life, 41
Lifestyles of the Rich and Famous, 113
Lifetime channel, 86, 105, 256, 300
Like Family, 230
Lindelof, Damon, 193, 196, 244, 305–12
Lionsgate, 285–86
Listen Up, 231, 232
Literal Hitler, 164
Living Single, 235
Livingston, Jennie, 317, 328
Lost, 26, 193, 196, 287, 305–12
Louie, 103, 135–37, 140–43, 145–47, 149, 150, 152, 196
Louis C.K., 79, 135–47, 149–51, 153, 156, 333
Louis-Dreyfus, Julia, 92
Lourd, Billie, 332
Lourd, Bryan, 332, 341, 345
Low Winter Sun, 185
Lowe, Rob, 268
Lucky Louie, 141
Lynch, David, 250
Lynch, Jane, 99

M

Mabley, Moms, 95
MacFarlane, Seth, 46
MacKinnon, Catherine, 113–14
Mad About You, 285
Mad at Miles: A Blackwoman's Guide to Truth (Cleage), 122–24, 128
Mad Men, 13, 105, 166, 209, 214, 255, 287, 299
Madison Road, 208, 211
Madonna, 70, 317, 328, 338, 341
MADtv, 207–8, 212, 222, 280

Mailer, Norman, 68, 75, 129, 155
Malin, Mike "Boogie," 85–86
Mander, Jerry, 6
Manhattan, 108, 112, 130–32, 142
Mann, Michael, 250
Manne, Kate, 139
Mansfield, Stephanie, 330
Manson, Charles, 120
Mara, Kate, 89
Margulies, Julianna, 182
Maron, Marc, 159
Martha Raye Show, The, 39
Martin, Brett, 48–49, 51
Martin, Jeff, 231
Martin, Trayvon, 227
Marvelous Mrs. Maisel, The, 97–101, 149
Marvel's Jessica Jones, 149, 260–64
Marx, Groucho, 167
Mary Hartman, Mary Hartman, 19, 23, 45–46, 173
Mary Tyler Moore, 51
*M*A*S*H**, 3, 43
Master of None, 205, 246
"Material Girl," 113
Maude, 37
May, Elaine, 65, 109
Mayron, Melanie, 173
Mbatha-Raw, Gugu, 205
McBrayer, Jack, 197
McCain, John, 161
McCarthy, Mary, 75
McConaughey, Matthew, 57, 58
McCrohan, Donna, 39
McDermott, Charlie, 199
McGee, Ryan, 90
McGrath, Chip, 7
Mee, Charles L., 67
Mehrhof, Barbara, 118–19
Meloni, Christopher, 256, 257
Men Are Stupid . . . and They Like Big Boobs (Rivers), 72
Mendez, Anthony, 172
Mensch, Carly, 288, 296, 297
Metcalf, Laurie, 146, 147

#MeToo movement, 107, 110, 121, 128–29, 143, 144, 148, 153, 333, 346
Miami Herald, The, 330, 331
Middle, The, 197–201
Mikkelsen, Mads, 250
Miller, David, 315, 341–43, 345, 346, 348
Mindhunter, 338
Mindy Project, The, 149
Minear, Tim, 321, 329, 338
Minkowitz, Donna, 117
Minor Characters (Johnson), 76–77
Minow, Newton, 17, 44
Miramax, 317
Miranda, Lin-Manuel, 83
Mr. Robot, 244
Miyazaki, Hayao, 189
Mock, Janet, 326, 328, 332–34
Modern Family, 198, 225, 237, 247
Moesha, 229
Mommie Dearest, 335, 340
Monaghan, Michelle, 58
Monty Python, 3, 178
Moore, Adrienne, 301
Moore, Julianne, 345
Moore, Mary Tyler, 50
Morelli, Lauren, 290–91
Morgan, Robin, 115
Morgan, Tracy, 213
Morris, Errol, 271
Morris, Wesley, 148
Morrison, Jim, 32
Moss, Adam, 25
Moss, Carrie-Anne, 261
MTV, 212
Mulgrew, Kate, 301
Mulholland Drive, 189
Murder House, 321
Murdoch, Rupert, 169
Murphy, Andy, 323–25, 344
Murphy, Darren, 315, 323, 330, 344
Murphy, Eddie, 128
Murphy, Ford, 315, 342
Murphy, Jim, 315, 319, 323–26, 334, 343–44

Murphy, Logan, 315, 342, 343
Murphy, Ryan, 46, 288, 291, 313–48
Murphy Brown, 50
Murrow, Edward R., 6
Mutchnick, Max, 283
My Neighbor Totoro, 189
My So-Called Life, 5

N

NAACP (National Association for the
 Advancement of Colored People),
 229
Nanette, 151–56
Nanjiani, Kumail, 95
Nasser, Latif, 288
National Urban League, 43
NBC, 69, 103, 178, 218, 229, 230, 244,
 249, 251, 255, 256, 279, 342
Neeson, Liam, 130–31
Nestle, Joan, 117
Netflix, 13, 23, 24, 60, 87–88, 103, 153,
 174, 181, 205, 281, 286–88, 290, 294,
 302, 316, 317, 340, 344–47
New Adventures of Old Christine, The, 211
New Normal, The, 342
New York magazine, 13, 25, 64, 68, 74,
 132, 135, 207
New York Times, The, 10, 13, 41, 42, 59,
 67, 68, 108, 118, 142, 143, 148, 201,
 287, 307, 321–22, 332
New York Times Book Review, The, 15, 78
New York Times Magazine, The, 7
New Yorker, The, 6, 13, 16, 36, 48, 56, 62,
 74, 81, 87, 91, 97, 102, 108, 129,
 139, 158, 171, 176, 181, 187, 192,
 197, 202, 223, 249, 255, 260, 265,
 270, 275, 279, 313
New Yorker Radio Hour, The, 153
Newsweek, 169
Nichols, Mike, 320, 323
Nielsen Media Research, 210, 211
Nietzsche, Friedrich, 58, 61, 252
Night of 100 Stars, 283

Nike, 209
9-1-1, 316–17, 342, 347
Nip/Tuck, 316, 319–20, 338, 345
Nixon, Cynthia, 50
Nixon, Richard, 41, 44
Normal Heart, The, 337
Norman Lear Achievement Award, 319,
 339
Nostradamus, 145
Notaro, Tig, 93, 136, 142, 150
Noth, Chris, 51
Noxon, Charlie, 283, 285, 295–96
Noxon, Christopher, 281–83, 285,
 297–98, 300
Noxon, David, 283–85
Noxon, Eliza, 283, 295, 297, 298
Noxon, Jono, 283, 284
Noxon, Marti, 212, 298
Noxon, Oscar, 282, 287, 295
Nurse Jackie, 288

O

Obama, Barack, 159, 164, 167, 226, 247,
 248
Obama, Michelle, 224, 226
O'Brien, Conan, 70
O'Connor, Carroll, 37, 38, 40–41, 43
Office, The, 19, 53, 103, 176, 211, 282
O'Hare, Denis, 258
Olds, Sharon, 73
Oliver, John, 161
On Our Backs magazine, 117
Onassis, Jackie, 72
One Day at a Time, 24, 174
One Flew Over the Cuckoo's Nest, 317
One Mississippi, 142, 149, 150
One Tree Hill, 214–15
Open, 336
Orange Is the New Black, 14, 46, 149, 181,
 204, 233, 279, 281–83, 286–96,
 298–303, 336
Orth, Maureen, 109
Oscars, 243

Our Lady J, 292, 326
Out, 269
Outlander, 105
Outline, The, 147
OWN, 243
Oz, 213, 255, 256

P

"Pack, The" (Buffy the Vampire Slayer), 8, 15, 22
Paiz, Carolina, 288, 303
Paley, Grace, 157, 206
Paltrow, Gwyneth, 332, 345
Paradise Lost, 271
Paramount Writers Program, 229
Paris Is Burning, 317, 327, 328, 332
Parker, Mary-Louise, 281, 286
Parker, Posey, 136
Parker, Sarah Jessica, 51
Parker, Trey, 161
Parks and Recreation, 79, 103
Paulson, Sarah, 317, 319, 321, 338–39
Peery, John E., 204
PEN15, 149
People magazine, 70
Perrotta, Tom, 193, 195
Perry, Jeff, 90
Perry, Tyler, 243
"Persistence of the Jewish American Princess, The" (Baumgold), 68
Peterson, Michael, 271, 272
Phair, Liz, 75
Phantom Teleceiver, 4
Phil Donahue Show, The, 43
Philadelphia Inquirer, The, 125
Picasso, Pablo, 128, 153–55
Pizzolatto, Nic, 57
Plath, Sylvia, 75
Platt, Ben, 317
Playboy magazine, 23, 24, 37
Please Like Me, 151
Pleasure and Danger (anthology), 118
Plug-In Drug, The (Winn), 6

Plus One (Noxon), 297–98
Podhoretz, Norman, 75
Polanski, Roman, 119–22, 132, 154
Politician, The, 317, 335
Pollack, Sydney, 131
Poole, Christopher, 164
Popular, 319, 320
Pose, 313, 317–19, 326–28, 332–37, 345–47
Postcards from the Edge (Fisher), 324
Powell, Keith, 219
Pretty/Handsome, 320
Previn, Soon-Yi, 110
Private Practice, 212
Producers, The, 159, 169
Producers Guild of America, 319
Project Runway, 209
Purple Rose of Cairo, The, 110, 112
Pushing Daisies, 251
Putin, Vladimir, 169, 170

Q

"Qasim" (High Maintenance), 196
Queen Sugar, 149
Quinto, Zachary, 321

R

Rabe, Lily, 316
Radner, Gilda, 65
Rae, Issa, 247
Rajskub, Mary Lynn, 179
Ramírez, Edgar, 314
Ratched, 317
Ratner, Brett, 128
Ray Donovan, 57
Reagan, Nancy, 113
Real Housewives franchise, 62, 81–83, 335
Real Housewives of Beverly Hills, The, 82
Real O'Neals, The, 198–99
Reaper, 214
Rectify, 196
Refusing to Be a Man (Stoltenberg), 116
Reiner, Carl, 178

exage363

Reiner, Rob, 40

Rejuvenile: Kickball, Cartoons, Cupcakes, and the Reinvention of the American Grown-up (Noxon), 297

Relatively Speaking, 109

Ren & Stimpy Show, The, 189

Returned, The, 196, 251

Rhimes, Shonda, 87, 89, 90, 233, 244–45, 287, 288, 300, 303, 323, 344–45

"Rhinestone as Big as the Ritz, A" (Hickey), 265

Rhys, Matthew, 149, 276

Rice, Tamir, 225

Rickles, Don, 160

Riddle, Diallo, 245–46

Ridley, John, 244

Riefenstahl. Leni, 131

Rihanna, 318

Rittenband, Laurence, 121

Ritter, Krysten, 260

Rivers, Joan, 62–73, 98–100

Roc, 229

Rock, Chris, 232

Rodriguez, Gina, 171

Rogen, Seth, 177

Rohmer, Éric, 130

Rokeach, Milton, 43

Roman (Polanski), 120–21

Romano, Ray, 78

Room 104, 205

Rooney, Mickey, 40

Roseanne, 125, 200

Rosemary's Baby, 119, 121–22, 150, 321

Rosen, Charles, 215–16

Rosenberg, Edgar, 64, 69, 72

Rosenberg, Melissa, 263

Rosenthal, Phil, 210

Ross, Diana, 241

Ross, Tracee Ellis, 224, 241

Roth, Philip, 68, 76, 128, 136

Rotten, Johnny, 145

RuPaul, 327

RuPaul's Drag Race, 327

Russell, Keri, 276

Russian Doll, 149

Ryan Murphy Television, 338

S

Sahl, Mort, 67, 72

Saji, Peter, 236

Salahuddin, Bashir, 245–46

Sandusky, Jerry, 258

Sanneh, Kelefa, 14

Sarandon, Susan, 316

Sarandos, Ted, 345

Saturday Night Live, 93, 156, 169, 207, 212

Saturday Review, 42

Scandal, 13, 59, 87, 89–90, 105, 148–49, 233, 259, 286, 344

Schlafly, Phyllis, 114

School Daze, 228

Schumer, Amy, 91–96, 142

Schwahn, Mark, 214

Scorsese, Martin, 59

Scott, A. O., 59

SCTV, 3, 65

SCUM Manifesto, 93

"Second Opinion" (*The Sopranos*), 31

Seinfeld, 5

Seinfeld, Jerry, 69, 78, 159

Serenity, 220

Serial, 271, 272

7th Heaven, 210

Severson, Jak, 211

Sex and the City, 12, 48–55, 49, 177, 285

Sex Pistols, 145

Shaffer, Atticus, 199

Shandling, Garry, 284

Sharp Objects, 149

Sharpton, Al, 244

Shaw, Frankie, 142

Shepard, Devon, 279–81, 290

Sher, Eden, 199

Sherman-Palladino, Amy, 26, 98, 100

Sherwood, Ben, 227

Shield, The, 285, 296

Shields, Brooke, 171, 173, 201

Short, Martin, 106
Showtime, 179, 229, 285–86
Shrill, 149
Shue, Elizabeth, 206
Side Effects (Allen), 107
Silence of the Lambs, The, 117, 250
Silverman, Sarah, 95, 153
Simon, Neil, 210
Simpsons, The, 3, 189, 231
Sinbad Show, The, 229
Sinclair, Ben, 203, 204
Sitcom: A History in 24 Episodes from I
 Love Lucy to Community
 (Austerlitz), 37, 46
Slate, 27, 106
SMILF, 142
Smith, Tom Rob, 337
Smith, Will, 229, 280
Snapple, 213, 216, 217
Soap, 19
Socrates, 44
Soderbergh, Steven, 265, 266, 268, 269,
 293
Solanas, Valerie, 93
Soloway, Jill, 142, 181, 244, 287, 292, 323,
 327
Sonoiki, Damilare, 235, 245
Sons of Anarchy, 255
Sopranos, The, 10–13, 25–35, 48, 49, 54,
 208, 255, 278, 285, 305, 322
Sorkin, Aaron, 26, 306
Soul Food, 229, 230
South Central, 229
South Park, 161–63, 165, 169, 170
SoyJoy, 217–19, 221
Spacey, Kevin, 87, 88, 311, 347
Speight, Johnny, 39
Spicer, Sean, 170
Spielberg, Steven, 323, 331, 332
Spike, 212
Sprint, 210
Staircase, The, 271, 272
Stapleton, Jean, 40
Star, Darren, 51

Star Trek: Voyager, 301
Star Wars, 162
Starsky and Hutch, 45
Starz, 88
Stassinopoulos, Arianna, 93
Stern, Howard, 62, 63
Steven Universe, 187
Stewart, Jon, 168
Still Talking (Rivers), 70–71, 73
Stoltenberg, John, 116
Stone, Laurie, 144
Stone, Matt, 161
Stones, The, 285
Straight Outta Compton, 243
Strain, The, 251
Streep, Meryl, 330
Streisand, Barbra, 323, 346
Strut, 329
Sundance, 22, 60
Sunkist, 214
Sunset Boulevard, 317, 335
Swanberg, Joe, 205
Switched at Birth, 105
Syed, Adnan, 271

T

Talladega Nights, 216
Tambor, Jeffrey, 327
Tarantino, Quentin, 293
Tate, Sharon, 120
Taxi, 3
Taylor, Elizabeth, 70
Taylor, Rachael, 261
Teen Jesus, 288
Television Without Pity, 17, 18
Tennant, David, 260, 262
Tequila, Tila, 163–65
Theroux, Justin, 193
Thin Blue Line, The, 271
30 Rock, 102, 103, 105, 178, 209, 212–14,
 216–21, 224, 234, 296
This Is My Life, 101
Thomas, Danny, 39

Thomas, Josh, 151
Thomas, Marlo, 109
Thompson, Candace, 204
Thorson, Scott, 265–68
"Tick" (High Maintenance), 202
Till Death Us Do Part, 39
"Time of Her Time, The" (Mailer), 68
Titters, 91, 93
TiVo, 11, 208
Toback, James, 111, 128, 333
Tolan, Peter, 285
Tonight Show, The, 69, 70
Tooken, 103
Top Chef, 218
Top of the Lake, 22, 60, 105, 149
Toyota Yaris, 207–8, 222
Trainwreck, 92
Traister, Rebecca, 167
Transparent, 142, 149, 181, 244, 287, 292,
 320, 326, 327
Trillin, Calvin, 119
Trow, George W. S., 6, 16, 17
True Detective, 56–61, 97, 182, 251, 322
"Triumph of the Prime-Time Novel,
 The" (McGrath), 7
Trump, Donald, 110, 141, 158–70, 197,
 201, 244, 247–48, 293, 298, 303, 318,
 327
Trump, Donald, Jr., 165
Turner, Kathleen, 179
24, 90, 211
Twilight, 262
Twin Peaks, 3
Twitter, 160, 165, 170, 197, 227, 244, 307
Tyson, Cecily, 123
Tyson, Mike, 258

U

Ullman, Tracey 285
Unbreakable Kimmy Schimdt, 102–6
Uncommon Women and Others
 (Wasserman), 75
Unreal, 86

Updike, John, 132–35, 154
Urman, Jennie Snyder, 172
"USS Callister" (Black Mirror), 205

V

Van Der Beek, James, 327, 328
Van Gogh, Vincent, 153–55
Van Meter, Jonathan, 64
Van Sant, Gus, 287
Vanderpump Rules, 81–85
Vanity Fair, 109, 113
Variety, 39, 41
Veep, 88, 244
Verizon, 216–17, 219, 221
Verrone, Patric, 210, 215
Versace, Gianni, 314, 317, 337
Vidmar, Neil, 43
View, The, 212
Vimeo, 181, 203

W

Waithe, Lena, 246
Walden, Dana, 338, 342, 347
"Waldo Moment, The" (Black Mirror),
 167–69
Wallace, David Foster, 6, 19, 147
Waller-Bridge, Phoebe, 142
Walter, Marie-Thérèse, 154
Ward, Pendleton, 189, 190
Warner, Malcolm-Jamal, 231
Washington, Kerry, 89
Wasserman, Wendy, 75
Waters, John, 313
Wayne's World, 216
WB, The, 22, 229, 230, 319
We Killed: The Rise of Women in American
 Comedy (Kohen), 69
Weeds, 211, 279–82, 285–88, 290, 292–93,
 296, 299, 300
Weiner, Matthew, 287–89, 299–300
Weinstein, Harvey, 107, 110, 128, 143,
 150, 332, 347

West Wing, The, 90
Whedon, Joss, 7–9, 18, 26, 220–22
Whitaker, Mark, 126
White, Mike, 79, 80
"White Bear" (*Black Mirror*), 196
"Whitecaps" (*The Sopranos*), 35
Why Can't I Be Audrey Hepburn?, 331–32
Widows of Eastwick, The (Updike), 132, 135
Wife Swap, 82
Will & Grace, 235, 283
Willis, Ellen, 145
Wilmore, Larry, 233, 245, 247
Winn, Marie, 6
Winslet, Kate, 64
Wire, The, 14, 19, 181, 182, 185, 209, 287, 301
Wit & Wisdom of Archie Bunker, The (Lear), 42
Witches of Eastwick, The (Updike), 132–34
"Within the Context of No-Context" (Trow), 6
Without Feathers (Allen), 107
Wolf, Dick, 26, 255, 256
Wolf of Wall Street, The, 59
Wolitzer, Meg, 101

Wolov, Julia, 137–39, 143, 150
Women Against Pornography, 113–15, 118
Wonderfalls, 251
Wood, Robert, 40
Woodall, Alexis Martin, 336
Wright, Robin, 87, 89
Writers Guild of America (WGA), 210, 215

X

X-Files, The, 5, 26, 183

Y

Yorkin, Bud, 39
Younger, 101
Your Show of Shows, 178
YouTube, 13, 210

Z

Zam, Michael, 336
Zoller Seitz, Matt, 143–44
Zook, Kristal Brent, 229
Zucker, Arianne, 167

PHOTO: © CLIVE THOMPSON

EMILY NUSSBAUM is the television critic for *The New Yorker*. In 2016, she received the Pulitzer Prize for Criticism. Previously, she wrote for *The New York Times, New York* magazine, *Slate, Lingua Franca,* and *Nerve.* She lives in Brooklyn with her husband, Clive Thompson; her two sons, Gabriel and Zev; and a variety of screens.

emilynussbaum.com
Twitter: @emilynussbaum